PRAIRIE RADICAL

A Journey Through The Sixties

Robert Pardun

SHIRE PRESS

For Jody, Jesse, and Heather
who inspired this book
with their questions.

Library of Congress #: 01-131028
ISBN: 0-918828-20-1

SHIRE PRESS
26873 Hester Creek Road
Los Gatos, CA 95033
(408) 353-4253

Contents

Making history isn't like reading about it in a book. There is no table of contents or index, and you can't skip ahead to see the future. You make decisions and do what you think is right. If, in fact, you're making history, you'll learn about it later.

Robert Pardun

Introduction

"Those not busy being born are busy dying."

Bob Dylan, *It's Alright*

The sixties was a decade of change – social change, political change, and personal change. A generation of young people challenged the existing order around issues as important as legal segregation in the South and the mass murder that was taking place in Vietnam, and as petty as hair length and dress codes. Those in authority – parents, school administrators, police, the FBI, legislators, and presidents – resisted that change. The result was a conflict that divided the nation in much the same way the Civil War had done a century before. The sixties changed America – and it changed those of us who lived through it. I was part of that generation.

Prairie Radical is the story of my journey through the turbulence of the sixties. Like the majority of my fellow activists, I had no family heritage of political involvement. My parents voted Republican, although they rarely talked about such controversial topics as politics or religion. To my knowledge, there were no closet socialists in my family.

I was born in Kansas in 1941 and grew up during the 1950s in Pueblo, Colorado, home of the largest steel mill west of the Mississippi. I went to public schools and attended Pueblo Junior College before transferring to the University of Colorado. I was raised in the shadow of the growing Cold War with its fear of both communism and the threat of nuclear annihilation. I believed the United States was the greatest nation on earth – and was proud of its devotion to freedom, independence, liberty, democracy, and equality. I was taught and believed that it was not just my *right* to speak out against injustice, it was my *duty* as an American citizen.

In September 1963, when I arrived at the University of Texas in Austin as a graduate student in mathematics, I would not have described myself as a radical. I was concerned about world events and had been following the civil rights movement in the South, but I had never been in a demonstration or spoken out publicly about any controversial issue.

All that changed during the fall when I encountered the reality of segregation. Soon after, I learned that my government had actively supported French colonialism in Vietnam and was continuing to support a brutal dictator there. I believed it was important to make America live up to its ideals, and as I expressed my opinions publicly, I began a journey that took me into the heart of the student movement and the political and social turmoil of the time.

Later that fall I learned about Students for a Democratic Society (SDS), an organization concerned with civil rights, poverty, unemployment, university reform, and the growing Vietnam War. I joined and was one of the founding members of the SDS chapter at the University of Texas. SDS's politics were based on a set of values about the worth and dignity of individuals and it offered a vision of participatory democracy – people being involved in the decisions that affect their lives – that resonated with my generation. Within a few years SDS would become the largest student organization of that decade, with over 100,000 members and 400 chapters. The Austin chapter quickly became one of the most active and innovative chapters in the country.

Following a spring of civil rights activity in Austin, I volunteered for Mississippi Summer in 1964 and became part of the White Folks Project. In 1964-65, I was asked to become a regional SDS organizer and later an SDS anti-draft coordinator. As more and more SDS chapters formed at state colleges and universities in the American heartland, the new energy we represented – a mixture of direct action politics and cultural rebellion – became known as "prairie power." While these changes weren't limited to the prairie states, they represented a broadening of SDS to include more students from working class backgrounds and gave us reason to hope that we could build a broad-based movement that would change America.

The political movement and the counter-culture are often treated as if they were separate creations of the sixties, but they are really different ends of a spectrum of ideas about how to change the world. In Austin, as in many other places, the political radicals and the cultural radicals were overlapping parts of the same community, resulting in a movement that was very experimental as it challenged authority and tried to change the world. We believed that politics should be fun and that breaking down people's social barriers was as much a part of politics as a demonstration or handing out leaflets. In Austin, this political/cultural mixture developed such successful organizing strategies as "Gentle Thursday," "Flipped-Out Week,"

and "Mother's Grits Austin Anarcho-Terrorist New Left Beatnik Evangelical Traveling Troupe." Along with these came counter-culture institutions such as the *Rag,* one of the early underground newspapers, the Milo Minderbinder Memorial Food Coop, the Critical University, and Greenbriar School.

In June 1967, I was elected to be Internal Education Secretary of SDS and spend the next year in the SDS national office. During that year, opposition to the war in Vietnam exploded across the country. The Vietnamese launched the Tet offensive that took Americans by surprise. Martin Luther King and then Bobby Kennedy spoke out against the war and were assassinated. Black insurrections rocked the nation. The FBI launched its Counter-Intelligence Program, COINTELPRO, with the intent of destroying the anti-war and black liberation movements. I watched as all these events unfolded – and was in the midst of the action as the antiwar movement grew larger and more militant in response. I also observed the growing divisions within SDS that would soon tear it apart.

As SDS was being destroyed by a combination of ideological battles, sectarianism, the FBI, and the unrelenting pressure of the war, the counter-culture was expanding and experimenting with different forms of community. I joined this growing counter-culture and spent from 1971 until 1976 trying to build a community based on movement values of cooperation, sharing, and respect for one another on a rural commune in the Ozark Mountains of Arkansas.

I began writing this personal history in response to questions from my children and their friends. They knew that something important had happened during the sixties, but the images gleaned from the popular culture were disconnected and lifeless. They wanted to know what it was like to live through that period, so I told them what it was like for me. I tried to create the fabric of the sixties – the swirl of events, the ideals, the moral crises of racism and the Vietnam War, the decision to act in the face of danger, and the nation-wide community of people who were trying to make the world a better place. Although I began with my personal stories, there were times when I needed outside information to set the context or fill in the background to help them understand what had happened.

Their interest prompted me to read more about the era and I discovered much that we didn't know at the time. Memoirs of high ranking government officials and the White House tapes of

Presidents Kennedy, Johnson, and Nixon reveal what was going on behind the closed doors of the White House and the Pentagon. As I began to write *Prairie Radical*, I incorporated some of that information where it helped clarify my story. Using the Freedom of Information Act, I obtained highly censored copies of some of my FBI and police files.[1] These, together with other files that have been released, provide details of the unconstitutional actions that were taken to destroy the movement. Since these agencies had informants taking notes at meetings, these files also contain forgotten details of discussions, copies of leaflets, papers I wrote, speeches I gave, and other information that I thought had long been lost. Where relevant, I have included information from all these sources to create a braided history of the sixties with my experience as the central thread.

Finally, I have refreshed and supplemented my memories with those of old friends and fellow activists – people who were as deeply involved as I was. I also had the privilege of being present at some seventy hours of interviews with nearly thirty SDS members for the documentary film, *Rebels with a Cause*, by Helen Garvy.[2] These conversations about SDS and the sixties were of great value in filling in details.

The national movements of the sixties and seventies, while they had a life of their own, were made up of thousands of local movements, each with its own story – and each, in turn, made up of individuals who tried to change America and, in the process, were themselves changed. *Prairie Radical* is a local, regional, and national history of SDS and the movement told from the point of view of one of those activists. I have never regretted my involvement in the movement. I spoke out against injustice and tyranny then and I continue to do so now. *Prairie Radical* is the history of the sixties that I remember. I have tried to make sure that it is factually correct, but memories fade. Others who lived through the same time may have a different perspective on the collective dance we call history. I encourage them to tell their own stories.

Growing Up on the Prairie

> "And the children go to school...and then to the university; and they all get put in boxes, and they all come out the same."
>
> Malvina Reynolds, *Little Boxes*

I was born on June 30, 1941, in Wichita, Kansas, where my father had been a welfare worker during the Depression. When World War II began he gave up his job-related military deferment and joined the Navy to fight fascism. Soon after I was born, my mother, my older sister Barbara, and I moved to Walnut, Iowa, to live with my mother's parents while we waited for the war to end.

My mother's family was an extended clan of hard-working farmers, the descendants of peat cutters who had left Germany in the 1870s and settled in what was then a swamp in southwest Iowa. Over the years, they dug ditches to drain the water and built prosperous farms on the eighty feet of topsoil that lay beneath. Walnut was one of numerous small towns scattered across the Midwest where the local farmers came to buy supplies, sell their corn and pigs, have their machinery repaired, or just sit and talk about the weather over a cold beer. My grandparents, Gus and Della Sievers, lived in a big old house in Walnut and when we walked the few blocks downtown to shop, it seemed like I was related to everyone we met.

When my grandparents moved into Walnut, my uncles Herb and Bus, took over the day-to-day operation of the family farm. Before the war the farm was worked with horses and hired hands, but when Herb was drafted into the army, Bus bought a tractor so that he could run the farm by himself. The family farm, with its creaking windmill, the barn, corncrib, pigs, and endless fields of corn, wasn't far from Walnut and I spent a lot of time there playing with my cousins. The farmhouse was old and drafty with a pitcher pump in the kitchen to draw water and an outhouse down by the pigpen. A

big pot-bellied stove kept a couple of downstairs rooms warm, but water froze in the upstairs bedrooms during the cold winter nights.

My dad was the only son of a Methodist preacher, William, and his wife Etta, who everyone called Mimi. My dad knew little about his ancestors except that on his father's side they were supposed to have been desperately poor and on his mother's side they were quite prosperous. The difference between my parents' families was striking. The German farmers on my mother's side liked to play jokes, tell dirty stories, and drink beer, while my father's parents were pious, self-righteous, and proper to the point of coldness. They never drank alcohol, told dirty jokes, or danced – and disapproved of anyone who did. My dad enjoyed my mom's family more than his own and avoided spending much time with his parents.

My mother's family: Gilbert, Herb, grandma Della, my mother Ruth, grandpa Gustav, and Everett, known as Bus.

My memories of Iowa are like a series of disconnected snapshots. I remember going to the hospital when my brother, Jim, was born and waiting in the hall because children weren't allowed inside. I can still see my uncle Herb crawling around on the floor of his bedroom one morning searching frantically for a weapon. It was July 4th and firecrackers were going off outside his window. Herb had been in North Africa and then in the Allied invasion of Italy during World War II. At Anzio, everyone around him was killed and something had snapped. After months in a military hospital he came home to Walnut, just before the Fourth of July. I remember Herb better from

later years, after he had married Beryl, one of his nurses from the army hospital, and my grandfather had bought him a farm close to the family farm. He was quiet and gentle. I always liked visiting him.

I remember the elation when the war ended. We burned the ration books of government coupons that had been required to buy everything from butter and whiskey to tires. Automobile production had been stopped during the war as the factories switched to war production, so when the first new Chevrolet drove down the street in 1946, we all ran out onto the front porch to see it. The war was really over!

I don't remember my dad coming home or leaving again to find us a house in Pueblo, Colorado, where he had gotten a job with the Veterans Administration. I do remember driving to the railroad station and boarding a train going to our new home somewhere in a place called "the West." It was 1946. I was almost five.

Me at age 5.

We arrived in Pueblo in the middle of the night and took a taxi to our new house. I wandered slowly through the rooms with dirty torn wallpaper, cracked windows, and bare light bulbs hanging from cords. My mom cried because the place was such a mess. This was

the only house my dad could find and afford because the demand for houses was high after the war.

The house was old and not tightly constructed, a lot like the old farmhouse in Iowa. We had a central gas furnace, but all the heat came out of one large grate in the living room floor so most of the house was cold in the winter. This was especially true when the temperature dropped to as low as thirty below zero In the winter, thick frost formed on the inside of the windows and I drew pictures in it with my fingernail as I sat eating breakfast. But compared with the old farmhouse in Walnut, this was an improvement – at least we had indoor plumbing. When we remodeled the kitchen, the newest part of the house, we found the walls stuffed full of crumpled up 1903 newspapers for insulation.

In 1946, our street was on the edge of town. A few blocks to the west, the streets ended and there was nothing but prairie stretching forty miles to the Rockies. The open prairie was a wild area of arroyos and cliffs, dry grasses, yucca and cactus – full of endless places to explore.

The wind that blew in from the prairie whistled in around the loose windows leaving a fine layer of dust on everything. Dust devils, sometimes a hundred feet high and full of swirling dust, tumbleweeds, and pieces of paper, came into the neighborhood from the prairie, following the dirt streets. Sometimes we would jump into them with outstretched arms to make them collapse. We rode bicycles at every opportunity. From the time I was ten or twelve I would go out alone onto the prairie and stay all day, walking in the arroyos and canyons and climbing the cliffs. I spent hours catching grasshoppers and horned toads. I learned to read the prairie and find the animals that hid by being still. Once, as I climbed up onto a narrow rock ledge overlooking a canyon, I came face to face with a gray fox. It sat watching me as I settled in about five feet away and we sat quietly together for a long time listening to the wind whisper. Another time I walked up on a mountain lion. She disappeared so quickly and silently that she seemed to evaporate. The love of nature and the desire to live with it have always been strong parts of my life.

When we moved to Pueblo in 1946, there were about 60,000 people living there. When I left in 1961 there were about 100,000. The Arkansas River, which flows through Pueblo, was the southern boundary of the Louisiana Purchase in 1803. The north bank became part of the United States while the south bank remained in

Mexico until 1848 when the US took a large piece of land from Mexico.

While I was growing up, the river still divided Pueblo along class and ethnic lines. The Colorado Fuel and Iron steel mill, the largest steel mill west of the Mississippi, was on the south side of the river and most of the mill workers lived there. Pueblo was multi-ethnic. There were many people in Pueblo with Spanish surnames and most of them also lived on the south side. A sizable Eastern European community with roots in Poland, Russia, Czechoslovakia, and Yugoslavia lived near the steel mill. There was also a large Italian community, some Greeks, and a few blacks[3]. The south side had a reputation for being more bare-knuckled than the more upscale north side. I grew up on the south side with well-paid steelworkers, members of the United Steelworkers Union, as well as people living below the poverty line. There were two black families on my block and for a time, the Ramirez family, who owned La Tolteca Tortillaria, Pueblo's tortilla factory, lived next door. The woman who lived at the corner was a prostitute, but no one complained. Fairly often the local cop would park his police cruiser around the corner and walk over to check up on her. There were two families on my block with deaf parents. I grew up knowing who all the racial and ethnic slurs referred to. Wops, Dagos, Beaujohns, Messicans, Kikes, Spics, Greasers, Niggers, and Shit Kickers all lived in Pueblo and generally got along. and all the kids played together.

Most of the people in my neighborhood knew how to build and fix things and I grew up knowing that I could do that too. When I was ten I took apart the engine of my dad's brand-new lawnmower because it wouldn't start. I freed a stuck valve, put it back together, and when he came home it was running. He was amazed that I had fixed it but it never crossed my mind that I couldn't.

When I was a teenager, my father told me he was glad he had moved into that neighborhood because it was a good place to grow up. He liked the fact that there were people from different races and backgrounds. He described himself as a conservative Republican, which meant to him that he strongly believed in the conservation of the rights given to the people by the Constitution and the Bill of Rights. His beliefs were more than lip service. One evening he received a phone call from a neighbor who wanted to let him know that my sister had walked home with one of the black neighbor boys. Barely containing his anger, my father told her clearly that it was none of her business who Barbara walked home with. After he

had hung up, he told me that discriminating against people because of their race was wrong. When my father joined the faculty at Pueblo Junior College, he learned Spanish because Pueblo had a large Hispanic population. In an era when Anglos pronounced names like Trujillo and Jimenez as if they were English, he made a point of pronouncing them correctly.

In many ways, my generation and my parents' generation lived in two different realities. For them, the late 40s and the 50s was the realization of the American Dream. They had come out of the Depression and World War II with the fear that another depression might follow. Instead, there was an era of prosperity fueled in part by the creation of the "Cold War," which stimulated the economy with war production during a time of relative peace. Until I was ten or twelve, my mom used an old wringer washer and set aside all day Monday to do the laundry. The junk man came down our street in his horse drawn wagon looking for scrap metal and the ice truck still came to supply the iceboxes. We had a vegetable garden and mom canned lots of food for the winter. We had a flock of chickens for both meat and eggs. My mom was in charge of buying the chicken feed because the bags were made of cloth that could be turned into shirts and pajamas for Jim and me. In 1953, after being married nearly twenty years, my parents bought their first car, a 1941 Mercury. Modern technology replaced the icebox with a refrigerator, and the old washing machine with an automatic washer and dryer. The supermarket had fresh fruit and vegetables all year long, and clothes were almost as cheap to buy as to make. For my parents' generation the 50s was a decade of amazing inventions that made life easier. After growing up during World War I and the Roaring Twenties and going through the economic crash of 1929, ten years of depression, and another five years of World War II, the 50s was the longest period of peace and prosperity they had ever known.

For me, growing up in the 50s was like being in both a wonderland and a wasteland. Teenagers during the 50s were called "the silent generation" because we seemed apathetic and uninvolved in the world around us. Given the Cold War, the threat of nuclear holocaust, and the memory of the McCarthy anti-communist hearings, it seems a better name would have been "the intimidated generation." There was an overwhelming sense of sameness, a sense that the future was planned, and that it was dangerous to stand out.

The late 1940s and the 1950s were a time of great contradictions

in America. We had the strongest economy and the most powerful military in the world and yet we lived in fear of communism and nuclear war. We were in a race with the Soviet Union to see who could build the biggest bomb, put the first satellite in orbit, and best educate our youth in mathematics and science. I grew up learning that communists were evil and their goal was world domination and the subjugation of all people. This message came through television shows, such as *I Led Three Lives: Citizen, Communist, Counterspy*, and through Congressional hearings investigating communist activity in the US. Loyalty oaths were required of government employees, including university professors, and those who objected and refused to sign lost their jobs. The atmosphere of fear and intimidation that settled over the country quieted dissent of any kind.[4]

I grew up thinking of war as glorious, but the Korean War gave me a different perspective. In 1952, when I was eleven years old, my sister became engaged to a young man who had just been drafted and was headed for Korea. When he got there, he sent me Korean newspapers, propaganda leaflets, and Korean money. He also sent love letters to my sister and, being a typical little brother, I waited for the opportunity to sneak a look at them. One day a letter arrived that greatly upset my sister and she hurried off to her room leaving the letter on the table. Of course, I immediately read it. It had been written at night after a battle and concluded with something like,

> It is night now and we have fought against the enemy all day with many casualties. They came before dawn this morning in wave upon wave with horns blowing. Most of them didn't even have guns, they just carried sticks and we shot them down as they came over the ridge toward our trenches. Then they were in the trenches with us and we fought them hand to hand until they retreated. They've been blowing the horns all night and will attack again at dawn. I hope you get this letter because it may be my last.

Below the signature was a note saying that they had retreated during the night and were safe. Suddenly war became a little more real and a few weeks later, when a documentary on Korea played at the local theater, I went to see it, hoping that I would learn more about what the war was about. Instead, the footage of bombed out villages, homeless families, and destroyed farms only made me more confused. People armed only with sticks had to have some reason for fighting the US military, but the only reason given was that they were communists or had been "brain-washed" by the communists. I knew that there had to be more to it than good versus evil, but not

knowing anything about the history of Korea meant that the war had no context.

As the Soviet Union and the United States raced to see who could make the most powerful atomic weapon, the fear that someone would push the button and annihilate us all became very real. There were articles in the paper with maps showing the potential targets in Colorado. Denver, a hundred miles north, was a prime target because of its industrial and communications base. Colorado Springs, forty miles north, had the central nervous system of the entire North American Air Defense system buried under Cheyenne Mountain. Pueblo had the steel mill, the ball bearing plant, and the ammunition storage depot. If war came it would be one big nuclear explosion all the way down the east side of the Rockies. Even without nuclear war, there was the reality of nuclear fall-out as the US tested and developed its arsenal by setting off atomic and then hydrogen bombs above ground in New Mexico and Nevada.

Starting when I was in grade school, we had regular air raid drills. We crouched down under our desks and covered the backs of our necks with our hands to protect ourselves from falling debris and flying glass. As I read about nuclear explosions, it became clear that hiding under the desk wasn't going to save me from nuclear bombs. The schools must have come to the same conclusion because they gave each of us "dog-tags" to wear on a chain around our necks. I don't know what possessed them to do this, but it didn't make me feel more secure knowing they would be able to identify my charred remains.

By the mid-fifties, everyone knew that the only way to escape a nuclear bomb was to get out of town. When I was in high school, there was an attempt to test evacuating all the students in Pueblo to a safe location. The assumption was that we would have two hours from the time the sirens went off to get out of the blast area. On the designated day, the parents, who were waiting at home with full tanks of gas, got in their cars, drove to the schools, and lined up to pick up the students. We all filed out in an orderly fashion, got into the waiting cars and school buses, and joined a traffic jam moving very slowly out of town. We drove toward the mountains, hoping to make it over the first big rise about ten miles from Pueblo. I sat in a car in the middle of the line and could see the first cars just getting to the top of the hill when the time was up. I looked back and imagined the mushroom cloud rising over the steel mill and the shock wave that would kill us all in a few seconds. The knowledge

that there was no escape from nuclear war made the future seem surreal – and made the present more precious.

One of the effects of the Cold War was that it tended to put issues into a black or white, right or wrong duality. The evils of communism contrasted sharply with the goodness of the United States. The USSR was a dictatorship; we were a democracy. Communists didn't believe in freedom of speech, of the press, or of assembly – and those were the ideas that made America great. America's self image as the country supporting freedom, democracy, and fairness for the little guy was taught in the schools and by the media. At the movies, we watched American heroes fighting the evil Germans or Japanese during World War II, or the cowboy with the white hat preventing the rich ranchers from forcing the poor farmers off the land. Robin Hood and Zorro helped the poor as they fought to end the oppression of those in power. I grew up knowing that America was on the side of goodness and helping the downtrodden – and that it was the greatest nation on earth because of that.

In my history and civics classes I learned that democracy, "government of, by, and for the people" requires the active participation of people in their government. The Bill of Rights was added to the Constitution to guarantee the right of the people to speak out against tyranny. History classes all tended to begin with Columbus and then moved on to colonial America, the American Revolution, and the Civil War. We learned from the Declaration of Independence that people have the right of revolution and the right to govern themselves. From the Civil War, we learned about the evils of slavery and about the constitutional amendments that guaranteed freedom to the former slaves. We didn't learn that these rights and freedoms had been, and still were, denied to many Americans because of their race, class, or political affiliation.

By the time I got to high school, I had begun to question what I was being told. The words "communist" and "communism" were used to connote some form of evil. People were accused of being communists or of following communist ideas; organizations were denounced for being "communist infiltrated." I knew that communism was a powerful force in the world, but I couldn't understand why people were attracted to it if it was so bad. I found a book at the public library containing some of the writings of Marx and Engels including the Communist Manifesto. I was afraid to check the book out on my card, so I spent several days reading it in the library. I found the ideas very interesting. Marx talked about

capitalism and the concentration of power in the hands of a few wealthy people. These people were rich because they paid the people who worked for them less than the value of the goods they produced and kept the surplus for themselves. The concept of "class struggle" made sense to me, since many people in my neighborhood were steelworkers and strong supporters of the union. While I was growing up, there were several strikes and my friends' dads would discuss the issues. I had overheard many discussions about the conflict between the steel mill's owners and the workers.

Marx's ideas and his description of life in the utopia called "the classless society" also intrigued me. Marx wrote that under capitalism a person was defined by his occupation, but under pure communism a person could be many different things – a farmer in the morning, a scholar in the afternoon, and an artist in the evening. This concept of living a seamless life that was an integration of various interests rang a bell with me since I was feeling the social pressure to become something specific – a mathematician, for example. I wanted to live a life where I could pursue intellectual activity, work with my hands, and spend time outdoors.

Religion, according to Marx, was used to turn people's attention away from the real problems of society. I had grown up going to church every Sunday with my mom, but I had begun to question what I was being taught there. I had recently written an essay for my French class titled, "Si Dieu existe, son plus mauvais ennemi c'est l'église" (If God exists, his worst enemy is the church) and had quit going to church. When the church gave food to poor people at Christmas it made the church members feel good but didn't do anything to eliminate poverty. From what I had read, Marx's ideas seemed to describe reality as I knew it. I hadn't found anything that made me think of communists and Marxists as evil people. I wondered if real communists believed something different from what I had read.

During the 1940s and 1950s many European colonies in Africa and Asia became independent. In some cases the European colonizers oversaw a peaceful transition to independence, but in many cases the colonies won their independence only after prolonged guerrilla wars. I was very sympathetic to the struggles of colonized nations for independence because the United States had gone through the same process. Part of the rhetoric of World War II was that America was fighting for an end to tyranny and for freedom and democracy around the world. To me this meant that the

colonies had the right to be free and independent. One of these struggles would later become especially significant to the movements of the sixties – the war between the Viet Minh and the French over control of the part of French Indochina called Vietnam.

I followed the growing struggle for social equality in the South with interest. I grew up playing and going to school with blacks and I was shocked when I learned how whites treated blacks in the South. The images of white adults attacking black children in Little Rock, Arkansas, when the high school was forced to integrate in 1954 horrified me. I couldn't understand how a system that so blatantly contradicted the American ideals of freedom and equality could continue to exist. It's not that there was no racial and ethnic tension in Pueblo. The country club was segregated and there were probably restaurants and bars that refused to serve some people, but I never saw anyone denied service because of their race.[5]

I graduated from high school in 1959 near the top of my class. I was good at math and science and planned to be a math major in college. I spent the summer before college in Albuquerque hanging sheetrock with my brother-in-law. When I returned to Pueblo in the fall, I registered at Pueblo Junior College (PJC). My father had joined the faculty at PJC in the late 1940s and helped transform it from a cluster of Quonset huts and industrial shops into an academically accredited two-year college. PJC provided an affordable education to working class and poor people – the people I had grown up with – who would never have considered going away to college. I grew up going to all of PJC's basketball games, seeing all the plays produced by its drama department (the only live theater in Pueblo) and going with my dad on faculty fishing trips. There was never any question about where I would go to college for my first two years. So, even though I had a full tuition scholarship for any school in Colorado, I registered at Pueblo Junior College.

I quickly made friends with Gerry Perko, Jerry Miller and Mike McNair, people I knew from high school but who hadn't been close friends. We went fishing on weekends and spent a lot of time drinking beer. When we couldn't think of anything better to do, we'd load the car up with Perko's guns and go out on the prairie to shoot cans or to the city dump at night to shoot rats. After classes we often went to the Third Street Cigar Store to shoot pool. There was no attempt to hide the fact that, in reality, this place was an illegal betting parlor. Across the room from a long case full of cigars was a chalk-board about twenty feet long and ten feet high with the

names, odds, and results of every ball game, boxing match, and horse race in the country. The phones rang continually and on several occasions I saw the neighborhood cop pay for a cigar with a dollar bill and get change for a twenty.

One weekend, Mike and I went fishing at a lake south of Pueblo. On the way home we pulled off at a monument commemorating the massacre of striking miners and their families at Ludlow in 1914. Eleven thousand men had gone on strike in the Colorado Fuel and Iron coal mines at Ludlow. The Rockefeller family, who owned the CF&I, hired a private army to break the strike. When the strikers refused to back down, the governor of Colorado had sent in the National Guard. The miners were living in a large camp near the mines and they and their families were asleep in their tents when the National Guard opened fire with machine guns and then set fire to the camp. Twenty-five people were killed, many of them women and children. The miners took their guns and retreated into the hills. Union sympathizers from across the country began to pour into the area to support them. President Wilson sent in federal troops to restore order, but the fighting went on for weeks. In the end the strike failed and sixty-six men, women and children had been killed. I didn't remember hearing this story in any of my history classes.

I did well academically at PJC, but I felt like I was on a treadmill going somewhere that was out of my control. I was expected to graduate from college, get an advanced degree, and then go to work for some company – but I wasn't sure that was what I wanted. When my father started a seminar on values clarification, I joined it to see if that would help me get my bearings. We read *The Organization Man*, *The Man in the Gray Flannel Suit*, and *The Lonely Crowd*, all of which are about people who lose their identities in becoming part of large organizations. Reading about the fate of most college graduates made me realize how strongly I believed in being an individual. I wanted to be part of something real and of value – although I had no idea what that was. I was not interested in becoming a cog in a machine. I identified with Thoreau's statement, "If a man does not keep pace with his companions, perhaps it is because he hears a different drummer. Let him step to the music which he hears, however measured or far away." About the same time I found a copy of Alan Ginsberg's poem, "Howl," and read it over and over. I didn't understand most of it, but it spoke to my alienation. I had felt that there was something wrong with me, but after reading "Howl" I began to think that maybe there was

something fundamentally wrong in American culture, even if I didn't know what it was.

My family, 1958: me, Jim, mom, dad, Barbara, and her husband Bob.

I followed the presidential election in 1960 because of the difference between the candidates. John Kennedy had a positive vision and it was exciting to hear a candidate appeal to the idealism of American democracy. Those of us who were looking for meaning in a materialist culture listened carefully when Kennedy said, "Ask not what your country can do for you – ask what you can do for your country." I would definitely have voted for Kennedy, but I was only nineteen and the voting age at that time was twenty-one.

In the fall of 1961, I transferred to the University of Colorado in Boulder. During my senior year, in October 1962, the US discovery of Russian missiles in Cuba led to a nuclear showdown between the US and the USSR – the Cuban Missile Crisis. In April 1961, Cuban refugees, with help from the CIA and the US military, had tried to invade Cuba to overthrow the government of Fidel Castro. It had been a miserable failure, but Castro was aware that the CIA wanted to try again and he wanted Russian missiles to protect Cuba. The United States blockaded Cuba and it looked quite possible that there could be war, possibly nuclear, over the issue. When I went to my

Sociology of War class on the first day of the crisis, the professor showed films about nuclear bombs and their effects, including footage of Hiroshima and Nagasaki and the human victims of those bombs. At the end of the class the professor announced, "If somebody pushed the button two hours ago, you'll be vaporized when you walk out the door." The fact that we were talking about a real nuclear crisis added to my sense that the world was out of control.

Jerry Miller, Gerry Perko, and me. Pueblo Junior College, 1961.

During the four years that I was in college, I spent most of my time studying, drinking beer, and hanging out with friends. I followed the news coverage of the student sit-ins in segregated restaurants when black students sat down and refused to leave until they had been served. This sit-in movement had spread across the south, and in some cases, had turned violent when mobs of whites attacked the non-violent students. I watched the evening news as integrated groups of people rode buses into the segregated South and were met by violent mobs in Alabama. During the spring of 1963, the Birmingham police turned fire hoses on people demonstrating against segregation. I had never seen a demonstration except for union picket lines in Pueblo during strikes. The civil rights movement in the South was growing, and although I supported it intellectually, it was far away.

As I got close to graduation, I had no clear idea of what I wanted to do so I checked out several options for the future. I applied to a number of graduate schools and also considered dropping out of

school for awhile. I assumed that if I quit school the military would draft me, so I talked to the Air Force recruiter. None of the choices were compelling, but a one-year commitment to graduate school was easier than a four-year enlistment in the Air Force, so when the University of Texas offered me a teaching assistantship in mathematics, I accepted the offer. I had been dating a young woman named Sharron for three years, and asked her to come to Texas with me. I wasn't surprised when she turned me down because we both felt uneasy about the future. She didn't know what she wanted to do either and didn't want to get trapped.

Before I entered graduate school, I spent the summer taking the courses that Texas required for admittance. Along with a course in American government, I took a course on the history of China and Japan taught by an American who had moved to Shanghai in 1921 and lived there until 1950. He had met both Mao Zedong and Chiang Kai-shek and had interesting stories to tell about them. One day he showed an American newsreel from the late 1920s about the struggle for power in China. The commentator identified the dozens of bodies in the street as having been killed by the communists. But the professor told us that he had been there at the time, and that the dead people *were* the communists. Chiang Kai-shek's army had pulled people out of their beds, taken them to the street, and executed them there. He described how bad the living conditions were for peasants and working people in China during that period, and he talked about Mao Zedong and the program of the communists. This was the first time I had ever heard anyone describe real communists as human beings and communism as a positive program to create a better world for ordinary people. Although I had read the Communist Manifesto and agreed with much of it, all I had ever heard was that communism as practiced was evil. Now I wondered what the truth really was.

To support myself that summer I got a job as a bartender at the American Legion, an organization of people who had served in the armed forces. One afternoon a lone customer sat at the bar, drinking steadily and telling stories about hand-to-hand combat during World War II. After six or eight drinks, he told me to come out to the dance floor so he could teach me some Judo. I refused but when he came behind the bar to get me, I knew he was serious. He took a little two-inch knife out of his pocket, handed it to me, and told me to try to stab him. I made a half-hearted lunge and he grabbed my wrist with one hand, put the other in my armpit, and flipped me off

my feet and onto the floor. After several more tries, he took the knife and said he'd show me how to do it. He came at me slowly and I grabbed his wrist, put my other hand in his armpit and we both fell into a pile on the floor. We got up laughing and he said, "One more try." This time I successfully threw him away from me, although he didn't fall down. He told me I'd had enough practice and that this time if I didn't stop him he'd stab me." Before I had time to think about escaping, he lunged at me with the knife and I reacted the way he had taught me. The next thing I knew he was flying through the air and landed hard on his back. He lay there stunned for a minute. I helped him up and he congratulated me for doing it right. After finishing off his drink, he left and I never saw him again. This whole event seemed like just another surreal event in my life – I had no idea that I would soon need to use what I had learned.

In September I boarded a bus for Austin, wondering what it was going to be like to start over in a totally new town. I was sure things were going to be different.

— 2 —

Things Are Going to Be Different
Fall 1963

"How many years can some people exist before they're allowed to be free? Yes, and how many times can a man turn his head and pretend that he just doesn't see?"

Bob Dylan, *Blowin' in the Wind*

It was hot and sticky when I got off the bus in Austin, and for the first time in my life I was in a town where I knew absolutely no one. I got a room in the Alamo Hotel and stayed there a few days while I explored the city. Austin was beautiful and very different from Pueblo. It was green — with flowers, huge live oaks, and century plants with flower stalks shooting twenty feet into the air. There were lakes and creeks and hills, all within walking distance of the university. I was struck by the architecture of the old Victorian houses, which was very different from the south side of Pueblo. Although Austin had a population of about 200,000, it felt smaller than that. The tower at the University of Texas and the Capitol dome a few blocks away stood high above everything else and I used them as beacons to keep me oriented as I explored.

After a few days of getting to know the city, I began to look for a place to live. Since my teaching assistantship paid only $3,600 a year, I couldn't afford an apartment by myself. I had met some of my fellow graduate assistants, but they all seemed pretty boring, so I moved into an apartment with a couple of students from Amarillo. Since one was an art major and the other was in business school, I wouldn't have to talk about mathematics when I was at home. Our apartment overlooked Shoal Creek, about a mile from campus, so I bought a ten-speed bike to get to school and around town.

Austin seemed a lot more conservative and image conscious than Boulder, where many students dressed casually and rode bicycles. At the University of Texas (UT) the latest clothing styles, beehive hairdos, and heavy make-up were everywhere, but bicycles were rare.

1963

After I'd been in Austin a month or so, I went to a little bar near campus to watch the Texas-Oklahoma football game on television. I met a couple of guys there and we drank a few beers and talked. At some point the topic turned to communism and I was amazed when one of them advocated dropping nuclear bombs on all the major cities in the Soviet Union as a "pre-emptive strike" to keep them from attacking us. The concept of annihilating the Soviet Union and its people in one big nuclear explosion appalled me and I said something like, "Wow! That's pretty extreme. You know, Russians are people too." The bigger of the two guys, who outweighed me by at least fifty pounds, jumped up, called me a "dirty communist," and said he was going to beat the shit out of me. He grabbed me by the arm and pulled me out the back door toward the alley while I looked for some means of escape. He let me go and I was getting ready to run when he lunged at me, setting himself up perfectly for the judo I'd learned at the American Legion Hall in Boulder. I grabbed his wrist, looked to see where he was going to land, and hesitated when

I realized he would come down on the picket fence behind me. My hesitation gave him enough time to grab my hand, and as I jerked it away I felt my finger snap. As I ran for the street I could hear him yelling "dirty communist bastard." I walked to the school infirmary, wondering if he really thought I was a communist. If so, it didn't take much to be a communist in Texas.

In October, Madame Nhu, the sister-in-law of President Diem of South Vietnam, came to the university to speak.[6] I was aware that something was happening in Southeast Asia and went to hear her speak. She told us the communist North Vietnamese were attacking the independent democratic country of South Vietnam, and she asked us to support US military intervention to save her country. As she was speaking, a few people stood up with signs calling for elections in Vietnam in accordance with the Geneva Accords – but they were quickly ejected from the meeting. Madame Nhu never referred to the Geneva Accords or elections, and I had no idea what the demonstrators were talking about. At the end of her speech the audience gave her a standing ovation, and although I stood with the others, I felt that I needed to know more.

As I left the auditorium, two of the protesters were standing on the sidewalk with their signs, so I stopped to ask why they were protesting. They introduced themselves as Charlie Smith and Lyndon Henry and asked if I'd like to go have a cup of coffee and talk about what was going on in Vietnam. Although I knew that Vietnam had been a French colony and that French forces had been defeated in Vietnam at a place named Dien Bien Phu, I didn't know what role the United States had played in all this. They began with a brief history of Vietnam.

Vietnam had been independent for over a thousand years and had a long tradition of resisting outside control. The French had colonized Vietnam beginning in the mid-1800s and when the Germans occupied France during World War II, the pro-Nazi French government gave the Japanese control of Vietnam. In response, Ho Chi Minh, a Vietnamese nationalist and communist, formed a resistance army, the Viet Minh, with the ultimate goal of establishing an independent Vietnam. The US military supplied them with advisors and weapons to fight the Japanese. When the war ended, Ho Chi Minh and his fledgling government drew up a declaration of independence and a constitution modeled on those of the United States and declared Vietnam's independence. Ho tried to convince the US to support an independent Vietnam, but the Cold

War was heating up and the US saw him as a communist and refused to talk with him. In 1946 the French military re-invaded Vietnam and the US, wanting France's support in the Cold War, supported the French by paying about 40 percent of the cost of the war.

The Viet Minh had broad support among the Vietnamese people and controlled much of the countryside. In spite of France's overwhelmingly superior firepower, the Vietnamese refused to give up and finally trapped and defeated the French at Dien Bien Phu. Fifty thousand French and half a million Vietnamese were killed during this "French war." A peace conference in Geneva established the terms of a cease-fire, temporarily partitioned Vietnam at the 17th parallel, and called for free elections to be held in 1956 to unify Vietnam and decide the future of the country.

The US didn't sign the Geneva Accords and immediately began to subvert the agreement. When Ngo Dinh Diem, Prime Minister of South Vietnam, appointed himself president in 1955 and declared South Vietnam to be an independent republic, the US recognized his government and sent military advisors and equipment to build up his army. Diem canceled the reunification elections, and began killing and jailing his opponents, including those who supported Ho Chi Minh and the reunification of Vietnam. Had the elections been held, President Eisenhower later estimated that 80 percent of the Vietnamese people would have voted for Ho Chi Minh.[7] The remnants of the Viet Minh in South Vietnam began to pull together in self-defense and organized the National Liberation Front (NLF) to fight back. The result was another growing guerrilla war in South Vietnam. As the fighting intensified, soldiers from the northern part of Vietnam began to go to the south to join the NLF in their struggle to reunify Vietnam. Diem called this combination of the NLF and North Vietnamese soldiers the Viet Cong, meaning the Vietnamese communists, and the name stuck.[8]

Charlie and Lyndon told me that the US had military "advisors" in Vietnam and that the war was destroying the country. Peasants working in their fields were gunned down, prisoners were tortured, and villages were bombed with explosives and Napalm. Herbicides were sprayed on food crops to deprive the enemy, and the people, of food. Areas where the guerrillas were strong were designated as "free-fire zones," in which any living thing was a target. All this meant that the civilian population, not just the guerrillas, was under attack by Diem's forces – and this was all happening with the support of the US government.[9]

What Charlie and Lyndon said the US was doing was so contrary to the basic American values of freedom, democracy, and the right to national independence that I wondered if I could believe them. I thought my knowledge of current events was fairly good, but this information was much more detailed than anything I'd heard. If what they were saying was true, then it was clear that what Madame Nhu had said was misleading. The average student listening to her speech wouldn't know that the support she was calling for was an extension of a colonial war or that the government she was asking us to support was a dictatorship. She was simply appealing to American's fear of communism without mentioning the nationalist struggle. It bothered me that she hadn't mentioned the Geneva Accords and the reunification elections or the fact that her brother-in-law had appointed himself as president. If what I had just been told was true then the United States was playing the part of the British while Ho Chi Minh was playing George Washington. If that was true then, in my opinion, the United States was on the wrong side!

The next day I went to the University of Texas library to read more about the history of Vietnam. From scholarly histories, supplemented by what I got from reading between the lines of the *New York Times*, *Time*, *Newsweek*, and *US News and World Report*, I came to the conclusion that what Charlie and Lyndon had told me was essentially true.

Charlie, who was affectionately known as the "Panda," lived with his parents and had invited me to come by. His mother let me in and I found Charlie in his bedroom typing up a stencil for a new leaflet he planned to pass out near campus. His room doubled as a print shop – the Panda Press – with a typewriter and a mimeograph machine in the corner. So many stacks of leaflets covered Charlie's bed that he slept in a sleeping bag on the floor. Politics seemed to completely consume Charlie's life.

As I got to know Charlie and his friends, I learned that they were also involved in the Austin civil rights movement. In the past few years, this movement, based in the black community and supported by some students, had forced the integration of restaurants and theaters around the university. Segregation was still common in most of Austin, however. Although the university had recently opened its doors to black students, the dormitories and most extra-curricular activities were still segregated.

Segregation in Austin became real to me one evening when I asked David McDonald, a black student I'd met through Charlie, if he'd like to get a cup of coffee at one of the restaurants close to the university. He politely refused saying that he had homework to do. As I tried hard to convince him, he finally told me that he didn't feel safe going to any of the local restaurants even if they were integrated because there were dangerous people in Austin who didn't believe in integration. I remembered the guy who had attacked me for my comment that Russians were people. When he labeled me as a communist, he made me a target. The realization that David was a target every day simply because of the color of his skin hit me like a slap in the face – suddenly the civil rights struggle became more real.

As I walked with David to his dorm, we talked about segregation at the University of Texas. The black men's dormitory in which David lived was an old army Quonset hut, located in a swampy area far from the main part of the campus. It was very different from the multi-story air-conditioned white dorms on campus. David told me that the visiting rules in the women's dormitories were quite specific about segregation. Black women could visit in the white women's dorms, but they couldn't use the drinking fountains or the bathrooms. White men could go into the waiting room in the white women's dorms to visit, but black men were forbidden. Intercollegiate athletics, the Longhorn band, drama, student employment and the beauty queen contest were all for whites only. This confrontation with reality was another step in a string of events that were changing the direction of my life.

David told me that when the civil rights movement started in Austin a few years earlier, the activists were mainly from the black community with a few white students joining in. They began by picketing segregated restaurants and movie theaters along "the Drag," the street next to the campus. From there it spread to segregated facilities in other parts of Austin. David said that the current project of the Campus Interracial Committee (CIC) was to put pressure on the university to integrate all its facilities and activities. This pressure partially succeeded later in the fall when the Board of Regents announced that all activities and facilities, except the university dorms, would be integrated.

When I look back, I'm amazed at how little I saw of what Austin was really like. I had noticed the shacks within view of the Capitol and had been through the part of town where black people lived. I had even noticed the boarding houses full of black women, but

somehow it didn't immediately register how much Austin was part of the segregated South. I began to see the segregation everywhere.

Charlie called himself a Marxist socialist and I asked him what that meant. He told me that Marxism wasn't a set of beliefs but rather a way of thinking about and analyzing social forces and the connections between issues. I was impressed with the way he put events into a historical context and talked about the social forces at work. It was as if he was telling history from the people's point of view rather than relating the same history of great men and isolated events that I had learned in school.

All these discoveries about Vietnam and segregation made me realize how little I knew about American history. I wondered why, a hundred years after the end of slavery, blacks were still excluded from so much of American life. Charlie had a large library that included books on the history of American slavery, and I began to read some of them. Although I had learned about slavery in my American History classes, much of that history had been written from the viewpoint of Southern white slave owners. These books were different.

I was particularly struck by the history of Reconstruction following the Civil War and the fact that the failure to distribute land to the freed slaves set the stage for what I saw happening in the South. Following the war, Northern troops protected the right of the freed slaves to vote and Blacks were elected to local, state and national government positions. When Northern troops withdrew from the South that quickly changed. Blacks had no economic power and were at the mercy of the old plantation owners for employment. The Ku Klux Klan began a reign of terror and intimidation that left blacks disenfranchised and totally at the mercy of whites. The resulting all-white legislatures passed laws to separate blacks and whites and instituted literacy tests and taxes on voting, called poll taxes, that effectively excluded blacks from all political participation.[10] Blacks had no hope of justice in the white courts and the result was a system in which blacks were "free" but had no rights that Southern whites felt they had to respect.[11] Even though this violated the amendments to the Constitution that made slavery illegal and guaranteed full rights to the freed slaves, the Federal government did nothing to stop it. In 1896 the Supreme Court ruled that segregation was legal as long as the separate facilities were equal.[12] By 1910 the system of segregation was firmly in place throughout the South.

The history I had been taught in school implied that black people were poor and at the bottom of the pile because they were unmotivated. They had access to schools that were equal to whites, but they didn't take advantage of them. From that point of view, trying to change the situation for blacks was a task that depended on changing one person at a time. Charlie's books indicated that the wealth of the South had been created by the forced labor of the slaves and that the current situation in the South was the result of giving that wealth to whites following the Civil War. If that was true then inequality wasn't the fault of blacks. The only way to fight back was by joining with other people for collective action to demand the right to vote and access to positions of power. I was beginning to realize the importance of history in understanding the present. These new ideas about social change and history excited me because they showed that people acting together could change things. Knowing that I could work with other people around civil rights issues and the war in Vietnam empowered me. The alienation I had felt while growing up began to disappear and I began to examine the world and myself more critically.

When I was growing up in Pueblo I assumed that the north was against racial discrimination, but as I read more I realized that racism was a nation-wide problem and deeply ingrained. Blacks could vote in the northern states but suffered discrimination in both housing and work everywhere. Racism had a long history of being encouraged by the government. President Woodrow Wilson had replaced black appointees with whites and had "white" or "colored" signs placed on all the bathroom doors of government buildings. President Harding, who followed Wilson in 1921, was actually inducted into the Ku Klux Klan in a White House ceremony. In this racist atmosphere, the KKK emerged as a powerful force across America, with strong groups in states like Ohio, Indiana, and Oregon as well as throughout the South. Historians estimate that during this period white rioters attacked nearly a hundred black communities, burning black homes and businesses, and lynching individuals.[13] Racism remained so firmly woven into the fabric of America that blacks served only in segregated units during World War II.

As I learned this history I thought about my black neighbors in Pueblo and wondered whether there was discrimination against them that I didn't know about because I was white. I remembered the person who called to warn my dad that my sister was walking

home with "that black boy" and wondered how many more people like that there were in Pueblo.

Reading Charlie's books made me look more critically at the economic and political forces behind issues. The books I read on slavery were mainly by two authors, W.E.B. DuBois and Herbert Aptheker. DuBois was a black intellectual and one of the founders of the NAACP (National Association for the Advancement of Colored People) in 1910. Both DuBois and Aptheker wrote from a Marxist point of view and this increased my curiosity about what it meant to be a Marxist.[14] I began reading Charlie's books by and about Marx and Engels and was particularly impressed by Marx's early humanist writings about human freedom and democracy. I thought about the meaning of the words socialism, communism, and capitalism – words so commonly used that I had never thought to analyze them. Their names revealed a lot. Socialism is a social/economic system based on the good of society, and communism, as written about in Marx's early writings, is a utopian form of socialism based on community. Capitalism, on the other hand, is a social/economic system based on power and accumulation of money. As I looked at the consumer society around me, I realized that part of my sense of alienation came from this emphasis on wealth and possession. Social need and community were clearly more important to me and I began to think of myself as a socialist.

Academically, all went well at first. I signed up for three courses and taught one section of engineering algebra. At the first meeting of teaching assistants, the department chairman informed us that one year of freshman math was required for graduation and that we were expected to fail one fourth of our students to help reduce the size of the sophomore class. I resented the use of mathematics as a way to winnow out students so I refused to set quotas. I figured that if a student couldn't understand what I was teaching that I must be doing something wrong.

While I enjoyed teaching, it wasn't long before my good intentions about studying math seriously began to fall apart. I was tired of studying math and tired of being a student. I discovered the arts and crafts center in the student union and started going there regularly to make jewelry and pottery. After an hour of Theories of Integration or Advanced Analysis, the center was a real joy.

I began reconsidering what I wanted to do with my life. I talked to representatives from the newly created Peace Corps and thought about joining, but decided to finish out the school year before signing up. In November I wrote a letter to Jerry Miller, my friend from Colorado, about where my life was headed.

> My problem is that I don't really know what I want to give my life to. I don't think I could stand just settling down to a nice uncontroversial teaching position. I guess I could be bumming around Europe but I think more than anything else I'd be looking for myself. This is one reason I've applied to the Peace Corps. I think perhaps that's where I belong, giving what I have to someone who needs help getting on his feet. It was good to be younger and lost because then you really didn't know you were lost. Now there's a kind of a panicky feeling to know you're lost and that what you're looking for is not something all the people you graduated from high school with have found, namely a nice job, a nice wife and nice kids with normal in-laws and soft dogs to meet you at the door after your eight hours are up. Sometimes I think that would be so comfortable, but I'd probably commit suicide after twenty years or so.

Four days after I wrote this letter, President John Kennedy was assassinated in Dallas. Like everyone else, I was in shock. President Kennedy had challenged young people to try to make our country better, to try to make the world better. He was the reason I was looking seriously at the newly formed Peace Corps. John Kennedy had seemed like a breath of fresh air. Now he was dead. When the Dallas police arrested Lee Harvey Oswald as the person who killed Kennedy, he claimed that he was a "patsy" and had been set up to take the rap. The next day, as Oswald was being moved from the Dallas jail, Jack Ruby, a local bar owner with ties to the Dallas police and the Mafia, walked up and shot him. Any information Oswald had about the assassination died with him, leaving speculation that the assassination had been a conspiracy. In the weeks and months after the killings, I followed the investigation and came to the conclusion that the investigators were more interested in establishing Lee Harvey Oswald as the lone gunman than in finding out what really happened. It seemed to me that there was too much evidence pointing to several gunmen and that Oswald may have been set up to get caught. This apparent cover-up just added to my growing distrust of the government.

Less than a month before Kennedy was killed, he had approved a plan to have the Vietnamese military overthrow the much-hated President Diem. President Kennedy and Henry Cabot Lodge, the US

Ambassador to South Vietnam, hoped that a new and more popular president would be able to win the hearts and minds of the people – who were increasingly siding with the NLF. On November 1, 1963, the Vietnamese military, with the support of the United States, staged a military coup, murdered President Diem, and made General Minh the new president.[15] As it turned out, Diem's government was more stable than any of the governments that South Vietnam was to have in the coming years.

In what seemed at the time to be totally separate from what I was learning about politics, I discovered psychedelic drugs. I had read an interview in *Playboy* with Dr. Timothy Leary in which he discussed the use of psychedelic drugs, such as LSD and mescaline, to expand human consciousness. A fraternity brother of my roommate noticed the magazine in my room and struck up a conversation about it. When he asked me if I had ever smoked marijuana, I replied that I'd heard it was addictive and was afraid of it. I told him I would, however, like to take one of the psychedelics, and was taken by surprise when he said peyote was legal and he could get me some. A few days later he brought me six small cactus tops, called "buttons," and told me how to prepare them. He warned me that they would taste terrible.

I waited a few weeks until both my roommates had gone home for the weekend and set about preparing the magic drink early in the evening. Bitter is not a strong enough word to explain the taste, but I forced myself to drink it. After a couple of hours, my stomach was churning and my legs felt like rubber as I headed for the bathroom to throw up. To my amazement a rainbow gushed out of my mouth and everything around me began to change shape. I crawled back to the living room and lay down on the couch as thousands of miniature multicolored characters, like cartoon figures, crawled out from behind the molding along the top of the wall and began chasing each other around the ceiling. They seemed to be playing as they crossed the ceiling, ran down the wall, and chased each other down the hall and out of sight. I watched as the characters merged into a river of swirling colors. Then, as if someone had turned off the faucet, the color suddenly stopped flowing and drained away, taking the room with it and leaving me alone on a couch, floating in a total void.

I looked over the edge of the couch and found total emptiness in all directions. I had no sensation of fear or anxiety, just total

amazement. I felt as if my boundaries were merging into all of creation. I was somehow intimately connected to the rocks, the trees and the stars. I closed my eyes and began to fly. I could feel the wind on my face. I could see my hands out to my sides, and if I looked back, I could see my body and my feet. I flew for hours over hills and mountains, forests and lakes, diving down to look more closely, then back up to do loops, and then off into the distance to explore new things. When I woke up the next morning, everything was pretty much back to normal but the feeling of being part of all creation stayed with me.

Except for the friend who brought me the cactus, I didn't know anyone else who had tried it. I soon discovered, however, that there was a sizable sub-culture of people in Austin who used peyote and also marijuana. In 1964 the state legislature tried to make peyote illegal, but they spelled it "pyote" so the peyote cactus remained legal until around 1966. As the sixties progressed, psychedelics – LSD, peyote, and psilocybin (from mushrooms) – spread throughout the youth movement and influenced its development. The experience of coming out of the body and merging into the surrounding universe, including other human beings, is something that is not possible to explain, but anyone who has experienced it knows that it is profound. People come away from the experience with a sense that all creation is one thing, that the observer and the observed are not separate, that all people should love each other because they are all one, and that the earth is alive and should be respected. The experience changes the user's perception of reality during the "trip" but also, and more importantly, afterwards as well. Many people who took psychedelics looked at their lives and decided to pursue their own path rather than doing what other people wanted them to do. They also wanted to live in harmony with one another and with nature. I would come back to psychedelics many times over the following years.

During that fall of discovery, in what seemed like another totally separate chain of events, I met Judy Schiffer. She was one of the few other students who rode a bicycle and I had noticed her several times as she rode across the campus. I finally introduced myself and we began seeing each other. Our relationship started slowly and I enjoyed being with her because she was like a friend. We made small gifts for each other and talked about what I had been learning about politics. She had been involved in the civil rights demonstrations the

previous year, and she had also tried peyote. I wondered if something about that experience had drawn me to her. After we got to know each other, I learned that her parents had been in the Communist Party during the thirties. They were then living in Beaumont, Texas, where her dad worked for an oil company. Judy was as close as I had ever gotten to a communist and I was anxious to meet her parents. When they came to Austin, I was fascinated to hear their stories about the labor movement and the Depression of the 1930s. They were still active behind the scenes in the civil rights movement in Beaumont. The fear of communism that I had been raised with was gradually melting away. I had expected Austin to be different, but I hadn't expected this.

Late that fall, Charlie Smith began to talk about organizing a chapter of Students for a Democratic Society (SDS), a group I had never heard of. He had ridden his motorcycle from Austin to upstate New York the previous summer for the annual SDS convention. Much to the amazement and amusement of the SDSers gathered there, Charlie introduced himself as a "Gandhian, Marxist, pacifist, anarchist organizer from Texas." Charlie told me that SDS was a multi-issue organization that had been around for a couple of years and he gave me a copy of the *Port Huron Statement*, the SDS "manifesto" adopted by the organization a year before.[16] It began with a set of values about the preciousness of human life that resonated with what I had been thinking and feeling.

> We are people of this generation, bred in at least modest comfort, housed now in universities, looking uncomfortably at the world we inherit....
>
> As we grew, however, our comfort was penetrated by events too troubling to dismiss. First, the permeating and victimizing fact of human degradation symbolized by the Southern struggle against racial bigotry....Second, the enclosing fact of the Cold War, symbolized by the Bomb....
>
> [W]e began to see complicated and disturbing paradoxes in our surrounding America. The declaration "all men are created equal"...rang hollow before the facts of Negro life in the South and the big cities of the North. The proclaimed peaceful intentions of the United States contradicted its economic and military investments in the Cold War status quo....
>
> Our work is guided by the sense that we may be the last generation in the experiment with living....In this is perhaps the outstanding paradox: we ourselves are imbued with urgency, yet the message of our society is that there is no viable alternative to the present....

We regard men[17] as infinitely precious and possessed of unfulfilled capacities for reason, freedom, and love....we are aware of countering perhaps the dominant conceptions of man in the twentieth century: that he is a thing to be manipulated, and that he is inherently incapable of directing his own affairs. We oppose the depersonalization that reduces human beings to the status of things – if anything, the brutalities of the twentieth century teach that means and ends are intimately related....We oppose, too, the doctrine of human incompetence because it rests essentially on the modern fact that men have been "competently" manipulated into incompetence....

Men have unrealized potential for self-cultivation, self-direction, self-understanding, and creativity. It is this potential that we regard as crucial and to which we appeal, not to the human potentiality for violence, unreason, and submission to authority. The goal of man and society should be human independence: a concern not with image of popularity but with finding a meaning in life that is personally authentic....

This kind of independence does not mean egotistic individualism – the object is not to have one's own way so much as it is to have a way that is one's own....

We would replace power rooted in possession, privilege, or circumstance by power and uniqueness rooted in love, reflectiveness, reason, and creativity. As a *social system* we seek the establishment of a democracy of individual participation governed by two central aims: that the individual share in those social decisions determining the quality and direction of his life; that society be organized to encourage independence in men and provide the media for their common participation....

The economic sphere would have as its basis the principles:

that work should involve incentives worthier than money or survival. It should be educative, not stultifying; creative, not mechanical; self-directed, not manipulated, encouraging independence, a respect for others, a sense of dignity and a willingness to accept social responsibility....

that the economy itself is of such social importance that its major resources and means of production should be open to democratic participation and subject to democratic social regulation....

In social change and interchange, we find violence to be abhorrent. ...It is imperative that the means of violence be abolished and the institutions – local, national, international – that encourage non-violence as a condition of conflict be developed.

The *Port Huron Statement* noted that, although the American economy was growing, there was poverty and deprivation in its midst. In the workplace and at home, each individual was "regulated as part of a system, a consuming unit, bombarded by hard-sell, soft-sell, lies and semi-true appeals to his basest drives." The concentration of wealth and power in the "military-industrial

complex" leads to the "general militarization of American society" and creates a relationship between business, the military, and politics that undermines democracy and disempowers the average person.

The *Port Huron Statement* called for a politics that not only allowed people to participate but actively encouraged them to participate. It included elections and support for elected officials, but it was broader than that – it also encouraged local community-based action as a way to solve local problems. This concept of direct democracy emerged from what was already happening in the South. In Greensboro, North Carolina, students defied local law and custom when they sat-in at segregated restaurants. They were attacked and arrested but the restaurants were eventually integrated. In Montgomery, Alabama, Rosa Parks refusal to give up her bus seat to a white man set off a bus boycott that eventually integrated public transportation in Montgomery. The concept of participatory democracy spoke to my alienation, while offering a solution through involvement.

I was struck by the fact that the *Port Huron Statement* was written in plain English, while much of the Marxist literature that Charlie gave me used words like "bourgeoisie," "ruling class," "proletariat," and "internal contradictions" that had special meaning and weren't part of most Americans' vocabularies. Most of the socialist sects took Lenin, Trotsky, or Mao Zedong as their patron saints and relied on them as models. It seemed obvious to me that the American people were not going to be moved by foreign revolutionary heroes. The ideas of Marx and Engels were powerful tools, but Marxist rhetoric made nearly all Americans tune out. The traditional leftist organizations based on European socialist traditions and on the revolutionary struggles of Russia or China were part of the "old left." SDS saw itself as part of the "New Left," unburdened by the old ideologies, sectarianism, and seemingly endless splits over fine points of doctrine.

I liked this fresh non-dogmatic approach and agreed to help Charlie start a chapter of SDS. We believed SDS might be an organization that could move people into action around issues facing America. SDS's ideology was basic – reach out to people around issues that affect their lives and put them in contact with others who shared their interests so that they could collectively have a voice in making the decisions that affect their lives. This kind of grassroots democracy would change America from the bottom up.

Just before Christmas break we went to see the student activities dean to get SDS approved as a campus organization. This meant that we could use university rooms and pass out approved leaflets on campus and set up a recruiting booth at registration. While we didn't like the restrictions on our freedom of speech, we went along with them in order to build an SDS chapter at the University of Texas.

— 3 —

The Times They Are A-Changin'
Spring 1964

"Come mothers and fathers throughout the land, and don't criticize what you can't understand. Your sons and your daughters are beyond your command. Your old road is rapidly agin'. Please get out of the new one if you can't lend your hand, for the times they are a-changin'."

Bob Dylan, *The Times They Are A-Changing*

At winter registration we set up an SDS information booth and invited people to attend an organizational meeting later in January. I expected a few people would come to the meeting and that we would form a small chapter. During the spring we would discuss and then work on projects such as registering voters or confronting segregation at the university. To my surprise, about thirty-five people came, including members of the Campus Interracial Committee (CIC). They had a specific project in mind. The Picadilly Restaurant in downtown Austin was still segregated and they wanted SDS to sponsor demonstrations there during the spring to force it to integrate. The idea was approved unanimously and the first meeting became a discussion of when and where and how and what kinds of picket signs we should carry. It was an interesting group of people with incredible differences in background. Jeff Shero was a military kid, who had been to Europe and the Soviet Union and had already gotten in trouble at several other colleges because of his opposition to segregation. Gary Thiher came from West Texas and drove a big-rig during the summer to make money for college. George Vizard had been a divinity student but had changed his mind and was starting at the university. Alice Embree was the daughter of a professor at the university and had previously been involved with the CIC, as had Judy Schiffer. By the end of the first meeting we were off and running with twenty-five paid members and a project.

When it came time for the first demonstration at the Picadilly, I was nervous. Standing out in public was not something I did easily.

I had never been in a demonstration before and I knew that my students, my fellow graduate assistants, and the mathematics faculty would probably find out and some would certainly disapprove. I wondered if the guy who called me a communist and attacked me would be there. We gathered a block or so away from the Picadilly and then formed a continuous line as we walked back and forth in front of the restaurant entrance. Jeff Shero had entered the Picadilly as a customer before the demonstration and loudly announced that he wouldn't eat at a segregated restaurant and walked out. Several people opposed to integration pushed us aside to get in and one old lady poked me in the ribs with her umbrella as she pushed her way into the restaurant. The sidewalk across the street was lined with people yelling "Nigger lover" and "Communist," while members of the Austin police stood in the street between the counter-demonstrators and us. It struck me that I was being called a communist for the second time since I'd come to Austin. The first time was for saying that mass murder of the Russian people was wrong and now it was for defending the rights of American citizens.

The Picadilly was part of a chain of restaurants and the manager let us know that integration would have to be a corporate decision. We kept up the pressure by regularly getting fifty or more people on the picket line, including members of the National Association for the Advancement of Colored People (NAACP), local black community activists, students from Huston-Tillotson, a black college in Austin, and SDS members. Later that spring, the Picadilly decided to open its doors to everyone.

The Picadilly was just a symbol of the legal segregation in Austin. To confront this segregation, black community leaders went to the city council to demand an end to discrimination in the city's hiring practices and passage of a public accommodations law. To support their demands SDS members did research on different job categories to show the racial make-up of the employees. We found that 99 percent of the garbage men were black, but that none of the clerical help was. When confronted with this information, one member of the City Council insisted that it had happened by chance. When pressed he said that the only people who wanted to be garbage men were black. Apparently no blacks wanted clerical work.

As in other Southern cities, hotels and motels in Austin were segregated and there were few places for black travelers to spend the night. To force the council to outlaw this discrimination, the NAACP started packing the city council chamber and demanding

that the council deal with the issue of "racial progress." We supplied bodies for this effort until the police blocked the entrance to the council chambers. Because they didn't want to tarnish President Johnson's image, the police never arrested anyone, but the news got out and an NBC national news team ran a five-minute segment about the issue on the evening news. This unwanted publicity forced the council into negotiating an ordinance requiring motels and hotels to provide rooms for everyone, regardless of race.

Another of SDS's projects during the spring of 1965 was a voter registration drive in East Austin, the poor, mostly black and Latino community in Austin. We went in twos down the back streets knocking on doors and talking to people about registering to vote. I was surprised at the number of places where we heard people inside but no one answered the door. I asked some of the local people about this and was told that most of the time when a white person knocked on the door it was because there was some kind of trouble, so people just waited for us to go away. Lots of people did open the door and some invited us in to talk about their everyday lives and problems. I don't know how much success we had in getting people to actually vote, but we certainly learned a lot about what it meant to be poor and non-white in Austin.

Whenever we scheduled a demonstration, the police were there. One policeman, Lieutenant Burt Gerding, introduced himself and talked to us on the picket line. He was always friendly, but I noticed that he took pictures of all the demonstrators. Occasionally he came to SDS meetings and sat quietly in the back taking notes. I wondered why he was watching us since we were always peaceful and weren't breaking any laws. Our meetings were open to anyone who wanted to attend, including Gerding. At one of the Picadilly demonstrations Gerding told Judy and me that he had some nice pictures of us and that we could have them if we came to his office at the police station. I appreciated that the police had protected us from the mob at civil rights demonstrations, but although he acted as if he was just being friendly, we guessed that he wanted something. We went prepared to be evasive and it wasn't long before we needed to be. Gerding took a stack of photos out of his file cabinet and put them on his desk so we could look through them. Occasionally he would stop and point to someone and ask if we knew that person's name. He had called us down to identify people. Both Judy and I had total memory failure.

As we became more visible, articles about SDS began to appear in newspapers around the state implying that we were an "ultra-left wing, communist-infiltrated" organization. During the fifties, saying that an organization was somehow linked to communists had often been enough to destroy it, but things were changing. During the McCarthy era of the fifties, university professors in Texas, as well as in most other states, had to sign "loyalty oaths," affirming that they were not and had never been communists. Those who wouldn't sign lost their jobs. Anyone who was a member of the Communist Party or sympathetic to communists was not allowed to speak at the university. Rather than giving in to the attacks in the newspapers, we decided to confront the issue by sponsoring a talk by John Stanford, a member of the Communist Party from San Antonio. In 1963 the Texas State Police had raided the Stanfords' house and had seized all their papers including their income tax records and their marriage license. John had sued the State of Texas and the courts had ruled in his favor. The university didn't want to be at the center of another lawsuit, so they allowed him to speak under our sponsorship. This opened the door for us to sponsor other controversial speakers, such as Madelyne Murray O'Hair, an avowed atheist who filed the suit against prayer in the public schools that resulted in it being declared unconstitutional.

Demonstration against the Cowboy Minstrel show, with me in center.

Every spring at the university, the fraternities put on a minstrel show to raise money for charity. White students blackened their faces with charcoal and acted out black stereotypes. In 1964 blacks, and minorities in general, were rarely seen in the media except as happy-go-lucky simpletons who were employed as servants. Things were changing, however, and portraying black people this way was no longer acceptable to many of us – and especially to black students. SDS opposed the show, while supporting the raising of funds for charity. I wrote a letter to the *Daily Texan* accusing the minstrel show of being racist because it didn't depict blacks as people but as some kind of joke. This led to heated debate. The defenders of the show claimed it was all just innocent fun, but black students and SDS argued that it was degrading to blacks. The minstrel show went on, but the next year it was replaced by other fund-raising efforts.

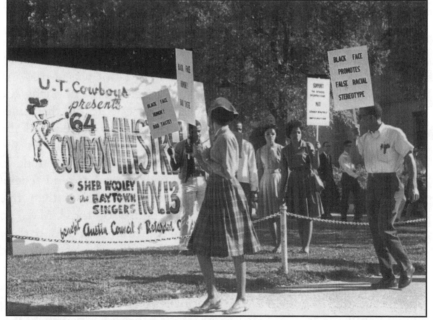

Demonstration against the Cowboy Minstrel show.

· Our civil rights activities in Austin were an extension of the sit-in movement that began in the early 1960s and spread across the South. The Student Non-Violent Coordinating Committee (SNCC, pronounced "snick") was born out of those early sit-ins and, from the beginning, SDS and SNCC were supportive of each other. SDS members went South to work with SNCC and many SDS chapters

organized civil rights demonstrations in the North and helped with legal, financial, and material aid.[18] At the same time that SNCC was doing voter registration in the South, some SDS people in the North were planning to confront economic issues such as decent housing, welfare rights, jobs, and racism. The Economic Research and Action Projects (ERAP, pronounced EeeRap) would coordinate community organizing projects in both black and white communities in the North with the long-range goal of organizing "an interracial movement of the poor" to solve local problems through local leadership.

Michael Harrington, a member of SDS's parent organization, the League for Industrial Democracy (LID),[19] had recently written *The Other America* describing the severe poverty that persisted in our country in spite of the economic boom of the 1950s. This book had a strong influence on the development of ERAP and in late March, 1964, national SDS sponsored a conference on poverty in Hazard, Kentucky, an area known for its economic problems.

Hazard had been a center of long and bloody battles as the United Mine Workers (UMW) fought to unionize the coal mines. They had succeeded, but during World War II labor was scarce and the mine owners had replaced men with machinery. Following the war, as the US switched from dependence on coal to oil, the mines began to close. This left many mineworkers unemployed and the mine owners used the opportunity to break the union. As the demand for coal dropped, the mine owners closed the big mine in Hazard and opened up the small ones in order to get around federal safety standards that didn't apply to mines with fewer than five workers. Without the benefits and protections of the UMW, an average of a man a week was dying in the mines in this part of Kentucky. The miners and their families were getting desperate and several SDS-ERAP organizers were in Hazard to see what could be done. SDS hoped to draw attention to the problems by holding a conference that would get the information out to the public and educate students in the process. As I got more involved in SDS I wanted to meet SDS people from other areas and the conference seemed like a good place.

A group of us from Austin took off in "Butterscotch," Jeff Shero's 1956 Pontiac stationwagon. David, the black student who had opened my eyes to the reality of segregation, was with us and so we were concerned that we might get stopped by the local police as we drove through the South. When we passed through towns, David

sat as low as possible in the middle of the back seat to keep from drawing attention to us. We made it across East Texas, Louisiana, and Tennessee without incident and followed the winding Kentucky roads through the mountains until we came to Hazard, a small town built around a mine. We drove slowly into the valley looking the whole situation over, not knowing quite what to expect. We pulled off at a dingy building next to the main road where we registered for the conference and were assigned to a family that would feed us and provide a place to sleep. Jeff, David, and I were sent to stay at the house of one of the area's few black miners. Part of the incentive for housing people was that the conference provided food for both the guests *and* the family – and this family needed food. When we discovered that three of the kids had given up their bed for us, we insisted on sleeping on the floor in our sleeping bags. They wouldn't hear it and we ended up in a really soft bed that sloped toward the center from all directions. We flipped a coin to see who would sleep in the middle and I spent the night pinned in place by Jeff and David. We got up in the morning to a breakfast of greasy sausage, eggs deep fried in the hot grease, and grits over which the family poured generous portions of the leftover grease. Since I knew the conference was buying their food, I wondered what they normally ate.

As we sat eating breakfast, I asked our host what it was like to work in the mines. He told us that the coal layer in the big mine was thick enough for people to stand up as they dug out the coal but the coal seams in the small mines or "scab holes" were much narrower, sometimes only three to four feet high. Most of these small mines had several miners working in them, but he worked alone. He rode in on his belly on a small railcar, pushing a coal bucket ahead of it, then worked on his knees in several inches of water cutting out the coal and loading it into the bucket. I asked him why he did it, why he didn't go north as so many other folks had done. He replied that he liked living in the hills, he had grown up doing it, and besides, "It ain't so bad." I was astonished. I couldn't imagine myself going into that hole every day and still not making enough money to feed my family.

About 175 students and thirty miners participated in the four-day conference. The miners were trying to maintain the union and were getting some support from the UMW. Our hosts talked about intimidation from the mine owners. They said that the owners had blown up several bridges and striking miners had been indicted for

it. I wondered about the whole situation. With the mines closing down, the scab holes open, and coal no longer in high demand, what could they actually do? The miners were trying to get safety standards implemented in the small mines but there was strong resistance from the coal companies. In any case, since the coal from this area was of marginal value, it wasn't clear how long the mines would be open. It was unsettling to know that there was no easy answer.

In addition to learning about coal and Appalachia, the conference was a good place to meet new people and to talk about a variety of issues. Jim Russell from the University of Oklahoma at Norman had been working in the civil rights movement with CORE (the Congress on Racial Equality) and had hitchhiked to Hazard for the conference. He needed a ride back to Norman and we took him as far as north Texas, talking all the way about organizing.

A few weeks later Jeff, Charlie, and I left Austin again heading for Atlanta for a meeting with SNCC to discuss the formation of a white, southern, student-based organization that would supplement SNCC's work by organizing white students in the South against racism. This was the first time that I had been across Mississippi, Alabama, and Georgia – the deep South – and I was appalled by the way blacks were treated. I saw separate but unequal facilities for blacks everywhere. When we stopped for gas, there were always three bathrooms, two inside with flush toilets for the whites and an outhouse for the "colored." At the town square, with its Confederate flag flying, there were two water fountains, the taller water cooler for whites, the plain lower faucet for blacks. Most public buildings had back entrances for blacks while whites entered through the front. As we drove through the towns I saw tree-lined paved streets, nice homes, and new schools – all for whites. The dirt streets, run down houses, and unpainted schools were always in the black part of town. In the country, long rows of shacks, and the obvious poverty that went along with them, were scattered along the edges of the cotton fields. Black men, women, and children were in the fields cultivating crops for the white owners.

At the meeting in Atlanta, we Texans advocated expanding SDS into the South rather than forming a new organization. The white southern students, however, feared that SDS would be seen as a northern organization and that southern students would be afraid to join an organization of "outside agitators," as northern civil rights activists were often called. Many of the southerners wanted to start a

southern-based organization that wouldn't be seen as being "too radical." The final result was the formation of the Southern Student Organizing Committee (SSOC). SNCC had a lapel button with a black hand and a white hand joined together, and SSOC's button showed the same clasped hands over the Confederate battle flag. I always felt uncomfortable with this image because in my experience the Confederate flag stood for white supremacy and resistance to black equality. We in Texas decided to keep our SDS affiliation, but we were in regular contact with the SSOC office in Nashville.

The SSOC meeting had been a welcome break from graduate school. I enjoyed teaching, but I was rapidly losing interest in the classes I was taking. There was so much that needed to be done to make America fit the image that I had grown up believing to be true. This conflict reached a conclusion one afternoon, while the professor droned on in my Advanced Analysis class. I was staring off into space when a large green plant with a multicolored flower at the top appeared in the air. It was like a peyote vision, but it had been several months since I had eaten any. As I watched, a beautiful caterpillar crawled up the stem and stopped just below the flower to weave a cocoon out of brightly colored silk. No sooner had it finished than the butterfly inside began to eat its way out and then spread its beautiful wings to dry. When it flew out the window, my spirit went with it. I stopped attending classes, although I continued to teach until the end of the semester.

In order to get our point of view before the student body we challenged the conservative Young Americans for Freedom (YAF) to a series of public debates. They opposed almost all of our positions and we thought the contrast would help us recruit new members. One debate was on foreign policy and Cuba and another focused on civil rights. YAF's brand of conservatism was so openly selfish and uncompassionate that they inevitably alienated many of the people at the debates. Their politics was based in extreme individualism and unregulated capitalism. They believed that one of the few functions of the government should be the maintenance of a military to protect the interests of the capitalist system. A social safety net to provide for the poor, on the other hand, was considered to be an undue burden on the rich. They believed it was up to the states to guarantee civil rights, and they stood by their position even when we pointed out what that meant in Mississippi and Alabama. To them, freedom meant capitalist free trade and the freedom to accumulate wealth. In contrast, we talked about the

freedoms guaranteed by the constitution and advocated government protection for civil rights workers in the South. The contrast between their ideas and ours was as stark as we expected and brought new people into SDS after every debate.

By May 1964, the Austin SDS chapter had over forty members. There were twenty-nine chapters of SDS around the country and we were one of the largest, although the forty members didn't really represent the size of the SDS community in Austin. For every dues paying member there were two or three people who considered themselves members but never paid their dues to get an SDS card. There were also many members of a larger community that were in basic agreement with SDS and joined our activities even though they seldom came to meetings.

When I arrived in Austin my impression had been that there was no "alternative" community. However, once I became active in SDS I found that there was a large and diverse community of non-conformists gathered into a wide range of overlapping social groups. There was a fairly large community of artists, folksingers, motorcycle riders, and other non-conformists loosely identified as being part of "the Ghetto."[20] There were civil rights activists from past years, religious people such as the Quakers, Methodists, and some existential Christians associated with the Student YMCA-YWCA. The University Y and its director Frank Wright had a long history of involvement in free speech and civil rights issues and had been at the heart of the civil rights movement in Austin from its beginning in 1960. The Y was housed in a large building near campus and we often held our SDS meetings there. Members of this community got together at the folk dancing club and went to the weekly sing-alongs of the folksingers group. Judy and I joined them quite often. One of the singers, a woman named Janice Joplin, was very good and when she left for San Francisco everyone expected her to do well.

SDS was a small community within the larger one and we spent many hours discussing politics, philosophy, and our personal lives with each other. We also partied, hiked, went to movies, and generally hung out with each other. As spring went by, Judy and I became a couple and several other romances began as SDS members got to know one another. I had joined a community of people working for social change and felt that I had found a direction for my life that reflected who I was. It felt good!

A few weeks before the end of the spring quarter, local civil rights activist Reverend Wesley Sims suggested that we should

demonstrate against segregated student housing at UT during President Johnson's scheduled commencement address in early June. The university had integrated everything except student housing and since the president's daughter, Lynda Bird, lived in a segregated dorm, a demonstration at his speech seemed appropriate. Since commencement takes place after the regular student body goes home, we knew we would be short of people for a big demonstration – but that didn't stop Charlie Smith from printing hundreds of leaflets announcing it. While I stood look-out, Charlie slipped into the largest women's dorm at about four in the morning and put a leaflet under every door to make sure that everyone knew what was planned.

Segregated university housing had been an issue for several years, so it's hard to say what effect we actually had, but just before commencement the university administration announced that it was integrating student housing. Freshmen and sophomore women, who previously had to live in dorms, could now move into off-campus university-approved housing, usually with a housemother. Junior and Senior women no longer had to find approved housing; they could live anywhere they wanted. The university set up this system so that any student who didn't want to live in the same dormitory with a black student could move off campus. This had significant and unexpected consequences for SDS. Junior and senior women, who were previously unable to stay out after 10:30 PM, could now have their own apartments and keep their own hours. The following fall, groups of SDS people began to rent houses together, and co-ed apartments became more common. This tightened the bonds between SDS members.

President Johnson started 1964 with a number of progressive social programs that he called the "Great Society." On January 8, he declared an "unconditional war on poverty." Johnson's vision for America included federal aid to education, training programs to help people get jobs, food stamps, medical care for the poor and the elderly, and affirmative action to help overcome the effects of generations of slavery, poverty, and racism. His domestic programs, however, were in competition with the growing war in Vietnam. Johnson's main fear was that the Republican Party would exploit his decisions about Vietnam when they challenged his bid for re-election in the fall. We now know that Johnson was conflicted about the war and had asked the Senate Armed Services chairman, Richard

Russell, about the importance of Vietnam to American interests. Russell replied, "It isn't important a damned bit." Johnson worried that the Senate seemed to want to get more involved and feared that, "They'd impeach a president that would run out, wouldn't they?" Russell responded, "I tell you it'll be the most expensive venture this country ever went into." Later, in June, Russell told Johnson, "It'd take a half million men. They'd be bogged down in there for ten years."[21]

After the US-backed assassination of President Diem in November of 1963, the government in South Vietnam became extremely unstable. Six South Vietnamese governments came and went during the next twelve months. The South Vietnamese government was having a hard time winning the hearts and minds of its ruling factions, let alone the people in the countryside.

While we were in Hazard, Kentucky, Defense Secretary McNamara was in Vietnam to assure the South Vietnamese that they had American military support. On his return he gave two reports, one for public consumption and the other for the President. For the press, McNamara said that all was going well and that the war could definitely be won. To the president he warned that the situation was getting worse. He estimated that the Viet Cong controlled forty percent of the countryside and in some provinces near Saigon it was more like ninety percent. Defections from the South Vietnamese army were high and increasing. He also noted that the government was very unstable and was incapable of fighting off the communists without help.[22]

It was becoming clear that US interest in Vietnam wasn't purely altruistic. The previous year, on February 8, 1963, General Harkins had stated that, "Vietnam has become for American troops a field of experimentation for anti-guerrilla tactics." On March 2, 1964 this concept was reiterated by General Taylor, LBJ's military advisor, who told the Joint Chiefs of Staff that the White House planned to use South Vietnam as a "laboratory, not just for this war, but for any insurgency." General Taylor saw Vietnam as an experiment in stopping communist insurgencies by the use of "graduated pressure." This meant that the US would slowly escalate the war as a means of "communication" with North Vietnam. General Taylor, Defense Secretary McNamara and others thought that when Ho Chi Minh saw that the US was serious he would be forced to the bargaining table and would accept their demands. The concept that the Vietnamese believed that they were fighting for a just cause and

would refuse to give in to the US seems never to have crossed their minds.[23]

In January 1964 Johnson had approved using US military "advisors" to fly "reconnaissance missions" over Viet Cong controlled territory as well as secret bombing missions over North Vietnam. He approved clandestine attacks by the South Vietnamese navy, with US support, against North Vietnam's oil refineries and radar units along the Gulf of Tonkin. None of this information was published in the mainstream American press, but various left leaning newspapers, such as the *National Guardian*, reported on the attacks and provided information that the government kept secret from the American people. These papers had a political agenda – but so did the mainstream dailies. We joked that the slogan of the *New York Times*, "All the news that's fit to print" should be "All the news that fits, we print." The *National Guardian* relied on information from Wilfred Burchett, an Australian reporter stationed in North Vietnam. After Charlie introduced me to the *National Guardian*, I read the articles carefully and compared what I read with other sources. I would often find a sentence or two in the middle of an article in *Time, Newsweek,* or the *New York Times* that confirmed what was in the *Guardian*. Because we read more than the mainstream press, we often had information weeks or even months before the American press made it public. Although our actions had focused on civil rights issues, we had been carefully following developments in Vietnam. Our concern mounted with time.

The politics of anti-communism distorted any honest debate over the wisdom of expanding the war in Vietnam. Anti-colonial civil wars suddenly became wars between the "super-powers." What Ho Chi Minh and the Vietnamese saw as a war of liberation from foreign domination, President Johnson and his advisors saw as part of an international communist conspiracy to take over the world.

As Johnson pursued the war, he surrounded himself with people who accepted the Cold War ideology and excluded people who didn't support his views. He knew that if he held back he would be accused by the right wing of being "soft on communism." To come out and challenge the assumptions of the Cold War, to openly say that the expansion of the war could lead to a disaster was politically suicidal in the anti-communist climate that existed.

After President Johnson retired he said, "Losing the Great Society [Johnson's domestic social programs] was a terrible thought, but not so terrible as the thought of being responsible for America's

losing a war to the communists. Nothing could be worse than that."[24] Throughout 1964, as he publicly pushed his Great Society and prepared for the November 1964 presidential election, he was secretly preparing for a much wider war in Vietnam.

The war was still far away and, while it concerned me, there were other more pressing issues. Mississippi was a symbol of all that was wrong with race relations in the South. SNCC and several other civil rights organizations had put out a call for students to come to Mississippi for the summer to register voters and Judy and I responded.

— 4 —

Mississippi Summer

Summer 1964

> **"[I]f someone insists there is discrimination against Negroes in this country, or that there is inequality of wealth, there is every reason to believe that person is a communist."**
>
> Albert Canwell, a Republican candidate in Washington State, 1946[25]

Throughout the spring of 1964 the Council of Federated Organizations (COFO), a coalition of SNCC, CORE, and other civil rights groups, had been recruiting student volunteers to go to Mississippi for the summer to register black voters. One of the primary objectives was to expose to the nation the legal terrorism that blacks lived under in Mississippi. SNCC organizers had been working for several years in Mississippi trying to register blacks to vote.

Blacks had been systematically excluded from the electoral process by threats and intimidation as well as by poll taxes and literacy tests since shortly after the Civil War. Whites were in complete control of the legal and political system and had no intention of letting blacks have voting power. Their reaction when blacks tried to register was predictable. Sheriffs turned them away at the doors of the courthouses and those who persisted faced arrest, loss of their jobs, and other retaliation. The intimidation was so severe that SNCC, while continuing to try to register voters at the courthouse, also registered them for a "Freedom Vote," a mock election with black candidates for Governor and Lt. Governor listed together with the official white candidates. Ninety-three thousand blacks had cast freedom votes in 1963 and the concept had been expanded. Summer volunteers would try to register voters at the courthouse but they would also register people into the Mississippi Freedom Democratic Party (MFDP). At the Democratic National Convention in August, delegates from the MFDP would challenge the seating of the all white Mississippi Democratic Party.

We discussed Freedom Summer at an SDS meeting and four of us – Charlie Smith, Judy Schiffer, Bruce Maxwell, and I – applied to go. We soon got a response asking us to join the "White Folks Project," a pilot project to explore the possibility of reaching whites in Mississippi. Both SNCC and SDS were interested in finding ways to get blacks and whites to work together around common interests or at least to blunt the white reaction to the civil rights movement. They wanted people with some experience in the South to work in this project so we signed on.

While COFO was preparing to send a thousand students into Mississippi, Mississippi was preparing for the invasion. On April 21, Klansmen burned sixty-one crosses in southwest Mississippi. Between April 1 and July 1, three black homes and a barbershop in Pike County were firebombed. Two civil rights workers were shot and two local blacks were killed in Adams County. In Madison County, the Freedom House and a church were bombed. In the rest of Mississippi at least seven churches were damaged or destroyed and eight homes were bombed or shot into. In anticipation of Freedom Summer, the Jackson, Mississippi, police force was doubled in size, garbage trucks were modified into paddy wagons, and an armored car was modified for use as a tank. The Mississippi State Patrol added two hundred troopers.[26] Everyone, including SNCC staff, expected people to be killed.

We had heard enough stories from civil rights workers to know that the federal government wouldn't protect us. Even when FBI agents were present as whites mobs attacked civil rights activists, they only watched and took notes. J. Edgar Hoover, director of the FBI from 1924 until he died in 1972, was extremely powerful in influencing the direction of the US government. Under his leadership, the FBI kept files not only on communists and other "subversives" but also on congressmen and other government officials, including presidents. Hoover's personal biases were key in setting the tenor of the FBI's work. Born in 1885 and raised in a well-to-do family with black servants during an era when racism was respectable, Hoover kept these biases as director of the FBI. In 1961 all FBI agents were white, except for a few who functioned as drivers or had other servant-like duties.[27] Hoover refused to have his men involved in protecting civil rights workers from racist violence. Such protection, he maintained, was up to the states.[28] Since it was often local police who attacked the civil rights movement, civil rights

workers had no protection other than trying to focus public attention through the press.

Worse than simply ignoring racist violence, many FBI agents were racists themselves. One agent reported that in the early sixties, "in about 90 percent of the situations in which bureau personnel referred to Negroes, the word "nigger" was used and always in a very derogatory manner."[29] The FBI knew that there were often connections between the local police and the Ku Klux Klan, but in spite of this they continued to work with local police forces and to supply them with information that was then passed on to the Klan. One example occurred in May 1961, when the Freedom Riders began an integrated bus trip into the deep South to challenge discrimination in interstate transportation. The FBI knew that the Klan planned to attack the bus when it arrived in Anniston, Alabama, and again in Birmingham, but instead of stopping the Klan, they told the Birmingham police when the bus would arrive. The Klan was waiting at the bus station and attacked the Freedom Riders with clubs. The police were nowhere in sight.[30]

President Kennedy and his brother, Robert, the Attorney General, pushed to some extent to obtain more protection for civil rights workers, but they could only do so much because Southern segregationists held powerful positions in Congress and resisted all proposals to have the federal government protect civil rights workers. The result was that law enforcement was left in the hands of southern police and judges who refused to enforce federal laws they didn't like.

The first thing the FBI did in response to Mississippi Freedom Summer was to direct their field offices to identify everyone who had signed on as summer volunteers. On June 30, my 23rd birthday, the FBI office in Denver received a request for information about me from the Mississippi FBI office. The Denver office discovered that I had a Colorado driver's license and found my address in Pueblo. They opened a file under the title "Racial Unrest" that was the beginning of a long set of files kept by the FBI on my activities. The Mississippi Sovereignty Commission also kept files and they had an informant in the COFO office in Jackson, Mississippi, where the summer project was being coordinated. That person copied information and passed it on to the Sovereignty Commission, which claimed to have files on "all known radical agitators in the state." I don't know if the FBI got my name from the Sovereignty

Commission, but it wouldn't surprise me if the two groups were working together.

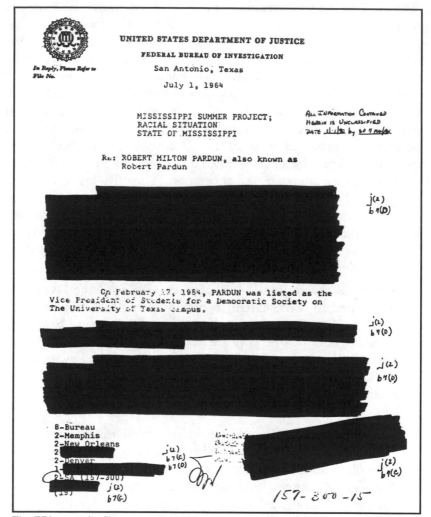

The FBI opened a file on me when I joined the Mississippi Summer Project.

Although we didn't know what was going on behind the scenes with the FBI, experienced civil rights workers were angry about the lack of support and protection provided by the government.

I knew that working in the South was dangerous and that it was possible I could be attacked and beaten or even killed. I was apprehensive because I had no idea what I would be doing in Mississippi, but I wasn't really afraid. It's not that I didn't think about the possibility of being attacked, but I refused to let my fear

keep me from doing what I thought was right. It was a time for putting my body on the line in spite of the danger.

Jackson, Mississippi
Wednesday May 13, 1964

Report of Operator #79

Re: Special Report

Around 10:00 P. M. I was able to obtain the "I - P" file of accepted applications for summer student workers from the COFO office. I then gave this file to my supervisor to copy. There were about 95-100 accepted applications in this file. Of this number, only twenty-seven had photos attached. Only these twenty-seven applications and photos were reproduced. All are white people. Their names, schools, and hometowns are as follows:

Harold Ickes, Stanford University - Olney, Maryland
Theodore R. Jacqueney, University of California Berkley - Berkely, California
Stephen LaVene Johnson, Iowa State University - Rockwell, Iowa
Sharon Gail Kaplan, St. John's College - Philadelphia, Pennsylvania
Joseph Dean Keesecker, Emporia College - Washington, Kansas
Parrish Kelley, Harvard College - Dallas, Texas
Margaret Ann Kerr, University of California Berkley - Berkley, California
Gibbs Von Kinderman, Harvard - Palo Alto, California
Kenneth Kipnis, Reed College - West Englewood, New Jersey
Howard Kirschenbaum, John Hopkins University - Long Beach, New York
Daniel Adam Kline, John Hopkins University - Peekskill, New York
Michael L. Kogan, University of California Berkley - Los Angeles, California
Jean Ann Konzen, St. Mary's College - Marion, Iowa
Bob Lines, University of Washington - Bothell, Washington
Shirley Jean Littlejohn, Eureka College - Eureka, Illinois
Fred V. Martin, University of Alberta - Lacombe, Alberta, Canada
Hulbert Martin, Indiana University - Bloomington, Indiana
Susan Martin, Indiana University - Bloomington, Indiana
Paul A. Miller, Eastern Mennonite College - Holmesville, Ohio
Eleanor Beth Moore, University of Minnesota - St. Paul, Minnesota
Tim Morrison, Beloit College - East Lansing, Michigan
Anthony John O'Brien, Harvard - Cambridge, Massachusetts
James C. Ohls, Harvard - Callicoon, New York
Jo Ann Ooiman, Knox College - Galesburg, Illinois
Robert Pardun, University of Texas - Pueblo, Colorado
Dial Parrott, Princeton University - Greenville, Mississippi
Eleanora Willing Patterson, Radcliffe College - Philadelphia, Pennsylvania

Shortly after midnight, the files were returned to me and I then replaced them in their proper place in the office. No suspicion was apparent of the missing file.

Copy of a Mississippi Sovereignty Commission file on summer volunteers.

Before going to Mississippi for the summer, I went to Pueblo to visit my parents. They were concerned that I could be killed in Mississippi and my dad wanted to know why I thought going to register voters was so important. I answered that segregation had to be confronted and that if we didn't do it now, when would it get done. To my surprise he agreed with me, and although my parents

continued to fear for my safety, they didn't discourage me from going. Judy and I met back in Austin and caught a bus for Oxford, Ohio, to attend a week-long training session before going to Mississippi.

Judy and me at Oxford, Ohio. Summer 1964.

When we arrived in Oxford, we met the other members of the White Folks Project and found that there would be more than a dozen of us going to Biloxi, Mississippi. We also met other young people like ourselves who were already working in the South and who told stories of high-speed chases down country roads, of being shot at and beaten. They also talked about the bravery of the local people who were risking their lives to stand up against the Ku Klux Klan and the White Citizens Councils. Part of our training was in how to react non-violently to violent situations, how to protect each other, how to roll into a ball and get up against a wall or curb to protect the vulnerable areas of our bodies. This training and the stories brought home the reality that we were going into a dangerous situation. We sang "freedom songs" based on old spirituals or labor

songs. These were songs to raise our spirits when things got tough or to celebrate when things went well.

In the middle of our training session, Bob Moses of SNCC announced that three civil rights workers – James Chaney, Andrew Goodman, and Michael Schwerner – had disappeared after being arrested by the local sheriff near Philadelphia, Mississippi. They had been held without access to a phone until after dark and were then released. They hadn't been heard from since. Everyone was silent as Bob said, "The kids are dead."

Bob and the other SNCC people, who had seen the violence of Mississippi, knew what it meant to "disappear." He warned us that it could get rough in Mississippi and told us that it was quite possible that some of us would be killed before the summer was over. He made sure that all of us knew that we could leave at any time without any questions being asked. I considered leaving, and I imagine everyone else did also. I also thought about my father, who gave up a military deferment and risked his life during World War II to stop the evil of fascism. Racism was a similar evil and I was willing to risk my life to end it. As far as I know, all the other volunteers also stayed.

In Mississippi the civil rights movement was accused of bringing in "outside agitators" who were "stirring up *our* nigras," and the Mississippi press played up the speculation that the three missing men were really alive but just hiding somewhere to focus attention on Mississippi. The news coverage in both the North and the South invariably listed white student volunteers, Goodman and Schwerner, first and sometimes omitted Chaney, a local Mississippi black SNCC worker, altogether. James Chaney was just another dead black man and, like so many others murdered in the South, the press didn't consider another dead black man to be news. At the beginning of the summer the FBI had twenty agents in Mississippi and following the disappearance of the three civil rights workers they stepped up their efforts by opening an office in Jackson to track down the killers. One of the FBI's first actions was to investigate Michael Schwerner's father in order to prove his connections with the "left." We all paid close attention as the FBI and members of the military were brought into Mississippi to look for the missing men.

The fact that the national press would cover the situation in the South more extensively if white northerners were involved was one of the reasons behind the summer project. It was also why many of the SNCC staff had initially opposed the whole concept. They knew

that bringing a large number of white students into Mississippi for the summer worked against the goal of building local black leadership. Southern blacks were taught from the day they were born that white people were in control and were not to be questioned. Not being seen as what southern whites called an "uppity nigger" was a survival skill reinforced by lynchings, burnings, and bodies floating in the rivers. SNCC finally decided that making the daily violence against blacks in Mississippi visible to the American people outweighed the disadvantages and decided to go ahead with the project. It was a sad fact that the nation would pay attention to violence against white students while violence against black southerners routinely went unreported.

Some 800 young people went to Mississippi that summer and many wrote home describing what Mississippi was like for black people at the local level. These letters were often published in hometown papers and in that way people who had never been to the South learned about it from one of their neighbors. I wrote a number of letters to my parents describing my experiences and they were published in the Pueblo paper.

The White Folks Project was only a tiny experimental part of Mississippi Freedom Summer. Sam Shirah and Ed Hamlett were the directors of the project. Charlie Smith, Bruce Maxwell, Judy and I came from Austin, while Sue Thrasher, Gene Guerrero, and Howard Romaine were from the Southern Student Organizing Committee. John Strickland, Nelson Blackstock, and Bob Bailey had grown up in the South. Others included Liz Khrone and Dianne Burrows. Sam Shirah, from Alabama, was seen by southern racists as a turncoat southern "nigger lover" and he had been severely beaten on several occasions and had spent time in local jails and state prisons for his civil rights activity. Sam had been selected to lead the project because of his experience – he was twenty-one years old.

Biloxi had been picked, at least in part, because it was probably the safest city in Mississippi in which to talk to whites about the civil rights movement. Because it was a resort area and bad publicity would discourage tourists, we hoped the local businesses would keep the Klan under control. Biloxi had been a resort town since before the Civil War. Plantation owners left their field slaves to take care of the crops while they took their house slaves to Biloxi to wait on them while they enjoyed the ocean breezes from the Gulf of Mexico. Apparently that wasn't all they enjoyed because there was a higher percentage of light-skinned black people – they were never

considered to be dark-skinned white people – on the coast than in the rural areas. We hoped that racism on the Gulf Coast would be less violent because of the blurred difference between black and white.

Before going to Biloxi we were sent to the Highlander Folk Center, in the mountains outside Knoxville, Tennessee, for an additional week of training. Highlander, begun by Myles Horton in the early thirties, had been a center for various forms of organizing activity for years and many southern activists, black and white, had attended workshops or meetings there. Martin Luther King had been there, as had Rosa Parks, who started the Montgomery bus boycott. Myles had been a labor and farm cooperative organizer across the South, and refused to organize segregated organizations. Over the years he had developed techniques for breaking down the resistance whites had to working with blacks.

In an attempt to discredit Martin Luther King, a photo taken at Highlander was spread across the South on huge billboards. It showed Martin Luther King and several other men with the words "Martin Luther King at Communist Training School." When I asked Myles about the picture and he explained that King and many other people had come to Highlander in 1957 to celebrate the school's twenty-fifth anniversary. A free-lance photographer, who turned out to be an undercover agent from the Georgia State Segregation Commission, came to the gathering and took pictures. Not long after that the billboards appeared across the South.

Myles taught us some basic techniques of organizing. One of his most important lessons was that the goal of an organizer is to find local leaders so that the organization isn't dependent on outside organizers. He talked about the importance of "finding the Joes," the people, male or female, who everyone confides in and who know the pulse of the people. To illustrate the idea, Myles told a story about organizing a union in a factory where he didn't have any contacts among the workers. He bought a bag of apples and, at the change of work shifts, he sat down under a tree just outside the gate. Whenever one of the workers asked him what he was doing, he offered an apple and asked about conditions in the plant. Over the course of a few days he met a number of workers and heard the same complaints over and over. He introduced the workers to one another and asked them to bring other people they knew in the plant to a meeting where they could talk about their problems. By having each person talk about his own small piece, Myles helped people see

the big picture and understand their common needs. By simply being an intermediary for information, he was able to find the local leaders and to form a committee that ultimately unionized the plant. He always emphasized that local people needed to run the meetings and do the actual organizing so that they were in total control of their organization.

Myles also talked about putting people in situations where their racist beliefs contradicted what they wanted to accomplish. Since racism divides, situations that require unity confront racism. To explain his point Myles told a wonderful story about helping to form a farm cooperative in rural Alabama. He invited white and black farmers to come to Highlander for several days of discussions, and it wasn't until everyone was there that the white farmers realized that they were spending the weekend with black farmers. When they told Myles that they wanted to leave, Myles didn't argue but told them that there wouldn't be a car going to town until noon the next day. Myles then used the time to put the black and white farmers in close contact with each other so that they could begin to talk about their common problems. When it came time for supper the meal was served at one table so that they could all talk about the advantages of the cooperative. At bedtime the bunks were all in one room. The next morning, after eating breakfast together, they gathered on the grass to talk. As the day got hotter and hotter everyone got thirsty, but there was only one drinking dipper in the bucket of cool water. The farmers talked about their common problems and when they got thirsty they all drank from the same dipper. When the car left for Knoxville at noon, none of the white farmers were in it – they were too busy forming an integrated co-op.

Toward the end of our stay at Highlander a group of us drove into the Great Smoky Mountains and stopped to visit Sam and Florence Reese. Sam had been a union organizer in Hazard, Kentucky, during the 1930s and Florence had written a famous union song, *Which Side Are You On?*, to unite the miners. Sam and Florence told us about the bloody struggle against the coal company in Hazard and its hired army as the miners fought to be treated as people instead of as expendable machines. Their story added a personal account to a much larger history that I was learning – the history of common people's struggles for freedom and human dignity. By the time we left their house, I knew that I was part of that much larger struggle for freedom and justice that spanned many

generations. The civil rights movement was just another link in the chain.

We left Highlander headed for Biloxi in several cars. Sam Shirah, Charlie Smith, Bruce Maxwell, Judy, and I drove down together in the lead car. To avoid detection by the Mississippi police, we had decided to drive straight south through Alabama to the Gulf Coast. Shortly after we crossed the Tennessee-Alabama border, an Alabama state police car pulled in behind us. He followed us for mile after mile and finally pulled off only to be replaced a few miles down the road by another state trooper. Every few hours Sam stopped at a pay phone to call the SNCC office and tell them where we were and where we were going. This was standard SNCC safety procedure. If we didn't call in on time, the office would mobilize whatever forces they had to find out what had happened to us.

As we crossed Alabama, I was again struck by how separate and unequal everything was. Every little town had its statue of a Confederate soldier. It was easy to tell where the black part of town began because the sidewalks and paved streets stopped at the boundary. Every white-owned field had black adults and older children working in it, while the smaller children played around the unpainted one or two room shacks that bordered the fields. We also passed through large areas of dense woods with deep slow rivers and I wondered how many black people had been killed and dumped there in the past hundred years.

When we crossed into Mississippi, our Alabama police escort pulled over and we were left alone, which was a relief. We drove to Biloxi and went to the apartments we had rented in advance, but the owner told us that the apartments were no longer available and returned our money. It was getting dark and the entire White Folks Project, more than a dozen people, was stranded in Biloxi without a place to stay. We needed someplace cheap and finally rented several apartments with cooking facilities in the Riviera, (pronounced Ruhveeruh) Hotel, a rundown ante-bellum hotel across the highway from the beach.

The next day Charlie and I started looking for houses to rent. We found one small place big enough for three or four people and paid a hundred-dollar deposit, but the next day when we went to move in our key didn't fit the lock. Charlie and I went to the owner's office to get new keys and found him waiting for us and in a bad mood. He jumped up when we walked in the door, saying that he had found out that we were "Freedom Riders," that the deal was off, and

that he was keeping the hundred-dollar deposit for his trouble. We tried to calm him down and to convince him to return our deposit, but he adamantly refused. I finally told him that the civil rights movement had some of the best lawyers in the country and that we'd sue him if he didn't return our money. As I talked he opened the drawer of his desk, pulled out what looked like a .38 revolver, pointed it at my head from a distance of about a foot, and yelled "Get the hell out of here you nigger-lover. I don't ever want to see you again." "Yes, sir!" I replied and as I went out the door I heard him tell Charlie to stay. Charlie came out about fifteen minutes later with fifty dollars and said we'd better count ourselves lucky.

We all got together at the hotel to discuss what to do next. It was obvious that people knew who we were and that even sympathetic people would be afraid to rent to us. We would need three or four places the size of the house Charlie and I had found and we would be more vulnerable to being attacked if we were scattered around town. Staying in the hotel as a group seemed like our best option so we decided to tell the hotel manager who we were and see if he would let us stay. When we approached him, he laughed and told us he knew who we were because he had been receiving threats ever since we arrived. He let us stay and over the course of the summer became very friendly.

We held a number of long strategy meetings to decide how to approach whites in the charged atmosphere of the "summer invasion." There were two different ideas for what to do during the short time that we would be there. The majority of us thought that organizing poor whites made the most sense politically because they seemed like the natural allies of poor blacks. Both poor whites and black suffered from low-paying jobs, inadequate housing, and poor education. Racism, however, kept these natural allies apart. No matter how poor and powerless whites were, their status was higher than all blacks. Many poor whites were aggressively racist because all the power they had came from their "white skin privilege." While organizing poor whites along these lines seemed important, it also seemed like more than a summer project. None of us wanted to get people involved and then just leave them at the end of the summer. Ed Hamlett suggested that we look at areas where we might have more short-term success, such as working with small businesses, clergy, and school administrators to try to defuse potential violence. Rather than start something we weren't prepared to finish, we decided to follow Ed's suggestion.

A young couple, Robert and Lois Williams, both native Mississippians, had moved into the Riviera Hotel. shortly after we did. We quickly got to know them and they spent almost as much time in our apartment as in their own. We had several long discussions with them about the economic situation in the South and emphasized that the South would always be depressed if it spent all its time holding down the blacks. They seemed almost too open to what we were saying and we wondered if they were spying on us. We had no evidence that this was the case and decided to be open with them and see what happened as the summer progressed.

We did a lot of library research to learn about the politics of Biloxi and divided up into groups to pursue different objectives. We talked to a number of white business owners and over thirty ministers. Most of the business people said they didn't want any trouble and would be willing to quietly integrate if everyone did it at once. But no one was willing to be first. The ministers were also unwilling to step out. One incident stands out in my mind because it revealed the social forces that kept segregation in place for so long. At one of the local schools, Judy and I met with an administrator to discuss school integration. He was very friendly and sympathetic, but when the principal walked in he suddenly became very hostile. After the principal left he explained that he could lose his job if people knew he supported equality for blacks. The influential people we were talking with were all trapped in the system of segregation and were afraid of the consequences of stepping out of line. Southern racism, enforced by the KKK and the White Citizens Councils, was as intimidating to some whites as it was to blacks. As word got around that we were there, a few sympathetic young people dropped by to talk. One came to visit a few times and told us that he had no sympathy for the white racists. His great-grandfather had hidden in the swamps to avoid the Civil War because, "He didn't own slaves and wasn't interested in dying for someone who did."

In July, Sam, Judy, and I visited several other projects around the state. Our first stop was the COFO/SNCC office in Jackson, where we spent a day. Information flowed into the office from across the state about incidents ranging from petty harassment to major confrontations as the local people and the police reacted to the summer project. All this information was entered in a log. While in Jackson we drove past the new FBI office. Although they had opened this office to investigate the disappearance of the three civil rights workers, they hadn't changed their policy of not adequately

protecting civil rights workers. A few days before we arrived, civil rights workers had been attacked by men with ax handles right outside the doors of this new FBI office and the FBI agents had done nothing.

JULY 11: *Shaw:* Local Negro offered $400 by five whites to bomb SNCC Freedom House, $40 for list of residents' home addresses.
Laurel: Four young Negroes injured during and after attempts to integrate Kress' lunch counter, where Negroes had eaten earlier.
Canton: Small fire bomb thrown at Freedom House lawn.
Vicksburg: Amateur bomb thrown through window of Negro cafe.

JULY 12: *Canton:* Two summer volunteers, visitor refused admission to First Methodist Church. Volunteers had been welcomed a week earlier.
Greenwood: Bomb threat.
Jackson: Half-body found in Mississippi identified as Charles Moore, former Alcorn A&M student. Second half-body found in river. (In mid-April, more than 700 students, all Negroes, were summarily dismissed from Alcorn after a nonviolent general grievance demonstration.)
Jackson: White teen-agers slash Negro woman's tires, spit in face of volunteer coed after integrated group eats at drive-in.
Jackson: Elderly man attacks Negro woman at Greyhound coffee shop. She is treated for cut head, hand, then charged with disturbing the peace. Out on $50 bond. Assailant escapes.
Biloxi: Volunteer picked up while canvassing, informed of complaints by local residents, released.
Itta Bena: Local woman attacked by two white boys while baby-sitting. Both her arms cut.
Natchez: Jerusalem Baptist and Bethel Methodist Churches burned to ground. Home of Negro contractor in Natchez fire-bombed.

JULY 13: *Clarksdale:* Negro volunteer chased out of white laundromat, picked up by police for failure to signal turn, taken to jail and beaten. Sheriff says: "You're a nigger and you're going to stay a nigger." Charged with resisting arrest, out on $64 bond.
Clarksdale: Chief voter registrar closes courthouse for next few days. Stated reason: court in session, no time for registration.

Entries from the log of incidents during the Summer of 1964.

From Jackson we headed toward the Delta in northwestern Mississippi, where the land is flat and rich – prime land for cotton. We stopped in Ruleville, a town of several thousand where big old trees stood in front of white painted houses. The local white farmers looked a lot like my uncles and the other farmers around Walnut,

Iowa. They were burned brown by long hours in the sun, wore overalls, and drove pickup trucks, each with a rifle in a rack across the back window as if it were hunting season. I knew that most of these men were hard working family men who loved their children and went to church on Sunday. I also knew that some of them were willing to kill people who tried to stir up "their nigras." We didn't want to draw any attention to ourselves.

We drove out of town past fields and farms and, after making sure that we weren't being followed, turned down a dirt road past a long row of unpainted board shacks with crooked doors and cracked windows looking out on the fields. We pulled off the road behind one of the buildings to conceal our car as much as possible and Sam got out and knocked on the door. A middle aged black woman opened the door, gave Sam a big hug, and invited us in. Sam introduced us to Hattie and we settled in for the night. Hattie told us about the local movement to register blacks to vote and about the intimidation from the white community. Blacks had been threatened with everything from being evicted from the houses along the edges of the fields and losing their jobs on the white-owned farms to being killed. Black southerners, particularly in rural areas, knew that standing up for their rights was an open invitation for a midnight visit from the Klan.

In the middle of the night a car pulled up outside the house and there seemed to be a short argument between Hattie and someone outside. I had a moment of fear as I wondered if the local Klan had discovered our presence, but the car drove away without incident. In the morning Hattie told us that the visitor was a local white man who wanted to "spend some time with her." Although whites believed in strict segregation during the day, some of them practiced integration at night. To get the man to leave she told him that she already had "a visitor" who was spending the night. Since these same white men who visited at night provided work during the day, there was always the threat that refusal could mean losing your job.

The next day we drove from Ruleville to Helena, Arkansas, where the SNCC project was under attack. Two days before we arrived, a couple of cars full of whites had driven past the project house and fired shots at it. The police had refused to do anything, blaming the civil rights workers for provoking the action by being outside agitators. I was surprised and somewhat comforted to find that this group was armed and prepared to defend itself if attacked. I asked one of the people about non-violence and he replied that he

was tired of being a non-violent target and that too many good people had already died at the hands of violent white racists. That night, since I had grown up around guns and knew how to use them, I took a spell on watch with one of the people from the project. The next day we headed back to Biloxi.

When Sam, Judy, and I got back from our trip, Robert Williams was waiting for us and wanted to talk with Sam. He began by admitting that he had known who we were before he came to the hotel and that he had come to gather information on us so that he and his friends could drive us out of town. He said that everyone in his family was in the Klan, but that he had never been part of it because the Klan didn't have a program for making the South a better place to live. He saw it as a negative force maintaining the *status quo* with violence. He said that he had been looking for a group with a program and had been trying to join the American Nazi Party for the past year. While we were gone he had been accepted and now he had a problem. Our ideas about how racism held the South down had made him reconsider, and he told Sam, "I don't know whether to join the American Nazi Party or to join SNCC." After a long discussion, Robert and Lois joined us. Because they were both from the Biloxi area, people knew them and word of their relationship with us soon got around. A local police officer stopped Robert and demanded, "What do you think you are?" Robert replied, "A goddamned Freedom Fighter!" When he began getting death threats and the Klan denounced him, Sam arranged for them to safely leave the area. In August, Robert was one of the few white delegates of the Mississippi Freedom Democratic Party (MFDP) as it challenged the seating of the all white Mississippi Democratic Party delegation at the national convention of the Democratic Party.[31]

In late July, Judy's parents urged her to go to New York with them in August to visit relatives. They agreed to my coming along and lured us by saying that they had friends there who might give money to support SNCC. Since the project in Biloxi didn't seem to be going anywhere, everyone in the project agreed that going to New York to raise money seemed more productive. We were about to buy bus tickets to Texas when Charlie Smith offered to give me the Panda Wagon, his little English Austin A-40 station wagon. He had fallen asleep at the wheel and had gone off the road, smashing the front bumper and destroying the grill so that the hood was now held down with a rope. The fan belt had recently broken and Charlie

was tired of "all the trouble" so he signed the title over to me. I installed a new belt and we took off. This little car was to take me many miles before it finally disintegrated.

After Judy and I left, the project switched gears and focused on registering poor whites in the Mississippi Freedom Democratic Party. They teamed up with some black SNCC workers and went in integrated pairs to talk about the issues that poor whites and blacks had in common – poor schools, low-paying jobs and bad living conditions. The response was better than anyone expected and in two weeks of canvassing twenty white people registered with the MFDP.

On August 4 the bodies of Chaney, Goodman, and Schwerner were found buried beneath an earthen dam near Philadelphia, Mississippi. Goodman and Schwerner had been shot and it appeared that Chaney had been tortured and beaten to death. During the search for the bodies all the local rivers had been dragged and a number of murdered black men had been found, including a man's torso wearing a CORE T-shirt. Pushed into doing something by the bad publicity they were receiving after the three men disappeared, the FBI launched a full-scale investigation, discovered the three bodies, and eventually found the killers. Several local men were indicted and the sheriff of Philadelphia and his deputies were later shown to have been accomplices in the murders. An all white jury acquitted them all of murder.

On August 2, an incident in the Gulf of Tonkin brought Vietnam to the attention of the American people. The newspapers told us that the North Vietnamese Navy had sent three high-speed torpedo boats to attack the US Destroyer *Maddox*, which was in international waters off the coast of North Vietnam. On August 3, another torpedo attack on the *Maddox* was reported, and on August 4, President Johnson retaliated by "bombing the hell out of the Vietnamese."

The press called the attack on the *Maddox* an act of unprovoked aggression by the North Vietnamese, but I knew that wasn't true. I had been reading the *National Guardian* reports about secret military operations along North Vietnam's coast for months before the incident. We now know that in January 1964, President Johnson had approved secret attacks against North Vietnam using the South Vietnamese Navy.[32] With American technical support, these forces had been shelling and sabotaging facilities along the coast of North

Vietnam for six months before the incident involving the *Maddox*. On July 31, four South Vietnamese PT boats attacked two North Vietnamese islands in the gulf of Tonkin while the *Maddox* was in the area doing electronic surveillance to detect radar and other military installations. Since the North Vietnamese were under attack, their attack on the *Maddox* was not unprovoked. This was an early incident where those of us who opposed the war knew that the government was lying to the American people about what it was doing there. As the war escalated, this pattern of official lies and our distrust of the government increased.

In response to the "unprovoked" attack, Congress gave its support to the growing war by passing a resolution that the Johnson administration had been preparing for months.[33] The Gulf of Tonkin Resolution, passed on August 7, 1964, gave President Johnson power to "take all necessary measures" to "prevent further aggression" in Southeast Asia. Johnson later described the resolution as being "like grandma's night shirt – it covered everything."[34] Only two senators, Wayne Morse of Oregon and Earnest Gruening of Alaska, voted against the resolution, alleging that the United States had provoked the attacks. Many others in Congress opposed getting involved in a war in Southeast Asia, but publicly they remained silent because of the potential political repercussions of opposing the president or of appearing to be "soft on Communism."

Judy's family and I stayed with her grandmother in New Jersey. Judy's aunt and uncle hosted a gathering for us to talk about our experiences in the South and to collect money for SDCC. After our presentation I was approached by one of the guests, who seemed very interested in the civil rights movement and the white folks project, and wanted to know if SNCC or any of the New Left groups had any plans to organize labor unions in the South. I told him about SDS's support for the striking miners in Hazard and that organizing unions might become part of the civil rights movement in the future. I was surprised when he responded that he wouldn't support SNCC because he had factories in the South and wasn't interested in having them unionized.

On one of our trips to New York City we went by the office of the Young Socialist Alliance (YSA), the youth group of the Socialist Workers Party (SWP). While in Biloxi, I had written to the YSA and asked about membership. The SWP newspaper, *The Militant*, called for immediate withdrawal of American troops from Vietnam, a

position I agreed with. They also had good coverage of Malcolm X and published his speeches. Malcolm X urged blacks to strengthen their communities and advocated that blacks defend themselves against attacks by whites. He believed that blacks needed to have political and economic power before there would be any basic change. Political, social, and economic power was very much on the minds of the leadership of the civil rights movement as they registered voters. I agreed with much of what Malcolm X advocated and sympathized with the SNCC members in Arkansas who were armed and prepared to fight back. Years later I learned that the FBI had an informer in the YSA office and that all my correspondence was copied and placed in my FBI file in Denver. I was actually a member of the YSA for three months but let it lapse because it seemed irrelevant to what I was doing. My brief membership was important to the FBI, however, who decided that I was a Communist infiltrator of SDS and opened a "COMINFIL" file on me.

After about fifteen minutes in the YSA office, we headed for the SDS office, where we met the national secretary, Clark Kissinger, and Helen Garvy, the assistant national secretary. We talked for several hours about the University of Texas chapter and as we were preparing to leave, Clark asked if I would be interested in organizing SDS chapters in the Texas-Oklahoma region. This took me totally by surprise and, when he offered to send me a hundred dollars a month, I eagerly accepted. I had already decided not to go back to school and wanted to work in the movement but hadn't decided what to do. We agreed that I would go to Chicago in September to work in one of SDS's community organizing projects for a month or so before returning to Texas to start traveling. I would organize in Texas and Oklahoma and, if possible, Colorado, New Mexico, and Louisiana. I don't think Clark had any idea just how large an area that is.

In late August, the nominating convention of the national Democratic Party met in Atlantic City, New Jersey, to pick its candidate for the coming presidential election. Mississippi summer volunteers had been registering disenfranchised black voters in the Mississippi Freedom Democratic Party all summer and the MFDP came to Atlantic City representing 80,000 black people. They challenged the all-white Mississippi delegation on the grounds that, by excluding blacks, it violated the US Constitution and civil rights

laws that were on the books, even though they weren't being enforced. President Johnson, wanting information on the MFDP, asked the FBI to wiretap, place bugs, infiltrate the office, and pose as reporters in order to obtain inside information.[35] The FBI gladly complied.

After much discussion, the Democratic Party refused to seat the MFDP delegates but offered a compromise to admit them as non-voting observers. When the MFDP refused, they were offered two voting seats as at-large delegates. The MFDP had counted on the liberal Democrats for support but now, under tremendous pressure from President Johnson, these liberals were urging the MFDP to compromise. Even Martin Luther King urged the MFDP to take the offer. SNCC, the MFDP delegates, and others, including SDS, felt betrayed. In our eyes, the liberals in the Democratic Party were willing to compromise away the gains that those in the civil rights movement had made by risking their lives. Since the beginning of Freedom Summer there had been over a thousand arrests, thirty-five shootings, eight beatings, and six murders.[36] Black citizens of Mississippi faced serious reprisals for trying to exercise their basic constitutional rights. When Fanny Lou Hamer, one of the MFDP delegates from Ruleville, had tried to register to vote she had been evicted from her house and lost the job she'd had for nearly twenty years. She had been arrested for her activity and beaten by the sheriff. When he became too tired to continue the beating, he forced a black inmate to continue. When Ms. Hamer spoke to the Democratic convention, her comment on the offer of two at-large seats was, "We didn't come all this way for no two seats. All of us is tired."

For many of us the Gulf of Tonkin incident and the refusal to seat the MFDP were watershed events that convinced us that neither the Democratic Party nor the liberals could be counted on for meaningful social change. It reinforced our belief that change would come from pressure from below and not as a gift from above; that the only means open to us to change society was to organize at the grass roots.

Toward the end of August Judy and I returned to Austin. As I prepared to work full time for SDS, the sense of urgency in the civil rights movement and the sudden expansion of the war in Vietnam made building a movement seem more important than ever.

Campus Traveling
Fall 1964

"There's a change in the wind, a split in the road. You can do what is right or you can do what you're told. But the price of victory will belong to the bold, for these are the days of decision."

Phil Ochs, *Days of Decision*

While I was in Mississippi, SDS, largely inspired by SNCC organizing, had begun its own projects in northern cities. These Economic Research and Action Projects (ERAP) emerged from both practical experience gained from working on civil rights and poverty issues as well as theoretical analyses that pointed toward a coming crisis in America and suggested new alliances to deal with it.

An ERAP recruiting pamphlet explained its goals.

> ERAP organizers work with poor people who are struggling to create their own organizations capable of protesting economic and social injustices. Work is among the white and Negro unemployed, among mothers on welfare, public housing residents, displaced Southern miners, the young and old who face a future of economic insecurity, and the neighborhood groups with common goals for social change.
>
> Central to [the] Economic Research and Action Project is the assumption that poor people – Negro and white – can be organized around economic and political grievances, and that there is a natural alliance among all poor people in their common need for jobs, income and control of their lives.

Although most of the inspiration for ERAP came out of our own experiences, we always blended practice and analysis. In 1963, the SDS convention debated and approved a paper drafted by Dick Flacks called *America and the New Era*. It predicted increased unemployment as a growing number of people entered the labor market and the number of industrial jobs decreased due to automation. The result of this economic transformation would be lower wages, racial tension due to job competition, and increased poverty. In response to this changing situation, the paper predicted

"a new discontent...groping towards a politics of insurgent protest."
These new insurgents were "active generators of a wide variety of
political activities in the neighborhoods and communities where they
are located....The outcome of these efforts at creating insurgent
politics could be the organization of constituencies expressing, for
the first time in this generation, the needs of ordinary men [and
women] for a decent life."[37]

Students from Swarthmore College, who regularly drove through
Chester, Pennsylvania, on their way to do civil rights work in the
South, realized that there were problems closer to home. In 1963
they began working with local civil rights groups in Chester. Carl
Wittman described the work there in an SDS pamphlet called
Students and Economic Action. A later more theoretical piece, *Toward
an Interracial Movement of the Poor*, by Tom Hayden and Carl
Wittman, argued that racism and poverty could both be challenged
by organizing blacks and whites together around common issues.

In the spring of 1964, SDS began setting up organizing projects
in both black and white neighborhoods in primarily northern cities
including Chicago, Newark, Cleveland, Philadelphia, Trenton,
Baltimore, Louisville, and Hazard. Organizers there found that poor
people could be organized, and in many cases were already getting
together around issues such as poor housing, inadequate schools,
and welfare. While these were initially seen as summer projects, most
continued on after the summer was over.

As with the White Folks Project, ERAP went into each individual
community and then figured out what to do there. The theory was
that poor people could be organized, and so the general plan was to
organize people around their needs; but finding the issues and the
local people who wanted to work on them depended on the
community. As each project developed in its own way, the network
of friendships among the project organizers and the constant sharing
of ideas about what worked and what didn't were more important to
ERAP than theory.

While I was in Mississippi, a dozen ERAP volunteers had spent
the summer living in a neighborhood in North Chicago talking to
people about unemployment, housing, and welfare. In order to
determine what part of Chicago to settle into, the staff had leafleted
at the employment office and then plotted the addresses of
interested people on a Chicago map. The addresses clustered in an
area called Uptown so that had become the focus of the organizing.
As they later realized, this was a difficult area in which to organize

because the population was transient. Men had jobs and lost them, people didn't pay the rent and were evicted, and families moved back and forth between Appalachia and Chicago – all of which made it more difficult to find a stable core of people. The Chicago project was called JOIN, which stood for Jobs Or Income Now. By fall there were ten to fifteen local people – mostly whites from the upper South, but also a few blacks and Puerto Ricans – who were interested in doing something. When fall came, the summer volunteers returned to school leaving Richie Rothstein, a graduate of Harvard who had just returned from a year at the London School of Economics, and Paul Millman, an undergraduate from Antioch College who was spending a work-study semester with JOIN.

In early September I caught a bus to Chicago where I found Richie and Paul trying to pull the project together. I didn't know what to expect from Chicago because, except for my brief visit to New York with Judy, I had never been in any of the large northern cities. The mostly run-down, three story brick apartment buildings were crammed together so tightly that the only open space was out on the street where there were always lots of people. There were more taverns, pawnshops, and storefront churches than I'd ever seen crowded into one area. The Chicago Police, known for beating people up and figuring out why afterwards, were always nearby. They must have considered the combination of white Appalachian refuges, a sizable Puerto Rican community, high unemployment, poverty, and alcoholism to be a potentially explosive situation.

One of the first things I noticed were the clusters of young guys with slicked-back hair and black leather jackets hanging out on the street corners. They reminded me of the gang kids in my high school, who I knew could be dangerous if they singled you out for any reason. Organizing them would be important to organizing the neighborhood, but it would take someone special to do that. I wasn't that person, so I avoided them.

One Saturday we went on a fund-raising mission to a theater where folksinger Pete Seeger was giving a concert. To attract the attention of the people attending the event, we sold apples on the street corner near the entrance. During the depression of the 1930s, unemployed men often sold apples on street corners to get money to feed their families and we hoped that the people attending a Pete Seeger concert would make the connection. As people left the hall, Pete walked over to me, bought an apple, and we talked briefly

about JOIN. Many people in the movement knew of Pete Seeger but I had only recently discovered him and was thrilled to meet him.

The JOIN office in Chicago.

We continued to go to the employment office regularly to talk with people and to get more names. Paul and I spent the afternoons visiting people who'd shown interest, to find out what issues concerned them, and to encourage them to come to meetings at JOIN's small store-front office. While I was in Chicago, we held a couple of community meetings in the JOIN office. Many of the neighborhood people wanted to do something about the high rents for apartments that were often in bad repair. People talked about withholding their rent until repairs were made and decided to find out how to do it legally so that they wouldn't be evicted. "Rent strikes" did eventually take place, although not while I was there. One of the highlights for me was when a white man from Tennessee urged the group to find ways to work with black people because, "We're all in the same boat and black and white have to work together if we want to change things." In the month that I worked in Chicago, I learned a lot and left convinced that a community based political movement was possible. But my heart was elsewhere; I was ready to go back to Texas [38]

I left Chicago in early October, hitchhiking south toward Austin. After a day on the road I had covered only about a hundred miles so

I caught a bus. I arrived in Austin in the evening and headed for Jeff's apartment to drop off my stuff before going to find Judy. She was a sophomore and had to be in by ten o'clock, but the ground-floor apartment where she lived had a back window opening onto the alley and soon we were back at Jeff's talking about all that had happened while I was gone.

I spent some time enjoying Austin and trying to contact the people whose names I had gotten from the SDS national office. The *Texas Observer*, published by a group of renegade Texas Democrats who were active in the civil rights movement, published an ad for SDS and that gave me several additional contacts. The contacts in Dallas and Sherman, Texas, responded, and I arranged to visit them. I didn't hear anything from the University of Oklahoma in Norman, but I had several names there. The names I had in Denton were old, so I'd see if I could find anyone when I got there.

With the Panda Wagon, ready to hit the road.

In mid-October I headed north for Dallas, Denton, Sherman, and Norman. I was glad I had the Panda Wagon for transportation

because it was hard to imagine hitchhiking over the vast expanses of the Southwest. I stayed in Dallas for a couple of days, but the contacts I had were no longer in school and didn't know each other. I got them together for a meeting but it didn't click as a chapter. In Sherman, my only contact had gone to another meeting and wouldn't be back for a week. I continued on to North Texas State at Denton, a small town north of Dallas that lay on the boundary between the South and the West. To the east was a town with a banner across the main street that said, "The Blackest Dirt and the Whitest People." To the west were Fort Worth and Abilene – towns built around the cattle drives of the late 1800s.

I had names of several people in Denton, but the only information I had was that they were somehow associated with the music department, one of the few in the state that taught jazz. Even though during the early sixties people dressed and wore their hair very much alike, there was usually some small hint of non-conformity that one non-conformist could spot in another. I never put my finger on exactly what it was, but other organizers described the same thing. Hoping to spot the SDS people, I decided to go to the music building. I stood in the hall and watched the students as they went to and from class. One person attracted my attention, so I introduced myself and asked if he knew any of the local SDS people. It turned out that he was one of the people I was looking for and was surprised that I had picked him out of the crowd. He offered me a place to sleep and I stayed in Denton for three or four days.

A lot of what I did was one-on-one organizing. I would "hang out" with people, answering questions and providing information. Since it was easier to get SDS pamphlets and buttons than it was to get the $100 that I had been promised, I always carried a supply of these items that I could sell for a dime here and a quarter there. That plus a few contributions provided enough money to eat and put gasoline in the car so I could make it to the next place. SDS pamphlets covered topics ranging from economic issues to segregation and community organizing and they were always eagerly read because they were generally well written and covered important current issues. The fact that SDS was a multi-issue organization attracted students because connecting the issues gave a better understanding of the nature of the problems.

After meeting with as many people as I could, I got everyone together to talk about the growing student movement and possible activities. The main interests were civil rights and voter registration,

but because of the recent Gulf of Tonkin incident, people were beginning to ask questions about Vietnam. The information coming from the news media described North Vietnam as "communist aggressors" and South Vietnam as "free and democratic." I countered this by telling the history of Vietnam and of US military aid to France as it tried to recolonize Vietnam. I told them about the US provocation of the Gulf of Tonkin incident, and Ngo Dinh Diem's refusal to hold the elections mandated by the Geneva Peace Accords. I described the "free-fire zones," "strategic hamlets," Napalm, torture, and other atrocities being committed in Vietnam. By the time I finished they were upset.

I encouraged them to make a public statement against the war because the presidential election campaign was in full swing and President Johnson was running on a position of "no wider war." I didn't trust Johnson, but it seemed possible that he might not escalate the war if he knew that enough people were opposed. When I left Denton, the small SDS chapter had been energized. Several new people had joined and the group was planning actions around both civil rights and the war.

Campus traveling was challenging and fun because every campus had its unique blend of individuals and problems. As I traveled I found that there were small groups of students almost everywhere who were concerned about a variety of issues. Jim Russell, who I had met at the Hazard conference, was no longer in Norman, but he had given me several names. I found a small chapter that had been involved in civil rights activity the previous year in both Norman and Tulsa and I spent a week meeting with people and sharing ideas with them. The group in Norman was a lot smaller than our group in Austin, but it had the same feeling of being a community that went beyond political activity.

As I got to know the members in Norman our conversation wandered from civil rights and Vietnam to psychedelics. Instead of peyote they had LSD and a group of us took some one evening. It was my first LSD trip and it was a lot easier to take than peyote because it was just a tasteless blue dot on a piece of paper instead of six foul-tasting cactus tops. Like peyote, LSD dissolved the boundary between the person taking it and the rest of the universe. It's difficult to explain what it was like but Jody Bateman, a local member, captured part of it when he tried to explain what LSD was like to someone who had never taken it. Jody had tried several times without success to put the experience into words. He finally picked

up a cookie and gave it to the person, who took a bite of it. Jody looked at him in dismay and said, "Don't eat the cookie! Be the cookie!"

Later that fall I went to Texas Tech in Lubbock. Since the one person whose name I had never responded to my letters, I went onto the campus cold. I tried to spot people who might be interested, but no one stood out. I asked several students if there had been any political activities, but everything had been quiet. I thought about putting a notice up on the bulletin board, but it was locked and notices needed administrative approval. I had a few leaflets that mentioned SDS as a new organization and civil rights as a possible concern and I passed them out but got no response. I was trying to figure out what to do next when I remembered Myles Horton's story about sitting in front of the factory gate with a bag of apples and waiting for someone to ask what he was doing. I wrote the letters "SDS" on a small piece of cardboard and attached a stick to it. I stuck my sign in the ground and sat down on the grass next to it. Most people walked by, but a few stopped to ask what I was doing. One person had heard of SDS and was interested in learning more. He told me the person I was looking for had transferred to another school, but he had a couple of friends who he thought might also be interested, so by evening I had found people to talk to and a floor to sleep on. I never knew where I would sleep when I was on the road so I always carried a blanket in my car and found that if I stuffed my shirt into a shoe it made a reasonable pillow.

I spent the next few days talking with these students and with their friends and then got everyone together to talk about SDS. The one-on-one talking paid off because when we got together they already knew about the issues and the importance of a multi-issued approach. We talked about segregation and poverty, racism and the growing war in Vietnam. Even though Lubbock is in West Texas, segregation was still an issue because Texas Tech had been segregated until 1961. As in Denton, many of the questions had to do with Vietnam, which was just beginning to appear in the news. The students on the campuses had all been fed the same anti-communism that I had grown up with and had accepted it to some degree. Everywhere I went it was the history of Vietnam and the details of what the US was doing there that convinced people that the US should find a way out of Vietnam. This new generation wanted to know more about what was going on in Vietnam than the government's simple answers about "the communist threat." By the

end of the meeting five students joined SDS and formed a chapter, although they were too intimidated to approach the administration to request official campus approval.

Having to obtain approval from the administration was part of a larger problem. Universities treated students as if they were children and acted *in loco parentis*, in place of the parents. This meant that the university took upon itself the power to restrict freedom of speech and of assembly as well as setting dormitory hours. At the University of Texas, we had to take a copy of any leaflet we wanted to hand out on campus to the Dean for approval. Rallies and outside speakers had to be approved beforehand and large spontaneous gatherings were not allowed.

During the fall of 1964, events at the University of California at Berkeley brought the issue of university control of students' lives to the attention of many students around the country. Clark Kerr, chancellor of the University of California at Berkeley, noted in his 1963 book, *The Uses of the University*, that the nature of the university was changing from an institution that put students first to one that put research and government contracts first. Kerr called the new university "the multiversity" and noted that many students had a hard time finding their place within it. He saw students as compliant and easy to control and commented, "employers are going to love this generation...they are going to be easy to handle. There aren't going to be any riots."

Clark Kerr was wrong. Students at Berkeley had been active at least since the demonstrations against the House Un-American Activities Committee (HUAC) in 1960 and political awareness had continued to grow.[39] By the fall of 1963, many students had joined the local civil rights movement, demonstrating against discrimination in hiring at local hotels and businesses. To recruit for these demonstrations, activists set up tables on campus. In the fall of 1964 the university announced that it would no longer allow students to use that area to solicit funds, advocate for issues, or recruit people for off-campus activity. The students noted that these rules only applied to them – the Marines could still recruit on campus, the university advocated for political action in its interests, and instructors were still coerced into contributing to the United Crusade charity fund. There was also a widespread belief among students that the ruling had come because of pressure from businesses, such as William Knowland's *Oakland Tribune*, that were the target of civil rights activity.[40]

A broad coalition of student political groups ranging from the Young Republicans to various socialist organizations tried without success to negotiate with the dean on the key issues. Students, some of whom had just returned from Mississippi, set up tables on campus in violation of the rule. Five of the SNCC and CORE people and three other students were told to report to the dean and when they refused, all eight were suspended from school. The next day the students again set up the tables and the campus police arrested CORE worker Jack Weinberg and put him into a police car. A few people gathered around the car and sat down to keep it from leaving. Soon several thousand students surrounded the police car in a spontaneous rally and throughout the afternoon and into the evening, students stood on top of the car as they spoke to the crowd. The confrontation continued all night and the next day as seven thousand students rallied in front of the administration building to show their support for the demonstrators. The siege finally ended when the administration agreed to negotiate the issue of free speech and promised not to press charges against Jack Weinberg. When Jack was finally released after 24 hours, the demonstrators allowed the police car to leave. Over the next nine weeks the conflict continued and a Free Speech Movement (FSM) grew. Students organized sit-ins and rallies, but the administration repeatedly refused to negotiate. Finally, frustrated by the administration's lack of good faith and by disciplinary action taken against a number of student leaders, the students issued an ultimatum. When the administration ignored it, the students again rallied outside Sproul Hall, the administration building. One of the speakers, Mario Savio, a returning Mississippi Summer volunteer, spoke about the arrogance of those in control of the university and concluded:

> There is a time when the operation of the machine becomes so odious, makes you so sick at heart, that you can't take part; you can't even passively take part, and you've got to put your bodies upon the gears and upon the wheels, upon the levers, upon all the apparatus and you've got to make it stop. And you've got to indicate to the people who run it, to the people who own it, that unless you're free, the machine will be prevented from working at all!
>
> Now, no more talking. We're going to walk in singing "We Shall Overcome."[41]

Fifteen hundred students marched slowly into Sproul Hall, occupying all four floors of the building. The next day the police brutally cleared out the building, arresting 814 people. In response,

ten thousand students went out on strike and the university came to a standstill. This finally forced the administration to the bargaining table and all significant free speech demands of the FSM were granted. Amnesty was granted for all action prior to the sit-in in Sproul Hall, but students arrested there were given fines and some were sent to jail.

Although to some extent the FSM could be seen as the result of student alienation from the increasingly impersonal nature of the multiversity, this was not its primary motivation. There were real political issues at stake. University administrators backed up by Boards of Regents and government officials, thought they had the right to declare rules that overruled students' constitutional rights. The civil rights movement was about bringing the freedoms guaranteed by the constitution to black people, and when these same rights were denied to students it changed the way that we saw the world and ourselves.

In large part due to the SDS network, the news about what was happening at Berkeley spread quickly to campuses across the country. Steve Weissman, an SDS member who was also on the FSM steering committee, regularly called the SDS national office with up-to-the-minute news about each meeting, sit-in, and confrontation. SDS passed the information on to the chapters through phone calls and through the SDS *Bulletin* that went out to all members. In the spring of 1965, the national office organized a speaking tour for several FSM organizers to SDS chapters around the country explaining the issues involved. Steve left Berkeley after that semester and worked in the SDS national office before becoming a regional organizer speaking about the FSM and SDS around the South. He was one of many people who came through Austin bringing ideas and news about protests on other campuses. As the movement grew, so did the number of people on the road and they became a source of valuable information. The FSM was an inspiration to us because it showed the power that students could exert if they used the tactics that had been used in the civil rights movement. The fact that the FSM had been able to rally support from 10,000 students gave us hope that we could organize a large movement if we kept at it.

The FSM raised questions about the nature of the university and what students should be doing to bring about social change in the country. Were the universities useful as a source of knowledge and skills? Or were the universities simply defenders of the *status quo*, a

place where people are taught the skills necessary to manage the
society as it is? Could we change the university, or would the
university change us? Should we stay in the universities and try to
make them more democratic and relevant? Or should we drop out
and join civil rights workers or the ERAP organizers in the ghettos?
At this point we had no idea how big and ugly the war in Vietnam
would become or how it would distort the American economy. It
still seemed distant enough that our domestic concerns took priority.

SDS, always ready with a pin-on button for the cause, had several
that reflected these concerns. One that reflected our hope and
optimism for the future said simply, "There's a Change Gonna
Come." For those who wanted to change the university there was
one that read, "A Free University in a Free Society." Others thought
that the universities were too distant from the lives of ordinary
people and that students should move into "the real world" and
organize people to demand what they needed. This point of view
was summed up by the SDS-ERAP buttons with the slogan, "Let
the People Decide." My favorite button said simply, "Not With My
Life You Don't." I was ready to resist all attempts to use me as a
pawn in someone else's game.

When I was in Austin, Jeff Shero and I often met for breakfast
and discussed the growing movement and what it would take to
make lasting social change. We knew that it would take more than
passing laws because plenty of laws had been passed guaranteeing
equality and voting rights to the freed slaves and here we were, a
hundred years later, still fighting to end racism. Deep social change
has to come out of a change in the way people see the world, a
change of consciousness. Respect for and obedience to authority
and tradition were pillars of the existing social order. That order also
included segregation, poverty, and war as well as petty university
rules. Jeff had also been doing some campus organizing and we were
both excited because everywhere we went we found people who
were questioning racism, materialism, consumerism, the Cold War,
and authority in general. We talked about how this healthy
skepticism could be used to change people's underlying beliefs, and
how a profound change of consciousness was what we were seeing
on the campuses. Although we knew this change was important, we
had no idea how big it would become.

By the end of 1964, there were budding SDS chapters at several
schools in my region and groups of individuals who were active
without chapters at others. Some schools were just too repressive for

SDS chapters to function, so when members found out about the Austin community they transferred to the University of Texas in order to live in a freer environment – and to join the largest, most dynamic chapter in the area.

One of Austin SDS's goals was to expand the community of people involved in making social change. To do this we used any issue that helped us educate people about civil rights, poverty, free speech, or Vietnam. SDS members joined a community-based tutorial program for students at the *de-facto* segregated black high school in Austin. As with most segregated schools, the education of blacks was separate but definitely not equal. Later, when SNCC contacted us because their workers in McComb, Mississippi, were being seriously harassed and threatened, we collected 1200 signatures on a petition demanding that the government give federal protection to the SNCC workers in McComb.

Alice Embree collecting signatures for McComb petition

Sometimes we just stumbled onto an issue. SDS member Rick Robbins noticed that there were three bathrooms in a row in the basement of the student health center. He asked a nurse why they

needed three instead of the usual two and was told, "This is the South, honey. One is for Negroes." This made Rick curious about other facilities, so he went to the State Capital building and found a similar situation there. He brought the information to the next SDS meeting and we put out a leaflet explaining the situation under the apt slogan, "Let my people go." Both the university and the state government had already officially ended segregation in all their facilities, and these two "oversights" were immediately corrected.

Although we were involved mostly in civil rights activities, we were aware that the war in Vietnam was heating up. I had been talking about Vietnam while on the road and the Austin chapter had held several public debates about it. At this point there were only US military "advisors" in Vietnam and we decided to hold a public demonstration to try to build popular opposition to expansion of the war. We all dressed very neatly – the men wore suits and ties and the women wore dresses – because we wanted to appeal to as wide an audience as possible. A small group of twenty or thirty of us walked the few blocks from the university to the State Capitol carrying signs with slogans such as, "We Advocate Immediate Cease-Fire and Negotiations in Vietnam" and "Congress Shall Have the Power to Declare War." We thought it was unconstitutional for the Congress to give its power to declare war to the President through the Gulf of Tonkin Resolution.

These were not radical proposals and showed our deeply held, though somewhat diminished, trust in the American system of government. We still believed that if we petitioned our government it would listen to well-reasoned argument. These slogans reflected our politics at the time – most SDS members didn't consider themselves to be radicals. We were just doing what we thought was right and expressing our opinions.

Members of the conservative campus organization, the Young Americans for Freedom (YAF), met us at the Capitol with signs saying, "Withdraw? Hell No! Attack," "Better Brinksmanship than Chickenship," and "We support President Johnson and Barry Goldwater in Advocating Victory in Vietnam." There was a lively debate on the Capitol lawn with curious students and other bystanders listening to both sides. A few people sided with us, but for many people who grew up with slogans such as "Politics stops at the water's edge" and "My country, right or wrong," the idea that anyone would question American foreign policy was shocking.

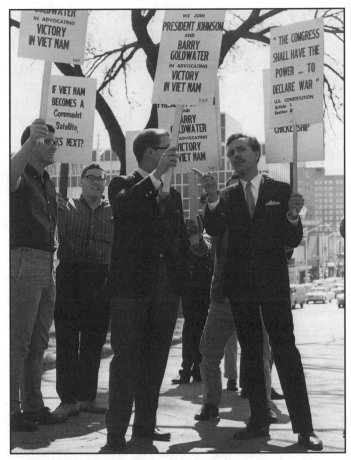

Paul Pipkin explains our position to a YAF member.

Following the demonstration we challenged YAF to a debate on campus about Vietnam, hoping that it would help us turn people against the war. YAF's position was opposite to ours on every issue so the debate was heated. We told the history of the conflict, compared the Vietnamese struggle for independence with our own revolution, and then talked about what the war was doing to the Vietnamese people. YAF's position was that it was acceptable to do almost anything to keep Vietnam from becoming communist, including bombing the civilian population and using nuclear weapons if required. The contrast convinced a number of new people that we were right and they joined SDS. Since that debate was a success, we challenged the Young Democrats to debate the same topic. They parroted the government line about North and South Vietnam being separate countries with the Communist North

attacking the democratic South. They became so flustered when we told the history of Vietnam and refuted their claims that they simply gave up. A few of their members joined SDS.

On July 2, LBJ signed the Civil Rights Act of 1964 – but all was not well in black communities. Two weeks later there was civil unrest, a small "riot", in New York's Harlem, followed by one in Brooklyn and one in Rochester, New York. In August the rioting spread to New Jersey, Illinois, and Pennsylvania. These insurrections represented a growing consciousness among blacks that change in their situation would come from direct action and not by waiting for "leaders" or the government to do something. As they faced the daily indignity of racism, unemployment, and police harassment, they turned toward meeting violence with violence.[42] These events threatened LBJ's attempts to achieve racial justice through civil rights legislation and the War on Poverty.

As the November elections approached, Republican candidate Barry Goldwater blamed the unrest on those very same liberal reform measures, saying that they encouraged civil disobedience. Goldwater and arch-segregationist Alabama Governor George Wallace came out strongly for "law and order." This was the beginning of a strategy by the Republicans, who had once boasted of being the "Party of Abraham Lincoln," to attract the conservative southern Democrats and other whites into the Republican Party by playing what came to be known as the "race card." The Republican Party was generally considered to be the "conservative" party and some young people had grown up being told, as my father told me, that the Republican Party stood for the conservation of the rights of the people. When the Republicans blamed the riots on the black people who wanted to vote, work, and go to school, some of these Young Republicans headed toward organizations that actively supported civil rights. During the next several years a number of them joined SDS at the University of Texas.[43]

The key issue in the campaign was not civil rights but Vietnam. President Lyndon Johnson presented himself as the candidate of peace and reason and told the American people that he wanted no wider war. Johnson ran a "peace campaign" against Barry Goldwater from Arizona, an outspoken Cold Warrior. In a campaign speech in October, Johnson said, "[W]e are not about to send American boys nine or ten thousand miles away from home to do what Asian boys ought to be doing."[44] LBJ did his best to imply that Goldwater would lead the US into a serious escalation of the war, possibly

including nuclear bombs. One of Johnson's television ads featured a little girl walking through a field pulling the petals off a flower while a voice counted, "ten, nine, eight...." At zero a mushroom cloud from an atomic bomb filled the screen followed by a message to vote for Lyndon Johnson. What the public didn't know was that Johnson had secretly ordered the attacks on North Vietnam that led to the Gulf of Tonkin incident, that he had ordered air strikes against Laos in October, or that he planned to begin a major bombing campaign against North Vietnam after the elections.

SDS was divided about the election. We knew from the reports coming from North Vietnam in the international and the left press that Johnson was secretly escalating the war, and we didn't trust him to end it. We also didn't trust him because, while he had supported some civil rights legislation, he had strongly opposed the seating of the Mississippi Freedom Democratic Party. On the other hand, many people feared that Goldwater would seriously escalate the war, possibly with nuclear weapons, and supported Johnson as the lesser of two evils. In response to Johnson's campaign slogan "All the way with LBJ," the Political Education Project (PEP) of SDS came out with a slogan, "Part of the way with LBJ."[45]

Many in SDS didn't vote at all. And, of course, all those younger than twenty-one didn't have the right to vote.[46] Since I was almost certain that LBJ would escalate the war, I planned either to boycott the election or cast a protest vote. I was twenty-three so this was the first presidential election in which I could vote. I decided to vote for Clifton DeBerry, the Socialist Worker's Party candidate for President, because he called for immediate unilateral withdrawal of American troops from Vietnam. I set up a "Vote for DeBerry" table in front of the student co-op across the street from the university with signs opposing US involvement in Vietnam. Most people thought I was crazy, but I was right about Johnson and the war. On November 3, 1964, the day Johnson won the election, a high level committee headed by William Bundy and approved by President Johnson recommended that the US bomb North Vietnam. A month later, Johnson approved the plan.[47]

As 1965 approached, the situation in Vietnam was deteriorating rapidly. On November 1, three days before the US presidential elections, the National Liberation Front (NLF) attacked the airfield at Bien Hoa with mortars, killing five Americans and two Vietnamese and wounding almost a hundred other people. Twenty-

five million dollars in damage was done as six B-57 bombers were destroyed and more than twenty others were damaged.

While the NLF was growing in strength, the government of South Vietnam was becoming increasingly unstable as one military commander after another took control. There were 23,300 US military "advisors," in Vietnam helping the South Vietnamese army and trying to implement the American strategy of winning the hearts and minds of the people to the side of the South Vietnamese government. Political stability was essential to that goal, and without it the US was put in the position of either taking over the war and sending in US troops, or withdrawing altogether.

From information now available, we know that President Johnson considered both options. From his office tape recordings, it's clear that he knew that going to war in Vietnam was a tremendous mistake. As a seasoned Congressman, he knew that Congress wouldn't fund both the Great Society and the War in Vietnam. Looking back in 1970, Johnson said:

> I knew from the start that if I left the woman I loved – the Great Society – in order to get involved with that bitch of a war on the other side of the world, then I would lose everything at home. All my programs. All my hopes to feed the hungry and shelter the homeless. All my dreams to provide education and medical care to the browns and the blacks and the lame and the poor.[48]

Because Johnson won by a landslide, he had a unique opportunity to use this political capital to explain the situation to the American people, and to back out of Vietnam. But Cold War ideas were deeply imbedded and for President Johnson not to fight the communists in Vietnam was unthinkable.[49] The Cold War was the modern equivalent of a religious war with the "free world" pitted against "godless communism" or the "evil empire" as President Reagan later called it. Johnson and his advisors were all Cold Warriors and never realistically discussed getting out.[50] So, in spite of the instability of the South Vietnamese government, the Johnson administration prepared to blunder onward into the fog.

Meanwhile the police were keeping their eye on us and their invasion of our privacy began to reach new levels. One afternoon Jeff, Alice, Gary, Judy, and I went out to Hamilton's Pool, about thirty miles from Austin, for a picnic. Hamilton's Pool is a deep pool of water about two hundred feet across, fed from the cliff above by a waterfall. We hiked down from the top of the cliff and reached the

pool early in the evening. We sat on the rocks and talked and ate our supper and by the time we were finished it was getting dark. We were the only people there and several of us decided to go skinny-dipping. A few days later, Lt. Gerding approached Alice and mentioned that he had some good pictures of her swimming at Hamilton's Pool that he had taken with his new infrared camera. We couldn't believe it. What right did the police have to follow us around and take pictures? None of us ever saw the photos and I have no idea if Gerding actually had them. He may simply have wanted us to know that we were being watched. A few weeks later several of us were in Gary's second floor apartment talking when I happened to look out the back window. In the alley below I saw Gerding and his partner in an unmarked car with a directional microphone pointed at our window. When they saw me watching, they drove away.

At Christmas Judy and I went to Pueblo to visit my parents. The whole trip had a feeling of the surreal about it – the last year had changed the direction of my life so much that Pueblo, my parents, and even my old friends seemed out of some other world. Judy and I had been essentially living together and were considered a couple by all of our friends. In Pueblo, however, we slept in separate rooms because we weren't married. Living together wasn't an option for most people of my parents' generation. It was a relief to get back to Austin!

While we were in Pueblo, the first major debates over the issue of Vietnam took place at the SDS National Council Meeting in New York. Although everyone opposed the war, many people, particularly those who supported ERAP's community organizing emphasis, were hesitant to get too involved with this issue. They were afraid it would take energy away from community organizing and civil rights work and that a single-issue antiwar movement would overwhelm SDS's multi-issue approach to social change. There was also much disagreement as to how far SDS should go with this issue. Proposals ranged from petitions against the war to sending medical supplies to the Viet Cong, advocated by Jeff Shero from the Texas chapter. In the end it was decided to organize a march on Washington to show the government that there were people who were strongly opposed to what it was doing in Vietnam. Optimists hoped we could draw three to five thousand people to Washington, which would be the largest peace demonstration to date. Naively we still felt that the war was something that could be

stopped fairly easily if only we could get enough people to protest against it. We didn't understand how powerful the military-industrial complex had become or how much they had their heart set on making war.

A Visit to the LBJ Ranch
Spring 1965

"I am against sending American GIs into the mud and muck of Indochina on a blood-letting spree to perpetuate colonialism and white man's exploitation in Asia."

Colorado Senator Ed. Johnson, April 1954[51]

"[W]e are not about to send American boys nine or ten thousand miles away from home to do what Asian boys ought to be doing for themselves."

Lyndon Johnson, campaign speech, October 21, 1964[52]

After Judy and I got back to Austin, we decided that the only way to avoid having to sleep apart whenever we visited our parents was to get married. We thought this was a private decision that didn't need to be sanctioned by either the church or the state, so we went to the jewelry store, bought gold bands, and declared ourselves married. During the fall, I had rented a small furnished two-room house that was in the back yard of another house and wasn't visible from the street. The walls were brick inside and out so Judy and I taped posters and quotations on the walls to make it feel warmer. Not long after Judy moved in, a large white Persian cat with blue eyes moved in with us. He was totally deaf and I had read in one of Frederick Engels' books that almost all white cats with blue eyes are deaf, so we named him Engels.

The neighborhood was friendly, but there was always a sense of danger in Austin. Bumper stickers with slogans like, "America: Love It Or Leave It," and "Better Dead Than Red" were common. The identification of activism with communism was evident every time a counter-demonstrator yelled, "If you don't like it here, why don't you go back to Russia!" One morning, as I rode my bike to the grocery store, I cut a corner by riding through Don Weedon's gas station. As I rode away, I heard someone yell, "Goddamned communist! Don't ever drive through my property again." I looked

back and saw a man standing by the gas pump shaking his fist at me. I wondered if he knew who I was, or if he considered anyone riding a bicycle to be a communist. As I passed the station on my way back home, I heard someone yell, "There he is!" and three guys ran out of the office to catch me. They, too, were yelling and, as I took off, I heard the word, "communist" again. When they realized that they couldn't catch me, they jumped into a car to give chase. I had a head start and cut down a narrow alley and through a gate that put me into someone's back yard, where I hid. It wasn't long before I heard them speeding down the alley. They'd obviously been waiting at the station for me to come back, and I wondered if they'd recognized me as an SDS member. I had been warned that the Minutemen, an armed paramilitary group, was in Austin and I wondered if some of my neighbors were among them. It was obnoxious to be watched by the police, but the concept of being targeted by a group like the Minutemen was scary.

In November, Lyndon Johnson overwhelmingly defeated Republican candidate Barry Goldwater, and my fear that Johnson would escalate the war came true. In early February the Viet Cong attacked the US military barracks near Pleiku, killing eight and wounding a hundred and twenty-six Americans. President Johnson retaliated by bombing a military base in North Vietnam and on February 24 he ordered the massive bombing of North Vietnam, called "Operation Rolling Thunder." This bombing was planned to last for eight weeks, but when it failed to break the morale of North Vietnam, it was extended – and continued until November 1968. During that time nearly eight hundred tons of explosives a day were dropped on the areas in North Vietnam thought to be staging areas for sending troops and supplies into the South.[53] The Joint Chiefs of Staff supported sending in troops and called for them to actively seek out and engage the enemy. On March 8, 3,500 Marines landed in Vietnam to defend the air base at Danang. Less than a month later, on April 1, their mission was changed from defensive action to offensively pursuing the Viet Cong. Until then US forces in Vietnam had supposedly only been advisors to the South Vietnamese military, but now US troops would go into active combat. This was the beginning of the "Americanization" of the war.[54]

The Cold War mentality was so deeply rooted that, even after winning re-election on a peace platform, Johnson still felt obligated to wage war against the "communists" in Southeast Asia. After the

election, Vice President Humphrey reminded Johnson that his landslide victory over Goldwater, by one of the largest majorities in history, would allow Johnson to back out of Vietnam with very little political damage. Humphrey added that he had personal reservations about the wisdom of being in Vietnam, but he assured Johnson that he would support the President's policy, whatever it was. Johnson's response was to exclude Humphrey from all meetings where the war was discussed.[55]

Throughout Johnson's administration he was torn between two contradictory goals – he didn't want to be the first American President to lose a war and he wanted to leave a legacy of social programs that would meet the needs of common working people. He knew from the beginning that there was not enough money for both and he knowingly deceived both the Congress and the American people about the cost of the war.

One of SDS's goals was to show how issues such as racism and poverty were connected to other issues, such as foreign policy, by the social and economic fabric of America. SDS's Peace Research and Education Project (PREP) discovered that American banks were loaning money to the overtly racist government of South Africa, which had a policy of segregation called "apartheid."[56] These loans were coming up for renewal, and since the Chase Manhattan Bank in New York was one of the main banks involved, SDS contacted them and asked them not to renew the loan. When the bank refused, SDS called for a demonstration to coincide with the fifth anniversary of the Sharpeville Massacre, where South African police had opened fire on black demonstrators, killing sixty-nine.

On March 19, 1965 several hundred people jammed the streets in front of the Chase Manhattan Bank on Wall Street in New York City, carrying signs and singing freedom songs. Forty-three people linked arms in front of the bank entrance and were arrested. The SDS office, as always, sent out information about this demonstration to educate the membership about the issues. This demonstration, one of the early attacks on apartheid, was another step in exposing the nature of power in the US.

In late March, we heard about the first Vietnam "teach-in" at the University of Michigan. A small group of radical faculty wanted a way to speak out against government policy and they proposed devoting one day of their classes to discuss the war. When both the administration and the state legislature objected to that use of class

time, the faculty decided instead to have an all-night meeting where experts on Southeast Asia and interested students could debate and discuss the issues. The teach-in presented a wide variety of speakers and workshops – and the energy it generated was electric. At many universities, undergraduate classes took place in huge lecture halls where personal give-and-take between the students and the professor was impossible. Staying up all night debating important issues with professors and students as equals was exciting – and the students wanted more.

As the war in Vietnam grew, teach-ins spread rapidly across the country. Over the next two months, there were teach-ins at over a hundred colleges. We organized a small teach-in at the University of Texas, but it was more a discussion among those who opposed the war than a real give and take with all sides. The real debate happened when the State Department, stung by the success of the teach-ins, sent "Truth Teams" to the universities to discuss the "facts" with students.

When the Truth Team came to Texas, they spoke in a large lecture hall that was packed with hundreds of students, including several SDS members who came prepared to ask tough questions. The government spokesmen repeated the official government position about North Vietnamese Communist aggression against the sovereign democratic nation of South Vietnam. When they asked for questions, we confronted them with the history of the French war in Vietnam. We reminded them that the 1954 Geneva Accords were intended to separate North and South Vietnam only temporarily until reunification elections could be held in 1956. We asked them to explain how South Vietnam could be considered democratic since its leaders acted like dictators. As they tried to explain their way out of the contradictions, we pressed them to justify "free-fire zones," "strategic hamlets," Napalm, and high civilian casualties. The Truth Team was unprepared for aggressive questions from people who had facts to back them up, and many in the audience turned against US policy in Vietnam as the team fumbled around trying to defend the war with a story that wasn't true. This scene was repeated all over the country, and antiwar sentiment among students grew.

The give and take dynamic of the teach-ins was much more exciting than listening to a lecture and students began to think of ways to extend this experience. In Austin, SDS member Dick Howard and others organized the Critical University as a place where topics of social relevance could be discussed from a variety of

points of view and where these ideas could lead to action. These "free universities" began to spring up as students and professors began to teach topics left out of the normal curriculum.

Meanwhile, tensions were escalating in Selma, Alabama, as a major confrontation over voting rights was brewing between the civil rights movement and the white establishment. Selma had been a slave market before the Civil War and although Dallas County, where Selma was located, was sixty percent black, less than one percent of blacks were registered to vote. In Lowndes and Wilcox Counties, which adjoined Dallas County, there were no registered blacks at all. SNCC had been in these three counties since 1963, but because of the repressive nature of the power structure, there had been little change. Sheriff Jim Clark encouraged his deputies and other local whites to intimidate the black population by firing people from their jobs, evicting them from their homes, or by random violence.

Austin civil rights leader, B.T. Bonner, Judy, and me at a demonstration about Selma.

In January 1965, Martin Luther King and the Southern Christian Leadership Conference (SCLC) had taken up the cause, and SCLC and SNCC organizers began a voter registration drive. By early February Dr. King and some three thousand others had been arrested by state and local police and over 150 blacks had lost their

jobs in and around Selma. On February 17, when a few hundred blacks marched to City Hall, the police attacked with clubs beating many people savagely. In a nearby town, the police attacked a support demonstration, and when a young black demonstrator named Jimmy Lee Jackson tried to protect his mother and invalid father from the violence, he was shot by a state trooper and died several days later. Martin Luther King called for a march from Selma to Mongomery, the state capitol. Alabama Governor George Wallace declared the march illegal and vowed to stop it. King wanted to postpone the march and left Selma, but SNCC and the local people continued without him.

On Sunday March 7, 1965, 600 people marched toward the Pettis Bridge on their way out of Selma. On the other side they were met by a hundreds of deputies and state troopers. The marchers were given two minutes to turn back and when they didn't move, Sheriff Clark gave the signal to attack. Troopers, some on horseback, clubbed men, women, and children to the ground. The whole event was televised nationwide and became known as Bloody Sunday. Two days later, on March 9, segregationists severely beat Rev. James Reeb, a Unitarian minister from Boston who had come down to join the march. He died two days later. This brutal murder of a white man got national publicity in a way that the killing of Jimmy Lee Jackson hadn't, and people from across the nation began to arrive in Selma. There was continuous news coverage of the situation and the President and Congress were flooded with letters, telegrams, and phone calls from people demanding that something be done. President Johnson federalized the Alabama National Guard to protect the demonstrators and on March 21, Dr. King joined SNCC and 3,000 people as they marched out of Selma toward Mongomery. In August the Voting Rights Act of 1965 was passed – and within two weeks sixty percent of black voters in Dallas County had registered.[57]

As the march to Mongomery got under way, Jeff Shero, Charlie Smith, and I were on our way to the SNCC office in Atlanta, Georgia, to meet with members of the Southern Student Organizing Committee (SSOC). Jeff, Charlie, and I worked with SSOC whenever possible. We drove to the highway that the march was following and found a long line of people walking along the edge of the highway. The Alabama National Guard and the State Police watched from the other side of the road. We drove past the demonstration to a point where we could still see the people in the

distance, parked the car along the highway and walked back to join the march. After everyone had passed our parked car, we got in it and continued on, past the marchers and their police escort, toward Atlanta. Not far down the road, we passed one of the huge billboards with the picture of "Martin Luther King at Communist Training School."

In March the University of Texas held elections for the student body officers for the coming year. SDS used this election as a forum for our ideas by running one of our members, Gary Thiher, for president of the student body. Gary ran a spirited campaign based on real issues. For example, every leaflet that SDS, or any group, passed out on campus had to be approved or the group would lose its right to work on campus at all – we challenged this blatantly unconstitutional rule and demanded that the Bill of Rights be recognized on campus. Campus cafeteria workers were from an institution for retarded people and were paid next to nothing for their work – we supported their demand that they be paid at least the minimum wage. The university's requirement that freshman and sophomore women live in approved housing made that housing more expensive than apartments on the open market – we advocated ending the housing restrictions all together. The administration had veto power over everything the student government did – we demanded a student government that could advocate for the students instead of being powerless. Our positions on racism, the war, and the military draft appeared on Gary's campaign posters all over the campus as we called for a peace curriculum. Our campaign was the only one with its own theme song about the issues.

> Now here they're supposed to teach us about a free society,
> Which is something we don't have at the University.
> 'Cause they tell you where to live and how to live your life,
> And your life is not your own 'til you're a husband or a wife.
>
> Now we know that contraception is a very dirty word.
> We don't do that nasty thing; the idea is absurd,
> And all those extra children are mistakes of the stork.
> Vote for Gary Thiher; give the stork a direction chart.
>
> Chorus:
> We know he cannot win, 'cause he's advocatin' sin,
> And if you vote for Thiher, they'll wonder what you're in.
> But if you wanna show 'em how you feel,
> Vote for Gary Thiher, if you don't want this kind of deal.

Gary Thiher for president.

Gary lost the election, but he spoke about all these issues in the public debates and in articles in the *Daily Texan*. The whole campus was more aware of the issues and our positions by the time the campaign was over.

Meanwhile in New York, the national office of SDS had been working since January 1965 on the demonstration planned for April 17 in Washington DC. The number of people working there jumped from two to over a dozen as some worked full-time on the march and others reached out to the public or used the march to get new SDS chapters started. In the call that SDS issued for the March on Washington, we stated our objections to the war – and it is interesting to note that, as the war continued for another ten years, all of our fears and predictions proved to be true. The call said in part:

> • The war is fundamentally a civil war, waged by South Vietnamese against their government: it is not a "war of aggression." Each repressive government policy, each napalm bomb, each instance of torture, creates more guerrillas.

> • It is a losing war. Well over half of the area of South Vietnam is already governed by the National Liberation Front.... How many more lives must be lost before the Johnson Administration accepts the foregone conclusion?

> • It is a dangerous war. Every passing month of hostilities increases the risk of America's escalating and widening the war.

- The facts of the war have been systematically concealed by the US government for years...[This] erodes the honesty and decency of American political life, and makes democracy at home impossible.... What kind of America is it whose response to poverty and oppression in South Vietnam is napalm and defoliation, whose response to poverty and oppression in Mississippi is...silence?

- It is a hideously immoral war. America is committing pointless murder.

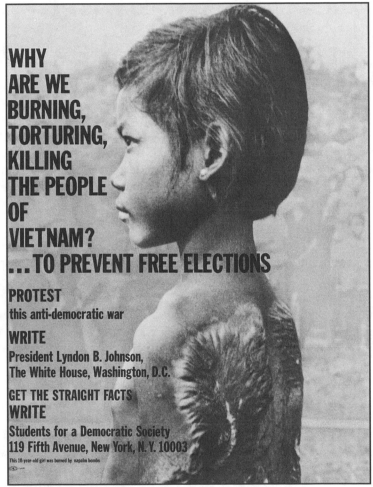

The SDS antiwar subway poster.

One of SDS's first mass outreach efforts was an attempt to display an antiwar poster in the New York City subways. The large poster, featuring a photograph of a young Vietnamese girl who had been seriously burned by napalm, asked the question, "Why are we

burning, torturing, killing the people of Vietnam?" and answered it with, "To prevent free elections!" The poster urged people to write to President Johnson and to contact SDS for more information. The New York Transit Authority rejected the poster saying that it was inflammatory and too controversial. SDS sued on the grounds that controversy was what freedom of speech was about. Several years later the courts ruled in SDS's favor, but by then all the information on the poster was out of date. The poster didn't go to waste, however, and was shipped all over the country where it appeared in numerous antiwar demonstrations.

Texas is a long way from Washington, so we decided that instead of trying to get people to go to Washington, we would have a local demonstration at the gate to President Johnson's ranch near Austin. The LBJ ranch was an obvious target because we didn't want Johnson to be able to escape the antiwar demonstration in Washington DC by hiding out at his ranch. To recruit as many people as possible I spent the early spring traveling to Houston, Dallas, Denton, Norman, and even made a trip to Albuquerque, where Jim Kennedy had organized a small SDS chapter. People from other chapters planned to join us in Austin.

Less than a week before the demonstration I was scheduled to take a pre-induction physical for the military draft. When I dropped out of graduate school my draft board reclassified me 1-A. I held them at bay for awhile by telling them that I was opposed to the war in Vietnam and that I considered myself to be a political objector. To make my point I sent a copy of a pledge being circulated by a group called the May Second Movement (M2M) [58] that I had signed.

WE THE UNDERSIGNED, ARE YOUNG AMERICANS OF DRAFT AGE. We understand our obligations to defend our country and to serve in the armed forces but we object to being asked to support the war in South Vietnam.

Believing that United States participation in that war is for the suppression of the Vietnamese struggle for national independence, we see no justification for our involvement. We agree with Senator Wayne Morse, who said on the floor of the Senate on March 4, 1964, regarding South Vietnam, that "We should never have gone in. We should never have stayed in. We should get out."

BELIEVING THAT WE SHOULD NOT BE ASKED TO FIGHT AGAINST THE PEOPLE OF VIETNAM, WE HEREWITH STATE OUR REFUSAL TO DO SO.

I received a letter back asking for updated information and informing me that being a political objector was not an option. Most people who filed for Conscientious Objector (CO) status did so on religious grounds that they were morally opposed to killing people. I would have fought in World War II to stop fascism, but I disagreed strongly with what was happening in Vietnam. After much thought, I filled out a CO form saying that I conscientiously objected to the war in Vietnam on political grounds. I included a lengthy paper outlining my position on the war and told them that I was actively organizing against the war because the US was fighting on the wrong side. I explained that I considered the National Liberation Front to be fighting for Vietnamese independence and that I was working for freedom and equality here at home. I assured them that fear was not my motive – I had volunteered to go to Mississippi – but that I thought the real fight was not against communists in Vietnam but against racism here in the United States. I said that if I were drafted I would go, but that I would organize against the war from inside the military. I finished by telling them that if I were sent to Vietnam I couldn't guarantee which side I would fight on. A few weeks later I received a letter stating that they would not consider my Conscientious Objector status unless I took a pre-induction physical.

Early in the morning, of April 13, just four days before the marches on Washington and the LBJ Ranch, I caught a military bus in Austin that took me to a base in San Antonio. We were all herded into a big room and given a questionnaire about our personal lives. They wanted to know if I had homosexual tendencies, or if I belonged to the Communist Party or any of perhaps a hundred other organizations that were classified as subversive. SDS wasn't on the list and my brief membership in the Young Socialists Alliance seemed irrelevant so I answered that I hadn't and went to the next question. "Do you now or have you ever taken addictive drugs?" I answered "yes" thinking about the peyote that I'd taken, but then I changed my mind, since peyote isn't addictive. I crossed out the "yes" box and checked "no." After hesitating some more, I added a note: "I have taken drugs, but I'm not an addict." When I finished the form, the soldier at the desk looked it over and said, "You mean you take prescription drugs?" I replied that everyone did that. He asked if I took prescription drugs without a prescription. I replied that I considered that to be dangerous. He looked up with a glare and asked, "Do you use heroin?" I said I didn't. "What exactly *do* you do?" he asked with exasperation in his voice. I told him that I

had eaten peyote and he asked me what that was. When I told him it was a kind of cactus, he became even more confused. He circled my answer in red and sent me to take the mental skills test, which required a score of 40 out of a possible 100 points to pass. This was only slightly better than guessing, and I passed it easily.

I was told to strip down to my shorts and went through a series of tests to check my general physical condition. On the vision test, they said I should be a pilot, and on the hearing test they said I should go into sonar. My blood pressure was fine and it looked like I was going to pass the physical with flying colors. Finally, all of us who were considered to be fit for the military were told to put our clothes on and to go to another room where an officer would make the final evaluation. As I sat down, the man looked up from the form and said, "I see you take drugs." He told me that peyote wasn't illegal in Texas, which I knew, and then, to my surprise, he asked if I'd ever smoked marijuana. I thought about my answer carefully, since marijuana was illegal. At that point, I had only smoked it once, a couple of months previously, but nothing had happened. I had completely forgotten that when I answered the question about addictive drugs. When I acknowledged that I had smoked a little, he asked if I smoked it more than once a day. I laughed and said, "No." "Do you smoke more than once a week?" "No." "How about more than once a month?" "No." "Every two months?" I hesitated because I had smoked it once, two months ago and said, "I guess you could say that." He wrote down, "Smokes marijuana once every month or two, definitely not an addict."

The officer looked up and told me that he was sorry but he was going to have to classify me 4-Y on psychological grounds. He handed me a form and told me to read it and sign it. The form was my acknowledgment that I knew I would be committing a felony if I ever tried to enlist in any branch of the armed services. This was unbelievable! I had walked into the office a few minutes ago believing that I would be getting an induction notice within a month and now it was illegal for me to join the military even if I wanted to. I signed the form and left wondering if my draft board had told them to find some way to get rid of me because of my political objection.

I went home and told my friends what had happened and one of them lit up a pipe. Maybe the marijuana I smoked the first time wasn't strong enough or maybe I was expecting too much after the experience with peyote, but I definitely got high this time and I liked

it. Compared to peyote it was quite mild but it had some of the same qualities. I liked the way it brought everyone together as we sat in a circle and passed the pipe around.

While we were organizing to end the war, President Johnson, Secretary of Defense McNamara, and other advisors were quietly expanding the ground war in Vietnam. All this was done in a way to hide the magnitude of US involvement from both Congress and the press – and thus from the American people. By fudging the figures, Johnson underestimated the cost of the war to Congress by about ten billion dollars. When he spoke to the American people, he gave a troop figure that was 75,000 men less than were really there. So that the money and size of the troop commitment could be altered later, he covered himself by saying that the US would do whatever it took to stop communism in Vietnam. Both President Johnson and Defense Secretary McNamara wanted to know how their strategies were working and settled on the number of enemy killed, the "body count" as it was called, for measuring the "productivity" of the war. The Joint Chiefs determined that in order to increase the Viet Cong kill rate they would have to resort to the massive use of air power in South Vietnam. It was unclear how bombing an enemy that lived within the civilian population would end the war, but it certainly increased the body count, mostly with civilian casualties.[59]

As April 17 approached, other peace organizations wanted to co-sponsor the march with SDS, hoping in that way to control both the political message and which groups could participate. In particular, they wanted to exclude Communists, because anti-communism was as much a part of the established peace movement as it was in the society at large. SDS had faced this issue early on, refusing to take part in what it saw as part of the Cold War mentality. The *Port Huron Statement* explained SDS's position clearly:

> An unreasoning anti-communism has become a major social problem for those who want to construct a more democratic America....Much of the American anti-communism takes on the characteristic of paranoia. Not only does it lead to the perversion of democracy and to the political stagnation of a warfare society, but it also has the unintended consequence of preventing an honest and effective approach to the issues.

After carefully considering the request, SDS refused to share the sponsorship and refused to exclude communists from participating.[60]

Because of this, SDS was attacked in an ad in the *New York Times* that appeared a few days before the march and was paid for by several of the groups and individuals whose offer had been rejected.

The SDS March on Washington, April 17, 1965.

On April 17 an astounding 25,000 people came to Washington to show their opposition to the war. After marching around the White House for several hours, the demonstrators walked en masse to the Washington Monument to hear folksingers and speakers.[61] When SDS President Paul Potter gave the concluding speech, he spoke for us all.

> The incredible war in Vietnam has provided the razor, the terrifying sharp cutting edge that has finally severed the last vestiges of illusion that morality and democracy are the guiding principles of American foreign policy....The further we explore the reality of what this country is doing and planning in Vietnam the more we are driven toward the conclusion of Senator Morse that the US may well be the greatest threat to peace in the world today....That is a terrible and bitter insight for people who grew up as we did – and our revulsion at that insight, our refusal to accept it as inevitable or necessary, is one of the reasons that so many people have come here today....
>
> What kind of system is it that justifies the US or any country seizing the destinies of the Vietnamese people and using them callously for our own purpose? What kind of system is it that disenfranchises people in the South, leaves millions upon millions of people throughout the country impoverished and excluded from the mainstream and promise of

American society, that creates faceless and terrible bureaucracies and makes those the place where people spend their lives and do their work, that consistently puts material values before human values – and still persists in calling itself free and still persists in finding itself fit to police the world? What place is there for ordinary men in that system and how are they to control it, make it bend itself to their wills rather than bending them to its?

We must name that system. We must name it, describe it, analyze it, understand it, and change it. For it is only when that system is changed and brought under control that there can be any hope for stopping the forces that create a war in Vietnam today or a murder in the South tomorrow or all the incalculable, innumerable more subtle atrocities that are worked on people all over – all the time.

Paul then went on to suggest what we needed to do in order to end the war.

If the people of this country are to end the war in Vietnam, and to change the institutions which cause it, then the people of this country must create a massive social movement....

By a social movement I mean more than petitions or letters of protest, or tacit support for dissident Congressmen; I mean people who are willing to change their lives, who are willing to challenge the system to take the problem of change seriously....

But that means that we build a movement that works not simply in Washington but in communities and with the problems that face people throughout the society. That means that we build a movement that understands Vietnam, in all its horror, as but a symptom of a deeper malaise, that we build a movement that makes possible the implementation of the values that would have prevented Vietnam.

Paul's speech was important to me because it echoed my feelings that the war was both morally and politically wrong, and spoke of the need for the kind of deep changes in the culture that can only come with a change of consciousness. Paul's speech was a masterful example of the way SDS talked – he spoke simply and from the heart. Rather than giving a simple name to a complex system, he called on *us* to think about the system and to "name it, describe it, analyze it, understand it, and change it."

Meanwhile, in Texas, a group of about forty of us with signs urging President Johnson to "Stop the Bombing and Negotiate" were lined up along Ranch Road 1 in front of the gate to the LBJ Ranch. Many of us had come the day before to begin a silent vigil against the war. We had spent the night in sleeping bags under the watchful eyes of law enforcement personnel ranging from the local sheriff to the Secret Service and resumed our vigil the next morning.

Demonstrators at the LBJ Ranch.

The announcement of 400 demonstrators at the LBJ ranch drew cheers from the demonstrators in Washington, but there were really only forty of us. I was a spokesman for the group, so when the press asked why we were there, I read our petition intended for President Johnson:

> This vigil is an expression by concerned Americans about the war in Vietnam. We have gathered here to call upon President Johnson to implement a new and more creative policy in Southeast Asia, especially Vietnam and to support any efforts on his part to bring peace into this tragic region of the world.
>
> We ask the following:
>
> 1. Immediate cessation of bombing of all of Vietnam, and United States initiatives for a cease-fire.
>
> 2. Immediate negotiations among all interested groups, including the National Liberation Front (the Viet Cong), to implement the replacement of United States military forces with a neutral body whose purpose will be to conduct free elections in Vietnam.
>
> 3. Removal of all censorship of the United States press in South Vietnam.
>
> We endorse President Johnson's proposal offering further aid and development to all Southeast Asian countries under the control of the United Nations.

LBJ remained out of sight although a member of his staff came out to the gate to get a copy of our petition.

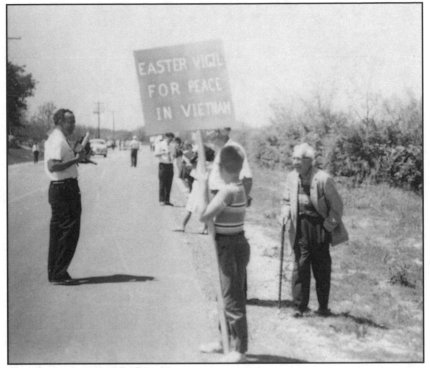

Demonstrators at the LBJ Ranch.

In Texas we received widespread, but not very sympathetic, media coverage of the vigil. SDS members, who had gone home for Easter break, reported back on their parents' reactions to the TV coverage of our vigil. Some were sympathetic, but the majority didn't think it was right to disagree with US foreign policy. Those students who defended our demonstration often got into long heated discussions, and some were warned by their parents not to get involved with SDS.

Immediately following the vigil I caught a plane – my first plane ride – to Washington, DC to attend SDS's spring National Council meeting that was held after the march. This was my first national meeting because Texas was so far from the northeast where the National Council meetings were usually held. Although I didn't know it at the time, this meeting marked a major transition in the nature of SDS. Before the march, the organization was small enough that members often knew each other and the national meetings were small gatherings of old friends. Now, many of the people were new to national SDS and came from chapters that had formed within the last three months.

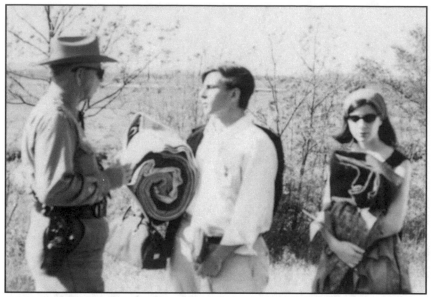

Jeff Shero & Alice Embree face an officer of the law at the LBJ Ranch.

Much of the discussion at the meeting revolved around whether SDS should try to establish a national presence around the war or whether it should concentrate on local organizing. The march had been such a success because antiwar sentiment among university students was more widespread than anyone had suspected. The question now was what SDS should do with all this energy. National demonstrations required a lot of organizational energy and money – and many people believed that our energy was better used in local organizing and local actions. There was a proposal encouraging teams of SDS members to go to military bases and induction centers to leaflet, picket, and otherwise convince young people not to serve. If the government invoked the 1917 Espionage Act then we would use the Nuremberg Doctrine concerning war crimes against the civilian population as our defense. The proposal was referred to the membership because it violated the law. There was some desire for another national march but the clear sentiment was that local organizing was more important than national marches. Toward the end of the meeting there was a proposal to move the SDS national office to Chicago. Many of the new members were coming from outside the northeast and that would put the office closer to the center of the country. It was approved and in May the office moved to Chicago.

Following the march, the number of SDS chapters jumped from forty to eighty. This was a spontaneous uprising, a "movement," of young people all across the country. SDS had been formed as a multi-issue organization, but many of the people who joined right before or after the march were primarily concerned with the war and were ignorant of SDS's other concerns. As we discussed a strategy to end the war, everyone agreed that what the US was doing in Vietnam was morally wrong and had to be stopped. We knew it would be a big job, but our experience in the civil rights movement had taught us that a dedicated group of people could create enough pressure to force social change. Segregation was finally giving way and we believed that if we kept telling the truth about the war in Vietnam and organizing people against it, we would be able to stop it.[62]

While many of us thought that our march of 25,000 people would force the government to reconsider, we didn't understand that nobody was really listening. Although the antiwar movement was a concern to President Johnson, he was much more concerned about the political right wing than about antiwar students. Clark Clifford, Johnson's second Secretary of Defense, quotes LBJ as telling George Ball in July, 1965, "George, don't pay any attention to what those little shits on the campus do. The great beast is the reactionary elements in this country. Those are the people we have to fear."[63] Before the March on Washington National Security Advisor McGeorge Bundy told the President that he should try to defuse the growing anti-bombing sentiment among college students by making a "strong, peace-loving statement. On the day of our demonstration, President Johnson issued a statement saying that he understood and shared "the feelings of those who regret that we must undertake air attacks." He went on to say that until the freedom and independence of South Vietnam were "guaranteed there is no human power capable of forcing us from Vietnam." He appealed to Congress and the American people by suggesting that anyone who questioned his policy was abandoning the 400 or so American boys who had already died for the "freedom and independence" of South Vietnam. Before this dubious war would end, US war dead would number over 58,000 and another five million or more Vietnamese, Cambodians and Laotians would also be dead.

While we were organizing to stop the war, the government and the military were escalating it. Twenty thousand more troops were sent to Vietnam and in July 194,000 more men were approved. We were on a collision course with the government although we really didn't realize what that meant.

In late April, as if to validate our understanding of imperialism, President Johnson sent troops to the Dominican Republic to "protect American citizens and stop communist influence in the government." The elected president, Juan Bosch, had threatened to take land from the sugar plantations and give it to the peasants. Ellsworth Bunker, the American troubleshooter in the Dominican Republic, said there were communists in the government and asked President Johnson to send in the US Marines. Bunker was not a neutral peacemaker, however. He was a member of the board of directors and a major stockholder of the National Sugar Refining Company, which had large financial investments in the Dominican Republic.[64]

In Austin, SDS organized a demonstration linking the military interventions in Vietnam and the Dominican Republic. As a result, I received an invitation to speak about SDS and its position on Vietnam, the Dominican Republic, and civil rights to a sociology class at Southwest Texas State in San Marcos, Texas. This was a definite change in the political climate – instead of struggling to find a few interested individuals to form a chapter, I was invited to come and talk about SDS. Southwest Texas State was LBJ's alma mater and I was delighted to go.

In the class, I gave a brief introduction to SDS and spent the rest of the time responding to questions. The main concern of the students reflected their fear of communism and I realized that I needed to confront this issue head on if I wanted to talk about what was happening in Vietnam or the Dominican Republic. I asked if people thought that communism was an idea that was so powerful that only a few communists in a large group could control the group. "If I were a communist could I control this class because of my ideas? Would you all become communists because my ideas are so powerful?" They didn't think so. "If not, why are you willing to undo a democratically elected government in the Dominican Republic because of what turned out to be possibly three communists?" That opened the discussion so that we could talk about the issues behind the anti-communist rhetoric. Was the US

really concerned with "freedom and democracy" in the Dominican Republic or were we supporting the sugar companies by helping a dictator maintain control in the name of "anti-communism"? These were ideas that they had never heard before and they opened the door for me to ask why the FBI was more concerned about communists in the civil rights movement than it was about the systematic denial of constitutional rights to black people. What was really going on in Vietnam anyway? When the hour ended, about half the class stayed behind to continue the conversation.

In May Austin SDS was again thrown into the civil rights movement. A black woman student had walked into Roy's Lounge, a bar near campus, and asked to use the phone. She was told to leave, apparently because she was black. On her way to the university, she ran into SDS member George Vizard and told him what had happened. The two of them went to the student cafeteria, where they found Mariann Garner, who is white, sitting with a black man. George asked Mariann and her friend to come to Roy's Lounge to see if they would all be refused service. Mariann had gone to Roy's Lounge for a beer on several occasions and believed there was some kind of misunderstanding because she had never been thrown out although she was too young to legally buy beer. The two interracial couples were stopped when they entered Roy's and were told that they weren't welcome. They immediately called members of the Campus Interracial Committee (CIC) to see what could be done.

The CIC asked SDS to help and the next night we had a continuous line of several hundred people walking back and forth in front of Roy's door. Unlike the earlier demonstrations at the Picadilly, the people yelling at us were on the same side of the street as we were. Our continuous picket line was completely surrounded by a mob that looked like it would like nothing better than to kill us. We refused to respond to the insults, shoving, or occasional spitting and, while tense, the situation didn't turn violent as we continued picketing. The Austin police were there in force, and as always, Lt. Gerding was there taking pictures and writing in his notebook.

The second night almost got out of control when several people, who where not well known SDS members, went into Roy's in preparation for a possible sit-it. When George Vizard tried to enter, the bouncer recognized him and threw him out. There were a few tense minutes as the mob pressed toward the door to support the bouncer – and we tried to protect George. The police solution was

to arrest George for assault. The counter-demonstrators backed off and no one was hurt that night. The demonstrations continued for a number of weeks and in the end Roy's declared bankruptcy and went out of business rather than integrate.

It was the end of the school year and the SDS chapter would be inactive until fall because many students would be working or spending the summer with their parents. Clark Kissinger had invited Judy and me to come to work in the national office in Chicago for the summer, so in June, we loaded up the Panda Wagon and headed north. We spent a few days familiarizing ourselves with the office before joining other Texans at the SDS national convention in Kewadin, Michigan.

Prairie Radicals

Summer 1965

"...we seek the establishment of a democracy of individual
participation governed by two central aims: that the individual
share in those social decisions determining the quality and
direction of his life; that society be organized to encourage
independence in men and provide the media for their
common participation"

Port Huron Statement, 1962

The 1965 SDS convention was held at Camp Maplehurst near
Kewadin, Michigan, and nearly 500 people attended, twice as many
as the year before. Half of those attending were new members who
had recently joined because of their opposition to the war and had
never been to a national meeting. The March on Washington had
been a spark that ignited activity on campuses across the country
and those of us from Texas were delighted to meet people from new
chapters in Iowa, Nebraska, Missouri, and Kentucky – the American
heartland. Like us, these new people had grown up in towns and
cities across the great middle of the country where no one read the
New York Times, conformity was the norm, and people generally
avoided discussing two topics – politics and religion. Most of us had
become politically involved because of our moral outrage at the
contradiction between what we had been taught about America and
the reality of Southern racism and US involvement in Vietnam.
Taking a stand on controversial issues often resulted in conflict with
family and community.

While America invoked the spirit of individualism, in reality there
was a culture of conformity that was overly concerned with how
people looked, what kind of clothes they wore, and what they were
thinking. The message implicit in this culture was, "Do what you're
told and don't talk back." In Texas, we rejected this culture and
adopted a style of our own that included blue jeans, workshirts,
boots, longish hair, mustaches or beards, and marijuana. As we got

to know the other new people from the heartland, we found that their experience was much like ours. In coming years, as the new guard became dominant, those of us from the heartland were often referred to inside SDS as "prairie power."

SDS members who had been active since the early years were referred to as the "old guard," to distinguish them from the new people or the "new guard." Many of the old guard came from large northeastern cities and had gone to "good" schools, although many had since graduated and moved, often to ERAP projects or graduate school. A significant number had been born into the Jewish intellectual tradition and some had a family heritage of liberal or leftist activism – including a few whose parents had been communists or socialists. Many had grown up with progressive ideas as part of their daily lives. The new guard was more anti-establishment, more alienated, and more anarchistic than the older generation of SDS. Even though I had joined in 1963 and had been working as an SDS regional traveler, I lived in Texas and had gone to only one National Council meeting. I wasn't part of the old guard social network and considered myself a member of the new guard.

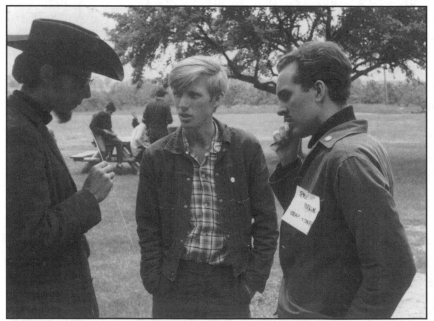

Robert Carnal, Paul Pipkin, and me at the 1965 SDS convention.

Tensions existed between the new and old guards. The March on Washington had been a great success and many new people had

joined SDS, but the old guard seemed unprepared for this rapid change in their organization. The new members were strangers to the old guard and largely remained so. Except for Helen Garvy and Clark Kissinger, people I already knew, I don't remember having a conversation with more than one or two old guard people during the entire convention. We wondered why the old guard seemed so stand-offish and they in turn must have wondered how to relate to the "crazy Texans" who were also a strong social presence. The personal conversations and friendships that would have helped break down the boundaries between "us" and "them" never occurred at Kewadin.

As the convention got under way, we discussed strategies for ending the war and different ideas about what SDS's role should be. The March on Washington had thrust SDS, with its growing network of chapters, into the leadership of a rapidly growing antiwar movement – but not everyone was comfortable with that. The ERAP organizers were afraid that the war would take energy away from their work and make organizing in poor black and white neighborhoods more difficult. Many chapters, especially new ones such as Texas, with more anarchistic tendencies, believed that we needed to build local opposition not sporadic national marches. We all feared that the single issue of the war would overwhelm SDS's multi-issue approach. At the same time, we all knew that the war had to be stopped.

There was general agreement that the strength of SDS was in the chapters and in the community organizing projects and that this local emphasis would suffer if SDS took on the job of coordinating national antiwar actions. Organizing a national demonstration took lots of time, energy, and money – resources that were in short supply for SDS – and most of the organizers of the April antiwar march believed there were a whole range of local activities that were more important than another large demonstration.

The discussions in the plenary sessions were both informative and tedious. Important information, analysis, and insight helped clarify the issues that we were debating. But the debate tended to be dominated by a few articulate men who spoke often and seemed to enjoy the political bantering. To make a point, they would repeat what others, or they themselves, had already said. It reminded me of my high school debate team where we honed our arguments and counter-proposals with one objective in mind – winning. But democracy and winning aren't the same thing. Winning is about

overwhelming the opposition while democracy, as we defined it, encouraged everyone to participate in making collective decisions. Those who spoke often intimidated less articulate or less experienced members and made them feel excluded or irrelevant. Because it was usually men who controlled the debate, this later became an issue for the women's movement, although many men also felt left out. As the meetings droned on and on, small groups would slip out the back door to share information about local organizing or simply to sit by the lake and watch the sun go down.[65]

The issue of anti-communism, and in particular the "communist exclusion clause" in the SDS constitution, was one of the final items on the agenda. The original clause read:

> SDS is an organization of democrats. It is civil libertarian with those with whom it disagrees, but clear in its opposition to any totalitarian principle as a basis for government or social organization. *Advocates or apologists for such a principle are not eligible for membership.* (Italics mine)

This clause was usually ignored but the run-in with anti-communist groups over the march had angered many SDS members, and some people wanted it changed. The clause had long been a source of conflict between SDS and its "parent" organization, the League for Industrial Democracy (LID), and we knew that changing it would have repercussions on the SDS-LID relationship, but we didn't really care. In 1965 most people in SDS didn't even know of the LID's existence. SDS was growing rapidly and the little financial support provided by the LID was no longer significant. Trying to accommodate their anti-communist politics was more trouble than it was worth.

The LID was strongly anti-communist, and while SDS shared many of their domestic concerns, their anti-communism put them at odds with us over foreign policy. Many LID members actually supported US military intervention in Vietnam and in the Dominican Republic.[66] Our experience was different. We wanted a third way, without the Cold War mentality, and considered ourselves to be anti-anti-communist. The LID took this as being pro-communist. I was neither pro nor anti-communist but I was definitely anti-anti-communist because I had grown up during the McCarthy hearings and had seen how destructive anti-communism was to the democratic process. It warped the political debate so seriously that people who could have had an impact on stopping the growing war in Vietnam were afraid to speak out. As the Port Huron Statement put it:

[M]uch of the American anti-communism takes on the characteristic of paranoia. Not only does it lead to the perversion of democracy and to the political stagnation of the warfare society, but it also has the unintended consequence of preventing an honest and effective approach to the issues.

After a heated debate, and by a large majority, the clause was changed to:

SDS is an organization of democrats. It is civil libertarian with those with whom it disagrees, but clear in its opposition to any anti-democratic principle as a basis for government or social organization.

As the election of national officers approached, Jeff Shero and I, among others, raised the question of whether SDS should even have a president and vice president or whether we should come up with a more collective structure more in tune with our ideas about participatory democracy. The question of organizational structure had not really been an issue when SDS was small and the social network of the old guard connected the chapters. Most activity was local and a simple informal structure worked. The president and vice president were spokesmen for the organization, but policy decisions were made at the relatively small quarterly National Council meetings composed of chapter representatives and some elected at-large delegates.[67] We had faced this issue in Texas. When the university administration demanded that we give them the names of our president and vice president, we resisted because we didn't need a president any more than we needed a king. We practiced collective leadership and encouraged everyone to participate.

The March on Washington and the rapid growth of SDS changed SDS's internal dynamics and greatly increased its national visibility. The National Council was no longer a small group of friends. The larger meetings were more unwieldy, and contacting everyone for quick decisions was much more difficult. It also seemed inevitable to me that, as SDS continued to oppose the war, the press would want to know what SDS was doing and would seek out the president and vice president because, like it or not, the world defines those offices as positions of authority. No matter how well intentioned the officers were their words would be taken as SDS policy and would be subjected to the usual press distortion. Putting the officers in that position didn't seem to me to reflect the spirit of participatory democracy or local control. Jeff and I advocated abolishing the offices of president and vice president and replacing them with a more democratic structure, although I had no worked-out model to

offer. There was significant support for the idea, but since it was a major change, the decision was referred to a vote by the membership.

Jeff Shero and me at Kewadin

At the end of the convention we elected a president and vice president. The old guard nominated two people for president and the new guard nominated me. I ran on a position that if I were elected I would go back to Texas and continue to organize locally. Dickie Magidoff, from the ERAP project in Cleveland and one of the old guard candidates, planned to maintain the old low-key concept of president and would stay in Cleveland if elected. The third candidate, Carl Oglesby was older than most of us and a relative newcomer to SDS. He was a writer and playwright with a wife, three children, a house, and a mortgage. His politics had been influenced by contact with the SDS chapter in Ann Arbor, Michigan, and by his experiences while working as a technical writer for the Bendix Corporation, which was doing military research on defoliants for Vietnam. As he became aware of what the United States was really doing in Vietnam, he decided to work full-time against the war. Carl had been one of the speakers at the first teach-in on

Vietnam at the University of Michigan, had written SDS's basic pamphlet on the war, and led the workshop on this issue at the convention. Thoughtful, a good speaker, and very knowledgeable about Vietnam, Carl wasn't in either the new guard or the old guard. Everyone liked him and so he was easily elected to be the next president. Dickie and I were both so relieved that we went out later for a beer and became good friends.

Workshop at Kewadin Convention. Todd Gitlin and Mike Davis in foreground. Carl Oglesby, with beard, between them.

Jeff Shero, from the University of Texas chapter, was nominated for vice president. Jeff was a real skeptic when it came to dogma of any kind and would challenge any idea he didn't completely agree with. At one of the plenary sessions he had challenged Tom Hayden, one of the foremost proponents of ERAP, to a debate about the value of organizing the poor. Jeff argued that instead of dropping out of school to work in poor communities, SDS should be organizing university students into SDS chapters and then, when they left the university, into a broader Movement for a Democratic Society (MDS).[68] During the elections, Jeff proposed turning the monthly SDS *Bulletin* into an expanded printed publication with pictures and up-to-date information about the chapters and other movement activities. People liked Jeff's energy and his ideas for the *Bulletin* and he was elected vice president.

The convention elected fifteen at-large members of the National Council, and I was elected as one of perhaps three people from the new guard. The National Council was supposed to elect a national secretary to oversee the day-to-day functioning of the organization and to run the office, but the people approached for the job were all busy for the summer so the election was postponed until the fall. Neither Jeff nor Carl had expected to leave Kewadin as national officers and both already had plans for the summer. Carl was going to South Vietnam. In response to government criticism of the antiwar movement for not understanding what was really going on in Vietnam, the "teach-in" committee, which had formed the previous spring around the Ann Arbor teach-in, had raised money to send Carl to Vietnam to learn about the situation firsthand. Jeff Shero was also off traveling for the summer and planned to return in the fall to work in the SDS office and edit the *Bulletin*.

On the way to Camp Maplehurst, Judy and I had stopped at the national office in Chicago to find out what we would be doing for the summer. We had spent a couple of days helping unpack from the move from New York and learning the basics of servicing chapters and keeping the organization going. When we returned to the office, both Clark Kissinger and Helen Garvy were gone. Helen had moved to Hoboken, New Jersey, to work in an ERAP project and Clark was living in Chicago and trying to raise funds for SDS. He rarely came to the office but was available for advice.

The office was located at East 63rd Street and Woodlawn on Chicago's south side, a predominantly black neighborhood with a reputation for being among the roughest in the city. I had never been in a northern ghetto and it was both interesting and depressing. The environment was dirty, noisy, and constantly moving. The elevated train roared past just outside our second floor windows, police cars with wailing sirens sped down the crowded streets, and burglar alarm bells rang for hours before someone shut them off. The neighbors around the office and the staff apartment a few blocks away didn't feel hostile, but they didn't feel friendly either. Even though all of the office staff was white we had very little trouble during that summer.[69] The quiet dark nights that I had grown up with didn't exist in the ghetto and by the end of the summer I really missed them.

The office felt strangely disconnected from SDS. Several of the staff members had worked on the March on Washington when the

office was in New York, but they had not been involved in the day-to-day running of the organization. This meant that there were no knowledgeable people on staff to provide a transition, no national secretary, and no members of the old guard to connect us to what had come before. For the first two weeks, we weren't sure who would be on staff. People we expected to stay left, and other people wandered in and stayed. As a result, the national office, during a time of mounting interest in SDS, had been left in the hands of a small group of volunteers – all from the new guard and with little preparation for the task.

Since we were on our own we called a staff meeting and decided to run the office as a democratic collective. We elected Jeff Segal as office manager because he had worked for several months in the New York office getting ready for the March on Washington. Dena Clamage and Mel McDonald took on the task of coordinating the rapidly growing antiwar activity within SDS. Bruce Schmiechen, Jim McDougall, David Stamps, Judy and I divided the country into regions and each of us took the responsibility for maintaining contact with the chapters in one region. Larry Freudiger ran the printing press and Nancy Yost typed and did the billing. One of our objectives was to give everyone the opportunity to do "real" work rather than dividing the staff into "the important people," who did important things with political content and "the shitworkers," who performed the tedious tasks of addressing envelopes, licking stamps, cranking the mimeograph, or collating pamphlets. We held weekly staff meetings to evaluate what was being done and what needed to be accomplished. This created a camaraderie that helped us get through the summer.

Because SDS had organized the March on Washington, young people were curious about us and the office was flooded with phone calls and letters requesting information, membership cards, chapter status, or someone to speak at a rally. SDS had always maintained an inventory of literature, mostly written by its members, on a wide variety of topics, but the demand had increased so dramatically because of the April march that the supply had been depleted. Because of the move to Chicago there hadn't been time to reprint them, so before we could fill the orders we would have to reprint all the pamphlets.

Since we were completely out of literature, we were faced with creating a new supply of pamphlets to meet SDS's rapidly growing needs. This would have been a never-ending process in the best of

times, but our days were already full with answering phone calls and letters, processing memberships, and helping chapters get started. Reprinting, collating, and stapling enough of each pamphlet to keep ahead of the demand was a daunting task in the days of the mimeograph machine. For most of the pamphlets, we already had a useable stencil, but if we didn't, we had to create one by typing the text onto a special kind of coated paper. This stencil was then put on the drum of the mimeograph machine, and as the drum turned, ink came through the stencil and was transferred to the paper. When the printing was done, the stencil had to be cleaned, and carefully saved so it could be reused until it wore out. After all the pages of a pamphlet were printed on both sides we would lay them out in order around a table and then walk around and around the table putting together pamphlet after pamphlet and stapling them together.

An even bigger problem than the lack of time was the lack of money to meet SDS's rapidly growing needs. When the SDS office was in New York, the LID had given a modest amount of money each month to help with office expenses and salaries, but when it moved to Chicago and deleted the "exclusion clause" at the convention, the LID stopped sending money. The March had brought in some large donations, but that money was long gone. A few dollars came in here and there to pay for literature and dues, but our bank account was always on the edge of empty. We were constantly juggling paying the rent and utilities for both the office and the staff apartment as well as buying food for the staff. What was left over went to buy paper, pay salaries, and meet other basic needs. Because we could only afford to buy small quantities of paper at one time, we printed only enough of each pamphlet to meet the demand for a few days, so it was impossible to get caught up.

About two weeks after the national convention, the office sent out a "worklist mailing" to the chapters and members of the National Council. None of us had ever put out such a mailing and we weren't sure what was supposed to be in it, so we wrote a two-page summary of the convention and an overview of how we were responding to the problems of the national office. We soon received several critical responses from members of the old guard who seemed to be totally unaware of the transition that was taking place in the national office. They wanted details of chapter activity, intellectual articles discussing the issues, and information that we couldn't possibly have gathered in the two weeks that we'd been in the office. What really surprised me, however, was the angry and

hostile tone of the letters. It was as if these members of the old guard were only now realizing that they had inadvertently left the office in the hands of the "new guard anarchists" and felt uncomfortable about it.[70]

By the middle of July the bank account was empty and the office was grinding to a standstill. The worklist mailing dated July 16, 1965 began, "HELP! The telephone has been temporarily disconnected, mail is only trickling out (including this worklist mailing), publication is practically nil, staff is starving – all because there is no money in the peoples' coffers." In order to keep the office running some of us took part-time jobs. I packed boxes and loaded moving vans. Judy and I spent many hours interviewing people for a public opinion survey. Other staff members took whatever odd jobs came up.

Following the Kewadin convention, right-wing columnist Fulton Lewis III had written an article saying that SDS had considered recruiting young Americans for guerrilla warfare so they could fight with the National Liberation Front in Vietnam. None of us who had been at the convention remembered anything like that having been discussed there, but we braced ourselves for the repercussions. The *Reader's Digest* reprinted the article then United Press International sent it out to be printed in newspapers across the country. The intent was undoubtedly to hurt SDS and a number of SDS chapters came under attack from local politicians and college administrators. The main effect, however, was that young people across the country learned about SDS and inquiries about membership flooded into the office.

As the summer progressed and the requests for information about SDS increased steadily, we went to two shifts so that the office would be open from early in the morning until midnight or later. Things were happening all over the country and we spent hours talking on the phone, writing letters, and sending out information. People called who wanted to start chapters or who wanted help and advice for chapters that were under attack. In addition, as the ERAP community organizing projects began to have an effect in their communities, local police and politicians began to take notice and, in some cases, tried to stop them. In June, JOIN members in Chicago sat in at the public assistance office and four were arrested. In July, the Chicago police raided the JOIN staff apartment and arrested people on narcotics charges, but the charges were later dropped for lack of evidence.

There were demonstrations and activities all over the country as a growing number of people worked on issues ranging from civil rights and poverty to ending the war. Since SDS was the largest student organization of its kind, people called the office hoping that we could send a speaker, publicize what they were doing, mobilize our membership in support, or, occasionally, find them a good lawyer. There was more work than we could reasonably do and the little feedback we got from those members of the National Council who lived in Chicago was that we simply needed to work harder, to sacrifice ourselves for the movement. It was exciting that so many things were going on, but working twelve hours or more every day with no recreation was too much and began to get to all of us. Each staff member was supposed to get five dollars a week, but the office could rarely afford it. We were all living in an over-crowded staff apartment with wall-to-wall sleeping bags and mattresses. For a while our main food was a five-gallon can of peanut butter and loaves of day-old white bread. Given all this, it wasn't surprising that morale began to decline.

Although we didn't know the details at the time, the FBI began to gather information about SDS following the March on Washington. They had opened a file on me when I went to Mississippi and in their eyes my brief membership in the Young Socialists Alliance was enough to make me into a communist and therefore a "communist infiltrator" of SDS. The San Antonio FBI office had opened a COMINFIL (communist infiltrator) file on me and tried to keep track of where I was. The Detroit FBI office noted that my car was at Kewadin and the San Antonio office noted that I hadn't returned to Austin and presumed I was in Chicago. An informant told them that I was in Chicago before the convention. Attorney General Katzenbach approved an FBI tap on the office phone in May 1965 and they confirmed that I was in the office by my phone conversations. They seem to have been very interested in my marital status because they checked the records in Austin, Pueblo, and Beaumont, Texas, but failed to find anything. They were also interested in my draft status and contacted my draft board in Pueblo. We were aware that they were probably watching the office, but we weren't particularly concerned because we weren't doing anything illegal. If they wanted to know what we were doing, all they had to do was ask. We joked about how the phone was probably tapped, which it really was, and would occasionally comment on strange noises during phone calls.

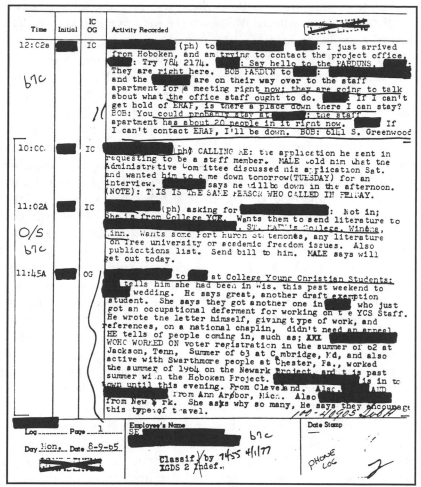

Page of the log for the FBI's wire-tap on the SDS phone, summer 1965.

Following the Kewadin convention, the LID asked the new president, Carl Oglesby, to come to their next board meeting to give them a report on the convention. Carl didn't want to go and convinced National Council member Helen Garvy to attend in his place. Helen went to the meeting and wrote to Carl as soon as she got home.

> They attacked us on almost everything....Some of them really support Johnson. And the Dominican Republic. Their anti-communism warps everything.[71]

A month or so later the LID called the national office to say they were sending a delegation to Chicago to talk with some SDS members and that they would like to see the office and talk with the

office staff as well. We told them there was no national secretary in the office, the new national officers were off traveling, and we were essentially a volunteer staff. They insisted on coming anyway.

They arrived at the office, and after looking it over, some of us went with them to the staff apartment, which we had cleaned up as best we could for the occasion. I didn't know any of the LID people and don't remember how many came although I believe that both Tom Kahn and Bayard Rustin were there. Jeff Segal, Judy and I sat on the couch facing the LID representatives while Bruce Schmiecken lay on the floor behind the couch. The LID members had two concerns: the removal of the anti-communist clause and our demand for withdrawal of US troops from Vietnam. Since they supported US intervention, we decided to talk about the war first. We were in the middle of a heated discussion about the Cold War and Vietnam when Bruce stood up behind the couch and asked, "What do you think about the Soviet intervention in Hungary?" referring to the brutal repression of the Hungarian freedom movement in 1956. One of the LID members immediately called it a ruthless act of Soviet imperialism. Bruce replied, "You condemn Russian imperialism and support US imperialism. You're nothing but a bunch of damned hypocrites!" and he stormed out of the room effectively ending the meeting. The relationship between SDS and the LID continued to deteriorate until October 1965 when they officially broke off their relationship with SDS.

Throughout the summer, the antiwar movement continued to grow as new organizations were formed and led demonstrations opposing the war. When SDS decided not to take on the task of organizing and coordinating antiwar marches, other organizations rapidly filled the gap. The Fifth Avenue Peace Parade Committee in New York and the National Coordinating Committee to End the War in Vietnam were both formed in 1965 to coordinate actions against the war. In Oakland, California, demonstrators began trying to stop troop trains carrying soldiers headed for Vietnam, and on August 16, *LIFE* magazine ran a picture of a student burning a draft card. The emerging antiwar movement went far beyond just SDS, but at many schools SDS was the main focus for antiwar activity.

In August President Johnson signed the Voting Rights Act of 1965, guaranteeing all citizens the right to vote and prohibiting the use of literacy tests or other means to block that right. The confrontation in Selma, Alabama, the previous spring had forced the

issue to the front. In Lowndes County, Alabama, next to Selma, SNCC had been trying to register voters for a number of years. During the summer, they organized the Lowndes County Freedom Organization, the first all-black political party in the United States. The symbol of the segregated Alabama Democratic Party was a white rooster, and the Lowndes County Freedom Organization took as its symbol a black panther. This symbol would take on increased significance as the black movement gained momentum.

Just five days after Johnson signed the Voting Rights Act, the Watts ghetto in Los Angeles exploded. It was as if the people of Watts were saying that the right to vote didn't make up for the thirty-percent unemployment, the racist harassment of the black community by the Los Angeles police, or the other indignities that black people suffered every day. What started with the arrest of a black man turned into a riot that lasted for six days. Anger that had long been simmering finally exploded.

As an indication of the political climate in 1965, the white mayor of Los Angeles, Sam Yorty, claimed that black demands for federal funds to be spent in Watts were the result of "communist agitation." During the riot Mayor Yorty referred to black rioters as the "criminal element" and as "monkeys."[72] A federal team sent to investigate the riot had a different view and concluded that police brutality was one of its primary causes.

Meanwhile, the situation in Vietnam continued to deteriorate. Following the overthrow of President Diem, one general after another took control of South Vietnam. In yet another military coup in early June, General Nguyen Cao Ky took over the government and became the premier. When a reporter later asked General Ky who his heroes were, he named Adolph Hitler. I thought this was fitting since what our government was doing reminded me of Hitler's actions during World War II. In early May President Johnson called a bombing halt in hopes of starting negotiations with North Vietnam. The US demanded that all fighting stop immediately but there was no mention of reunification. This was interpreted in North Vietnam as a call for surrender. Having already fought both the Japanese and the French, the Vietnamese were willing to continue to fight to unify their homeland, so the talks fell through and the US started bombing again. By July, Secretary of Defense McNamara was discouraged. Although he urged Johnson to meet

General Westmoreland's request for forty-four battalions he was privately skeptical about the war. He told the President:

> The war is one of attrition and will be a long one. Since troops once committed as a practical matter cannot be removed, since US casualties will rise, since we should take call-up actions to support the additional forces in Vietnam, the test of endurance may be as much in the United States as in Vietnam.[73]

Under Secretary of State George Ball, who consistently warned that the US would get into a war it couldn't easily get out of, went further and advised that the US find a way out of the war as soon as possible because, "we can, by accepting some short-term costs, avoid what may well be a long-term catastrophe."[74]

We didn't know how much opposition to the war there was within the government because almost everyone maintained a façade of unity. On July 28, President Johnson held a press conference announcing that he was sending 50,000 troops right away and more later. He didn't mention that he had already approved 150,000 men, raising the total to 225,000. Honest straightforward information was an early casualty of the war.[75]

In late August, when Carl Oglesby and Jeff Shero were on their way to Chicago, Judy and I drove to Iowa to visit my grandmother and then on to Colorado to visit my parents. From there we returned to Austin, where I registered for a full load of anthropology courses. After the intense summer in the office I was burned out and was looking forward to getting back to Austin where there was a supportive community and where the nights were quiet

I had no idea at the time that I was doing anything that was important enough for the FBI to be keeping track of me. They obviously disagreed because they had noted in my file that I was at Kewadin and then in the national office. After I left Chicago they made an anonymous phone call to the SDS office and asked to speak with me. They were told I had returned to Texas.

— 8 —

Organize Locally
Fall 1965

"For the first time since 1918, a democratic power is using gas and the outrage is, if anything, aggravated by the statement that these methods are being used on an 'experimental' basis. Thus the Americans, like Hitler and Mussolini in Spain, are treating the hapless inhabitants of Vietnam as a living laboratory in which to test their weapons."

The Statesman, March 26, 1965

"Vietnam has become for American troops a field of experimentation for anti-guerrilla tactics."

General Paul Harkins, February 8, 1963

"We should bomb them into the stone age."

General Curtis LeMay, November 25, 1965

The fall National Council meeting was held in early September at a camp in Indiana. Scott Pittman and I hitchhiked up from Austin partly for the adventure of it and partly for the opportunity to talk and listen to people who weren't in the movement. Our first ride was with a member of the John Birch Society, an extreme right-wing political group named after a CIA agent killed during the Chinese Revolution. He went on and on about "the damned communists running the civil rights movement and the antiwar protests." We held our own while trying hard not to make him too angry, but it was a long ride to Dallas. From there, three young guys going to Canada squeezed us into the back seat with their suitcases. There was a large hole in the floor, and to keep the exhaust from killing us all, they had all the windows rolled down. It was too loud for us to talk with them about the war or anything else. The lights on the car didn't work so as soon as it got dark they pulled in behind another car as we raced across Oklahoma. We abandoned them at a truck-stop and almost immediately caught another ride with a couple of

guys headed for Kansas City for a hot weekend with their girlfriends. They didn't like the idea of going to war in Vietnam and hoped it would be over soon, but they thought that we had to stand up to the communists somewhere. They let us off in Joplin, where we spent the night in a cheap downtown hotel and were back on the road first thing in the morning. A woman in her late fifties drove us seventy-five miles to Springfield, talking the whole time about the troubles she was having with her husband and her lover, both of whom she'd known since high school. When she let us out she handed us each a silver dollar and told us she knew what it was like to be on the road. Hitching is never predictable and by late afternoon we were only about a hundred miles down the road, standing under an overpass in a driving rain, when a pickup with a couple of soldiers from a military base near Amarillo picked us up. They said they were going within a few miles of the camp in Indiana and we could ride under the waterproof tarp in the back. We rode all night dozing to the sound of the rain pouring down on the tarp just inches above us. Early the next morning they let us out a couple of miles from our destination.

It was still morning when Scott and I got to the camp. The meeting was scheduled to begin that evening so we spent the day talking with other delegates as they arrived and helping set up. Everyone was concerned about the escalating war. The bombing of North Vietnam, under the name Operation Rolling Thunder, had been going on continually since February. General Westmoreland, known as Waste-more-land to the movement, requested more troops every month, and as a result the number of American casualties had reached a hundred a week and the number of Vietnamese civilian casualties was skyrocketing. The enormity of the task of stopping the growing war was on everyone's mind when the National Council convened. Debate revolved around how we saw our role in ending the war. Should we support national demonstrations, local demonstrations, or some combination of the two? Should we advocate negotiations or should we push for immediate withdrawal? What was our position on the National Liberation Front (NLF) in South Vietnam and Ho Chi Minh's government in the north? Did we have to support their political positions before we could support their struggle for independence? I didn't know much about either the NLF or the government in the north but I supported their right to establish their own government

without being dominated by outside forces. The majority of the council members believed that the US should get out immediately.

Proposals for action ranged from more demonstrations and civil disobedience to stopping troop trains and sending Americans to target areas in North Vietnam to see if that would stop the bombing. The majority sentiment was for local demonstrations and the National Council again encouraged the chapters to build student antiwar sentiment and opposition to the military. Activity aimed at disrupting the draft was more controversial because it might be illegal, so the national office was asked to prepare draft-counseling information and to submit it to the membership for approval before any action was taken. The National Coordinating Committee to End the War in Vietnam was organizing an International Days of Protest in mid-October. Instead of trying to get everyone to one location there would be local protests in cities and on campuses across the country. The National Council voted to support this merging of local demonstrations into a national focus

A discussion of the role of the national office and how it should be organized to meet the growing demands on SDS, turned into a debate about our summer experiment in office democracy. In spite of the problems and the resistance we had run into, I was encouraged by our attempt to have everyone who worked in the national office involved in running it. We tried to explain that participatory democracy was important enough that it should be the guiding principle of the way SDS functioned day-to-day now, not an ideal to wait for sometime in the future. Even though it might be less efficient, it valued each person and made everyone's contribution important. Our critics description of the summer as "anarchy" and "chaos" made it sound as if there was no structure at all and the staff members just did whatever they wanted to do.[76] Several of us who had worked there tried to explain that we had job descriptions and accountability and that it wasn't the experiment in democracy that caused the chaos but the lack of money and material, crowded living conditions, too much work, and very little outside help. After long and heated debate, it was finally decided to hire a national secretary and to set up a National Administrative Committee (NAC) to oversee the functioning of the office. A series of amendments that once again reflected the majority view that the office should not make policy for the organization were passed limiting the power of the national secretary and the NAC. Paul Booth became the new national secretary.

Back in Texas, the new school year was starting and everyone had to go through the tedious process of registering for classes. We set up an SDS booth outside the exit of the registration area so that the entire student body had to walk past it. There were usually two or three of us at the booth to talk to anyone curious enough to stop. I was surprised at how many people did stop to ask questions, particularly about the war. Civil rights was still an issue, but young men in particular were being forced to look at the possibility of going to Vietnam.

Jeff Shero, Gary Thiher, and Judy Schiffer Pardun at recruiting table.

By the fall of 1965 a small group of draft counselors in Austin were advising people on ways to get out of the draft. They primarily provided information on filing for Conscientious Objector (CO) status, although some of them were also gathering information about ways to deliberately fail the physical or psychological pre-induction tests. These counselors weren't part of SDS, but we referred young men to them. At that time men of draft age could get a deferment from military service if they were in school, but if a

student dropped out, flunked out, or graduated he immediately became eligible for the draft. Once that happened there were a limited number of ways to keep from being drafted. Homosexuals and members of subversive organizations like the Communist Party were usually rejected. One could join the National Guard, take a job deemed to be in the national interest, be declared physically or psychologically unfit, get married and have a child, or be approved as a CO and do alternative service.

Being approved for CO status was a difficult process and if the person succeeded he still had to do two years of alternative service. If, by some chance, you could convince your local board that working in a poor community was in the national interest, you might be able to do that, but most likely it meant serving two years as a medic in the military, carrying a medical kit instead of a weapon. Getting out on physical or psychological grounds was a much better option because it set the person free from the Selective Service System. The 4-Y psychological rejection I had received in 1965 meant I could organize full-time without having to worry about being drafted.

During registration we invited everyone who stopped at our booth to come to a weekend "goat roast and camp-out" in a county park south of Austin. Quite a few people came to talk, drink beer, and eat barbecue with us. About fifty feet from our campsite, a fraternity was having a party for their freshman recruits, and there was a striking difference between their community and ours. They were getting roaring drunk, yelling, and showing pornographic movies in a big tent while we were having a good time eating and talking while sitting around the fire. At one point, four or five of the SDS women were approached by some of the fraternity boys who jokingly invited them into the tent to watch the movies. The women accepted and once inside the tent they began laughing and making fun of what they were seeing, using graphic language that finally embarrassed the fraternity guys so much that they shut off the projector. With the fun over, the women returned to the goat roast, leaving the fraternity boys to figure out what had just happened.

We spent the first month of the new school year planning for the International Days of Protest on October 15-16 and getting the word out to people in Austin who we thought might participate. Shortly before the protest, CBS ran a two-part series on SDS and the antiwar movement. At the same time, as if it had been planned, the government and the pro-war media launched a concerted attack on

the antiwar movement. Senator Dodd of the Senate Internal Security
Committee said that the antiwar movement had obviously passed
into the hands of the communists. Ex-President Eisenhower
complained of "moral deterioration." Attorney General Katzenbach
said that anti-draft activity "begins to move in the direction of
treason." He went on to state that there were known communists in
SDS and although I didn't know it at the time, my FBI COMINFIL
file suggests that I was considered to be one of them.

In spite of this attempt to intimidate the antiwar movement, over
100,000 people demonstrated against the war in ninety cities. Fifty
SDS chapters were involved. In Austin, about fifty of us held what
we called a Death March to the state capital. We all came dressed in
our Sunday best except for a dozen or so people who were dressed
all in black with white faces and carried black coffins and large
masks of people crying.

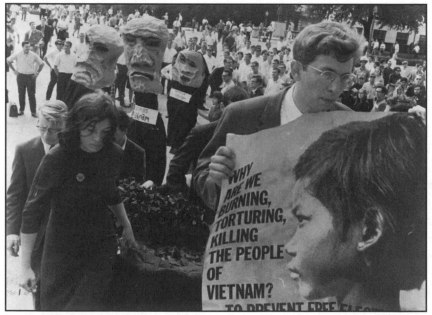

Austin Death March. October 1965.

Several hundred people gathered to watch as we assembled in
front of the university library and then walked silently from the
university to the state capitol building. Our most prominent picket
sign was the large SDS poster that had been made for the New York
subways, with a photo of a young Vietnamese girl burned by
Napalm. Some of the onlookers yelled at us but most just watched
as we marched along. It was those silent people who we wanted to

reach, even if they were too afraid to join in. Many years after the war was over, I met one of those observers, who remembered the march in detail. He had later included a description of the march in a letter to his daughter about his antiwar activities, and he gave me a copy of the letter.

> Each person was dressed in black from head to foot. Their faces were painted white and they carried coffins down the main street in front of the university. This was a very courageous group of people. There was almost no vocal opposition to the war in those days....Passersby started shouting and booing at the marchers. I was very intimidated so I didn't join the march.[77]

He told me our demonstration had a big effect on his decision to join the antiwar movement in California the next year.

Austin Death March, October 1965.

We had tried to get a parade permit for our demonstration, but for reasons that appeared to have more to do with our politics than anything else, the city council refused to grant one. We filed suit in court for the right to assemble freely and have our parade in the street. By parade time, no decision had been reached, but we had a contingency plan to force the issue. Our lawyer, an SDS member, had advised us that if a token demonstrator went into the street and was arrested that we could then file suit to clarify the whole issue of parade permits. Larry Freudiger, who had worked in the national

office during the summer and moved to Austin in the fall,
volunteered for the job. As the rest of us walked on the sidewalk,
Larry walked out into the street. Several police immediately told him
to get back onto the sidewalk, and when he refused they picked him
up and put him on the sidewalk. He went into the street again and
they repeated the action. After several tries, the police put Larry into
Lt Gerding's car, and he was taken away. We all assumed that Larry
was under arrest, but as it turned out Gerding had put him in
"protective custody" because he was under twenty-one. When the
demonstration was over, Larry was set free. There was no arrest –
and therefore no lawsuit. We assumed that Gerding had someone at
our meetings, but we hadn't expected him to use that information to
subvert our legal right to use the courts to clarify the issue of parade
permits. He had used our openness to out-maneuver us.[78]

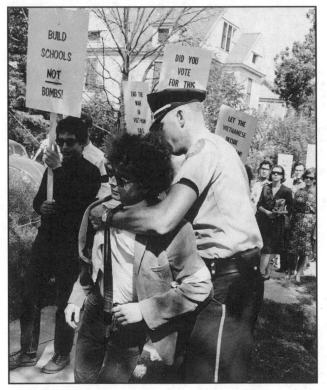

Larry Freudiger being put gently back on the sidewalk.

The *Dallas Morning News*, a conservative newspaper, covered the
march and called us "shaggy maned," "homegrown leftists," with
"shoulder length hair," wearing "T-shirts, sandals, leotards and dirty
jeans."[79] The photographs of the demonstration clearly speak for

themselves. As was often the case, the media emphasized how we looked – or, more to the point, how they wanted people to *think* we looked. Describing us as "beatniks" or "weirdos" relegated us to the fringe and discouraged others from joining us.

Because SDS chapters in the Texas-Oklahoma region were so far apart it was easy for them to feel isolated in a sea of conservative pro-war opinion. My class and work schedules were flexible enough that I could spent some time traveling to other campuses to help create a sense of unity. From Austin to Norman is 400 miles, a long drive but something I always looked forward to. The spirit in Norman was very much like Austin's. Jody Bateman was one of the people I always spent time with in Norman. He had what could truly be called a photographic memory. Jody read constantly and could cross-reference and quote *verbatim* things he had read years before. On one of my visits, Jody and I encountered a young Christian debating another person in the hallway of the student union. A big crowd had gathered and the Christian quoted some passage from the Bible and then said, "but Karl Marx said that religion was the opiate of the people." Jody stepped into the circle and said, "You've quoted both the Bible and Marx out of context and neither one means what you imply." He then quoted, word for word, the chapter from the Bible containing the verse in question. "There, see, in context it doesn't mean what you say it means at all." He then did the same thing with the quotation from Marx, quoting from memory as if he were reading the text. He admonished the crowd to be careful about things taken out of context and left saying, "You just can't let them get away with that." SDS attracted people who were bright and not afraid to question the world around them and Jody was one of many truly unique people who I met through SDS. Traveling from campus to campus talking with these people was always an intellectual treat.

The American people still knew very little about what was happening in Vietnam and generally supported American foreign policy. A national poll taken about the same time as our demonstration in October showed that two-thirds of Americans favored Johnson's policies in Vietnam with only eleven percent favoring negotiations or withdrawal. The polls missed a growing disillusionment among young people about the war and the government in general. In Chicago a radio station ran a competition between two songs, the pro-war *Ballad of the Green Berets* and *Eve of Destruction*, which had a definite antiwar theme.[80] People voted by

calling in to request one song or the other and the pro-war people won, although by only one vote. The young people voting in this poll had a decidedly different view of the war than the national poll cited above. They were more representative of the growing opposition to the war that we were seeing on campuses across the country.[81]

The attack by the press and the government that had come before the International Days of Protest had singled out SDS and its "anti-draft program." I didn't consider urging young men to apply for Conscientious Objector status and to demonstrate against the draft to be controversial because people were already doing those things and they were legal. But SDS was accused of·"draft-dodging" and having a master plan to "sabotage the war effort." In order to counter this and to tell the nation what SDS's anti-draft position really was, Paul Booth and Carl Oglesby held a press conference. They said that SDS advocated alternative service to rebuild communities such as Watts, or to work in the Peace Corps or VISTA, rather than torturing and burning in Vietnam. They were asking that political objectors be granted a political form of alternative service and predicted that if this were granted that most young men of draft age would choose to "Build, Not Burn."

The response to this press conference within SDS was immediate and critical. The National Council had clearly stipulated that any SDS program around the draft had to be ratified by the membership in a referendum. While a referendum had been sent out, at the time of the press conference many members had not even received it. The issue of the role of the national office in making policy for the organization was no longer theoretical and this time some of the old guard members were just as angry as the rest of us. Not only had the procedure specified by the National Council for keeping national officers in check been ignored, but there was also political opposition to the concept of alternative service. The movement was growing and people were being radicalized. Saying that SDS members were willing to do alternative service instead of going to Vietnam didn't confront the immorality of the war and seemed like a way for the government to co-opt the movement. Some people who were opposed to this program half-jokingly changed the slogan "Build, Not burn" to Build not! Burn!"

Following the October demonstrations, the attack on the antiwar movement continued. J. Edgar Hoover of the FBI, the Attorney General, and politicians all accused us of being under the influence

of communists and of treason. This rhetoric had two effects. Most young people who opposed the war did so on moral grounds. They had never met a communist and they knew that their moral outrage wasn't being directed from outside. When the government implied that they were communists or were being manipulated by communists, their response was to look for other people like themselves and SDS's membership soared. But there were also many people, like the guy who attacked me when I first came to Austin, who believed that communism had to be stopped by any means necessary. All the government rhetoric about communists in the movement incited these people to action and we began to hear stories of attacks on peaceful antiwar demonstrators by pro-war citizens. The bumper sticker with the slogan, "Better Dead than Red" took on a new meaning as it became apparent that the person who could get killed was me.

During the Thanksgiving weekend there was another national demonstration in Washington. The Committee for a Sane Nuclear Policy, known simply as SANE, had wanted to sponsor the demonstration alone but they quickly realized that they would have a much better turn-out if SDS were involved and SDS agreed to co-sponsor the demonstration. This time 40,000 people came to Washington and the last speaker was SDS president Carl Oglesby, whose speech continued the "name the system" theme of Paul Potter's speech the previous spring. This time Carl called the system "corporate liberalism" and didn't pull any punches as he spoke to the heart of the issue.

> The original commitment in Vietnam was made by President Truman, a mainstream liberal. It was seconded by President Eisenhower, a moderate liberal. It was intensified by the late President Kennedy, a flaming liberal. Think of the men who now engineer that war...Bundy, McNamara, Rusk, Lodge, Goldberg, the President himself.
> They are not moral monsters.
> They are all honorable men.
> They are all liberals.

Carl also attacked the cloak of anti-communism that was used to justify the war.

> To understand the war, then, it seems necessary to take a closer look at this American Liberalism....Their aim in Vietnam is...to safeguard what they take to be American interests around the world against revolution or revolutionary change, which they always call Communism — as if that were that....

There is simply no such thing now as a just revolution – never mind that for two-thirds of the world's people the 20th Century might as well be the Stone Age, never mind the melting poverty and hopelessness that are the facts of life for most modern men, and never mind that for these millions there is now an increasingly perceptible relationship between their sorrow and our contentment.

Far from helping Americans deal with...truth, the anti-communist ideology merely tries to disguise it so that things may stay the way they are. Thus, it depicts our presence in other lands not as coercion, but as protection. It allows us even to say that the napalm in Vietnam is only another aspect of our humanitarian love...So we say to the Vietnamese peasant, the Cuban intellectual, the Peruvian worker: 'You are better dead than red. If it hurts or if you don't understand why – sorry about that.'

Carl also stressed the enormity of the task that lay ahead of us and ended his speech with an impassioned plea to liberals to join us in stopping the catastrophe that was unfolding in Vietnam.

[I]f your commitment to human value is unconditional, then disabuse yourselves of the notion that statements will bring change, if only the right statements can be written, or that interviews with the mighty will bring change if only the mighty can be reached, or that marches will bring change if only we can make them massive enough, or that policy proposals will bring change if only we can make them responsible enough.

We are dealing now with a colossus that does not want to be changed. It will not change itself. It will not cooperate with those who want to change it. Those allies of ours in the Government – are they really our allies? If the *are*, then they don't need advice, they need *constituencies*; they don't need study groups, they need a *movement*. And if they are *not*, then all the more reason for building that movement with the most relentless conviction.

There are people in this country today who are trying to build that movement, who aim at nothing less than a humanist reformation. And the humanist liberals must understand that it is this movement with which their own best hopes are most in tune. We radicals know the same history that you liberals know, and we even understand your occasional cynicism, exasperation, and even distrust. But we ask you to put these aside and help us risk a leap. Help us find enough time for this enormous work that needs doing here. Help us build. Help us shape the future in the name of plain human hope.[82]

The text of the speech was reprinted by SDS and widely distributed. It had a tremendous impact on me because it eloquently summed up what I had discovered about America as I confronted the issues of racism, poverty, and American foreign policy. My belief that America stood for freedom and democracy and that the government listened to the people had been replaced by the

knowledge that my government was supporting dictators around the world and lying to the American people about it. Instead of listening to our concerns and openly debating the issues, which we thought was the essence of democracy, the government tried to stop dissent by accusing us of being communist-led traitors. The result was an increasing awareness that our only access to the political process was through organizing a movement that couldn't be ignored.

Throughout the fall, the battle over democracy in the national office continued. Jeff Shero, vice president of SDS and editor of the SDS *Bulletin,* sent us regular updates from the office. The problems of the summer continued – too much to do, no money, and overcrowded living conditions. Paul Booth, the new national secretary, ran the office from the top with little input from the staff. Sam Bennett, who was hired as the office manager, lasted two months and left saying that the office staff was "profoundly dissatisfied" because the vast majority of office work had no political content.[83] We had lots of problems during the summer, but the staff had been actively engaged in the office and knew that what they were doing was politically important. Now that they were just workers in the office, doing what they were told to do, the political context was gone.

Those of us from Texas, including Jeff Shero in the national office, continued to argue for office democracy throughout the fall. Judy Pardun wrote a letter to the SDS *Bulletin* expressing her concerns about the national office and top-down decision making.

> [In Austin] we all felt it was necessary to treat people as individuals not things, that in order to achieve our goals we had to, as much as possible, live them as we were fighting for them...if the movement itself [can't] treat people as human beings, I [can't] understand how it expect[s] to miraculously transform America....Maybe your goals...are different from mine. If so I would like to know what you see as the *spirit* of the society you are working for. Explain to me how you can change America at the same time you accept her methods.[84]

Jeff Shero complained:

> One of the great causes of my alienation here in the office has come from people who espouse expedient answers to our problems....Booth for example sees us as applying our total political force through a focal point, the national office, so [as] to have the greatest effect. In the short term his method is correct. It is hardly revolutionary though.[85]

It wasn't revolutionary because it used the same hierarchical methods that we were trying to change rather than the participatory democracy we said we believed in. As I wrote at the time, "Participatory democracy is nonexistent within the national office. [Working for SDS] is like getting saved by a traveling preacher, who you later find out is a drunkard and beats his wife."[86]

In December, SDS held a Rethinking Conference just before the winter National Council meeting in Champaign-Urbana, Illinois. The number of new members and chapters was exploding, the war in Vietnam was escalating, ERAP was trying to decide what to do next, and the relationship between the national organization and local chapters was unclear. SDS was being pulled in many directions and the conference was an attempt to re-examine SDS and to make a fresh start.

I didn't attend the conference, but I submitted a paper, "Organizational Democracy," that along with Jeff Shero's paper, "The SDS national office: Bureaucracy, Democracy and Decentralization," presented our view that the national office should be run using the principles of participatory democracy and staff involvement as much as possible.[87] These papers strongly advocated the decentralization of SDS because we felt this would allow for greater participation. Many people in Texas and elsewhere, joined SDS because it was a community of people working together on real issues. They were as attracted to the community that valued their participation as they were to the radical politics. Many of us Texans didn't trust politics without the social component and the national office seemed to be just that.

> From one point of view [SDS] is a political structure which operates in much the same way that political structures have always operated. That is, there is a central focal point...that represents the organization to other groups and to the press, and which makes certain kinds of action decisions concerning the organization as a whole. Another view of the organization is that it is a loose knit group of people who have come together because they feel that the values of the society are not human values, that the society restricts people's free development. This group sees [SDS] as a tool for social change within which a nonrestrictive human community based on a new set of values can develop.
>
> I don't think that any organization can depend on just the good will of the people in [positions of power] to remain democratic....I want to see the decentralization of power....The term "participatory democracy" seems to many people to mean only that those who participate decide.

> That, however, is not adequate. Unless the organization does everything
> in its power to make participation as easy as possible, then the principle is
> a farce.[88]

Jeff and I were both aware that the change in consciousness among young people was about more than just political ideas. In the next several years "social radicalism" would become one of the streams leading into the rise of the counter-culture and the development of counter-institutions.

The Texas delegation left the December Conference early because of what was called a "racial incident." One of the Texans decked a black man who had been threatening people and making sexual advances toward some women. Some of the people at the conference accused the Texans of racism but the Texans thought that the racists were those who refused to confront the man because he was black. The Texans, all of who had been active in fighting for civil rights in Austin, resented being called racists and left the conference early.[89]

After the delegates returned to Austin I talked with Mariann and George Vizard and Paul Pipkin about what had happened. They were angry about the racial incident and had missed part of the meeting by leaving early, but they didn't think that much of substance had come of the Rethinking Conference. They mentioned that a paper entitled "Sex and Caste" had prompted quite a bit of discussion among the women.[90] This paper, written primarily by Casey Hayden, a member of both SDS and SNCC, with help from Mary King of SNCC, compared the discrimination against women in both the society and in the movement to the discrimination against blacks. The role of women in the movement was an issue that had been waiting to emerge and this paper brought the issue out into the light. The paper focused on the role that society, in particular education, training, and socialization, played in defining women's roles. Women played important roles in every part of the movement, but they still took on many of the traditional roles as well. Although I didn't learn much about these workshops at the time, I later found out from women who attended them that the energy was electric as women talked to each other about who they were as women. This was one of the early meetings that led to the large and influential women's movement that began to change gender roles in America.

One SDS member conspicuously absent from the winter National Council meeting was Tom Hayden. On December 28, Herbert Aptheker, Staughton Lynd, and Tom went to Hanoi at the

invitation of the government of North Vietnam. Aptheker, a member of the Communist Party, was a historian and the author of a series of books about slavery, slave rebellions, and reconstruction. Lynd was a pacifist who had helped organize the Freedom Schools in Mississippi and Tom Hayden, a former SDS president, was working in the SDS ERAP project in Newark, New Jersey. Their trip brought even more attacks on the movement and was controversial within SDS in part for that reason. Carl Oglesby had gone to Saigon during the previous summer to observe what was going on in South Vietnam, but the trip to Hanoi was different. This group was going to meet with the "enemy" – the North Vietnamese and members of the NLF – and our critics played this up. This was the first of several trips over the years by movement people to meet with the people who our government and military were trying to destroy.

As 1965 came to a close, the chances of an early end to the war looked more remote than ever. In November, Westmoreland asked for 154,000 more men to bring the total to 375,000. In December, he asked for a total of 443,000 men by the end of 1965 and then increased the request to 459,000 in January 1966. But, there was hope. We had organized demonstrations involving over 100,000 people nationwide and the number of SDS chapters and members was increasing rapidly. In spite of this, it seemed that our position on the war was not even part of the public debate except as a target for attack by government officials. There was only one thing to do – keep on organizing.

— 9 —

The War Intensifies
Spring and Summer 1966

"Our 'counter-insurgency war' takes the privileged few, the oligarch, as friend and the people themselves as foe. I know this sounds like doctrinaire radicalism. Too bad. It is still a fact. The Generals know it. The reporters know it. The politicians know it. Russia and China know it, and so do France and Britain. Besides the ordinary American citizen who pays for the helicopters and sees his puzzled sons go off to war and who votes for peace, who does not know it?"

Carl Oglesby, 1964[91]

January 1966 marked the end of the first year of President Johnson's war in Vietnam. At Christmas, the president called for a thirty-hour truce, stopped the bombing of North Vietnam, and offered a peace proposal to Ho Chi Minh and the North Vietnamese. We didn't know it at the time but this was really a cynical rouse played on the American people. Secretary of State Dean Rusk cabled US Ambassador Henry Cabot Lodge in Saigon explaining the real reason for the cease-fire:

> The prospect of large-scale reinforcements in men and defense budget increases for the next eighteen-month period requires solid preparation of the American public. A crucial element will be a clear demonstration that we have explored fully every alternative but that the aggressor has left us no choice.[92]

Ho Chi Minh denounced the cease-fire as a "trick" and refused to negotiate. After the thirty hours were up, American forces resumed the fighting in the South, including heavy bombing, but the bombing halt in the North continued until the end of January. Meanwhile the US military was building up its forces in South Vietnam in preparation for expanding the war.[93] The whole concept of a Christmas bombing halt appalled me. America claimed to be a Christian nation. Stopping the bombing for a few days in the name of Jesus before returning to the killing of innocent civilians in the

name of anti-communism was the height of hypocrisy. From what I'd been taught, Jesus would have been with us trying to stop the war, not in a B-52 dropping bombs from over 50,000 feet.[94]

By the spring of 1966 any illusions we had about ending the war quickly had been shattered. Week by week and month by month, President Johnson and his advisors escalated the brutal war. While the bombing of North Vietnam was destructive, what the US military was doing in South Vietnam was horrendous. Soon after the US military arrived in early 1965, Bernard Fall, a French military historian, commented:

> What changed the character of the Vietnam war was *not* the decision to bomb North Vietnam; *not* the decision to use American ground troops in South Vietnam; but the decision to wage unlimited aerial warfare inside the country at the price of literally pounding the place to bits.

Because the National Liberation Front lived "in the sea of the people," US strategy was to dry up the sea with bombs and Napalm. Between 1965 and 1967 the US dropped a million tons of bombs on South Vietnam, twice as much as it dropped on the North. American B-52s bombed parts of the Mekong Delta where the population density was 1,000 people per square mile. By mid-1966 a million peasants had fled to the cities or to refugee camps. [95]

The foreign press carried more detailed reports about American atrocities than the American press. There were pictures of Napalm victims, stories about the torture of prisoners, eye witness accounts of the destruction of whole villages, and reports of massacres of civilians. The International Red Cross complained that American soldiers supervised the torture of prisoners or, increasingly, did it themselves. An American language paper in Saigon ran a glowing report of a battle with a photograph of a large pile of bodies labeled "Viet Cong dead." A close look at the photo showed men, women, and children with their hands tied behind their backs.[96]

Anticipating other guerrilla wars in places like Central and South America, the US military was testing weapons and techniques in a living laboratory.[97] Operation Ranch Hand, approved by the Kennedy White House in 1962, used herbicides to destroy fields of rice, sweet potatoes, bananas, and tapioca plants to deny food to the enemy. Some of these herbicides contained dangerous amounts of arsenic that remained in the soil. The *New York Times* reported that by 1966, chemicals had destroyed 130,000 acres of farmland. In an attempt "to deny cover to the enemy," millions of acres of rain forest and mangrove swamp were poisoned by aerial spraying using

Agent Orange, a powerful chemical defoliant. By 1967, 3.8 million acres of arable land had been defoliated and poisoned.

The weapons being used in South Vietnam to kill the Viet Cong were devastating to the rural peasant population. Napalm, a highly flammable gelled plastic/petroleum product dropped as a bomb, was technically defined as a defoliant – but it was dropped on populated villages, resulting in huge fireballs. The burning liquid stuck to everything it hit – killing or causing burns that looked as if the flesh had melted.

end the war in Vietnam

students for a democratic society

SDS antiwar poster by Judy Binder

The US was also using chemical warfare in direct violation of the Geneva Protocols of 1925. "Non-lethal" gas, such as tear gas and pepper gas, was sprayed on entire villages. Since these gases are

heavier than air, they went down into the tunnels that the villagers used to protect themselves from bombs, suffocating the villagers, especially old people and children. Whole villages were burned to the ground, all suspected Viet Cong executed on the spot, and the remaining people forcibly moved to relocation camps.[98]

The official US position was that all of its targets in North Vietnam were of military significance, but eyewitness reports contradicted that. Observers on the ground reported that schools, hospitals, leper colonies, and other civilian facilities were routine targets, and that the civilian population was being deliberately targeted. We learned from SDS members who visited North Vietnam that the US was dropping cluster bombs – large bombs containing hundreds of smaller fragmentation bombs. The large bomb exploded scattering the smaller bombs over a large area. When the smaller fragmentation bombs exploded they threw small steel pellets in all directions, indiscriminately wounding or killing any living thing within range – soldiers, women, children, old people, or cattle. The pellets were meant to wound because a wounded person requires someone to care for them and so further reduces the number of people available to fight. These bombs were often dropped with time-delayed fuses so that the pellet bombs exploded after people had come out of their air-raid shelters. The military justified the use of these weapons on the grounds that they reduced the enemy's desire to continue the war by demoralizing the people.[99] It is estimated that one of every ten Vietnamese civilians was killed or wounded during the war. The attacks on the civilian population were part of US military policy. General Westmoreland commented on the civilian casualties by saying, "It does deprive the enemy of the population, doesn't it?"[100]

All this information was coming to us at the same time that the government was saying that it was saving South Vietnam and the Vietnamese from destruction by the communists. It was – and is – hard to imagine that the communists could have been more destructive than the US military. US government denials of the targeting of the civilian population appeared alongside articles that proved that they were lying. The government's reaction to being exposed was to accuse the press and the antiwar movement of being unpatriotic. To those of us raised in the aftermath of World War II, and the war crimes trials that followed for Nazis accused of genocide, the war in Vietnam seemed remarkably similar. We knew what our government was doing and we were determined not to be

like the "good Germans" who blindly followed their government and did nothing to stop the Nazis.

The Banned *Texas Ranger* Cover

Many university administrators believed that they had the right to control what students said and did, on and off campus, and we challenged them on constitutional grounds. Administrators at the University of Texas censored a caricature of President Johnson that appeared on the cover of *The Texas Ranger*, a student magazine published by the university. Dean Holland of the Board of Directors

of Texas Student Publications said that it put the president in a "ridiculous situation" and another board member went so far as to say, "after all, this is the President's University."

The editorial staff of the student paper, the *Daily Texan*, was too intimidated to do anything, but just to make sure, the board ordered that there be no editorial criticism of the Board of Regents. In the controversy that followed the staff members of the *Daily Texan* caved in and refused to stand up for freedom of the press and autonomy in their editorials. SDS protested this blatant interference with the freedom of the press, but since the students running the paper wouldn't take a stand, the protest just simmered beneath the surface.

As the number of SDS chapters in our region grew, we decided to hold a regional conference in Austin to get everyone together. There were now chapters in Houston, Dallas, Fort Worth, Denton, and Lubbock, Texas, as well as at Norman and Sweetwater, Oklahoma, and Albuquerque, New Mexico. These chapters were so far apart that it was easy to feel isolated, especially if the local chapter was under attack, as most were at one time or another. In April, some twenty people from chapters across the region came to Austin to talk about issues and just to have fun. The war in Vietnam had become the dominant issue everywhere and we shared ideas about ways to reach out to new people.

Terry Roberts, originally from New York, had recently arrived in Norman and he, Jody Bateman, and a number of other SDS members had energized the Norman chapter by setting up a booth with antiwar posters across from the military recruiters in the student union. Soon the hall filled with students arguing about the war and then some of the pro-war students attacked Terry and Jody and beat them in front of the campus cop, who just stood and watched. This polarized the campus because many people who supported the war also supported the right of antiwar people to speak out against it. The result was that students who had simply been observers before now became activists and some of them joined SDS. Members from the other chapters told similar stories about confrontations with both students and university officials when they spoke out against the war. Although it was sometimes dangerous, they were all committed to using their freedom of speech to speak out about important issues. At the end of the conference we all went to the LBJ Ranch for another vigil. As before, President Johnson didn't seem to notice.

As the war escalated, General Westmoreland requested a total of 459,000 men for Vietnam. In February 1966, to meet the increased need for manpower, the Selective Service System (SSS), under the direction of General Lewis Hershey, extended the military draft to include university students in the lower academic levels of their classes. Under the new system, a student's eligibility for induction depended on how well he was doing academically and on his scores on a national draft exam to be given later in the spring. This meant that the universities, by providing information to the Selective Service, would be aiding the war effort. This new extension of the draft forced young men in the universities to look at what was going on in Vietnam because they were now faced with the real possibility that they might be drafted and sent there.

All draft age students had to take the national draft exam at specified local centers across the country – all on the same day. Seeing an opportunity, SDS members, with assistance from Vietnam experts, created a counter-exam with questions and answers that would educate students about the war. The SDS national office printed 500,000 of these counter-exams and SDS members across the country passed them out to students on exam day. Several questions and answers were:

> **Q**. Who said: "I would like to see American students develop as much fanaticism about the US political system as young Nazis did about their system during the war."
>
> **The answer**: President Lyndon B. Johnson.
>
> **Q**. Who said: "The Communists are closer to the people's yearning for social justice and an independent life than [my] own government."
>
> **The answer**: Premier (of South Vietnam) Nguyen Cao Ky
>
> **Q**. Which of the following American military heroes has, in the past, warned against committing a large number of American troops to a land war on the Asian mainland?
>
> (A) Gen. Douglas MacArthur
> (B) Pres. Dwight D. Eisenhower
> (C) Gen. Matthew B. Ridgeway
> (D) Gen. Maxwell Taylor
> (E) Gen. James Gavin
> (F) Gen. Omar Bradley
>
> **The answer**: All of these people had made such warnings.

Mike Davis, one of the organizers of the anti-apartheid demonstration at the Chase Manhattan Bank the previous year, came to Austin during the spring, and he and I went to the official exam site to pass out the counter-exams. Most students were in a hurry and took them to look at later, but some stopped to talk for a few minutes. Those who stopped were genuinely concerned about the possibility of being drafted and sent to Vietnam to fight a war they knew little about. They wondered why they were considered to be old enough to go to war when they weren't old enough to drink alcoholic beverages in Texas or to vote for people who might change the policy. We encouraged them to come to the next SDS meeting to find out more about the war and the draft – and what they could do about it.

While there was still a lot of hostility toward the antiwar movement, the number of people coming to SDS meetings and to antiwar demonstrations was increasing. Students were upset that the universities were cooperating with Selective Service and there were protests against university complicity with the military at a number of schools including Harvard, Wisconsin, Cornell, and the University of Chicago, where 400 students sat in for five days.

While the war was always on our minds, we also worked on other issues. The issue of free speech was always just below the surface at the University of Texas. The administration and the Board of Regents tried to control or suppress any student activities that they considered too controversial, such as the recent incident with the *Daily Texan*. But it wasn't long before the issue of censorship came up again. The Dean of Students had to approve any leaflets that were to be passed out on campus, and we usually went along with the rule even though we didn't like it. Since the campus was public property, we considered having to request permission to be a violation of our right to free speech. During the spring of 1966, a group of students formed the Texas Student League for Responsible Sexual Freedom to lobby the state legislature for an amendment to the Texas sex laws. Texas, like many states at that time, had laws that made many sexual activities illegal. Homosexuality was illegal. Fornication, having sex without being married, was also illegal. Oral and anal sex were punishable crimes even if they took place in the privacy of a married couple's own bedroom. The League wanted to pass out a leaflet on campus outlining their goals and calling for support from the student body, but the Dean of Students refused to

approve the leaflet, saying it was in bad taste. The League passed out the leaflet anyway and was immediately banned from campus.

A Free Speech Movement grew quickly following the ban, and more unapproved literature calling for free speech was passed out with no reaction from the administration. SDS member Scott Pittman helped organize a panel discussion of administrators, professors, and students to get the issue out in the open, but three days before the forum Dean Holland backed out because the Board of Regents had decided to handle the issue themselves. Scott continued to press for a public hearing and was invited to go before the Board of Regents to give the position of the FSM. A large crowd of students gathered to hear the results of the meeting. The Board decided to uphold the banning of the League and to maintain the rule of approving literature before distribution. They knew as well as we did that it was already mid-May and too late for us to organize any action to challenge their power before the school year ended.

As summer approached Judy and I needed to earn money for the fall. While I was at the University of Colorado, I had worked two summers for the Smithsonian Institution on archeology digs. I had written to the archeologist, Bill, who I considered to be pretty liberal and also a friend, to see if Judy and I could work for the summer. He invited me to come to Wyoming to help excavate a site about fifteen miles east of Yellowstone Park, not far from Cody. He said, however, that he couldn't offer Judy a job because the Smithsonian didn't hire women for fieldwork. Since there would only be four people on the crew, I reasoned that if Bill couldn't hire Judy, he'd let her work for free. Judy and I talked it over and decided to go, hoping that she could get a summer job in Cody, a summer tourist town, if all else failed. When we got there, Bill absolutely refused to allow Judy to work at the site even as an unpaid volunteer. We got a small apartment in Cody and I drove back and forth to the site, while Judy looked for work. It didn't take long to figure out that there was no work in Cody, which left us in a bind. If we left we had no guarantee that we'd quickly find work elsewhere so we decided to set up a tent next to the Shoshone River, within walking distance of the archeological site, and lived there for the rest of the summer. The area is beautiful, but it soon got boring for Judy, who had nothing to do. For her, it was a long summer.

While we were in Wyoming, there was a qualitative shift in the nature of the black movement. In June, James Meredith, the first

black student admitted to the University of Mississippi, began walking across Mississippi in a "Walk Against Fear" to show that blacks could exercise their rights. Before he had gone very far, a shotgun blast put him in the hospital. A few days later a fragile coalition including SNCC's newly elected chairman Stokely Carmichael, Floyd McKissick of CORE, and Martin Luther King of the SCLC took up the march. There was tension within the black movement over the issue of black response to white violence, with both SNCC and CORE leaning toward black separatism and self-defense. Too many blacks had been jailed, beaten, and killed and the shooting of Meridith was the last straw.

As they marched toward Jackson, Stokely and other SNCC field secretaries discussed an organizing slogan they had used in Alabama – "black power for black people." When the march arrived in Greenwood, Stokely was arrested for defying a police order and jailed for six hours. After his release, he addressed the marchers, who were assembled in a church, and told them that he had been arrested twenty-seven times and was tired of white people having all the power. "What we are gonna start saying now is Black Power!" The crowd of mostly local black people shouted back, "Black Power! BLACK POWER!" These were the voices of people who were tired of being at the mercy of white power. This sentiment grew as the marchers were attacked several more times on their way to Jackson.[101]

SNCC knew that power was the name of the game. That was why they had been so heavily involved in voter registration. As long as whites held all the political offices they had the power to suppress the desires of blacks. But black power, like cultural radicalism, implied more than just political power – it encouraged blacks to change the way they saw the world and themselves. They needed to liberate themselves from white standards and to be proud of their own culture, of the way they looked, and of their history of resistance to white oppression.

Many of the marchers enthusiastically embraced black power, but King and other members of the established civil rights leadership greeted it with dismay. They knew that the slogan would worsen the growing white backlash by bringing to the surface the deep fear white people had of losing power. Later in the summer, when Martin Luther King went to Chicago to bring the civil rights movement to the North, the white backlash was very evident. When King led a march of 200 blacks into the all-white suburb of Cicero, it

took 700 police and 3,000 National Guard to protect him and his followers. Northern whites could be just as hateful and violent as Southerners.

Black power had many repercussions – one was that it changed the role of whites in the civil rights movement. Blacks needed to develop their own organization without having to rely on whites. As SNCC stated the problem,

> Blacks, in fact, feel intimidated by the presence of whites, because of their knowledge of the power that whites have over their lives. One white person can come into a meeting of black people and change the complexion of that meeting....
>
> The reason that whites must be excluded is not that one is anti-white, but because the effects that one is trying to achieve cannot succeed because whites have an intimidating effect....
>
> It must be offered that white people who desire change in this country should go where that problem (racism) is most manifest...into white communities.[102]

For these reasons SNCC voted to become an all black organization. Although the white organizers intellectually accepted this, it was still a very painful process for those whites who had risked their lives as part of the "beloved community" of "black and white together" standing up against segregation. The belief that SNCC could only develop local black leadership if it were a black organization was not new and many whites had already left the organization.[103] Black power and black pride made a lot of sense to me. I had read Malcolm X's writings and speeches as well as Frantz Fanon's *The Wretched of the Earth*. Both wrote about the need of the oppressed to stop looking at themselves through the eyes of the oppressor and to liberate themselves from the identity that had been imposed upon them. That transformation included taking pride in who they were, how they looked, and where they came from. But black separatism didn't mean isolation. In Austin, for example, SNCC and SDS had always worked closely together and continued to form coalitions around joint interests.

During the summer there were insurrections – the government called them riots – in 150 black neighborhoods across the country. These ranged from minor events to widespread looting, arson, and sniping in Newark and Detroit. In all, over 3000 people were arrested, 400 were injured, and seven were killed. Before the insurrections, J. Edgar Hoover of the FBI had predicted disturbances in eight or nine cities. Republicans and Democrats alike

blamed the riots on the "permissiveness" of the Great Society rather than on substandard housing, unemployment, bad schools overcrowding, and continuing discrimination. Although Congress favored investigating the insurrections, they had no idea how to handle them except through force. Maryland's Republican governor, Spiro Agnew, claimed the riots had been thoroughly planned beforehand by subversive conspirators. Former President Eisenhower called on Congress to pass legislation to "empower the FBI to move into the situation." Meanwhile, black nationalists were saying that the War on Poverty and civil rights reforms were proof of the elitism of liberal politicians. They demanded power, not paternalism, and saw liberal reforms as a way to buy people off without really confronting the racism so deeply ingrained in the culture.

To make matters worse for President Johnson, many black groups began to come out in opposition to the war in Vietnam, in part because it undercut domestic spending and because the draft came down so disproportionately on young blacks. Both SNCC and CORE were quite open in their principled opposition to the war and called for unilateral withdrawal of all US troops. In January 1966, SNCC issued a statement against the war that read in part:

> We believe the United States government has been deceptive in claims of concern for the freedom of the Vietnamese people, just as the government has been deceptive in claiming concern for the freedom of the colored people in...other countries...and the United States itself.
>
> We are in sympathy with and support the men in this country who are unwilling to respond to the military draft which would compel them to contribute their lives to US aggression in the name of "freedom" we find so false in this country....
>
> We therefore encourage those Americans who prefer to use their energy in building democratic forms within the country. We believe that work in the civil rights movement and with other human relations organizations is a valid alternative to the draft. We urge all Americans to seek this alternative, knowing full well that it may cost them their lives – as painfully as in Vietnam.[104]

Black radicals felt they had more in common with the world's colonial peoples than with the liberal reformers of the Great Society. The US had created an army that was disproportionately lower class and black to fight a white man's war against a non-white people and the war on poverty and racial injustice at home were part of the casualties.

On June 30, the American public learned that it wasn't only students who opposed the war in Vietnam. At Fort Hood in Killeen, Texas, three army recruits refused orders to go to Vietnam on the grounds that the war was illegal. On July 7, they were arrested and were later court-martialed and sentenced to two years in prison. We didn't know these soldiers, but it didn't surprise me that young men with antiwar feelings were being drafted and would show their antiwar feelings in the military by refusing orders or by going Absent Without Leave (AWOL).

On August 1, Charles Whitman, a UT student, went to the top of the University of Texas tower and began randomly shooting people on the campus and on the adjoining streets below. He shot 44 people, killing twelve, before a policeman killed him. One bullet hit Claire Wilson, a young SDS member in her last month of pregnancy, and killed the baby. Another shot killed the baby's father, Tom Campbell. SDS member Sandra Wilson (no relation to Claire) was wounded. Whitman was an ex-Marine who everyone described as quiet. He had been one of the counter-demonstrators at Roy's Lounge when we picketed there because it was segregated, and he may have had connections to the Minutemen, a right-wing paramilitary group. Why he decided to go up on the tower and shoot people was never explained. It reminded me of the senseless violence that was going on in Vietnam where unseen machines flying at 50,000 feet killed unsuspecting people below who were simply going about their business.

As the war continued and the government pulled more and more young people into it, we had an easier time organizing against the war. In Berkeley, California, Robert Scheer challenged the Democratic Party for a congressional seat on a strong antiwar ticket and won 45 percent of the vote, which was encouraging. On the other hand, opposition to us seemed to be everywhere. In Berkeley, the Vietnam Day Committee office was bombed. In Newark, the SDS office was broken into and ransacked. In Chicago, the police raided the JOIN apartment in September and arrested several people after the police planted and then found marijuana. The US Constitution makes arresting people for their political views illegal, so the Chicago police used drugs to stop political activity. Although the charges were eventually dropped, valuable time and money that could have been used for organizing were diverted into legal defense.

In August, Judy and I left Wyoming and drove down into western Colorado, across New Mexico, and back to Austin to get ready for the fall term. The summer had been hard on our relationship and I hoped that getting home would help that.

— 10 —

Political and Cultural Radicalism
Fall 1966

"Against the ruin of the world, there is only one defense – the creative act."

Kenneth Rexroth, 1957

"We have within our ranks Communists...socialists of all sorts, three or four kinds of anarchists,...social democrats, humanist liberals...libertarian laisez faire capitalists, and, of course, the articulate vanguard of the psychedelic liberation front".

Carl Davidson, SDS

By the fall of 1966 the movement was growing rapidly. In addition to returning students, many freshmen at UT had heard about the movement while in high school and when they got to the university they sought out our booth at registration. The first meeting of the academic year was exciting, partly because of the innovative proposals for ways to get our ideas out to new people and partly because there were now enough people to put them all into action. There was lively discussion of each proposed plan of action – not to see if they met some ideological standard, but to clarify ideas and to suggest ways to improve them.

Our goal was to find ways to break down the social barriers and stereotypes that separated us from the majority of students and from the people of Austin. One group wanted to form a speakers bureau to seek out groups and organizations that would like to have an SDS person come to explain our position on the war, the draft, racism, or university issues. As we set this up we were thinking especially of the fraternities. They had been among our most vocal opposition, but we expected that to change as they were forced to face the fact that they might be drafted and sent to Vietnam.

The university allowed the military, the CIA, and manufacturers of war materials, such as Dow Chemical, to come onto the campus to recruit students to work for them.[105] We thought that our views

should be represented too, so we established the "General Booth Committee" to keep track of these recruiters, and to be prepared to set up a table next to theirs.

Following SDS's antiwar demonstration in the spring of 1965 and its decision not to spend its resources on more national demonstrations, other organizations had been formed to coordinate large national demonstrations every fall and spring. We usually tried to coordinate our demonstrations with those happening elsewhere so we set up a permanent committee to plan the parade route, try to convince the city council to give us a parade permit, and to take care of all the other details. We began planning for the national demonstration to be held in October.

Finally, two proposals that had long-ranging consequences at the University of Texas and on other campuses as well were adopted. One was a proposal to establish an "underground" newspaper that would carry our point of view directly to the people. The other was the idea of "Gentle Thursday," a day dedicated to opening communications between SDS and other students. Jeff Shero argued that that the way to open people up to the political movement was to challenge their cultural and political assumptions and that the way to do that was through social interaction rather than political confrontation.

At the University of Texas we didn't make a fine distinction between politics and culture. Our experience in the South was that cultural assumptions led to political reality. For example, the assumption of white supremacy led to the reality of segregation. Integrating public facilities, getting the right to vote, and demanding equality on all levels were political actions that could only accomplish so much without a change of white consciousness.

Challenging the culture by questioning authority was what the growing "counter-culture" was about. The *Port Huron Statement* spoke directly to the issue by proclaiming the value of human beings and the importance of participating in the decisions that effect our lives. Paul Potter, at the 1965 March on Washington, spoke about the system that "creates faceless and terrible bureaucracies and makes those the place where people spend their lives and do their work, that consistently puts material values above human values." The prospect of being swallowed up by this materialist culture led many young people to follow Timothy Leary's advice to "Turn on, tune in, drop out." Drop out of what? Drop out of business as usual, out of hierarchy, power politics, racism, and war. In general, the counter-

culture was less concerned with political debate and more interested in putting participatory democracy into action. We wanted to create communities that valued cooperation and respect for all individuals. Gentle Thursday caught the imagination of the cultural radicals within Austin SDS.

THIS THURSDAY IS GENTLE THURSDAY THE CELEBRATION OF OUR BELIEF THAT THERE IS NOTHING WRONG WITH FUN • SO WE ARE ASKING THAT ON THIS PARTICULAR THURSDAY EVERBODY DO EXACTLY WHAT THEY WANT

on gentle thursday bring your dog to campus or a baby or a whole bunch of red balloons on gentle thursday hold a picnic in front of the West Mall Office Building or maybe read poetry to the picnickers and there will be musicians all around the campus leading merry bands of celebrants on gentle thursday you may bring your paintings to the "Y" and they will exhibit them on the sidewalks or maybe you would like to wade in a fountain or sit on one of the Mustangs you might even take flowers to your Math Professor on gentle thursday feel free to fly a kite on the main mall and at the very least wear brightly coloured clothing! P.S. Short rehearsal Wed. noon near Union

Flyer announcing the first Gentle Thursday.

Many students ate in the Student Union or on the patio and the informal boundaries that separated different social groups from one another were a good example of what we wanted to overcome. We, the counter-culture-politicos, had our own section of the Union and people who weren't "us" didn't sit there. The same was true of the fraternities and other groups. The Gentle Thursday committee decided to confront this separation by creating a day for people to have fun. It would all start with a picnic lunch outside on the grass and everyone was encouraged to eat lunch with strangers. After the picnic there would be poetry readings, balloons, and musicians scattered across the campus encouraging people to join in. We hoped to break down the "us and them" mentality on both sides – the "freaks" versus the "frat rats," the "straights" versus the "hippies," even the "hippies" versus the "politicos" in the movement itself. On Gentle Thursday people could step around the boundaries and get to know one another as people.

At noon on Thursday a large crowd gathered, waiting for someone to make the first move. Some of us invited people we didn't know to join us on the grass. Soon there were mixed groups eating, talking, and having such a good time together that many people lingered into the afternoon. This was the beginning of an important breakthrough that let us reach new people. Students who had been hostile a year before, but who were now facing the draft were questioning the war and were willing – and sometimes eager – to talk with us. Gentle Thursday was a success – and would be copied by other chapters.

The *Rag* was among the first underground papers in the country during the sixties. Participatory democracy was so basic to the Austin radical community that the running of the paper was set up as a collective. People had job descriptions, but they wanted to get away from traditional terminology and to redefine the roles. Instead of an editor there was a "funnel," Thorne Dreyer, and a "funnella," Carol Neiman. Other positions had names like the "copy cat," the "artsy crafters" and the "super shitworkers." George Vizard was in charge of getting the paper out to the people and was affectionately called the "sell out."

This structure was much like what we had attempted in the national office but with a major difference – the *Rag* was imbedded in a community that provided support and a place to relax and have fun. The staff made collective decisions and volunteers from the growing movement did much of the lay-out and paste-up in

preparation for printing. The collective was a combination of people with both political and counter-culture perspectives and the *Rag* was a highly imaginative paper with lots of graphics and articles about both local and national issues. Gilbert Shelton, a local artist, had been drawing comics of the Austin scene for some time and his adventures of the *Furry Freak Brothers* first graced the pages of the *Rag* before becoming an underground comic with nation-wide distribution.

George and Mariann Vizard selling the *Rag*.

In October, in coordination with the national protests, ten SDS women – Judy Schiffer Pardun, Alice Embree, Mariann Vizard, Sandra Wilson, Judy Binder Kendall, Julie Cadenhead, Trudy

Minkoff, Carol Nieman, Judy Fitzgerald, and Nancy Freudiger with her new baby – held a sit-in at the State Selective Service office in Austin. This action was a way for women to show that the draft was not just a men's issue, but that women were also affected when their husbands, brothers, boyfriends, or fathers were sent off to fight an immoral war.

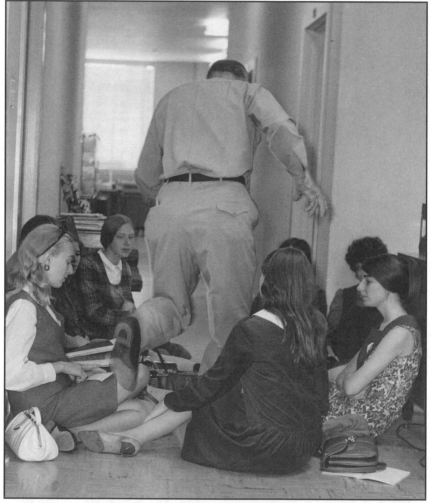

The draft board sit-in. Mariann Vizard on left, Carol Nieman in center, Alice Embree on right.

The sit-in was planned and carried out solely by the women involved and was among the earliest all-women's protests of the decade. The women went to the Selective Service office and announced that they planned to sit in until 3:30PM. The director

warned them that they might be subject to a five-year jail sentence and a $5,000 fine and they told him that they were quite aware of that. He reminded them that they were in the Texas State office of Selective Service and asked them to go across the hall to the Austin draft board. They politely declined the offer, and when he offered them the conference room as a place for their sit-in, they replied that they would rather block the hallway and sat down. For the rest of the day, the people working in the office did their best to get around them by either stepping over them or using an auxiliary entrance. The women stayed into the afternoon and left after presenting a statement to the director and the press. No one was arrested.

> We are women of the Austin area who wish to register out protest against the Selective Service System.... We represent no group, but are here as individual citizens....
>
> We feel that the Selective Service System is an affront to democracy and to the freedom of the individual. If a war is just men will fight, but if they as individuals feel that a war is unjust, they must have the right to refuse military service without fear of imprisonment or intimidation....
>
> We feel compassion for the families of the...American men who have been killed so far in Vietnam, and the unnumbered Vietnamese dead....
>
> We do not want our husbands, brothers, and sons turned into killing machines. We stand behind those decisions of the Nuremberg Trials which say that a man has a higher duty than that to his superiors. We believe that murder remains murder no matter how it is cloaked.
>
> We appeal to all the women...to join us in protesting, by whatever means they deem best, the entire concept of the Selective Service System until this system is stopped and our young men can begin to learn to follow their consciences rather than the consciences of uninvolved and unemotional men in Washington, DC or in Austin, Texas.

By the fall of 1966, there was a growing feeling of frustration in the antiwar movement. Opposition to what the Vietnamese called the "American War" was growing around the world, but the US government seemed not to care. In September, General DeGaulle of France, who had been in charge of the ten-year-long French war in Vietnam, visited Cambodia and called for the withdrawal of American troops from Vietnam. President Johnson, who called Vietnam a "little piss ant fourth rate country" couldn't understand how the Vietnamese could continue fighting against the largest, most powerful military in the world that was pounding Vietnam mercilessly. The US hit every possible industrial target in North

Vietnam. In the South, it was destroying the villages and the social infrastructure and poisoning the land and the water with chemicals. In 1967, General Earle Wheeler of the Joint Chiefs of Staff declared that there were no more "major military targets" left. Even with casualties running at sixty Vietnamese dead for every American killed, the Vietnamese continued to fight for their independence.[106] The bombing campaign was intended to demoralize the people but it was Secretary of Defense Robert McNamara, a key architect of the bombing campaign, who was becoming demoralized. In a memorandum to President Johnson in May 1967 McNamara wrote:

> There my be a limit beyond which many Americans and much of the world will not permit the United States to go. The picture of the world's greatest superpower killing or seriously injuring 1000 noncombatants a week, while trying to pound a tiny backward nation into submission on an issue whose merits are hotly disputed, is not a pretty one.[107]

The antiwar movement at state colleges and universities had been growing rapidly. Although this growth happened everywhere, much of it was in the great middle of the country – the heartland of America. The term "prairie power" was first applied to these chapters but came to represent a political/cultural point of view that they symbolized.

Many of the people who joined these chapters had come from culturally and politically conservative towns and cities where people avoided talking about politics, religion, or other controversial topics. Many came from working-class families, where the younger generation was now able to attend college. For many of these new activists, the movement was also about personal liberation and joining the movement meant challenging the culture and possibly breaking ties with family and friends at home. They put participatory democracy into action and challenged the social rules by rejecting them. Because they tended to support decentralized, non-hierarchical organization, they were often called anarchists.

During the summer, while Judy and I were in Wyoming, these "prairie power" people replaced the "old guard" in the leadership of SDS. In June, the National Council elected Jane Adams to replace Paul Booth as national secretary until the national convention at the end of the summer. Jane was from rural Illinois, had worked with SNCC in Mississippi in 1965, and had been organizing on campuses in the Iowa/Missouri/Kansas/Nebraska region. In August, at the National Convention in Clear Lake, Iowa, Nick Egleson from

Swarthmore College was elected president and Carl Davidson, from Penn State and the University of Nebraska, became vice president. Greg Calvert, a young professor from Iowa State, replaced Jane as national secretary. Of the fifteen National Council members, only two were students, reflecting the fact that many of the most active people in SDS had graduated or dropped out of school to work full time organizing against the war.

Although the vast majority of SDS members didn't attend SDS conventions or council meetings, the discussions at these meetings were important. They reflected the thinking on the local level and set the general direction of the organization while the chapters decided how to make it happen on the local level. At the summer convention, Carl Davidson presented a paper titled "A Student Syndicalist Movement: University Reform Revisited," which made the connection between the universities and corporate liberalism. Syndicalism was a concept of the Industrial Workers of the World (IWW), an American anarchist labor union at the turn of the century. Their strategy was to organize local unions, called syndicates, in all industries across the country and then to call "one big strike" when the workers would take ownership of industry for their own benefit. Carl extended this concept to students.

> What we have to see clearly is the relation between the university and corporate liberal society at large. Most of us are outraged when our university administrators or their "student government" lackeys liken our universities and colleges to corporations. We bitterly respond with talk about the "community of scholars." However, the fact of the matter is that they are correct. Our educational institutions *are* corporations and knowledge factories. What we have failed to see in the past is how absolutely *vital* these factories are to the corporate liberal state.
>
> What do these factories produce? What are their commodities? The most obvious answer is "knowledge." Our factories produce the know-how that enables the corporate state to expand, to grow, and to exploit more efficiently and extensively both in our own country and in the third world. But "knowledge" is perhaps too abstract to be seen as a commodity. Concretely, the commodities of our factories are the *knowledgeable*. AID officials, Peace Corpsmen, military officers, CIA officials, segregationist judges, corporation lawyers, politicians of all sorts, welfare workers, managers of industry, labor bureaucrats (I could go on and on) – where do they come from? They are products of the factories we live and work in...
>
> What would happen to a manipulative society if its means of creating manipulative people were done away with? We might then have a fighting chance to change the system!

> Obviously, we need to organize, to build a movement on the campuses with the primary purpose of radically transforming the university community. Too often we lose sight of this goal. To every program, every action, every position, and every demand, we must raise the question: How will this radically alter the lives of *every* student on the campus? With this in mind, I offer the following proposal for action.
>
> That every SDS chapter organize a student syndicalist movement on its campus. I use the term "syndicalist" for a crucial reason. In the labor struggle, the syndicalist unions worked for industrial democracy and workers' control, rather than better wages and working conditions. Likewise, and I cannot repeat this often enough, the issue for us is "student control" (along with a yet-to-be-liberated faculty in some areas). What we do not want is a "company union" student movement that sees itself as a body that, under the rubric of "liberalization," helps a paternal administration *make better rules for us*. What we do want is a union of students where the students themselves decide what kind of rules they want or don't want. Or whether they want rules at all. Only this kind of student organization allows for decentralization, and the direct participation of students in all those decisions daily affecting their lives.

Carl's paper was another step in the process of learning how the different institutions of the country were involved in maintaining the *status quo*. We were beginning to discover just how pervasive the tendrils of the war machine were and how deep the resistance to change was. *New Left Notes* reprinted an older SDS pamphlet by Jack Minnis entitled, "The Care and Feeding of Power Structures" that showed how to do research on the interconnections between institutions and individuals who were in positions of power. We began to discover that members of the boards of regents at many universities also sat on the boards of directors of major corporations with direct financial ties to the war. It seemed obvious that this would have some effect on how they dealt with the antiwar movement.

The CIA, the Department of Defense, the Army, and many other war-related government agencies had contracts with universities to do war related research. Investigation found that at least thirty-eight universities were involved in chemical and biological weapons research. Universities were big businesses with research and development grants playing a larger part in their operations than teaching students. Universities were not innocent by-standers in the debate over the war. They were in fact complicit in the war and we decided that they should be confronted as such.

At the University of Texas Balcones Research Center, where I was then employed part-time in the archeology laboratory, the

engineering department was doing research on how to drop jeeps and other military vehicles from the air without destroying them. I watched many times as they strapped a jeep to a thick, shock absorbing cardboard pad, lifted it a hundred feet off the ground, and then dropped it. I always cheered when the dust cleared and I could see that the wheels had bent outward from the impact. There were a dozen or so jeeps with broken axles parked around the testing area as they tried to develop a better shock absorber. The University of Texas also had an applied research laboratory where faculty members conducted military research. Entry to this area was restricted to people with the proper clearance.

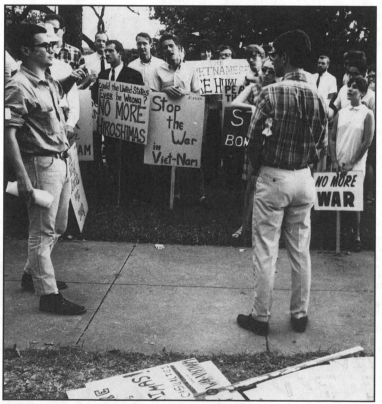

Jeff Shero rallying the troops before a demonstration.

Almost every campus had a Reserve Officers Training Corps (ROTC) program to train students to be officers in the Army when they graduated. ROTC usually had a building of its own and the University of Texas was no exception. We wanted to expose the ties between the university and the military so we picked the ROTC building as a symbolic place to demonstrate. A group of us went to

the ROTC buildings with signs but we weren't having much effect until Art Turog climbed up on a decommissioned military jet in front of the building with a sign saying, "The sole purpose of this machine is the destruction of human flesh." The university administration sent the campus police to tell us that we couldn't sit on government property and we argued that as government property it belonged to the people. We promised not to hurt the plane and the administration decided we weren't really doing any harm and let Art sit on the plane with his sign. Art was replaced by others, and someone was on the plane for most of the day.

SDS Pickets Plane; Asks ROTC Purpose

Students for a Democratic Society picketed the ROTC Building Monday, sitting astride the cockpit of the Air Force F-84F "Thunderstreak" outside "to jolt people into realizing the purpose of this machine."

Two members of SDS began picketing at 11 a.m. Monday. Gary Thiher, SDS chairman, said six pairs will rotate, keeping the vigil throughout the night until 11 a.m. Tuesday. When asked what would happen at that time, Thiher replied, "No comment."

CAMPUS POLICE told Thiher and Robert Carnal, the second pair of picketers to get down off the cockpit. The two, with their sign reading "The sole purpose of this machine is the destruction of human flesh," went with campus police to see Dean Edwin B. Price, director of student activities.

Dean Price told the Texan, "We are aware SDS has a sign. They feel it's accomplishing something to display it. But walking on the airplane is something else. The campus police told them to get off it. They were told to quit walking on government property."

The plane was donated to the University by the Air Force at the dedication of the ROTC Building a decade ago.

PICKETERS RESUMED their campaign, moving to the platform of the staircase climbing at the plane's side to the cockpit.

Squinting as the afternoon sun glared off the jet, Chief Allen R. Hamilton, head of the campus police, later addressed several pairs of bare SDS feet dangling from the platform. He told the students, "As long as you don't inflict any damage or prevent anyone from seeing the plane, you may continue."

THIHER SAID SDS decided Sunday night to picket the jet as a "symbol" of all military budgets, airplanes, ROTC programs for the purpose of destroying human flesh."

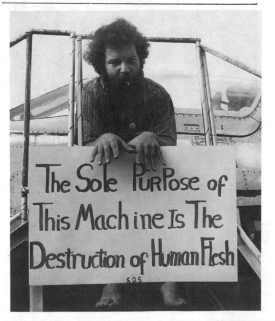

Art Turog at the anti-ROTC demonstration.

All of these activities were part of a re-evaluation of how best to oppose the war. As long as we considered the war in Vietnam to be an aberration of an otherwise freedom-loving, democratic system, we tried to stop it by appealing to the basic morality of those in power. We were learning, however, that those in power were making conscious calculated decisions to continue the war. Military officers and politicians were building their careers, the government was getting a realistic laboratory for testing new weapons and techniques, industries were profiting from weapons sales, and universities were getting lucrative research contracts. Paul Potter, at the spring March on Washington in 1965 had urged us to "name the system" and Carl Oglesby had called it "corporate liberalism" during the fall of that same year. Now, a year later, many of us were beginning to name the system capitalism or imperialism and to realize that the war in Vietnam wasn't an aberration but a result of a system that wanted to control the political economy of the world.

Simple protests were being ignored and we began to think about how to force the issue of the immorality of the war and what was really going on in Vietnam into the public debate. To accomplish this, chapters all over the country were considering new levels of militancy. Militant action should not be confused with violence. Sit-ins are more militant than quietly picketing. Making the Marine recruiter talk about the weapons being used in Vietnam and the issue of war crimes is more militant than setting up a booth with an opposing point of view. Militancy is confrontational and it can sometimes provoke violence, but it's usually the militant people who are attacked, either by the police or the opposition.

As we exposed the web of interconnections that supported the war in Vietnam it became apparent that America's problems ran very deep. Attempts at working within the system seemed increasingly futile. Electing a "peace" candidate in 1964 had given us President Johnson and military escalation. Even when we seemed to win within the system, the game was rigged. In Georgia, when Julian Bond from SNCC was elected as a State Representative, the Georgia State Legislature refused to seat him because he opposed the war in Vietnam.[108] The "system" began to appear so overwhelming that it was difficult to see any way to make real change other than to turn it upside down.

In our frustration and anger, we began to talk about revolution. From the national office, both Greg Calvert, the national secretary, and Carl Davidson, SDS's vice-president, talked about making

fundamentally revolutionary change in the society and many chapter members began to use the word freely. But while the word revolution became common, what it meant in practice was less clear. We had no plan to overthrow the government – we simply hoped that if enough people challenged our racist and imperialistic system it might crumble. We used the word revolution because it reflected our understanding of the depth of change that was needed. We wanted to change the system that caused the problems. We wanted more than a few civil rights reforms. We wanted economic and social equality, and an end to the culture of racism that bred inequality and discrimination. We didn't only want to end this war in Vietnam. We wanted to change the system that caused it. In 1965, Paul Potter had said, "What we must do is build a democratic and humane society in which Vietnams are unthinkable."[109] We now understood much better what he meant. As we tried to end the war in Vietnam, we were trying to set in motion a process that would also stop the seventh war from now.[110]

The debate at the December 1966 National Council meeting in Berkeley revolved around the nature of US involvement in Vietnam. The delegates agreed that the US was an imperialist country and was committing war crimes in Vietnam. Stopping the war was so urgent that encouraging illegal acts seemed justified. SDS adopted a draft resistance program that stated that all conscription was coercive and anti-democratic and that the draft was being used by the US government to oppress people in the US and around the world. It stated that SDS would organize to resist the draft, to end the draft, and to end the war.[111] It called for the organization of draft resistance unions to reach out to all men of draft age around the common principle that they would not allow themselves to be drafted. To accomplish this there would be direct action at draft boards and induction centers, direct action during induction physicals, and encouragement of men in the military to oppose the war. The national office was mandated to coordinate the local anti-draft unions and to provide staff, supplies, and funds.

Jeff Segal, who had been convicted of draft evasion and was now out on appeal, became SDS's national anti-draft coordinator and worked to establish and coordinate the draft resistance movement within SDS. SDS wasn't alone in this kind of activity. The Resistance, an organization of young men opposing the draft, was growing rapidly especially since several white ex-SNCC organizers had joined them. SDS's anti-draft program, which encouraged illegal

activity, reflected what many young men were already doing – burning their draft cards, going underground or to Canada instead of being inducted, and inventing ever more devious methods for being rejected at the induction physicals. In passing its anti-draft program, SDS nationally was catching up with what many of its members on the local level were already doing. But attacking the draft was important because it was an issue that affected almost all college-aged men and it was connected to other issues – the role of the university in the war and the racist nature of the war. Because it was illegal to either avoid the draft or help anyone else do so, the anti-draft movement radicalized people by putting them into direct conflict with federal law.

Members of Progressive Labor (PL), a small pro-Chinese split-off from the Communist Party, attended the December National Council meeting. A few had come to the August convention at Clear Lake as members of SDS and Greg Calvert had noted this with some concern. He questioned their motives for joining as individuals rather than coming as observers from PL as they had in the past. PL had been around for a while, but I knew little about it. I knew more about the May Second Movement (M2M), an organization they had established in hopes of building an antiwar movement under their influence. In 1965, M2M had circulated a strongly worded petition against the war that I had signed and sent to my draft board. M2M had remained small while SDS grew, and in early 1966 PL dissolved M2M and encouraged its members to join SDS.

The main concern of SDS members was that PL practiced "democratic centralism" which meant that once PL had reached a decision on an issue all PL members were bound to argue for that position in public debate no matter what their private position was. Since this applied to debate within SDS also, it meant that PL members all said the same thing and voted as a block, which gave them more power than was reflected by their small numbers. At the 1966 SDS national convention in Clear Lake there was discussion about restricting PL's voting rights because they didn't believe in democracy as defined in the SDS Constitution. Because SDS members were very sensitive about anti-communism, nobody wanted to invoke the exclusion clause in the SDS constitution so PL stayed. Most people considered them to be just another of the many small Marxist sects which hovered around SDS and didn't see them as a threat. In hindsight, we greatly underestimated the power of a

dedicated few to control the direction and substance of debate by practicing democratic centralism.

PL had submitted a proposal at the Clear Lake convention calling for an end to the draft and immediate unconditional withdrawal of US troops from Vietnam. They also advocated "student power" and called for students to begin to move toward self-determination on campus and to relate this to foreign policy and racism. The delegates at the convention debated the proposal, but came to no conclusions. Many people agreed with PL's ideas even if they didn't like PL's style. I had signed the M2M statement because it reflected my position that the US was acting as if it were an imperialist power. Immediate withdrawal made a lot of sense to those of us who thought that the US should never have gone there in the first place.

While all this was going on, Judy and I were breaking up. Mike Davis, Judy and I were all friends, but during the fall I became increasingly the odd man out. At Christmas we all drove to southern California because Mike was from the San Diego area and Judy's parents had recently moved to Los Angeles. I stayed with Mike at his parents' house in El Cajon while Judy stayed with her parents in LA. After Christmas, Judy and I returned to Texas, leaving Mike in California, but toward the end of January, Judy said she wanted to go to LA to live with her parents. I helped her pack, drove her to the San Antonio airport, and watched her fly out of my life. I was supposed to pack up her books and send them to her, but I gave them away when she moved in with Mike after a month or so. Bob Dylan's, "How does it feel to be on your own, with no direction home, like a complete unknown, like a rolling stone?" seemed to be written for me personally.

To Know and Do Nothing is Complicity
Spring 1967

"[The Vietnamese peasants] must see Americans as strange liberators....They watch as we poison their water, as we kill a million acres of their crops. They must weep as the bulldozers... destroy the precious trees. They wander into the hospitals, with at least twenty casualties from American firepower for one "Viet Cong"-inflicted injury....[America is the] greatest purveyor of violence in the world today."

Martin Luther King Speech on April 4, 1967

"Based on King's recent activities and public utterances, it is clear that he is an instrument in the hands of subversive forces seeking to undermine our nation."

J. Edgar Hoover's response to King's speech

In the spring of 1967, I was at a crossroads. What should I do next? My father warned me that I might not be able to get a job if I continued in my opposition to the war. He assured me that when I got older I would look back and realize that the movement wasn't as important as I thought it was now. Besides, I was twenty-six years old, too old to be in a student organization. It was time to be a serious adult and think about the future. I pondered his advice and considered going back to graduate school. I also thought about what was happening in Vietnam and the racism that was so pervasive here at home. I remembered the Germans who did what they were told during the holocaust. Could I later claim that I didn't know that my government was committing war crimes in Vietnam? I decided that continuing in graduate school was cooperating with the system and began to look for ways to immerse myself in the movement once more.

While television brought the brutality of the war into America's living rooms, information about the deliberate targeting of civilians wasn't heard on the evening news. Official government sources told the American people that the bombing of North and South Vietnam

was "surgical," that only targets of strategic military importance were being hit and all with minimal civilian casualties. The government got away with lying about the war because people didn't question what they were told, even when the government demanded that they send their sons off to war. There were cracks in this wall of deception, however. Harrison Salisbury, writing for the *New York Times* on December 25, 1966, reported that US bombs were falling on schools full of children, hospitals full of the wounded, and villages full of peasant farmers. The State Department loudly denied these reports and planted stories in other papers implying that Salisbury was getting his information from communist propaganda. But three weeks later the Associated Press reported that aerial photos had confirmed Salisbury's reports.[112] Incidents like this just confirmed my belief that the government would go to any lengths to hide what it was really doing in Vietnam – and that I was doing the right thing in trying to stop them.

In January, Secretary of State Dean Rusk, one of the foremost architects and representatives of the government's policy in Vietnam, came to Austin to speak to the Texas legislature. We immediately planned to confront him and printed a "wanted" poster, which we put up all over town. There was heated debate within the SDS chapter about the design of this poster. Some people argued that the war was far too serious for a poster with psychedelic lettering and ridiculous accusations. Others, including me, argued that it was easier to reach alienated young people with humor, sarcasm, and ridicule than through academic debate. If we could take away Rusk's legitimacy and convince people that he really was a "Boob" then the legitimacy of what he said would be suspect also.

When Rusk arrived, the police cordoned off the capitol building to keep us away. While several hundred of us picketed outside, Mariann Vizard and Mary Mantle slipped in through a side door and started handing out leaflets. Capitol security guards caught them and pushed them out the door. George Vizard went to their aid and was arrested for assaulting a police officer. The demonstration continued into the evening when 200 students chanting antiwar slogans forced Rusk to cancel his scheduled dinner at the University of Texas Alumni Center. As was typical of the government spokesmen sent to close the "credibility gap," Rusk hadn't come to speak to the young people who would do the dying in Vietnam. He came to talk with the legislators and the Board of Regents who supported the war and opposed the antiwar movement. Rusk's reception in Austin was

typical of the greeting that members of the Johnson administration received when they traveled around the country. To avoid this confrontation by protesters they often traveled from military base to military base and spoke only in "safe" settings.

Psychedelic poster of Secretary of State Dean Rusk.

Our activities were slowly making inroads in the Austin community. Twenty percent of the UT faculty signed a petition urging President Johnson to stop the bombing of North Vietnam. Gentle Thursday had successfully opened doors and the SDS speakers' bureau was getting invitations from different campus organizations that wanted someone to come and talk about the war. Alice Embree and I went to several fraternities and spoke at

meetings of between ten and twenty young men who were facing the possibility of being drafted. The fraternities had been among our most vocal opponents, but now they too had questions about the draft and about what was really happening in Vietnam. I enjoyed meetings like this because it was an opportunity to talk with people who weren't in the SDS community. They told us how we were seen from outside and we learned ways to reach more new people. It was fun having a good discussion about the war and other issues with people who had been hostile a year before.

The SDS national office was trying to coordinate regional draft resistance activity and needed regional organizers. Since I was available, I called the office in January about traveling in the Texas-Oklahoma region. Greg Calvert, the national secretary, asked me to come to Chicago to discuss what was needed. Bill Hartzog, the Kansas organizer, was also going and I arranged to meet him and Carl Davidson, the SDS vice president, in Columbia, Missouri.

On our way to Chicago, we ran into a severe snowstorm. The snow was over a foot deep and we were driving slowly when suddenly out of the snow a hitchhiker appeared next to the road. He was completely bundled up in a heavy coat with a hood pulled over his head and a scarf to protect his face. Although the car was already crowded, we were afraid he'd freeze to death if he stayed there, so we pulled over and made room for him. As he got into the back seat, we asked where he was going. He pulled back his hood, took the scarf off his face, and answered, "To the national office, just like you!" It was Chas Bauman, an SDS regional organizer! We all had a good laugh – the only people crazy enough to be on the road in a blizzard were SDS members.

I spent a few days in the national office, which had moved from the south-side ghetto to the edge of the west-side ghetto on West Madison Street. The office was on the second floor of a seedy building owned by John Rossen, an old radical who liked SDS and rented to us at a good price. Greg Calvert, Carl Davidson, and I talking about organizing anti-draft unions as a way to get young men involved in collective resistance to the draft and to the war. Individual resistance was too easy for the government to ignore, as the selective service picked people off one at a time, but young men who joined together to help and support one another were more visible and had more impact.

I returned to Austin as one of SDS's eight full-time anti-draft coordinators and began traveling around the region talking about

collective resistance. As was the case with almost all organizers, I was responsible for providing for my own expenses as much as possible. The movement was expanding rapidly and SDS was just one organization in a broad spectrum of antiwar activity in Texas. Much of what I did was building channels of communication between existing groups. On one of my journeys, I stopped in Lubbock to encourage the people in the SDS chapter at Texas Tech. The chapter I organized in 1964 had fallen apart almost immediately when several of its members transferred to Austin, but now there were enough people against the war in Lubbock to create a sustainable community. Texas Tech was like many other schools where forming an SDS chapter had been difficult or impossible only a year or so before. Consciousness was changing among young people across the nation and new chapters were springing up in places like Sweetwater, Oklahoma and Pueblo, Colorado.

Dodging the draft was high risk gambling and draft counselors had their hands full as people came for advice. There were a number of legal options, but these were limited. Requesting Conscientious Objector status stalled the process, but the vast majority of cases were rejected. Joining the National Guard was another alternative, but there were a limited number of openings and you often had to know someone with political pull to get in. Besides, the Guard was being used to put down rebellions in the black ghettos and few of us wanted to do that. For most young men, getting out of the draft came down to failing the physical examination or being declared psychologically unfit. Some people in Austin got out by failing the hearing test or the vision test using a method discovered by an innovative draft counselor. Failing on psychological grounds was difficult and the rules changed constantly. The military rejected me for smoking marijuana in 1965, but by 1966 that was no longer sufficient. Some people took LSD during their physical exam and were rejected, but people who tried this later were held by the military until the LSD wore off and then re-tested. Being gay was an immediate out, but homosexuality was illegal and nobody trusted the Selective Service System to keep that information confidential. Fleeing to Canada was a possibility but getting refugee status was difficult as Canada tightened up the border under pressure from the US government. Another option was to "go underground" but that meant breaking ties with family and friends, creating a new identity, and moving somewhere to start over.

Although getting out of the draft was serious, sometimes it was the light-hearted solution that worked. Mark Kleiman, a high school student who had been expelled from several schools because of his antiwar activity, wrote an article for the SDS newspaper, *New Left Notes,* on how to harass the Selective Service System. In his research, Mark had found that federal law required potential draftees to keep their local draft board informed of all changes of address and other changes in draft status. The law also required draft boards to keep *original* copies of everything sent to them by potential draftees. Mark suggested that young men obey the letter of the law. He suggested sending the draft board copies of the phone books from every town you pass through with a personal note about your whereabouts. Of course the local board should know about your antiwar feelings, so it made sense to send whole newspapers with pertinent articles circled or an antiwar leaflet glued to a brick. There are many references to peace in the Bible, so send a copy of the Gideon Bible (free in every motel room in the country) with appropriate passages underlined. Better yet, send a different Bible for each verse. Of course, if the board didn't keep what was sent by a potential draftee and the person was inducted, that constituted legal grounds to take the Selective Service System to court. While this all seemed very light hearted, members of the draft board saw people who did this kind of thing as troublemakers and sometimes decided not to draft them so they wouldn't disrupt the military.

As a regional anti-draft organizer, I traveled from campus to campus putting local draft counselors in touch with one another and passing along ideas that I picked up along the way. There were a few draft resistance unions whose members supported one another as they took on their local draft boards and I helped build communication networks to keep people from feeling isolated. I was in contact with local chapters, other regional organizers, and with the national office. Things were very different now than they were in 1964-65 when I first worked as a campus traveler and had to look for people who might be interested in SDS. Now the movement was spreading everywhere and SDS chapters were growing as part of an expanding "movement" community.

I noted that as chapters grew, they were able to take on more projects at once and that the committees that formed to plan and see a project through quite often took on lives of their own. In Austin, for example, the speakers' bureau, the Gentle Thursday committee, and the *Rag* all came out of SDS but they were independent of each

other although they had overlapping memberships. The result was that local chapters were decentralizing into coalitions of independent committees in a larger community that was growing rapidly.

The national structure of SDS was also changing as SDS members dropped out of school and became full-time regional organizers. The concept of regions had been in SDS since 1964, when I became a regional traveler. A year later, regional offices with staffs and regional organizers had opened in New York, San Francisco, and LA. Now people were organizing regional meetings and talking about forming regional offices across the country. There was an ongoing conversation among the regional travelers and Greg Calvert and Carl Davidson about how strong regional organization could be the basis for a more democratic structure for national SDS. Local chapter people were more likely to come to regional meetings to clarify issues before sending regional representatives to the National Council Meeting. This was all in the future but as SDS grew the National Council meetings were getting too large to function. Regional offices might be a way of creating a more democratic and unified national organization.

In January, Greg wrote an article for *New Left Notes* about the anti-draft resolution that had been passed at the National Council meeting in Berkeley. In it he talked about going "from protest to resistance," a slogan that reflected a basic change already in progress within SDS. He wrote:

> That program does not talk about politics or the taking of power. It does not talk about the new society or the democratization of decision-making. It talks about "resistance."…it talks about the kind of struggle which has been most meaningful to the New Left–the revolutionary struggle which engages and claims the lives of those involved despite the seeming impossibility of revolutionary social change.…It offers no clear path to power, no magic formula for success, only struggle and a new life.… At its present stage of development, SDS cannot be understood in terms of traditional political organization. Neither ideological clarity (as political analysis) nor organizational stability are fundamentally important to SDSers. What counts is that which creates *movement*. What counts is that SDS be where the action is. What counts is that SDS be involved in the creation of a cutting-edge in the freedom struggle.[113]

Greg stressed that revolutionary movement came out of personal oppression. It was a way to change our own lives and not just a way to help other people. In February, Greg spoke at Princeton University about the "Guatemalan guerrilla style of organizing" in

which he described using your own personal experience as a way to move others. He said:

> [W]hen the Guatemala guerrillas enter a new village, they do not talk about the "anti-imperialist struggle" nor do they give lessons on dialectical materialism....What they do is gather together the people of the village...and then, one by one, the guerrillas rise and talk to the villagers about their own lives: about how they see themselves and how they came to be who they are,...about the way in which their deepest longings were frustrated by the society in which they lived.
>
> Then the guerrillas encourage the villagers to talk about their lives. And then a marvelous thing begins to happen. People who thought that their deepest problems and frustrations were their individual problems discover that their problems and longings are all the same—that no one man is different than the others. That, in Sartre's phrase, "In each man there is all of man." And, finally, that out of the discovery of their common humanity comes the decision that men must unite together in the struggle to destroy the conditions of their common oppression.
>
> There is one impulse, one dynamic, which can create and sustain an authentic revolutionary movement. The revolutionary struggle is always and always must be a struggle for freedom. No individual, no group, no class is genuinely engaged in revolutionary movement unless their struggle is a struggle for their own liberation....Revolutionary consciousness leads to the struggle for one's own freedom in unity with others who share the burden of oppression.[114]

This was probably the first time that an SDS national officer publicly talked about revolution. It is not that this topic was new to SDS, just that it was not part of the language of the national organization until then. SDS had always tried to put everything in common English and avoided the use of Marxist jargon. This began to change as we tried to understand how racism, the war in Vietnam, paternalism on campus, the draft, the Cold War, and poverty were all interconnected. While our government talked about freedom and democracy as the basis for foreign policy, the reality was that it was really about making the world free for American investment. The US government, using the CIA and the military, was supporting capitalism's need for markets. When we followed the money, it led to wealthy white men and a well-oiled system that funneled the tax money of the people into the pockets of the rich via military contracts with big industry. These interconnections of wealth and power were complex but taken together they described what Marx called the "ruling class." The main revolutionary critique of capitalism came from Karl Marx and throughout the spring the language of articles in *New Left Notes* began to include words like

"revolution," "capitalism," "class struggle," "anti-imperialism," "internal contradictions," and "socialism." These words contain a lot of meaning for those who understand them. The problem was that most people on the chapter level didn't.

Greg's ideas about personal oppression and the struggle for personal liberation made sense to me because I felt oppressed by the society that wanted to control my life. I knew that minorities and women were oppressed groups and I soon learned about another group that I hadn't thought much about.[115] A young woman I knew introduced me to a group of four or five young men she was sitting with in the student union. I soon discovered that they were all gay and that they were discussing the discrimination and harassment they experienced almost daily. This was the first time I had ever heard a discussion of homosexuality that was positive in its tone. Like most Americans, I was raised to believe that homosexuality was abnormal and something to fear. I thought back to the kid in my high school who was chased home every day by a gang of boys yelling, "queer," "faggot," "homo." In my daily life, however, I never wondered if any individual was gay or not. I remembered stopping off for a beer one evening in Boulder, Colorado, and getting into an interesting conversation with the guy on the next bar stool. When the bar closed, he asked if I wanted to continue the conversation at his place and I accepted. We talked a while longer and then he asked if I wanted to spend the night. There was an awkward moment while I realized that he was gay and he realized that I wasn't. Until then it hadn't crossed my mind that he might be gay. We both apologized for the misunderstanding and continued to talk for an hour or so before he took me home.

Being unaware of gay people meant that I was also oblivious to what it was like to be gay in a country where homosexuality was illegal, demonized, and openly reviled. As I listened to the stories these young men in Austin told, I learned that they lived with the fear of being attacked by the police or by other men who considered beating up queers to be a legal sport. The result of this fear was that in the 60s and earlier most homosexuals remained "in the closet," even within SDS. Because of this, we never learned about the oppression of gays in the same way we had learned from blacks and women about their oppression. SDS never confronted the issue of homosexuality because it was below the surface and was rarely discussed.[116]

I drove to Cambridge, Massachusetts, for the April National Council meeting. This was the first national meeting I had attended since the one Scott and I hitched to in the fall of 1965, and the change in the dynamics was notable. In 1965, the number of delegates was still small enough that there was time for everyone to have their voice heard. There were so many delegates at Cambridge that the debate on issues went on and on. Much of the discussion was about the draft and how to use that pivotal issue to reach young men in universities, factories, and the military. Part of the organizing process meant educating people about the issues that concerned us. Greg Calvert was concerned that the process of internal education needed to be a higher priority within SDS. He proposed that Teacher-Organizer (T-O) Institutes be set up in three or four cities during the summer to train new organizers who could then run similar programs locally.

This proposal passed and after the council meeting was over I returned to Chicago to help plan the Chicago institute. Jane Adams, who had preceded Greg as national secretary, was still in the national office and we hit it off right away. We both had connections to midwest farming traditions and both of us had been in Mississippi, although at different times and places. Jane was also interested in the T-O institute, so we talked with Greg and Carl Davidson and volunteered to run the one in Chicago. I returned to Austin to put things in order before moving to Chicago for the summer.

When I got back to Austin, the SDS chapter was in the midst of a campus election campaign. In early April, SDS and the *Rag* announced a radical slate of candidates for Student Assembly, including Gary Thiher for president, Alice Embree for vice-president, and Dick Reavis for an at-large position. Gary was a frequent writer for the *Rag* and had been involved in SDS since early 1964. He had first run for student body president in 1965. Alice was also one of the founding members of the Austin SDS chapter and had been in the women's draft board sit-in the previous fall. Dick had worked in the civil rights movement in Alabama before coming to Austin and joining SDS. The candidates' "Freedom Platform" challenged the paternalism of the university and called for a radical restructuring of the university. It called for the elimination of grades as a method for judging learning, an open door policy to non-degree-seeking students, a student Bill of Rights, and an end to university intrusion in student's private lives. We wanted military recruiters moved out of the hallways and into the employment office

like other corporate recruiters and an end to ROTC and all military research on campus. The platform demanded a minimum wage for all employees, the teaching of black history, and the disarming of the campus police.

At the same time the campaign was going on, SDS was organizing a celebration called Flipped-Out Week as an alternative to Roundup Week, the traditional spring fraternity and sorority celebration. While the Greeks planned numerous beer parties, we planned a Gentle Thursday, a rally where SNCC leader Stokely Carmichael would speak, and an antiwar march to the state capitol. There would also be a poetry festival, several band concerts, a parade, a "frenzied euphoric Gathering of Peace" followed by "an old fashioned picnic in the park on Soft Sunday." This was too much for the university administration. They said that Gentle Thursday was too ambiguous and that we couldn't advocate, "kissing, mellow yellow, en masse and 'all over campus.'" This kind of petty censorship made the administration look ridiculous and they eventually approved the week-long event. Dave Mahler, the general chairman of Flipped-Out Week and a *Rag* staff stalwart for years, summed up the concept for the press. "We want people not to be afraid to do things they have always been afraid to do: to be friendly, to talk to strangers, to sing, or to read poetry. Let's break down all the unwritten restrictions on people having fun."

Before the event Major K. R. Herbert of the Austin Police Criminal Investigation Division was quoted as saying, "I think I'll go to that gentle thing. It sounds real nice."[117] A day or so before Gentle Thursday, a university memo went out to all staff telling them how to deal with gentle people. It said:

> [I]f a group comes to your office, ask them what they want. If they say they want to be gentle, tell them to leave and report the incident as quickly as you can.[118]

Several thousand people came to Flipped-Out Week and everything went smoothly and peacefully as planned. Flipped-Out Week was Austin's part of the national Spring Mobilization against the War. We didn't try to count the number of people who joined us because there were many events over several days. During the same week over 300,000 people protested the war in Washington DC where sixty draft-age men burned their draft cards. There were 60,000 people in San Francisco and 200,000 people gathered in New York City, where 175 men burned their draft cards.

Immediately following Flipped-Out Week, Vice President Hubert Humphrey came to town to address a joint session of the Texas Legislature. His visit on Monday, April 23 wasn't announced until Thursday, April 19, so we rushed to organize a rally and demonstration. We printed up leaflets to alert people that Humphrey was coming and called for a rally on Sunday. We handed the leaflets out on campus without getting Dean Price's approval because that process would have taken several days, which we didn't have, and because this was a good time to confront the issue of administrative censorship.

On Saturday, Dean Price declared the leaflets illegal and announced that the rally "has not been and will not be approved." He made it clear that if we held the rally, SDS would loose its status as an approved campus organization. The Chancellor's office followed up with a statement that if we held the rally the organizers would be subject to disciplinary action. On Sunday, two hundred students gathered on campus to discuss the issue and to express their solidarity with SDS. On Monday, a hundred and fifty students demonstrated at the Capitol against Humphrey and the war while a smaller group of counter-demonstrators tried to stop us. When one of them grabbed a picket sign and hit Sandra Wilson with it, the police, who were standing next to Sandra, did nothing to stop the assault. George Vizard, seeing that the police were just standing there, said, "God damned cops" and stepped in to protect Sandra. Following the demonstration, the police drew up a warrant for George's arrest on "abusive language" charges, but they didn't immediately serve it. That same day the university withdrew SDS's status as an approved campus organization and initiated disciplinary proceedings against six students, including Gary Thiher, Alice Embree and Dick Reavis, the three SDS candidates for Student Assembly.

We didn't know it, but the state legislature had just passed a law that gave the university regents more police power. They also passed a resolution commending the regents "for their prompt action in denying the use of the campus and the facilities of the University of Texas to outside agitators whose sole purpose is to cause strife, dissension, and disobedience among the student body at the University of Texas at Austin and embarrassment to the government of the United States of America." One part of the law made it illegal to pick flowers on state campuses, apparently a blow against Gentle Thursday.

The disciplinary hearing for the six students accused of organizing an unauthorized rally was scheduled for 10 AM Thursday morning. People planned to gather at about 9:30 at the Chuckwagon cafeteria on campus and to go to the hearing as a group. Just before 9:30, several squad cars pulled up in front of the Student Union and members of the campus police and the Department of Public Safety came into the Chuckwagon. They found George Vizard and Chief Hamilton of the campus police read the warrant for his arrest on the abusive language charge from the Monday demonstration. George rolled out of his chair onto the floor. The police started to pick him up, but the supervisor ordered them to drag him. Two students jumped up, called the police "fascists", and were arrested. All three were dragged out on their backs receiving severe abrasions that required hospital treatment. The whole room went into chaos with the students following the police outside and yelling. As I tried to join the crowd, one of the campus cops grabbed me by the arm. I spun around, breaking his grip, and got away in time to see the prisoners loaded into the paddy wagon. Although I was a non-student, nothing ever came of my incident with the campus cop. The next day George's picture in handcuffs was on the front page of the Austin paper, his third arrest in two years.

Following the arrests, over 300 people went to the disciplinary hearings to demand that they be "tried" along with the six students who had been singled out. They all claimed equal responsibility for the unapproved rally, but the dean ruled that only the six students would be charged. Each would be tried individually for "failure to obey a rule stated in the General Information Catalogue." The rule stated that "All students are expected to show respect for properly constituted authority." That evening two hundred and fifty students and faculty gathered at College House, a large cooperative housing facility off-campus. Representatives of the Negro Association for Progress, the UT Veterans' Association, Young Democrats, and the Graduate Students' Association as well as SDS and other groups formed the University Freedom Movement.

The next day the Veterans' Association distributed unapproved leaflets and held an unauthorized rally on the main mall that drew five hundred people. Frank Erwin, Chairman of the Board of Regents, close friend of President Johnson, and the Texas representative on the Democratic Central Committee, blustered that the university didn't need 27,000 students, implying that there would be massive expulsions if this continued. The University Freedom

Movement demanded an end to obstruction of peaceful assembly and called for placing literature tables and leaflets under student control. Saying that the university didn't have the right to make rules violating students' constitutional rights, they demanded that the campus police be disarmed and that all charges against the students be dropped.

Ultimately all six students were found guilty and received one year probation. A faculty committee on discipline said that the six students showed a serious lack of respect for legitimate authority. However, they added that they thought that the student's actions, "though intentional," were "less in the spirit of defiance of authority than to assert their constitutional rights." The problem was that if we wanted to exercise our constitutional rights, we *had* to defy authority. It was those in authority who repeatedly told us that we had free speech but that we couldn't use it without applying for permission three days in advance! In the student elections, the radical slate was defeated but received between 20 and 30 percent of the vote. After the hearings and conviction of the six students, more people rallied to our side and demonstrations of several thousand students continued until the end of the school year.

Before I left Austin for Chicago, I went to see George and Mariann Vizard. George took me aside and told me about a strange incident that had happened at work a few days before. George had spent the day working with a young guy who claimed to be a member of the Minutemen, a right-wing paramilitary group. The guy told George that the Minutemen had a large cache of heavy weapons, including anti-tank weapons, hand grenades, automatic rifles, and ammunition stashed in caves outside of Austin. George told me that when the guy finished he said, "I really shouldn't be telling you this because if you were a Communist the Minutemen would have to kill you." George had reason to be concerned because he, Mariann, and a small group of others had joined the Communist Party the year before. George was a visible member of the W.E.B. DuBois Club, a Communist youth organization in Austin, and his name had been in the paper for having been arrested several times. George said several times that the whole situation seemed to be just casual conversation, but he wanted me to remember the incident.[119]

During the spring, George and Mariann had played matchmaker and introduced me to Marilyn Buck. Marilyn had grown up in Austin, where her father, Louis Buck, was an early civil rights activist. She had spent a year at the University of California in

Berkeley, but her father didn't like her political activism there and brought her back to Austin where he could keep an eye on her. Marilyn wanted to get away from Austin, so when I announced that I was moving to Chicago for the Teacher-Organizer Institute she decided to go with me to work in the national office. Marilyn spent most of the next year working in the national office. Though we were together for most of that time, I never considered it to be a long-term relationship.

In Vietnam, the spring of 1967 was a pivotal time. The US military was getting bogged down in an increasingly difficult war. On May 23, the CIA issued a report stating that, "Despite increasingly efficient 'search and destroy' operations the Vietnamese Communists have continued to expand their forces. It appears the Communists can continue to sustain their overall strength during the coming year." The Joint Chiefs of Staff had been pressing for heavier air attacks against North Vietnam and on May 20, they again urged heavier attacks by air, land, and sea. They thought that it might be necessary to invade North Vietnam, Laos and Cambodia and that the use of nuclear weapons should not be ruled out.[120] We didn't have this information at the time but we feared that the frustration of not being able to win the war might lead the military to use nuclear weapons.

Opposition to the war was spreading worldwide. Bertrand Russell from England and Jean Paul Sartre from France organized a War Crimes Tribunal that met in Sweden. Carl Oglesby, former SDS president, was one of the people invited to participate. At the tribunal, Vietnamese witnesses and US veterans accused the US of aggression against the Vietnamese people. They described war crimes including the bombing of civilian targets, the use of experimental weapons, the torture and mutilation of prisoners, and genocide involving forced labor, mass burial, and concentration camps. There was testimony about the "carpet bombing" of entire areas, the use of white phosphorus bombs and Napalm against villages, and the use of pellet bombs against civilians. We already knew much of this, because the information had been coming back through journalists stationed in Vietnam and from Vietnamese sources. Very little of the testimony given in Sweden ever made it into the American press, although it had a strong effect on European opinion. Carl shared his experiences at the tribunal with SDS through a long article in *New Left Notes*.[121]

At home, opposition to the war in the black community was growing. SNCC and CORE had already taken very strong antiwar positions. As the war escalated, the promises of President Johnson's "Great Society" and the "War on Poverty" evaporated because of lack of funds. At the time I remember hearing that the US spent $300,000 to kill one Viet Cong and $50 to bring one American out of poverty. Draft boards were typically made up of World War II or even World War I veterans who were white middle class businessmen. Blacks were drafted, ended up in combat, and were wounded or killed in higher proportion than whites. Across the nation as a whole, minorities and poor whites were drafted before white college students.

Martin Luther King had spoken out publicly for a halt in the bombing in 1965, but then backed off from making public statements against the war because he was afraid it would undermine his civil rights work. That changed when King spoke out forcefully against the war at the Riverside Church in New York on April 4, 1967:

> A few years ago…[i]t seemed as if there was a real promise of hope for the poor–both black and white–through the poverty program.…Then came the buildup in Vietnam and I watched the program broken and eviscerated.…the war was doing far more than devastating the hopes of the poor at home. It was sending their sons and their brothers and their husbands to fight and to die in extraordinarily high proportions relative to the rest of the population.…So we have been repeatedly faced with the cruel irony of watching Negro and white boys on TV screens as they kill and die together for a nation that has been unable to seat them together in the same schools.… I could not be silent in the face of such cruel manipulation of the poor.…
>
> I could never again raise my voice against the violence of the oppressed in the ghettos without having first spoken clearly to the greatest purveyor of violence in the world today–my own government.. For the sake of those boys, for the sake of this government, for the sake of hundreds of thousands trembling under our violence, I cannot be silent.…[N]o one who has any concern for the integrity and life of America today can ignore the present war. If America's soul becomes totally poisoned, part of the autopsy must read Vietnam.…
>
> [The Vietnamese] watch as we poison their water, as we kill a million acres of their crops. They must weep as the bulldozers roar through their areas preparing to destroy the precious trees. They wander into the hospitals, with at least twenty casualties from American firepower for one "Viet Cong"-inflicted injury. So far we may have killed a million of them--mostly children.…W]e test our latest weapons on them, just as the Germans tested out new medicine and new tortures in the concentration

camps of Europe....We have destroyed their two most cherished institutions: the family and the village. We have destroyed their land and their crops....

> We are at the moment when our lives must be placed on the line if our nation is to survive its own folly. Every man of humane convictions must decide on the protest that best suits his convictions, but we must all protest....These are revolutionary times. All over the globe men are revolting against old systems of exploitation and oppression and out of the wombs of a frail world new systems of justice and equality are being born....We in the West must support these revolutions. It is a sad fact that...the Western nations that initiated so much of the revolutionary spirit of the modern world have now become the arch anti-revolutionaries.

Dr. King's speech came under immediate attack by both the government and the press. A common theme was that by linking the civil rights movement and the antiwar movement, King was doing great harm to both. He was accused of being irresponsible and of falling under the influence of communists. J. Edgar Hoover sent a note to President Johnson saying, "Based on King's recent activities and public utterances, it is clear that he is an instrument in the hands of subversive forces seeking to undermine our nation."[122]

As the antiwar movement moved toward draft resistance and opposed recruiting for the war effort on campus, it came under increased surveillance by the government. By 1967, President Johnson was fully committed to discrediting the civil rights and antiwar movements. He was convinced that a small group of people was organizing all the riots around the country and asked the FBI to seek out the responsible people and organizations. The search was in vain because it was social conditions, and not individuals, that were causing the riots. As Carl Oglesby later said, "It's not the rebels who cause the troubles of the world, it's the troubles that cause the rebels." While the FBI was not yet mounting its own actions against us, it was keeping track of us and sometimes gave information to governors, state and local police and local pro-war groups. In San Diego, for example, the police supplied information on the antiwar movement to a violent right-wing paramilitary group and then looked the other way while that group attacked antiwar people and destroyed the property of antiwar groups.[123]

As we protested against the war and studied the nature of the capitalist system that caused it, we began to look for an analysis that described capitalism and many of us settled, somewhat uneasily, on

Marxism. Marxism defines the capitalist structure as consisting of three classes: the owners, who control the factories that manufacture goods; the workers, who sell their time to the owners and make the products; and the small owners, who work for themselves as small shop keepers or sell a professional skill, such as doctors or lawyers. Karl Marx asserted that the working class, because of its pivotal role in the production of goods, had the power to make fundamental social and economic change. We wanted to know where students fit into this analysis. During the time that Marx was writing, only a tiny minority went to college, but by the 1960s, the number of young people studying at universities had grown dramatically. Students didn't fit easily into any of Marx's categories. They weren't "workers" and thinking of them as "professionals" or "intellectuals" didn't fit either. Many of these new students were the sons and daughters of the industrial working class who wanted to escape the factories, with the blessing of their parents. Since SDS and much of the movement was made up of students, having some understanding of how they fit into the class system seemed important.

Toward the end of May, several papers were printed in *New Left Notes* analyzing America's socio-economic system from a Marxist perspective. Each attempted to define the role of students, but they came to different conclusions. The first article, "Toward a Theory of Social Change in America," was written by Bob Gottlieb, Gerry Tenney and Dave Gilbert from the New York regional office. Their paper, written in an apartment near the Port Authority terminal, became known as the *Port Authority Statement* as a joking reference to the founding document of SDS, the *Port Huron Statement*. The Port Authority group tried to bring Marxism up to date by applying Karl Marx's methods of analysis to the economic forces working in post-World War II America. They developed some important insights.[124]

The *Port Authority Statement* argued that the economic structure of America was changing as the large industrial factories of previous decades declined and automation replaced human labor with machinery and computers. They predicted a long period of economic growth, caused by government investment and automation, that would lead to a growing need for highly skilled college educated "workers." The same people who a decade previously would have gone directly from high school to a factory job were now going to college to learn the skills needed by the economy of the future. The authors called these new highly trained

people, ranging from teachers and welfare workers to technicians and engineers, the "new working class" to distinguish them from traditional blue-collar workers. The economic analysis of The *Port Authority Statement* meshed well with Carl Davidson's paper on student syndicalism and put the job of organizing students in a new light. After they left the universities these radicalized students could become the core of a larger "Movement for a Democratic Society" prepared to make alliances with other groups including blue-collar workers.

Members of Boston-area Progressive Labor wrote a long article that was printed in *New Left Notes* in May. In it they presented a traditional Marxist analysis of the US economy and argued that capitalism was facing a prolonged downturn caused in part by revolutions in the former colonies and partly by internal economic problems. As capitalism went into crisis the industrial working class would suffer and would organize to make fundamental change in the economy. They noted that the unions were mostly pro-war bureaucracies that didn't reflect the views of many in the working class. By supporting rank and file actions, students could help move workers in an antiwar, anti-racism direction. PL wrote off the "new working class" as being of little consequence. They argued that students were "middle class" and, therefore their main role was as helpers in working class struggles doing things such as supporting strikes, opposing anti-labor legislation, helping campus workers unionize, and taking other pro-worker action. To the rhetorical question "What should we do in this situation?" PL presented the reply, "To reach workers: Worker-Student Alliance."[125]

Another article by a group of PL and non-PL people began, "Where do we go from here?" and proposed a "Summer Work-in" during which students would take summer jobs as industrial workers. This program looked like the Worker-Student Alliance proposed in the first article but was signed by a dozen people, of whom only three were identified as Progressive Labor. The idea appealed to many students, who wanted to move out into the larger society and were looking for a way to do it. Many students took summer jobs anyway and this gave them a political reason to take industrial jobs.[126]

Having grown up in a working-class neighborhood, the idea of reaching out to workers sounded reasonable to me. In Austin, we had been helping the cafeteria workers at the university and local laundry workers as they attempted to organize. We had also been

organizing students, reaching out to GIs, and creating counter-institutions such as the weekly paper, the *Rag*. There were many things that students could be doing and I didn't want to restrict our actions to the ideas in the Worker-Student Alliance.

I thought that PL brought some good ideas into SDS, but their theory seemed more like dogma than analysis. On the cultural/political spectrum of the on-going rebellion, they were pure political with no culturally radical component that I could see. They were "straight" and rigid and had a stereotype that the working class was the same. They insisted that their members dress conservatively so that they wouldn't alienate the working class. They didn't seem to have noticed that many of the children of the working class, both in the universities and on the job site, were growing their hair long and smoking marijuana.

The real problem was that PL functioned very differently than SDS did. While SDS was open, inclusive, and encouraged participatory democracy, PL was a closed caucus whose members all agreed to support the positions that they had decided upon beforehand. SDS's usual approach was to come at a problem from many directions. We used participatory democracy to encourage freewheeling open debate, tried different hands-on methods to see what worked, and used what we learned to modify our approach. PL used their Marxist/Maoist theory to arrive at the "correct line" and then tried to get the SDS National Council to adopt their position on every issue. This conflict was growing and, while it didn't dominate National Council meetings yet, PL's role within SDS would become increasingly destructive. In the struggle for the heart and soul of SDS, openness and inclusiveness would be among the casualties.

— 12 —

Back in the national office
Summer 1967

"I do not see any end to the war in sight."

General Westmoreland April 24, 1967

I arrived in Chicago in June and stayed in the staff apartment near the national office. The block that the office was on separated the black ghetto a few blocks to the west from skid road that started a block to the east and ran toward downtown. Our block included a grocery store, a Woolworth's department store, a Spanish language theater, a pawnshop, a bar, and an all-night diner. There was also a church with a choir that filled the area with gospel music on Sunday mornings and during choir practice. A couple of prostitutes worked our block to supply their heroin habits and a few other junkies nodded out in the diner most evenings.

A few weeks after my arrival, we all went to Ann Arbor, Michigan, for the national convention. Between 250 and 300 people attended, of whom about 200 were voting delegates. SDS had been growing so rapidly that we could only estimate the number of people on campuses across the country who considered themselves to be SDS members. On most campuses there were often ten or more active SDS members who had not paid their dues for every member who had, and we estimated about 30,000 *de facto* members in some 250 chapters. As SDS grew locally, it also grew nationally. To meet the needs of a growing organization the national office had a dozen or so full time workers, and there were now regional offices in San Francisco, Los Angeles, New York City, and Boston. There were eight official regional travelers as well as many unofficial travelers bringing news from one chapter to the next.

As the delegates arrived at the convention, it was clear that the counter-culture was alive and well in many SDS chapters. Next to the small "sds" pin, people wore buttons with slogans like "Make Love Not War" and "Not With My Life You Don't." Many members of the new guard identified with the Industrial Workers of

the World and their concept of building "one big union" and then calling "one big strike" to usher in the revolution. They wore red IWW buttons. These "anarchists" saw the counter-culture and counter-institutions as the beginnings of an alternative society based on cooperation, participation, and sharing. Change would come as people joined this new culture and abandoned the existing society based on competition, greed, and rugged individualism.

SDS held its national meetings at different locations around the country, which inevitably meant they were a long way from most chapters. Chapter delegates were often chosen on the basis of who was willing and able to get to the site and since dedicated organizers, and many sectarians, were willing to travel any distance, both groups were disproportionately represented. Lots of new members, with no history of what had happened at previous meetings and little knowledge of SDS outside their own chapter, also attended when the meeting was reasonably close to them. The result was National Council meetings with their own dynamic separate from either the national office or the local chapters.

As usual, we debated how to end the war in Vietnam. We had learned a lot about the economic and ideological reasons for the war during the past two years. The delegates approved a statement that the war was "the logical result of a government that oppresses people in the US and throughout the world" as part of an "aggressive and imperialistic foreign policy." Proposals branding the US as imperialistic and encouraging collective draft resistance passed easily. Jeff Shero, from Texas, added an amendment supporting military personnel who wanted to go underground. Although such activity was illegal, the proposal passed as part of an anti-draft resolution. But a proposal for a national student strike in the spring of 1968, around the slogan "immediate withdrawal from Vietnam," met with strong opposition from these same delegates. They feared that the slogan would be too radical for many students. This contradiction was indicative of a growing problem within SDS. National Council delegates were willing to have SDS take stronger positions nationally than they were ready to act on locally. This created a national presence represented by the national office and the National Council that was much more radical than most SDS chapters.

Participants from a women's workshop presented a position paper calling for women to work for their own freedom because, "The struggle for liberation of women must be part of the larger

fight for human freedom." The paper advocated, "programs which will free women from their traditional roles in order that we may participate with all of our resources and energies in meaningful and creative activities." It urged men to "recognize that because they were brought up in the United States they cannot be free of the burden of male chauvinism" and challenged men to look at the cultural assumptions that made them feel superior to women. The paper, written in the rhetoric that was becoming common in SDS, said:

> As we analyze the position of women in capitalist society and especially in the United States we find that women are in a colonial relationship to men and we recognize ourselves as part of the third world....Women because of their colonial relationship to men have to fight for their own independence. This fight for our own independence will lead to the growth and development of the revolutionary movement in this country.[127]

The reaction of some men to this proposal showed how needed it was. Rather than taking it as a serious proposal, they hooted, yelled, and made fun of it as it was read. Rather than consider the spirit behind the proposal, some men attacked the use of the word "colonial" as applied to women. The women quickly made it clear that the paper was their statement about the existing gender roles and was being presented for approval, not for amendment.

I grew up in a family of strong women. My father's mother had run a retirement home with over a hundred residents and the women on my mother's side were necessary for the survival of the farms. My experience in Texas was that women played very important roles in organizing, both on the campuses and in the community. But it was obvious that women were treated differently from men, both in the society as a whole and within SDS. Judy's experience of not being allowed to work at the archeological dig in Wyoming was but one example. We had all been socialized to treat women differently from men and it was understandable that even men in SDS might not immediately see the problem. But our movement was about liberation from the old social norms, and if those norms were oppressive to women then it was clear to me that we needed to examine those assumptions seriously – and change them.

The convention also discussed recent events in the black community. Black Power had led to significant changes within the black movement and in SDS's relationship with it. SDS had always

had a close relationship with SNCC and continued to follow its development and that of the growing black liberation movement. When SNCC began organizing to take political control of Lowndes County, Alabama, they took as their symbol an angry black panther. In early 1967, Huey Newton and Bobby Seale took that symbol and started the Black Panther Party for Self-Defense in Oakland. They began organizing for "black liberation" using issues of police brutality, poverty, and the right of self-defense. The Panthers were fairly unknown until May 1967, when about twenty of them, all dressed in black leather jackets and black berets and armed with rifles and shotguns, marched into the capitol building in Sacramento to protest a bill that would restrict the people's right to carry loaded weapons. At the legislative hearing Bobby Seale read a statement about the people's right to self defense:

> [As] the aggression of the racist American government escalates in Vietnam, the police agencies of America escalate the repression of black people throughout the ghettos.... [T]he time has come for black people to arm themselves against this terror before it is too late.

Attacks on the black movement intensified during the spring of 1967. In May, 600 Houston police opened fire on students at Texas Southern University firing over 6,000 rounds of ammunition. A ricochet bullet killed one police officer and five local SNCC organizers were charged with murder. In New York, on June 20, sixteen members of the Revolutionary Action Movement, a black organization centered in the northern ghettos, were arrested and charged with conspiracy to assassinate moderate black leaders. In Los Angeles, PL organizer John Harris was arrested on "criminal anarchy" charges for advocating revolutionary socialism and PL organizer Bill Epton was indicted on the same charge in Harlem. On June 26, H. Rap Brown, chairman of the SNCC, was arrested for incitement to riot.

We were aware of these attacks and wanted to express our solidarity with the black movement. SDS passed a resolution at the convention reaffirming its commitment to working against racism and opposing government repression of "militant, radical, and revolutionary groups." In practice, this resolution meant that we would try to make information about these attacks public and that we would keep the membership up to date through articles in *New Left Notes*.

The convention also dealt with internal SDS issues. Greg Calvert and Carl Davidson had been writing about organizational problems

caused by the rapid growth of SDS and submitted a proposal to make the office more democratic and more functional. This change was very much in the spirit of the proposal that I had made to the National Council in late 1965. The duties of the president and vice president had always been unclear, and the national secretary had become the position of power. The new system would have the convention delegates elect three co-equal national secretaries and eight members of a National Interim Committee (NIC) that would also include the three officers. Each secretary would have specific duties and the NIC would meet monthly to make sure that the mandates of the National Council were carried out. The national secretary would be charged with running the national office, the internal education secretary would create educational materials for the field organizers and encourage education of the local membership, and the inter-organizational secretary would work with other organizations.

This proposal passed by the required two-thirds majority with almost no opposition and we moved on to deciding who these new officers would be. The convention delegates wanted balance in the office with more than one person making the decisions, and they didn't want people in those positions who would have too much power because of their personalities. This was reflected in the selection of national officers.

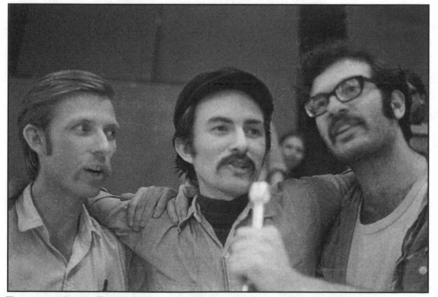

The new national officers: Robert Pardun, Carl Davidson, and Mike Spiegel.

Mike Spiegel, twenty years old, from Harvard was elected national secretary. Mike had spoken out forcefully in favor of the women's resolution and was also known from an incident at Harvard the previous fall. When Secretary of Defense McNamara came to talk to a select seminar of fifty students, the Harvard SDS chapter protested his presence and demanded that he debate US involvement with a spokesman for the antiwar movement. McNamara refused and went ahead with his scheduled class while nearly a thousand students gathered and waited for him to come out. As McNamara tried to sneak out the back door, Mike and several others spotted him and attempted to block his path. When bodyguards pushed McNamara through and into a waiting car, Mike sat down in front of the car, grabbed the front bumper, and held on tight until other students surrounded it. McNamara got out of the car, stood on top of it, and agreed to field questions. The students wanted to know why the US was supporting a military dictatorship, which it had helped set up, and why so many civilians were being killed. McNamara lost his cool and began shouting at the demonstrators that he was tougher then they were. Finally his bodyguards picked him up over their heads and carried him out of the crowd.

I was elected as internal educational secretary because I was an organizer from a strong chapter and also because I had helped pull together chapters in the Texas-Oklahoma region. I had spoken in favor of the organizational change because it made all three officers more accountable to the membership.

Finally, Carl Davidson was elected inter-organizational secretary. Liked and respected by the delegates because of his writings on student syndicalism and resistance, Carl was put in this position because he would add balance to Mike and me. Carl had already spent a year in the office and this position would limit him from having undue power in the internal workings of the organization, while using his skills to connect SDS with other organizations.

As soon as the convention ended, I returned to Chicago for the Teacher-Organizer Institute, aware that as a national officer I would have to split my time between the office and running the school. There were about a dozen people in the institute and although Jane Adams and I had planned a regular schedule every day, trying to get everyone in one place at one time proved nearly impossible. As we tried to force people into our schedule they rebelled, so we turned the direction of the school over to the students – their first

organizing project. They developed a loose structure that included working in the national office or with the Chicago Area Draft Resistors. Instead of regular meetings, the students called sessions around topics of their own choosing. This rebellion was probably the best thing that could have happened because it forced the new organizers to do the organizing, and it also freed me up. Even though we were no longer having regularly scheduled discussion sessions, we spent much of our time together in an on-going political conversation covering a large variety of topics and tying issues together.

Greg Calvert had put together a reading list for the institutes that was weighted heavily toward personal liberation and collective revolution. It including *The Wretched of the Earth* by Frantz Fanon, Wilhelm Reich's *The Mass Psychology of Fascism,* and Regis Debray's *Revolution in the Revolution?* These were read and discussed along with the history of ideas and movements from the past. Organizing was a social activity as well as a political one and learning about the issues and how to talk about them gave people the confidence to talk to other people, which is the essence of organizing.

Dee Jacobson, Greg's assistant national secretary from the year before, ran encounter sessions to help people talk about their own personal issues as a way of understanding the concept of liberation. At one of these sessions and after much soul searching, Guy Nassberg, told the group that he thought he was gay. Thirty years later he wrote, "I expected everyone to get up and walk out of the room in disgust. Nothing of the kind happened. Everyone just looked at me, nodded their heads, and said okay. I couldn't believe it. It was a revelation to me."[128] This was a turning point in his life and the next thing he had to deal with was his own internalized homophobia. Out of that internal struggle came the realization that he needed to fight for his own liberation.[129]

The Chicago T-O institute was more like a short-term intentional community than a school. The Beatles had just released *Sergeant Pepper's Lonely Hearts Club Band* and we must have listened to it a thousand times. We had decided that the school would be drug free because we knew that the Chicago Police were watching the office. If they decided to raid the T-O institute we wanted to be clean. There was a feeling of futility about this because we knew that if the police wanted to arrest us on drug charges they would probably bring the drugs themselves.

Three of these schools were planned for the summer, but the one in Los Angeles closed down early, leaving only our school in Chicago and one in Boston. Looking back, I feel that it was an interesting experiment but not very productive. The natural flow of opposition to the war on the campus created more organizers than the T-O schools did and in a more natural way.

On July 23, I received a phone call from Mariann Vizard in Austin. Her husband George had been murdered! The day before, he had spoken at a meeting of activists concerned about violence against the left. He had gone to work early in the morning at a convenience store and someone had taken him into the freezer and shot him several times. It didn't appear to be a robbery and there were no suspects. I immediately remembered George's urgency in telling me the story about the young Minuteman and the arms cache near Austin.[130] On July 24, I wrote an article for *New Left Notes*:

> [W]as it a political murder? At this point it is impossible to tell....The Klan and the Minutemen are very present in Austin. Texas is a violent state, and in many ways, the tolerance level is very low when it comes to SDS, DuBois, and the New Left in general. If it was political, we must look at the press and the power structure as the main assassins. It is they who constantly call us subversive and play the Communists up as inhuman conspirators leading the country into dictatorship. It is they who build a society which is intolerant of political dissent and which makes killing a 'commie' a moral thing to do. The society is built on violence, both overt and subtle, and it breeds violence internally as well as abroad. We must remember that the enemy is not only the man who pulled the trigger but also the society which makes murder a valid way of stopping political dissent.

In August I flew to Santa Barbara for a three-day conference at The Center for the Study of Democratic Institutions on the role of students in social change. The conference brought together a dozen or so representatives of the student movement, from student body presidents to student activists and full-time organizers like myself. The meetings were group discussions around topics proposed by the Center. I found the conference to be frustrating because it reflected the growing confusion in the movement about what we should do next. Everyone agreed that simple protest wasn't working and there was growing confidence that we could build a radical movement among young people, but the word "revolution" was easy to say while the analysis of the current situation was complex. I didn't have

much to add but I knew that wishing for a revolution wasn't enough to make one.

I looked forward to the end of each day's session because I found the political/cultural mix in Santa Barbara very much like Austin. Long hair, tie-dyed clothes, and beads, the new "look" of the counter-culture, was everywhere. Many people believed that these "hippies" only cared about music and drugs, but I found that they were also concerned about the war and racism. From Santa Barbara I caught a ride to Los Angeles and spent a couple days with Mike Klonsky in the SDS regional office. Here, too, the counter-culture was growing.

I caught a ride with friends to San Francisco and stayed with Robert, an SDS friend from Austin who was living in a two-story Victorian house in the heart of the Haight-Ashbury district. This was the Summer of Love and young people from all over the country had come to San Francisco and gathered in the Haight. For many of these young people, this was the first time they had lived in a community of other people who were like themselves. The area was crowded with longhaired people wearing tie-dyed shirts and beads. People were openly selling drugs on the streets and the smell of marijuana was in the air. When we went to Golden Gate Park there were hundreds of young people sitting in groups scattered across the lawn smoking marijuana and tripping on acid. My first thought when a police car stopped was to look for a way to escape, but no one around me moved. The police announced that some of the acid being sold on the street was dangerous and then drove on into the park to warn other people.

While in San Francisco I visited the regional SDS office and went to visit Helen Garvy and Steve Weissman, who were also living in San Francisco. After a couple of days, I asked Robert how he could afford to live by himself in that big house. He told me that there were two hundred kilos of marijuana on the second floor and that he got free rent for watching it. I was afraid that the FBI might be watching me, so I quickly moved in with Helen and Steve for the rest of my stay.

The Haight was interesting because the counter-culture was everywhere, but it seemed out of balance to me. There were too many drugs and not enough politics. The slogan in the Haight was, "Do your own thing" and while I was a strong advocate of individual liberation, I also believed in collective action for social change and didn't see that in the Haight. I found out later that there

was definitely a collective component influenced by the radical activity in the Bay area that led to food co-ops and medical facilities and ultimately to groups leaving the city to buy land so that they could live communally.

When I got back to Chicago I found the national office in a state of siege. The Chicago police had staked out the SDS office before I went to California and had been watching it the whole time I was away. We didn't know why they were watching us but it didn't surprise me since the police had been watching us for years in Austin. It was summer in Chicago and, in previous summers, there had been urban insurrections in the black neighborhoods of other cities. As money for the War on Poverty was spent in Vietnam, the hopes of black people for change were frustrated. Unemployment, inadequate housing, and police brutality made ghetto uprisings almost inevitable and the summer of 1967 saw massive civil disorder across the nation as cities were rocked by rebellions in the black communities. The National Guard in Detroit had been used to put down the worst insurrection in that city's history. Across the country the damage mounted into the tens of millions of dollars, thousands of blacks were arrested, and nearly a hundred were killed.

The police in Chicago were aware of the explosive nature of the ghetto and their response was to get young black men off the streets by making mass arrests on trumped up charges and then to keep them in jail by setting high bail. The SDS office was only a few blocks from the west-side ghetto, and ten SDS staff members were caught in this sweep on their way to the office. They were arrested for disturbing the peace, with bail set at $1,000 each. Soon after that the police arrested our in-house printer because he was putting up a poster with a line from a poem by Jane Stembridge,

The real and exact function of a cop: STOP, STOP.[131]

He was charged with resisting arrest, after the police beat him up, and bail was set at $5,000. Getting our people out of jail took all the operating funds of the office, which was probably the intent.

The urban rebellions were a concern to President Johnson so he had formed a commission, led by Illinois governor Otto Kerner, to study the reasons behind them and to make recommendations for the future. The Kerner Commission reported that the rioting had been caused by the living conditions of the poor and that there was no evidence to show that "outside agitators" had been involved. The commission concluded that, "Our nation is moving toward two

societies, one black, one white – separate but unequal." The solution was to change the conditions that lead to inequality, despair, and violence, but there was no political will to confront the social problems that the report revealed. Spending money on "law and order" was more popular than fighting poverty and the only conclusion of the Kerner Commission that was implemented was the call for more undercover police and informants. Local police forces were encouraged to develop their own programs and then to give the information to the FBI. This ultimately led to a domestic intelligence apparatus that was large, difficult to control, and ignored the constitutional rights of the people. This apparatus, combined with the power of the FBI, affected many of us as the government tried to stop the antiwar movement.[132]

My FBI files from the summer of 1967 note that I had been elected as internal education secretary. The San Antonio office, the Chicago office, and the Director tried to decide where my active files should be kept. The San Antonio office finally sent a copy of my files to Chicago and by August 1967 they were beginning to construct a profile of me. They collected articles that I wrote for *New Left Notes* as well as anything that appeared in the press. They noted when I attended the National Administrative Committee (NAC) meetings on various dates in July, August, and September. But by the end of the summer they still weren't sure if I was going to stay in Chicago. In October the "Director," J. Edgar Hoover sent a memo demanding to know my address in Chicago. The return memo explains that they hadn't been able to get that information because I wasn't listed in the phone book! Apparently the obvious method of following me home never occurred to them and so my paranoia about being busted by the FBI in San Francisco with two hundred kilos of grass probably wasn't justified.

Repression of the movement across the country increased during the summer. On June 23 in Los Angeles, the police attacked a peaceful, non-violent antiwar demonstration with clubs and tear gas before arresting fifty people and sending forty more to the hospital. On July 24, a large group of Marines attacked forty antiwar demonstrators in Houston. A pro-war group named "Support Our Boys" had called the demonstration and the antiwar demonstrators responded with a banner saying, "Support Our Boys, Bring Them Home." As the summer passed it was obvious that police departments across the nation were becoming more aggressive.

As the war continued and antiwar sentiment grew, the number of people in the military who opposed the war also increased. Returning soldiers told stories of mutinies and rebellions among the soldiers in Vietnam in response to the horror of what the US was doing there. Active duty personnel were beginning to agitate within the military and in June 1967, a group of GIs, many of them highly decorated, organized Vietnam Veterans Against the War (VVAW). The fact that military personnel and Vietnam Veterans were openly opposing the war was of great significance because it pointed to the crumbling of popular support for the war.

The Move to Resistance
Fall 1967

"Hell No! We Won't Go!"

"We're not against the soldiers! We're against the war!"

"Hell No! Nobody Goes!"

"Hey, Hey, LBJ. How many kids did you kill today?"

<div align="right">Anti-war chants</div>

With the Teacher-Organizer school over, I could now concentrate full-time on my duties as a national officer. My first task was to go to Madison, Wisconsin, to help set up the National Council meeting scheduled for early October. The local chapter members had already taken care of most of the details and I spent several days making sure there were spaces for workshops and meetings as well as places to sleep. It was always a big job getting everything arranged, especially now that the meetings were getting much larger. We finally managed to arrange adequate sleeping space by having people sleep on the floor of a gymnasium.

Members of the growing community of local and regional organizers began to arrive a day or so early to have more time to discuss new ideas with other organizers. Some of these people were delegates but many came just to see their friends and to take part in the debate. I identified with this community and enjoyed the opportunity to share ideas about the changes going on within the movement and how they affected SDS. In Austin the counter-culture was growing rapidly with groups of people working on many different projects ranging from starting alternative schools to providing healthy organic food. Only a few years before, the SDS chapter had been at the center of the movement, but now it was part of a much broader community. The structure of Austin SDS was also evolving from a small group of people all working on the same issues into a collection of committees and individuals working on a spectrum of different projects. The local and regional organizers that

I knew thought that this decentralization of the local movement was a positive development because it not only got the work done but it also provided a way to involved the large number of new people who were pouring into the local chapters.

With SDS and the surrounding community expanding, it was beginning to look as if we actually could end the war and change America. Even though SDS had decided not to organize large national demonstrations, SDS members always played an active part in getting people to the demonstrations, and there was excitement in the air as we discussed the local and national actions planned for the October Mobilization against the war. We had been politely demonstrating against the war for years and it appeared to have no effect. During the spring of 1967, Greg Calvert and Carl Davidson began to talk about moving "from protest to resistance" and to look at actions that would stop the war machine from functioning. We wanted to stop the flow of young men, scientific research, and weapons that kept the military going and we had several things in mind. Draft resistance could be extended to closing down an induction center. We could make it impossible for Dow Chemical, the maker of Napalm, and for military recruiters to recruit on campuses. We knew that many universities were doing secret research on topics such as counter-insurgency techniques, control of peasant movements, use of chemical weapons (including LSD) for use in crowd control, and mathematical models for bombing patterns to name just a few. Resistance implied an increase in militant action to expose and if possible stop this machinery that supported the war. As the week of protest began, news of what was happening across the country poured into the office, confirming that a new level of militancy was widespread.

On October 16 in Madison, Wisconsin, Dow Chemical came to recruit students as potential employees. The SDS chapter held a peaceful demonstration to educate students about Dow's involvement in the war as a manufacturer of Napalm. The next day about a hundred students walked into the building where Dow was recruiting and sat down in front of the office door, blocking anyone from entering. Soon there were 350 students inside the building and they informed the administration that recruiting was over for the day because Dow was involved in war crimes. The administration quickly called in the Madison police who attacked the students with clubs and cleared the building. Students gathered outside the building reacted to this brutality and came to the rescue by pulling

students away from the police and letting the air out of the police car tires. When the police began throwing tear gas canisters into the crowd, the students fought back with rocks and bottles resulting in both students and policemen being hospitalized. At a large rally that evening, students voted for a boycott of classes. As a result the university suspended interviews by Dow for the rest of the semester. This victory came at a price however, when the University of Wisconsin suspended sixteen students for their role in the confrontation.[133]

Meanwhile, in the San Francisco Bay area the Stop the Draft Week (STDW) committee, (including several SDS organizers, among them SDS's anti-draft coordinator Jeff Segal) planned to keep the Oakland Induction Center from taking any young men into the military. To show the resistance nature of the action they changed the slogan, "Hell No! We Won't Go!" to "Hell No! Nobody Goes!" The week began with a peaceful sit-in and arrests. On the second day the demonstrators found the area around the induction center empty – the police were nowhere to be seen. As they surrounded the induction center, the police came out of a nearby parking structure and began to viciously attack the demonstrators with clubs and tear gas. Stunned and angered by the violence, the STDW committee learned from the experience and came back on Friday with a different plan.

The induction center was in downtown Oakland with heavy early morning commuter traffic. The STDW committee reasoned that creating a huge traffic jam by blockading intersections would keep the buses of potential inductees from getting through. That would shut down the induction center. Having learned from previous demonstrations that the police were hesitant to enter areas where they were seriously outnumbered, the STDW committee planned "mobile tactics." Demonstrators would blockade intersections until the police came and then they would retreat slowly, defending themselves if necessary. There were three rules: don't sit down, don't run, and be aggressively defensive but don't fight the police. At dawn Friday morning, thousands of demonstrators, many wearing protective helmets, approached the induction center from several different directions. When the police advanced, the demonstrators retreated behind a moving barricade of people carrying signs reinforced to serve as shields against the police clubs. As they moved, the demonstrators erected more barricades in other intersections so that while the police tore down one barricade, the

people were building another one somewhere else. In the ebbing and flowing of the demonstration the police sometimes found themselves surrounded as they advanced against slowly retreating demonstrators and other demonstrators filled in behind them. When they backed out, the demonstrators followed, retaking the streets. This moving battle went on for over four hours, and the buses going to the induction center couldn't get anywhere close – the induction center was effectively closed! Early in the afternoon, Governor Ronald Reagan called out the National Guard and the demonstrators declared victory and left. Jeff Segal and other SDS activists called us in the national office with up-to-the-minute news. The fact that our side had outmaneuvered the police was exhilarating and we quickly spread the word across the country.[134]

The next day, October 21, in Washington, DC, more than 300,000 people gathered at the Lincoln Memorial to protest the war and to hear speakers including SDS's Carl Davidson. After the rally, 100,000 people crossed the nearby bridge into Virginia and headed towards the Pentagon. A long line of soldiers had been set up to keep people from getting close to the Pentagon, but a group of demonstrators, including many SDS members, took a short-cut, knocked down a small fence, and ran toward the Pentagon with thousands of other people following their lead. As they climbed the steps to the Pentagon they were met by paratroopers with rifles who slowly advanced, hitting people with their rifle butts as they pushed people back. Suddenly the demonstrators began to sit down. The soldiers, seeing that they weren't under attack, stopped advancing and there was a stand-off with paratroopers, military police, and federal marshals facing a huge crowd of antiwar demonstrators. As everyone settled in, there were spontaneous chants of "Join Us! Join Us!" and "We're not against the soldiers! We're against the war!" Demonstrators lit bonfires and talked with the soldiers about the war and the urban insurrections that were now so common. Many of the soldiers listened and it was reported that some actually joined the demonstrators. The federal marshals continued to aggressively attack demonstrators with clubs whenever possible and there was at least one major assault against the demonstrators during the night. In spite of the violence, many people stayed until dawn talking with the soldiers.[135]

Secretary of Defense Robert McNamara watched from his office window as someone from the crowd ran the flag of the National Front for the Liberation of Vietnam up the flag pole. McNamara

later said that he was terrified the demonstrators might break into the building and come after him.[136] We didn't know it then, but by this time in 1967 McNamara had become truly tormented by the human consequences of his policies. The previous June, he had asked members of his staff to assemble all government records on the Vietnam War. The war was not going well and McNamara thought that future historians would want to know why. This collection of information was later leaked to the *New York Times* by one of the staff members, Daniel Ellsberg, and was published in 1971 as the *Pentagon Papers*. These papers showed that the people running the war, including McNamara himself, lied both to Congress and the American people.[137] The *Pentagon Papers* also revealed that the government was aware that its policies were inflicting horrendous civilian casualties. As Secretary of Defense, McNamara must have been aware that vast numbers of innocent people throughout Vietnam were being killed by the indiscriminate use of bombs, Napalm, pellet bombs, and chemical defoliants. We knew about it – and his children, who opposed the war, knew about it. In a remark to a friend about the *Pentagon Papers* McNamara said, "You know, they could hang people for what's in there." Apparently he knew something about war crimes, too.[138]

A few days after the Pentagon demonstration, General Hershey, director of the Selective Service System, sent a letter to all local draft boards recommending that they reclassify and induct anyone who was in an "illegal demonstration," who interfered with military recruiting, or who otherwise violated Selective Service law. He said that military deferments were only given to serve the national interest and that any disruption of the Selective Service System was obviously not in the national interest. In Oklahoma, SDS member John Ratliff was reclassified by his local board because, in their words, they "did not feel that your activity as a member of SDS is in the best interest of the US government." This was a blatant abuse of the Bill of Rights because it threatened freedom of speech, and in 1970 the Supreme Court ruled that using the draft as a weapon to intimidate citizens was unconstitutional.

In early November, several of us from the office went to New York to meet with the NY regional office staff and to demonstrate at the 50th anniversary dinner of the Foreign Policy Association on November 14. Secretary of State Dean Rusk, an architect of the war in Vietnam, was the featured speaker at a meeting that symbolized for us what was wrong with America. The Foreign Policy

Association had helped define the policy that had led to the war in Vietnam, the invasion of the Dominican Republic, and intervention in other anti-colonial struggles. The meeting was at the Hilton Hotel in mid-town Manhattan. When Greg Calvert and I arrived, police on horseback were aggressively pushing everyone away from the hotel and onto the sidewalks across the street. Whenever a limousine drove through the barricades with its police escort and discharged its illustrious passengers, demonstrators waved signs and banners and jeered. When a few people tried to cross the street to the Hilton, they were arrested.

Suddenly a cheer went up from the crowd as the rumor spread that SDS people had gotten inside the Hilton disguised as waiters. Then another group of people, a block or so away, moved into the streets to stop traffic so the limousines couldn't get through. The police moved against them with batons and the demonstrators retreated into the crowd only to move back into the street when the police pulled back. This time they moved out into the surrounding streets and stopped traffic there too. The police near us began aggressively using their horses to push people back from the curbs and up against the buildings. A smoke bomb went off under one of the horses and Greg and I, along with many other people, were pushed out into a side street. These mounted police tactics did such a good job of clogging all the surrounding streets that the limousines, cars, and taxis couldn't leave. The result was three hours of chaos in the streets of mid-town Manhattan.

As I watched the traffic jam grow I thought about the people who were sitting in their cars. As demonstrations became more militant, innocent by-standers were going to get caught up in the action. We needed some way to educate people about what we were doing and why we were doing it. Attacking symbolic targets only makes sense if people understood what the symbols mean. I worried that if we didn't find a way to explain what we were doing, we could easily alienate people who we needed on our side.

The next day the *New York Times* accused the demonstrators of "disrupting the development of the national debate on Vietnam policy which is so urgently needed." What debate? We had tried to debate the issue of Vietnam for three years and the government's response was to treat us as the enemy. The *New York Times* still hadn't come out against the war even though a year earlier Harrison Salisbury, their correspondent in Vietnam, had documented the bombing of civilian targets and other atrocities against the civilian

population. All the years of peaceful demonstrations had changed nothing – and we were moving beyond debate. Protesting the war assumed that it was a mistake and that if we could convince the war makers of that then the war would end. Resistance recognized the fact that it wasn't a mistake, that the war makers knew what they were doing and didn't intend to change their policy. They would only stop when the cost became too high. People were being killed both in Vietnam and in America and we were tired of talking.

Throughout the fall, news from all these demonstrations poured into the national office and we passed the information along to the chapters either through *New Left Notes* or through personal contact. This encouraged other chapters to confront war-related activity on their campuses and the result was that many new people were drawn to SDS. Many of these action-oriented new people had no previous contact with the movement and the challenge was to incorporate them into chapter activities where they could learn about the broader issues and about strategy and tactics for reaching out to new constituencies and ending the war.

From the national office, we could see that militant action was increasing on campuses across the country and we encouraged chapters to do extensive education campaigns before they jumped into action. In early November 1967 I wrote an article for *New Left Notes* encouraging students to reach out beyond their own radical community.

> We cannot afford to set up barriers between ourselves and our potential allies....Those who are now hostile must be reached....We cannot afford to be afraid of the people!...The possibilities for student action relevant to other groups in the society are almost unlimited. When workers are trying to unionize, students should be ready to give support...With the war affecting young people and with more of them being disillusioned with the military, students can act to spread draft resistance into the community.[139]

A week later, in an article titled "Toward Institutional Resistance" Carl Davidson discussed driving war-related recruiters off the campuses as a way to change people's political consciousness. The goal of such action should be to destroy the legitimacy of those institutions, to radicalize students, and to disrupt, dislocate, and destroy the military's access to the manpower, intelligence, and resources of the university. He argued that the criticism that we were denying the recruiters' freedom of speech, didn't apply because our government and military were committing war crimes in Vietnam. If

the Nazis were on campus recruiting soldiers to invade France or
engineers to make poison gas we wouldn't think twice about
repressing their freedom of speech. Recruiters who work for war
criminals should be aware that they would be confronted wherever
they went.[140]

As the National Council meeting at the end of December
approached, Carl and Greg wrote a proposal for a program called
"Ten Days to Shake the Empire." This program called for local
actions between April 10-20, 1968, in resistance to the war, and it
encouraged chapters to select targets to show the connections
between racism, the war, poverty, and US foreign policy. The goal of
the program was to help chapters learn how to pick targets and how
to use them to reach new people. By setting the date so far into the
future, there would be time for each chapter to find a local target
and would also give the national office time to develop materials to
support what the chapters were doing. Coordinating actions during a
ten-day period would create a national focus on those responsible
for and profiting from the war. The proposal mandated the national
office to start on a publicity campaign to educate people about the
issues before the action took place. This would include an ongoing
communications network to help the chapters by coordinating
research, sharing information about what different chapters were
doing, and helping develop strategies and tactics. In addition there
would be people traveling from campus to campus to help on the
local and regional levels.[141]

In support of the Ten Days proposal, I wrote an article giving
some practical examples of what could be done and the pitfalls of
not doing adequate preparation and education. Using an industrial
plant as an example, I emphasized the use of power structure
research to find out everything possible about what it produced,
who owned it, and who worked there. Our objective should be to
use the plant as a symbol of the war while not alienating the people
who work there. Armed with this information we would then devise
a strategy for contacting sympathetic workers and members of the
surrounding community. As we talked with people we would try to
connect our issues with theirs and to look for ways to work together.
I emphasized that the Ten Days action was not an end in itself but a
tactic for mobilizing people for further political action.[142]

The December National Council meeting was in Bloomington,
Indiana, and the main topics on the agenda were resistance, the Ten
Days proposal, and a discussion of the changes that were happening

in SDS's local and regional structure. These were all part of a discussion about where a basically student driven movement should go from here, the role of militant action, and the relationship between the local, regional, and national offices.

I wrote an article entitled "The Political Function of the NC [National Council]" urging delegates to discipline themselves so that we could discuss the issues before us.

> We should see as our primary task the detailed discussion of the directions of resistance....and outline how that relates to specific constituencies and carries the struggle forward....These and many other questions must be discussed in detail if we wish to give the NC real political content toward real political action....The process of making radical change requires discussion of strategy, tactics, and program in relationship to our base.

Knowing that PL members would be at the meeting and having learned from the last National Council meeting that they repeated the same argument over and over, I wrote some things with them in mind.

> People must discipline themselves....Unless you have a position that has not been raised and that is important to the debate, you should assume that people can make valid decisions having heard each side a minimum number of times....Finally, don't raise issues for debate which have no other function than to give SDS the correct line....Experience has shown that our members' politics are determined by their role in the discussions leading to and following some meaningful action, and not on some resolution passed at a National Council. COME PREPARED TO SACRIFICE YOUR BULLSHIT.[143]

There were 250 people at the National Council meeting of which 40 or 50 were associated with Progressive Labor. Greg Calvert presented the "Ten Days" proposal and we expected there to be heated debate that would help SDS clarify its position on the issue of resistance and its relationship with the working class. We were cautious about working with unions because many of them supported the war in Vietnam and discriminated against minorities and women. PL was strongly opposed to any SDS program for reaching the working class other than through their Worker-Student Alliance. They believed that racism and sexism would be eliminated in the course of organizing the working class, but that didn't ring true to many of us. Racism and sexism have their roots deep in pre-capitalism history and rooting them out had to be dealt with as a separate problem. PL disagreed with the New Working Class analysis because it implied that student issues were connected to

workplace issues and justified SDS organizing off campus. PL wanted SDS to remain a student organization that they could work within. The conflict with PL over the vision and direction of SDS had been growing and we expected their opposition to the Ten Days proposal to revolve around these political issues and were ready for the debate.

They took us by surprise, however, when, rather than debating these political issues they attacked the national office and the officers. They repeated again and again that this proposal was a product of the "national office cadre," which they defined as a disciplined group with a new working class/resistance ideology that was trying to take over the organization. They accused the national leadership of being "too remote from chapter work" and portrayed themselves as being the people who had the interests of the individual chapters at heart. This personal attack forced us into defending ourselves rather than debating the issues that we thought were important to SDS. When we tried to defend the program we were accused of manipulation and our actions were used as proof of the conspiracy.

This is not to imply that there was no grass roots opposition to the Ten Days proposal. Smaller, more isolated chapters were afraid the program would be counter-productive for them. They were skeptical about being too militant because it was a good way to get expelled, thrown off campus, beaten up, or all three. They feared that the national publicity would focus the anger of the local pro-war people on their small chapter and could destroy them. This led some smaller chapters to side with PL in opposing the action. Dick Reavis, an Austin delegate who had gone from being a civil rights worker to an anarchist to the leader of the Austin Friends of Progressive Labor, clashed with the other Texas delegates more than once as he repeated the PL line. Several members of the New York regional office staff added an amendment stating that each chapter would develop its own specific program for the Ten Days in April based on local analysis. This amendment was accepted and the proposal was passed by a two-to-one margin.

The only practical result of the compromise was to symbolically take the content of the action out of the hands of the national office – where it never lay to begin with. Local SDS chapters didn't take orders from the national office and there was nothing in the proposal that said what local chapters were supposed to do. In the original proposal the office was only supposed to support and

coordinate local activity, not direct it. The two to one majority in favor of the proposal was a good indication of the sympathies of the local people, but Progressive Labor had demonstrated the power of a single-minded, disciplined minority to derail the process and steer the debate in their direction.

Because of PL's manipulative tactics I found the National Council meeting very frustrating. PL's adherence to democratic centralism, the principle that each member was bound to publicly support all previously agreed-upon positions, meant that each PL speaker repeated the party line on every issue. The result was that their line was heard over and over and so the debate revolved around their position. Part of PL's strategy for gaining political control of SDS involved separating the leadership from the membership.[144] In order to do this they accused the national officers and the growing number of local and regional organizers of being part of a conspiracy to take over the organization. In fact, it was PL that was using its power as a closed caucus to control SDS. Many people left the meeting frustrated because the National Council never debated the issue of SDS's structure. The National Council meetings were becoming too large and chaotic to allow the range of debate that was necessary for SDS to function and some of us wondered about organizing some kind of united front to take on PL in the future.

The accusation that I was part of a national cadre trying to take power away from the local chapters was particularly hard for me to take. From the time I joined SDS, I had opposed power being centered in the national office. I opposed the national office declaring SDS policy without membership consent. I had been elected as internal education secretary by the people who wanted strong local chapters, and I had done my best to keep in touch with them. I had written articles for *New Left Notes* as had the other national officers. These articles reflected what we saw happening locally and regionally across the country. Opposing articles were also printed and every article submitted by PL had been printed in its entirety in *New Left Notes*. We were willing to debate the issues openly and honestly.

Another issue raised at this National Council meeting was SDS's response to the growing crisis in the black movement. SDS members wanted to take a clear stand because the confrontation between militant blacks and the police was heating up all across the country. In Oakland, California, the Black Panthers were organizing

community-based programs, such as the Breakfast for Children program that provided breakfast for poor children on their way to school, and health services for ghetto residents. The Panthers also tried to curtail police activity in the black community, where the Oakland police had earned a reputation for stopping people without cause and for outrageous brutality. The Panthers followed police cars and then watched and took notes when the police stopped someone. The police didn't like being watched, even though it was legal to do so, and arrested or harassed the Panthers whenever possible. The situation was aggravated by the Panthers' use of the rhetoric of armed third world revolutionaries and their emphasis on armed self-defense. The Panthers, suspecting that the police might kill them, armed themselves. The police, aware that the Panthers might fight back, prepared to shoot first and ask questions later. The result was an escalating and deadly confrontation. SDS saw this as a result of the racism that was rampant in police forces across the nation. It was apparent that the police were much more willing to use deadly force against blacks than against whites and SDS expressed its solidarity with the black movement and condemned racism wherever possible.

Meanwhile, the Johnson administration was trying to figure out how to extricate itself from the mess in Vietnam. We didn't know it at the time, but as we worked to end the war, the Johnson administration was secretly working to get the North Vietnamese to negotiate. Potential negotiations had been agreed to on the condition that the US would restrict bombing around Hanoi and Haiphong. Two French negotiators were sent to Hanoi to try to arrange talks, but just as they were going into Vietnam, the US Air Force and the Navy began to bomb in the restricted areas, saying that they had a backload of targets to hit because they hadn't been able to fly during a rainy period. Because the agreement had been violated, the Vietnamese refused to meet with the negotiators. This happened on several occasions and one of the negotiators complained, "Every time I brought a message [for North Vietnam] we bombed the center of another North Vietnamese city."[145] The peace talks fell through.

As President Johnson deliberated about the war, he chose advisors who wouldn't disagree with him. Humphrey had been excluded from meetings about the war, but he was not the only member of the Johnson administration to have doubts. In August

1967, Secretary of Defense McNamara testified before a Senate Committee that the bombing was having no effect on the war effort. In a November memorandum to Johnson, he expanded upon this and called on the President to halt the bombing, freeze the number of troops, and begin the process of turning the war over to the South Vietnamese.[146] In November Johnson, his advisors, and a group of men called the "wise men," many of whom had helped forge foreign and domestic cold war policy, met to discuss the progress of the war.[147] Johnson didn't present McNamara's paper to the group and McNamara didn't bring it up because of "loyalty" to the President. In an atmosphere where all dissent was eliminated before the meeting began, there was never any talk about reversing course because anyone who felt that way was not invited. People with doubts, such as McNamara, felt that loyalty to the President was more important than stopping the killing of Vietnamese civilians and American GIs, so they said nothing publicly even though doing so could have saved millions of lives.

As the year ended there were a half million American military personnel in Vietnam. In September, the Viet Cong had begun a series of attacks on American outposts in the highlands of central Vietnam that were more like traditional warfare than the usual hit and run guerrilla attacks. When a communist force of forty thousand men attacked the Marine base at Khe Sahn, General Westmoreland moved in six thousand more Marines and prepared to bomb and defoliate the surrounding area. The situation at Khe Sanh deteriorated during the fall, and by December, the base was completely surrounded and under constant bombardment. The press speculated that this offensive might be an attempt by the Vietnamese to create an American "Dien Bien Phu" (the battle in which the French were defeated in 1954) and so the US military turned its eyes toward Khe Sanh and the highlands.

To counter the large number of antiwar demonstrations across the country, the Johnson administration launched a publicity campaign to build support for his efforts to bomb the North Vietnamese into submission. Vice President Hubert Humphrey told the public that, "We are beginning to win this struggle," and General Westmoreland told the American people that, "We have reached an important point when the end begins to come into view." The US military, believing its own propaganda that the Viet Cong was almost defeated, ignored evidence of a pending Viet Cong offensive against

the main cities of South Vietnam and concentrated on the siege at Khe Sahn.

— 14 —

The Light at the End of the Tunnel
Spring 1968

"Yes, the Americans have bombing planes, jeeps; they can move and fly very fast. But we can be faster than them, because we in South Vietnam are already there."

Huynh Minh – member of the National Liberation Front

"The most beautiful of all doubts is when the downtrodden and despondent raise their heads and stop believing in the strength of their oppressors."

Bertoldt Brecht, "In Praise of Doubt"

On January 5, 1968, the federal government indicted Dr. Benjamin Spock, the Reverend William Sloan Coffin, Jr., Michael Ferber, Mitchell Goodman, and Marcus Raskin for conspiracy in "counseling, aiding, and abetting" young men to avoid and resist the Selective Service System.[148] We were somewhat surprised by who was indicted, but we all knew that the repression was coming. The antiwar movement was making inroads into a broad cross-section of the country and the government had been blustering about stopping this unpatriotic activity. In an article for *New Left Notes*, I summarized our response to the indictments.

> On January 7, the national office in consultation with the National Interim Committee sent out a call to chapters to organize support demonstrations on Friday, January 12. The call urged that the target of demonstrations be induction centers and draft boards, the targets which the repression seeks to deny us. The government is attacking anti-draft work; our support work should take the form, on one level, of action around targets most closely related to that issue.
>
> Obviously the government is making a serious move to suppress the draft resistance movement....Why did the government decide to hit five prominent liberals?
>
> First, it is an attempt to divide the draft resistance movement on liberal-radical lines and deprive us of liberal support....By moving against these...supporters before mounting a full-scale attack on the anti-draft movement at its base, the government is attempting to scare [the liberals]

and thousands of other potential supporters away from resistance work....

The government has made a serious move against us. We can turn that move to our own advantage if we use the repression to unify and build the resistance movement rather than allowing them to divide and isolate us.

Dr. Spock was a household name and his book on baby and child care was in millions of homes across the country. Some "analysts," looking for the reason our generation was in rebellion, blamed Dr. Spock's advice on child rearing. By indicting Dr. Spock and Yale University chaplain Rev. William Coffin the government was giving notice that no one was safe if they opposed the war. Bringing conspiracy charges against people on the basis of what they *might* be thinking about doing was a way to keep people from speaking out. It was also a way of stopping antiwar activity by tying people up with lawyers, hearings, and trials. Following these indictments seven people were arrested in Iowa for an anti-Dow demonstration and seven of the Stop the Draft Week organizers, including SDS's national anti-draft organizer Jeff Segal, were indicted for their roles in that protest.

We were often reassured that the war was almost over and that we could see the light at the end of the tunnel. In late January, at the beginning of Tet, the Vietnamese New Year, the light at the end of the tunnel that we'd heard so much about turned out to be the Viet Cong Express thundering down the tracks. The reality of the situation in Vietnam suddenly exploded into the living rooms of America. We watched television footage of soldiers fighting to take the US Embassy in Saigon back from the Viet Cong and soon learned that the National Liberation Front had attacked over 140 cities and towns simultaneously, over-running many of them. The US military and the South Vietnamese Army were taken by surprise – as were the American people. All the assurances that the war was almost over turned out to be one more deception that helped turn the public against the war.

The Tet offensive showed that the Viet Cong was far from defeated and had wide-spread support among the people. During Tet, National Liberation Front soldiers came out of areas the US generals thought were under control. One area called the Iron Triangle had been a center of opposition to both the French and the Americans. In order to "pacify" the area, the US military had evacuated the peasants, heavily bombed and defoliated the jungle,

and totally destroyed the four main villages. They had cleared parts of the land by pulling off all the vegetation using tanks with chains tied between them. Although this barren wasteland was watched continuously, beneath the surface was a vast network of tunnels in which the liberation army lived and worked. During the Tet offensive, the main force attacking Saigon came from the Iron Triangle.[149]

The Tet offensive caught everyone off guard, including the policy makers in Washington. Clark Clifford, who later replaced Robert McNamara as Secretary of Defense, described the scene there:

> [The Tet offensive's] size and scope made mockery of what the American military had told the public about the war, and devastated Administration credibility. Five of South Vietnam's six major cities, 36 of its 44 provincial capitals and 66 of the 242 district towns were attacked....It is hard to imagine or even re-create the atmosphere in Washington in the sixty days after Tet. The pressure grew so intense that at times I felt the government itself might come apart at the seams. Leadership was fraying at its very center...There was for a brief time, something approaching paralysis, and a sense of events spiraling out of the control of the nation's leaders.[150]

We didn't know at the time what was going on behind the closed doors of the White House, but we knew that the government had been taken by surprise. Although the American embassy in Saigon was retaken in a day, it took a month of heavy fighting before the US and South Vietnamese forces were finally able to retake the city of Hue. The toll of the Tet offensive was heavy – 1100 Americans and 2300 South Vietnamese troops were killed. The liberation forces may have lost as many as 40,000 and because of this the US considered the Tet offensive to be a defeat for the North Vietnamese and the NLF. The Vietnamese, who had been fighting almost continuously since the mid-1940s, had a long-range perspective that put the whole thing in a different light. They knew that the American military machine could not be defeated on the battlefield and that the war would end when the American people no longer had the will to go on. The Tet offensive was such a shock to the American people that many began to rethink the war. For the Vietnamese patriots that was a step in the right direction.

All through the Tet offensive, the siege of Khe Sahn in the northern highlands intensified. The daily coverage showed GIs pinned down and under heavy bombardment by North Vietnamese soldiers. The airfield was unusable so food and ammunition had to be dropped in by parachute. To break the siege the US dropped

some 100,000 tons of bombs, including 60,000 tons of Napalm on a five square mile area surrounding Khe Sahn, making it the most heavily bombed area in the history of warfare. The siege was broken in April, and two months later the US abandoned Khe Sahn. The Viet Cong took it over shortly thereafter.

Before the Tet offensive, 60 percent of Americans favored the government's handling of the war while 24 percent opposed it. After Tet those favoring the war dropped to 41 percent, while 42 percent were critical. The credibility of the government suffered as the Tet offensive exposed the lies they had been telling the people and the press. As Americans realized that Vietnamese opposition to US troops was widespread and that the war was far from over, they began to change their minds about supporting it. The press also became more critical and we began to see articles in *The New York Times*, *The New York Post*, *Time Magazine*, *Newsweek*, and *The Wall Street Journal* condemning the brutality of the war and advocating a negotiated settlement. Walter Cronkite, the highly respected television commentator, went to Vietnam during Tet and returned to say that the war was a stalemate and the US should forget about winning and negotiate its way out.

Vietnam wasn't the only crisis facing America. Here at home, police violence against blacks was also increasing. In Orangeburg, South Carolina, students at South Carolina State, a predominantly black college, had been picketing and sitting-in at a segregated bowling alley near campus. The local police called in the state police who surrounded the campus and refused to allow the students to go into town. That evening, February 8, the students built a bonfire on campus and many were gathered around it when the state police attacked and began shooting. The students tried to run but twenty-eight were shot, most of them in the back or side as they ran away. Several were shot in the soles of their feet as they lay on the ground trying to avoid being hit. Three of the students died. The police story was that they had come on campus to put out the bonfire and had been shot at, but witnesses on campus and in the community contradicted this story. Cleveland Sellers of SNCC was arrested for inciting a riot and was later convicted of participating in a riot two days before the shooting. Nine state troopers were indicted for violating the students civil rights but the FBI covered up and falsified evidence as they defended the police against the charges. The troopers were acquitted.[151]

I wondered how long this killing of black students could go on before the police turned the guns on white protesters. The fact that the intensity of police attacks on blacks was of a different order of magnitude than attacks on white antiwar demonstrators was not lost on us. The police were attacking white demonstrators with clubs, but they were attacking black students with guns and killing them. Because of the racist nature of the society, blacks were more likely to be killed whether they went to Vietnam as part of the military or stayed home and fought for equal rights. We had noted that police violence against non-violent demonstrators was becoming commonplace and wondered if this was a coordinated change in tactics. We later discovered that this increase in violence coincided with an FBI program of training local police in riot control. The FBI told the police that they were the first line of defense against the New Left and the black liberation movement and encouraged them to stop demonstrators. A 1969 government commission reported that this led to a steady escalation of police violence toward demonstrators.[152]

In February, I went to Houston, Texas to speak at a memorial for Malcolm X. SNCC had been organizing in Houston for several years and had run into strong resistance from the Houston police. This rally was intended to draw both black and white activists, and Mariann Wizard (she changed her name after George's death) had been in Houston organizing whites to join the demonstration. The memorial began with a black power march through the black community. As we marched, people chanted "I want to be a Mau Mau just like Jomo Kenyatta."[153] An interesting sidelight was revealed years later when the FBI was forced to release documents concerning its Counter-Intelligence Program, COINTELPRO. A document dated March 4, 1968, shows that one of the FBI's long-range goals was to prevent the coalition of militant, black nationalist groups because they "might be the first step in the formation of a real "Mau Mau" in America, the beginning of a true black revolution.[154] Following the march, I spoke at the rally.

> When white people left the black movement they began to develop their own definition of their identity. In the struggles against the Vietnam War, the draft, the university, and the exploitation in the white ghettos we began to understand what this society is all about. For many that process was very hard. It is hard for a white American to stand against the assumptions of white America. The idea that this is the best of all possible worlds for white people is taught you every day of your life by the schools and the mass media. It was hard to understand that this

society exploits and regiments and destroys white people as well as black people – that it separates them from their brothers and keeps them from understanding what is happening to them. But we learned.

We learned that the same exploitive system which controls the ghetto controls the university. We learned that those men who use the schools to regiment and supply people for their use also profit from the war and demand that we give our lives to crush the Vietnamese people for them. And we learned that we could begin to understand what that enemy is about and that we could name it and we could fight it. That enemy's name is racism and imperialism and we have learned that collectively we can stand against that enemy and say – NO!

I was reading a National Guard handbook the other night which defines a resistance movement as a popular movement against legally constituted authority designed to withdraw the people's support from that authority. It goes on to say that if a resistance movement is not stopped it can lead to insurrection which has popular support among the people. We are building a resistance movement in this country....The biggest anti-draft movement in American history is going on – and those in power fear us for it....A resistance movement is being built, and those in power are beginning to move also – against us.

But the rulers don't understand what we want. In Johnson's State of the Union message we were told that this country has more color TVs than any other country in the world. And because he can't understand why we don't want them his response is to make the National Guard into a national riot squad. He doesn't understand that we can't be bought with color TVs because we are demanding something the master can never give or even understand – we demand freedom. Freedom from the masters who define a world of color TV's and riot control instead of human dignity.

And it is because they can't give what we demand that we are being repressed now. They have begun to understand that we are their enemy, that for us to have our freedom means that they will have to give up their control, their 'American way of life.'

The Man is doing what we could not do for ourselves. He has made meetings like this possible. He has forced the black movement and the white movement together because we all face a common enemy which is determined to destroy us. We cannot allow ourselves to go on the defensive and spend all our time and manpower in the courts. We must continue on the offensive reaching out to more and more people, building a movement which will be the basis for the struggle for a new society free from racism and exploitation. That struggle will not be easy. Many of us will go to jail; others will be killed. But that struggle must continue because we cannot be free until imperialism based as it is on racism and exploitation is destroyed. And we will be free because we will fight for our freedom together – as brothers.[155]

From Houston I went to Austin, and from there Thorne Dreyer, of the *Rag*, and I went on to Albuquerque to attend a New Mexico regional meeting to discuss the Ten Days of Resistance. Jim Kennedy, who I had met while campus traveling in 1965, had organized the meeting and about thirty people came. I talked about coordinating local activity with national action by using the national office as a resource. I encouraged them to decide what they wanted to accomplish and what kind of activity would help them do it. The national office could help coordinate what they were doing with other groups. Thorne talked about power structure research and explained the research we had done that showed that the University of Texas was the ninth largest recipient of research and development money from the Department of Defense. I suggested that they consider coordinating their activity with the Alianza, a Chicano organization representing New Mexicans of Spanish origin. Thorne and I spent a few days in Albuquerque talking with people before he returned to Austin and I flew back to Chicago.

Everywhere I went, the concept of "liberation" was in the air and new groups were organizing. Chicanos were organizing the Alianza in the Southwest, Puerto Ricans were forming the "Young Lords" in New York, and calls for "women's liberation" and "black liberation" were being heard everywhere. Native Americans were organizing, as were farm workers in California. Homosexuals were talking about gay liberation, although it would be another year before the Stonewall rebellion against police harassment in New York marked the beginning of the Gay Liberation Movement. Everywhere I went it felt like we were in the middle of a full-blown rebellion of young people against the war, racism, sexism – and the system that caused these problems. In the national office we worked from early morning to late at night trying to keep up with events and keeping chapters informed about what was happening on other campuses. As these issues and events swirled around us, the situation in the national office was almost surreal. It was easy to forget that the office was different from the chapters. We were like a central switchboard flooded with information from all over the country, while local chapters had a more limited view.

We knew we were under surveillance and that the phones were probably tapped, but we used them anyway. We were careful about what we said on the office phone and used random pay phones when we needed more security. One of the police agencies must have decided that they wanted to know the names of everyone on

our mailing list because an entire issue of New Left Notes "disappeared" for several weeks in the Chicago post office. When members began calling to say they hadn't received their paper, we filed a complaint with the post office. They finally found them and sent them on their way. Since the mailing consisted of many large bundles of papers all sorted by zip code, it seemed unlikely that they had simply misplaced all of them.

Following the December 1967 National Council meeting, PL went on the offensive against the New York regional office, which represented 23 chapters. There were a dozen people on staff working on draft resistance, women's liberation, and high school organizing. There was also a radical theater group and a chapter of Movement for a Democratic Society (MDS) formed by a group of non-students. Using the same tactic they had used against the national office, PL accused the regional office of being "out of touch" and "adventurist" for its role in the demonstrations at the Foreign Policy Association dinner. They proposed that the regional office be put under the oversight of a ten-member regional administrative committee. This was approved by the local membership and four of the ten administrators were PL members. This was a victory for PL's divide-and-conquer strategy and gave them much more control over the regional office than their numbers warranted.

A long article, printed in New Left Notes, explained PL's interpretation of the December National Council meeting and the difference between "base-building" and resistance. Without mentioning any of the many articles written about education and not alienating potential allies, they again portrayed resistance as militant disruption "based on a cynical outlook toward the vast majority of the American people."[156]

Carl Davidson responded to the criticism by calling for an honest debate on the issues. He pointed out that the "build a base" program and the "resistance" program had many similarities and should be able to work together. He went on to say:

> One aspect of the current debate is detrimental to the organization as a whole....[C]ontinuing to couch the debate in a "national" versus "grass-roots" or "local chapter people" dichotomy not only obscures the politics of the debate, but serves to alienate our chapter people from the national office in general....If someone disagrees with Davidson and Calvert, then he should politically attack Davidson and Calvert rather than institutionally attacking the national office..."

After going through PL's criticisms of resistance point by point, Carl concluded that the two programs had many similarities, but there was one clear difference.

> Base-builders" would like to keep student politics <u>confined to the campus</u>. On the other hand, according to Pardun in "Direction of Resistance" (*NLN*, Nov. 6, 1967) "If the organizing is done seriously a base in the community as well as an expanded campus base can be established."...The resistance strategy...is more flexible [than the Worker-Student Alliance] Not only does it allow for mass action, on and off campus, but it allows a wide range of organizing programs in a variety of different communities and workplaces....I will conclude with the remark that base-building is <u>not</u> a program. Rather it is a basic assumption, a <u>given</u> that all serious political workers are interested in, especially us "resistance" folks.[157]

As the National Council meeting in Lexington, Kentucky, approached we were apprehensive about another confrontation with PL. During the spring, PL had been busy in chapters across the country and they would surely have more voting delegates at this meeting. I heard that the Friends of Progressive Labor group was active in Austin and that the meetings were becoming heated debates leading to little action. Wherever people were pushing the "correct line," the days of free wheeling meetings where lots of ideas were put forth and tried were over. The Ten Days to Shake the Empire program was already set in motion and it hardly came up during the meeting. Although PL continued to accuse the national office of manipulation, none of the proposals generated the kind of confrontation we had seen at previous meetings.

Some 300 people gathered in late March for the National Council meeting in Lexington, Kentucky. Carl Davidson, Cathy Wilkerson and I presented a resolution calling for increased activity around the draft and several other anti-draft proposals also came to the floor. The main thrust of all of them was that the US had over-extended itself in Vietnam as it tried to defend its imperialist policies. Since the military draft was the main way that US imperialism impacted young people, it opened a door for us to reach young working class men as well as students.

The National Council debated SDS's relationship to the working class and poor people, GIs, high schools, and most of all blacks. The struggle of black people was seen as pivotal to the movement for social change in America because racism was part of every issue. Poverty, unemployment, sub-standard housing, education, the war, and government repression all had a racial component. Stokely

Carmichael from SNCC had summed up the racist nature of the war when he said that the draft was, "white people sending black people to make war on yellow people in order to defend the land they stole from red people."[158]

Noel Ignatin, a skilled machinist at the International Harvester plant, continued this discussion with a speech about his experience with racism and the working class. He noted that in his plant half the work-force was black but that all the skilled machinists were white. White workers had privileges because they were born white. They expected good jobs, good schools, and fair pay – and got them by just learning the necessary skills. Black people and other people of color didn't share those privileges. White workers were on the top of the labor market and equal job opportunity for blacks was against their perceived interests because it meant fewer jobs for whites. Noel argued that PL's Worker-Student Alliance could actually be harmful if it didn't challenge "white skin privilege."

––––––––––

A day or so after the National Council meeting, President Johnson gave a televised speech to the nation in which he surprised everyone by announcing, "I will not seek, and I will not accept, the nomination of my party for the Presidency of the United States." The war, which Johnson had not wanted at the beginning, which he could have backed out of in 1965, but which he vigorously pursued anyway, had derailed his presidency. He had hoped to be remembered as the president who carried on the legacy of Franklin Roosevelt. He had initiated and signed major civil rights legislation and had wanted to help the poor with his War on Poverty, but the cost of the Vietnam War made that impossible. The Congress knew what to do when given a choice between using tax money to help the poor and putting it into the pockets of defense contractors. As his War on Poverty was de-funded and he heard us chant "Hey, hey, LBJ. How many kids did you kill today?" he must have wondered why this was happening to him.

Earlier that spring, President Johnson had facing a rebellion by antiwar forces within his party. In March, Senator Eugene McCarthy, running on a peace platform, won 42 percent of the vote in the New Hampshire primary. This major challenge to Johnson's campaign shook his confidence. Soon after, Robert Kennedy announced that he, too, would run. With both McCarthy and Kennedy running on platforms which included ending the war; it seemed to us that there was some hope that people against the war

would at least have a candidate to support in the fall elections. Student support for Eugene McCarthy and Robert Kennedy was strong as some people tried one more time to make the system work.

In late March, Mike Spiegel and I attended a meeting of some 200 people in Chicago to discuss possible antiwar action at the Democratic National Convention, set for August in Chicago. The coverage of this meeting in my FBI file indicates that it was heavily infiltrated. Other SDS members were also present, including: Cathy Wilkerson from the Washington DC regional office, Rennie Davis from the JOIN project on Chicago's north side, and early SDS activists Paul Potter, Tom Hayden, Lee Webb, and Clark Kissinger. Dave Dellinger, from the Mobilization, was there, as were representatives from Women's Strike for Peace, the California Peace and Freedom Party, the Communist Party, and the Yippies. The discussion ranged over a variety of approaches to the convention and the coming presidential elections. Some people wanted to support either McCarthy or Robert Kennedy, while others wanted to use the opportunity to reach out to the young people who were working in those campaigns.

Many of us had lost faith in the two-party system and saw the elections as a diversion. McCarthy's chances of winning the nomination for President were zero, because vice president Hubert Humphrey already had the support of the delegates. Moreover, many people in the antiwar movement weren't old enough to vote – the voting age was twenty-one at that time. The average age of the soldiers in Vietnam was nineteen and they couldn't vote either. SDS opposed demonstrations at the convention while the Yippies were planning a gathering called the "Festival of Life." The meeting was long and tortuous as this tremendously diverse group of people tried to find common ground in showing opposition to the war. The groups were so different that I didn't see how any unified action could be agreed upon. There was no conclusion other than to call another meeting for June.

On April 4, 1968, a few days after LBJ's withdrawal speech, Martin Luther King was killed by a sniper in Memphis. It was a shock, but not a surprise. Dr. King had come out strongly against the war the previous spring and was in Memphis to help the garbage workers, who were all black, in their strike for decent wages. The combination of being an outspoken civil rights leader, supporting striking black workers, and being against the war made King a target.

While Dr. King is now recognized as a national hero, that wasn't true at the time. He was vilified by many people including J. Edgar Hoover of the FBI. Hoover hated Dr. King and had the FBI put wiretaps on his phones and listening devices in his office. Hoover released slanderous information to the press. At one point the FBI sent King a letter saying that they had recordings of him engaging in sexual acts and that if he wanted to do the right thing he should commit suicide.[159] The investigation of King's assassination by the FBI concluded that James Earl Ray was the lone assassin. When Ray was caught he admitted that he was part of a conspiracy to kill King, but said that he didn't pull the trigger.

The morning after King's death, as I walked to the SDS office, I noticed that all the businesses had their steel grates pulled down and locked. The west-side black ghetto, a block from the office, seemed strangely quiet. Mike James and some of the young guys from Uptown JOIN, the SDS-ERAP project on the mostly white near-north side, were in the office and, as we talked about King's murder, a sound like people murmuring began to come from the west. From the window we could see that the street about three blocks away was completely filled with people heading our way. Soon the street outside our office was filled with angry black people, many of who were breaking into stores and taking things. Mike and the guys from Uptown went out to talk with the people and were welcomed by the crowd. About a block beyond the office the crowd broke into the Woolworth's and took everything that could be carried off before retreating back into the ghetto. Soon we began to see smoke coming from the ghetto and heard the wail of many police and fire department sirens

The police arrived with orders from Mayor Daley to "shoot to kill" anyone committing arson and "shoot to maim" looters.[160] As the riot continued into the next day, the police were replaced by truckloads of National Guard troops who used the street in front of our building as a staging area. We were on the second floor and could lean out the window and talk to the soldiers. We hurriedly printed up short easy-to-read leaflets explaining why the ghetto was in flames and encouraging them to shoot high if they had to shoot. When we passed them out to the Guard, most of them were very friendly and gave us the V-sign, the universal salute of the peace movement. Many young men joined the National Guard as a way of getting out of going to Vietnam and it probably never crossed their minds that they would be involved in military action in the streets of

America. In the office the phone was ringing constantly as news about uprisings, rallies, marches, and vigils came in from all over the country.

As the ghetto went up in flames, the Guard was pulled out and the regular army arrived. Now we had the infantry with a tank in the street and a machine gun set up in the Woolworth's. We could hear shots here and there and heard on the radio that there were snipers shooting at the army. From the windows we could see flames and smoke rising into the sky as buildings in the ghetto burned. Word came in that the guys in Uptown were also causing a disturbance in order to draw some of the police away from the black area.

I had been on the phone all day and was hungry, so I decided to walk to the staff apartment a couple of blocks away to get a sandwich. I walked out the front door and hadn't gone ten feet when five soldiers in full combat gear came running toward me and surrounded me with their bayonets a couple of inches from my body. An officer, who looked very angry, ran over and yelled in my face, "Let me see your draft card!" By law, all men had to carry their draft card at all times. I dug my card out of my wallet and handed it to him. He looked at it in disgust, handed it back to me and told me to move on. I was glad I hadn't burned it. I walked to the apartment, had a peanut butter sandwich, and started back. As I rounded the corner, a big guy in civilian clothes came running straight at me with a pistol in his hand. I stepped off the sidewalk, he ran past as if he hadn't seen me, and I continued on back to the office. When I got there, Mike Speigel was on the phone assuring his mom that he was safe. He was facing away from the window and when he turned around he found himself looking straight down the barrel of the tank in front of the office. It was obvious that the Army knew who we were.

Following King's assassination there were insurrections in 125 cities and 75,000 Federal and National Guard troops were called out. By the time it all ended, 46 people were dead, 20,000 arrested and millions of dollars of damage done as whole sections of cities were burned and looted. In Chicago there were four killed and 48 wounded. Although King's murder set off ghetto uprisings on a larger than usual scale, there had been rebellions across the country during the summer months for a number of years. It felt as if the black community was on the edge of nationwide insurrection.

After the uprising in Chicago died down, we geared up for the Ten Days of Resistance planned for April 10-20 and for a national

student strike called by the Mobilization for about the same time. As the end of April approached, we began to hear of rallies, marches, teach-ins, and sit-ins all over the country.

True to SDS tradition the actions reflected the spirit of the local chapters. In Austin there was an anti-State Fair sponsored by SDS and a number of other groups opposed to the war. There were anti-draft booths, a giant war monopoly game, plays, guerrilla theater, and another Gentle Thursday. Ex-Green Beret Donald Duncan, who had served in Vietnam and was one of the early GI opponents of the war, spoke about the war. The whole thing was followed by a festive goat roast. Austin again came through with a non-traditional protest that again increased support for the antiwar movement. Unfortunately, both pro-PL and anti-PL forces more or less undercut its success, each determined that the other shouldn't get credit for anything.

On a national level, in spite of increased division within SDS, the antiwar movement was strong and growing. The National Student Strike succeeded in keeping about a million students away from classes. On April 27, 150,000 people demonstrated in New York and 25,000 in San Francisco. In Chicago, the police waded into a peaceful march, cracking heads and ribs, while Mayor Daley's spokesman stated that, "These people have no right to demonstrate or express their views."[161] For the people who were planning the demonstration in Chicago during the August Democratic Convention, this was a strong warning of what was to come.

By late April there was open rebellion at Columbia University as several different protest movements converged. One thread was the SDS chapter's opposition to Columbia's connection to the Institute for Defense Analysis (IDA), an off-shoot of the Defense Department that was coordinating the efforts of twelve universities involved in weapons research. This research included evaluating counter-insurgency methods used in Vietnam for possible use in American cities. At the same time, black students were organizing against racism – of 7,000 students at Columbia only 70 were black. Finally, the university was planning to build a gymnasium in Morningside Park, a public park serving the black and Latino neighborhoods adjacent to the university. The gym construction site was the focus of demonstrations by the community, the black students, and SDS.

The factional struggle within the Columbia SDS chapter between what was called the "Praxis Axis" and the "Action Faction" was also

in full swing. The Praxis Axis believed in organizing through education, peaceful demonstrations, and debate. The Action Faction believed that confronting power created a situation that would draw people into the movement. The Praxis Axis tended to include the older members, while the Action Faction was made up more of younger, more recent recruits to SDS, several of whom had been arrested at the Foreign Policy demonstration the previous November.

In late March, Mark Rudd, part of the Action Faction, led a hundred people into Low Library, the administration building, with a petition calling for an end to Columbia's involvement with the IDA. The president, Grayson Kirk, refused to respond to the petition and started disciplinary proceedings against some of the demonstrators. Five days after Martin Luther King's assassination, Grayson Kirk held a memorial service for King. As Kirk was preparing to speak, Mark Rudd walked up onto the stage, took the microphone, and told the crowd that an institution which was stealing land from the black community and doing research on riot control through its IDA contracts had no business holding a memorial for Dr. King. He then led a walk-out of the service.

On April 22, six Columbia students, including Mark, were put on probation because of the demonstration in Low Library. SDS held a large rally at the center of campus and members of the black students' group, people against the new gym, and SDS members all marched to the gym construction site where they began tearing down the construction fence. After a confrontation with security guards, the students moved back onto the campus and occupied Hamilton Hall, which the black students renamed Malcolm X Hall.

After hours of discussion inside the building, it was decided that Hamilton Hall would be left in the hands of the black students. In the middle of the night, other students went to Low Library, where they easily pushed past the lone guard and went upstairs to occupy the administrative offices. In Grayson Kirk's office, students searching through his files discovered documents that proved their allegations that the university was deeply involved in military and CIA activity. There were documents from high level meetings with the CIA-funded Council on Foreign Relations, which elaborated on CIA and covert military activities and the use of American universities for their activities. Jeff Shero, from Austin and from the underground paper, *RAT*, was one of the people in Kirk's office. He took the incriminating files, tied them together, and threw them out

the window to Alice Embree, also from Austin, who was waiting in the street below. She took them to the *RAT* office where they were examined and published. Over the next two days a thousand students took over another three buildings. PL joined this confrontation and helped to run "strike central," the communications network.

The national office was in contact with people inside the buildings at Columbia throughout the strike. We did our best to keep the other chapters informed about the situation and about what had been found in President Kirk's files. We hoped the slogan "Two, Three, Many Columbias" would encourage other chapters to challenge their universities around similar issues.

On April 29, the police were called in by the university. Students and faculty who were not occupying the buildings rushed to the campus to try to block the police, but they were attacked and beaten viciously, resulting in serious injuries. The police then attacked the buildings and the occupation ended with 700 arrested and 200 injured. Again the students were on the receiving end of the violence and did not resist. The students, appalled by the brutality of the police and that the university had used them, called a very effective student strike that crippled the university and forced the administration to end spring term early. A leaflet handed out on campus summed up student sentiment:

> A university which designs weapons for the Pentagon and the police, steals public park land to build a segregated gym, throws community residents out of their homes, and calls the cops to beat its students cannot be allowed to carry on its business as usual!

Students at Columbia were radicalized when their reasonable demands were met with police billy-clubs. The bold tactics of the Action Faction attracted new people to the movement.

What wasn't clear to me, however, was the depth of that understanding. Carl Davidson and I, among others, had tried to spell out a definition of resistance that pointed toward a positive way of reaching new constituencies. I was concerned that people who joined the movement because of action wouldn't understand what was needed to educate people and build a solid movement. Militant action is thrilling and addictive, but if the goal of educating people is forgotten it's isn't far from there to "running in the streets and breaking windows" as PL was fond of putting it.

The rebellion of young people against the dominance of the Cold War ideology was spreading around the world. In April we heard

that students and workers had taken to the streets in France. There were pictures of barricades and battles with the police, and rumors that France was on the verge of a popular revolution. There were photos from Japan of the Zengakuren, a student organization, fighting the police as they tried to stop a farming area from being turned into a landing strip for US planes on their way to Vietnam. There were photos and news stories from Germany about the actions of German SDS (same initials but a different meaning). In Korea, students were throwing fire bombs at the police and in England students were sitting-in for power at the universities. Greek students were fighting against the US backed military dictatorship, Mexican students were rebelling, and in Prague, Czechoslovakia, students were fighting Soviet control. Young people were in the forefront of all these rebellions. The Cuban poster in the SDS office summed it up with the slogan, "Youth will make the revolution!"

As I talked with the people in the national office and around the country, the concept of young people as a potential revolutionary force came up over and over again. We knew that we needed to get the white working class on our side because they were critical to the smooth running of the country and also the war. Talking with older workers about racism and imperialism was difficult, however, because much of their prosperity came from white skin privilege. In addition, most of them didn't support our antiwar protests even if they were opposed to the war. But we also knew that many SDS members were the sons and daughters of the working class and that more were joining every day. The more young people became active the more it looked to us that the way to the industrial working class was through their children – both in and out of the universities. The concept of a revolutionary youth movement was in the air.

On June 5, presidential candidate Robert Kennedy was shot and killed by another lone crazy and another option for changing things within the system died. Kennedy, who wanted peace in Vietnam, was shot right after giving his victory speech following an important win against Hubert Humphrey in the California primary. Humphrey had the backing of Lyndon Johnson's Democratic machine and the support of a majority of the delegates to the convention. Kennedy appeared to be the only candidate who could possibly beat Humphrey at the Democratic convention and then beat Nixon in the general election. Although Senator Eugene McCarthy continued in the race as a peace candidate, he was never a serious challenger

and it was now certain that the choice in the 1968 presidential election would be between Hubert Humphrey and Richard Nixon.

This assassination had little impact on me. I wasn't surprised when Bobby Kennedy was killed because it seemed that the actions of the government both at home and abroad were directed at beating the opposition into silence. Any voice which became too loud against racism or the war would be silenced – by whatever means necessary. I had lost all faith in the possibility of real change coming about through elections. As I said at the time, "What it comes to is that the only way to stop the war is to make a revolution, and the only way to stop racism is to make a revolution."[162] I also knew that there wasn't going to be a revolution in America any time soon.

SDS Under Attack

Summer 1968

> "[The pro-Chinese parties] are able to attract honest and resolute militants, thanks to their programs and their premises. Very soon, however, their method of work...[and] the noisy opportunism of their political line...lead the revolutionary strata, principally the youth, to abandon them."
>
> Regis Debray, *Revolution in the Revolution?*

We knew the government was on the offensive because news of indictments, arrests, and violent attacks came in to the office almost daily. We thought this was mostly the result of independent local repression and didn't realize until much later the extent to which this was a coordinated FBI effort to destroy the movement.[163]

The FBI had been watching me since the summer of 1964 when they opened a file on everyone who joined Mississippi Freedom Summer. They had been gathering information about SDS since at least 1965 when they had a tap on the SDS office phone and noted license plates at the national convention at Kewadin. This surveillance and information gathering continued for the next several years as the anti-war movement and the black movement gained momentum. In 1968 J. Edgar Hoover began to use the information he had gathered to destroy SDS, the antiwar movement, and the black liberation movement – particularly the Black Panthers.

Hoover already had experience destroying leftist organizations. Following World War II he had developed a Counter-Intelligence Program (COINTELPRO) to "cripple or destroy" the American Communist Party.[164] During the spring of 1968 he ordered FBI field offices to take the information they had gathered and use it to identify "individuals who have demonstrated a potential for fomenting discord."[165] Those individuals were then listed in the Rabble Rouser Index of people who would need to be "neutralized" in order to destroy the movement. In March 1968 this index was renamed the Agitator Index. Other special lists were also created,

such as the Key Activists Index with names of "individuals who are the moving forces behind the New Left and on whom we have intensified our investigations."[166] I was included in these indexes, probably because I was an SDS officer who already had a substantial FBI file from Texas and Mississippi.

The Rabble Rouser Index.

Late in the spring of 1968, the House Committee on Un-American Activities (HUAC), which had been investigating the New Left, issued a report claiming that SDS was planning guerrilla-type

operations against the US government. In response, the Internal Security Act of 1950 was modified to allow for "preventive detention" of people deemed dangerous to US security. All the people who were listed in the various indexes being created fit that description and FBI Agents were ordered to maintain "high level informant coverage" of these "agitators" so that we could be picked up whenever the government thought it necessary.[167]

Relet instructed that a survey be made of the informant coverage available to us on the subject. Such a survey has not been furnished. This should be done by return mail. It should not contain merely a listing of the informants who have furnished information on the subject but should note these sources who are closely associated with him and the nature of this association. The frequency the informant is able to furnish information should also be noted. This survey should contain a frank evaluation of the day-to-day coverage you are able to afford the subject along with your plans for improving the coverage if needed.

Despite the subject's activities no recommendation has been received from you for including him on the Agitator Index. This should be done promptly.

In evaluating this case, you should bear in mind that one of your prime objectives would be to neutralize him within the new left movement. The Bureau will entertain recommendations of a counterintelligence nature to accomplish this end. You should, therefore, furnish the Bureau with your suggestions as to how this might be accomplished. Take no positive action, however, in this regard until you have received specific Bureau approval.

In view of the subject's active leadership in the new left movement, it will not be acceptable to furnish this investigation cursory attention. You will be expected to pursue it aggressively and with imagination. Your reporting should be complete and prompt.

Pardun was designated a key activist by Bureau letter 1/30/68 based upon his leadership in the SDS and anarchistic activity. A review of his file has been made as a result of recent events taking place on various college campuses throughout the nation. The Chicago office is being furnished with the above observations in order that a more aggressive investigation of the subject may be instituted and to assure that the Bureau is fully apprised of the subject's activities.

Letter from FBI headquarters ordering acceleration of my case (re-typed).

As the war escalated, so did the government's attack on the antiwar movement. J. Edgar Hoover branded the New Left, and SDS in particular, as un-American.

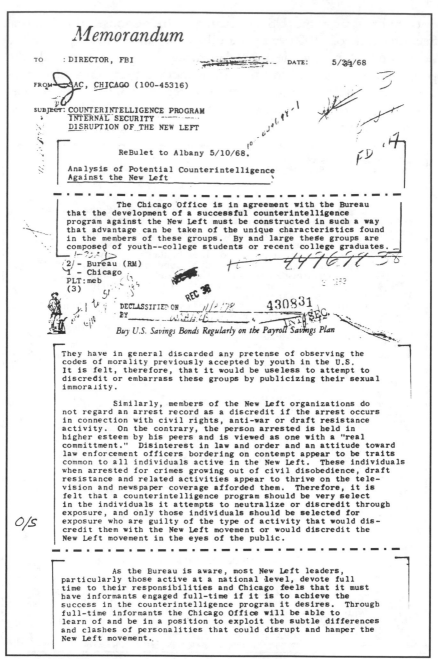

Memorandum

TO : DIRECTOR, FBI DATE: 5/29/68

FROM : SAC, CHICAGO (100-45316)

SUBJECT: COUNTERINTELLIGENCE PROGRAM
 INTERNAL SECURITY
 DISRUPTION OF THE NEW LEFT

 ReBulet to Albany 5/10/68.

Analysis of Potential Counterintelligence
Against the New Left

 The Chicago Office is in agreement with the Bureau
that the development of a successful counterintelligence
program against the New Left must be constructed in such a way
that advantage can be taken of the unique characteristics found
in the members of these groups. By and large these groups are
composed of youth--college students or recent college graduates.

2 - Bureau (RM)
1 - Chicago
PLT:meb
(3)

DECLASSIFIED ON 430831
BY

Buy U.S. Savings Bonds Regularly on the Payroll Savings Plan

They have in general discarded any pretense of observing the
codes of morality previously accepted by youth in the U.S.
It is felt, therefore, that it would be useless to attempt to
discredit or embarrass these groups by publicizing their sexual
immorality.

 Similarly, members of the New Left organizations do
not regard an arrest record as a discredit if the arrest occurs
in connection with civil rights, anti-war or draft resistance
activity. On the contrary, the person arrested is held in
higher esteem by his peers and is viewed as one with a "real
commitment." Disinterest in law and order and an attitude toward
law enforcement officers bordering on contempt appear to be traits
common to all individuals active in the New Left. These individuals
when arrested for crimes growing out of civil disobedience, draft
resistance and related activities appear to thrive on the tele-
vision and newspaper coverage afforded them. Therefore, it is
felt that a counterintelligence program should be very select
in the individuals it attempts to neutralize or discredit through
exposure, and only those individuals should be selected for
exposure who are guilty of the type of activity that would dis-
credit them with the New Left movement or would discredit the
New Left movement in the eyes of the public.

 As the Bureau is aware, most New Left leaders,
particularly those active at a national level, devote full
time to their responsibilities and Chicago feels that it must
have informants engaged full-time if it is to achieve the
success in the counterintelligence program it desires. Through
full-time informants the Chicago Office will be able to
learn of and be in a position to exploit the subtle differences
and clashes of personalities that could disrupt and hamper the
New Left movement.

COINTELPRO memorandum about the nature of the New Left.

The nature of the New Left, however, made it difficult for the
FBI to figure out how to repress us. SDS, and the New Left in
general, was very different from the old left organizations the FBI

had targeted in the past. Our meetings were open, but our membership was difficult to determine. Some people paid their dues and became official SDS members, but membership in SDS and the movement was really a state of mind. Anyone who shared our ideas and joined in our activities was considered to be one of us. To complicate matters for the FBI even more, the counter-culture overlapped the New Left and challenged a wide range of America's cultural assumptions, from hair length, dress codes, drugs, marriage, the work ethic, and the nature of academic education – as well as racism and the war. Hoover understood this, and wrote in 1966 that the New Left was:

> ...a new style of conspiracy – a conspiracy that is extremely subtle and devious and hence difficult to understand...a conspiracy reflected by questionable moods and attitudes, by unrestrained individualism, by non-conformism in dress and speech, even by obscene language, rather than by formal membership in specific organizations.[168]

Because we held different values, we were less vulnerable to the kinds of moral and economic pressures the FBI liked to use – so they tried other methods.

A memo dated May 9, 1968 from J. Edgar Hoover to the FBI field offices officially started COINTELPRO, the FBI's counter-intelligence program, against the New Left, the black movement, and the antiwar movement.[169]

> The purpose of this program is to expose, disrupt, and otherwise neutralize the activities of this group and persons connected with it.

It called for all offices to submit an analysis of possible counter-intelligence operations on the New Left and on the Key Activists by June 1, 1968. Another memo dated July 5, 1968 and titled "Disruption of the New Left"[170] included suggestions such as:

> • The instigation of or the taking advantage of personal conflicts or animosities existing between New Left leaders.

> • The creating of impressions that certain New Left leaders are informants for the bureau or other law enforcement agencies.

> • Since the use of marijuana and other narcotics is wide spread among members of the New Left, you should be alert to the opportunities to have them arrested by local authorities on drug charges.

> • [A]nonymous letters regarding individuals active in the New Left. These letters should set out their activities and should be sent to their parents, neighbors, and the parents' employers.

> • Anonymous letters or leaflets describing faculty members and graduate assistants...who are active in New Left matters. Anonymous mailings

should be made to university officials, members of the state legislature, Board of Regents, and to the press. Such letters could be signed "A Concerned Alumni" or "A Concerned Taxpayer."[171]

● There is a definite hostility among SDS and other New Left groups toward…the Progressive Labor Party (PLP). This hostility should be exploited wherever possible.

● Be alert for opportunities to confuse and disrupt New Left activities by misinformation. For example, when events are planned, notification that the event has been canceled or postponed could be sent to various individuals.

```
                                          1 - Mr. DeLoach
   SAC, Albany                            1 - Mr. Felt
                                             7/5/68

                                          1 - Mr. Bishop
   Director, FBI (100-449698)             1 - Mr. W.C. Sullivan
                                          1 - Mr. C.D. Brennan
  COUNTERINTELLIGENCE PROGRAM             1 -
  INTERNAL SECURITY                       1 -
  DISRUPTION OF THE NEW LEFT
  (COINTELPRO - NEW LEFT)

            Bulet 5/10/68 requested suggestions for counter-
   intelligence action against the New Left. The replies to
   the Bureau's request have been analyzed and it is felt that
   the following suggestions for counterintelligence action can
   be utilized by all offices:

            1.  Preparation of a leaflet designed to counter-
   act the impression that Students for a Democratic Society
   (SDS) and other minority groups speak for the majority of
   students at universities. The leaflet should contain photo-
   graphs of New Left leadership at the respective university.
   Naturally, the most obnoxious pictures should be used.

            2.  The instigating of or the taking advantage of
   personal conflicts or animosities existing between New Left
   leaders.

            3.  The creating of impressions that certain New
   Left leaders are informants for the Bureau or other law
   enforcement agencies.

            4.  The use of articles from student newspapers
   and/or the "underground press" to show the depravity of
   New Left leaders and members. In this connection, articles
   showing advocation of the use of narcotics and free sex are
   ideal to send to university officials, wealthy donors,
   members of the legislature and parents of students who are
   active in New Left matters.

            5.  Since the use of marijuana and other narcotics
   is widespread among members of the New Left, you should be
   alert to opportunities to have them arrested by local
   authorities on drug charges. Any information concerning the

   2 - All Field Offices

                                          SEE NOTE PAGE THREE
```

COINTELPRO document from the FBI director on the disruption of the New Left.

fact that individuals have marijuana or are engaging in a narcotics party should be immediately furnished to local authorities and they should be encouraged to take action.

6. The drawing up of anonymous letters regarding individuals active in the New Left. These letters should set out their activities and should be sent to their parents, neighbors and the parents' employers. This could have the effect of forcing the parents to take action.

7. Anonymous letters or leaflets describing faculty members and graduate assistants in the various institutions of higher learning who are active in New Left matters. The activities and associations of the individual should be set out. Anonymous mailings should be made to university officials, members of the state legislature, Board of Regents, and to the press. Such letters could be signed "A Concerned Alumni" or "A Concerned Taxpayer."

8. Whenever New Left groups engage in disruptive activities on college campuses, cooperative press contacts should be encouraged to emphasize that the disruptive elements constitute a minority of the students and do not represent the conviction of the majority. The press should demand an immediate student referendum on the issue in question. Inasmuch as the overwhelming majority of students is not active in New Left matters, it is felt that this technique, used in carefully selected cases, could put an end to lengthy demonstrations and could cause embarrassment to New Left elements.

9. There is a definite hostility among SDS and other New Left groups toward the Socialist Workers Party (SWP), the Young Socialist Alliance (YSA), and the Progressive Labor Party (PLP). This hostility should be exploited wherever possible.

10. The field was previously advised that New Left groups are attempting to open coffeehouses near military bases in order to influence members of the Armed Forces. Wherever these coffeehouses are, friendly news media should be alerted to them and their purpose. In addition, various drugs, such as marijuana, will probably be utilized by individuals running the coffeehouses or frequenting them. Local law enforcement authorities should be promptly advised whenever you receive an indication that this is being done.

11. Consider the use of cartoons, photographs, and anonymous letters which will have the effect of ridiculing the New Left. Ridicule is one of the most potent weapons which we can use against it.

12. Be alert for opportunities to confuse and disrupt New Left activities by misinformation. For example; when events are planned, notification that the event has been cancelled or postponed could be sent to various individuals.

You are reminded that no counterintelligence action is to be taken without Bureau approval. Insure that this Program is assigned to an Agent with an excellent knowledge of both New Left groups and individuals. It must be approached with imagination and enthusiasm if it is to be successful.

COINTELPRO New Left document (continued from previous page).

The FBI was not alone in its efforts to destroy the movement. The CIA had at least three domestic programs in operation. Both Army and Navy Intelligence were collecting information and working to disrupt the antiwar movement. Many state and local governments had their own intelligence gathering agencies. The

Austin, Chicago, and Detroit police all kept files on me, as did the
Mississippi Sovereignty Commission and the University of Texas. In
the United States there were many "Big Brothers" watching – and
some of them were doing more than just watching. In some places
the FBI took an active role in coordinating all these groups to
maximize their destructive potential.[172]

One of the FBI's earliest COINTELPRO-NEW LEFT actions
took place in May, shortly after Jeff Segal returned to Chicago from
a trip around the country. Jeff had been involved in Stop the Draft
Week in Oakland and had helped plan the mobile tactics that
eventually closed the induction center. Later, as he traveled around
the country, he stopped in Greensboro, NC, for a speaking
engagement and while there, joined a sit-in at the university
president's house. He was in New York at the time of the Columbia
University strike. When he returned to Chicago, he joined a sit-in at
Roosevelt University, where he had been the editor of the student
paper. Jeff had only been back in Chicago a few days, when his
lawyer called to tell him that he was to appear before a federal judge
about the appeal of his conviction for draft evasion. Jeff had refused
induction in 1965 and had been sentenced to four years in prison,
but was out on bond while he appealed the decision on the grounds
that the induction notice was illegal. Jeff's lawyer assured him that
this was a routine hearing and that it shouldn't take long, so Jeff,
Marilyn Buck, and I went to the Federal Court House with plans to
see a movie after the hearing.

The judge called Jeff up to the bench, and began to read a
detailed list of all the places in the country where Jeff had been
during the last six months. When he finished reading, he looked
down at Jeff and said that he believed Jeff had appealed not because
he was innocent, but because he wanted more time to cause trouble.
The judge's final statement took us all totally by surprise,
"Therefore, I find your appeal to be frivolous and hereby revoke
bond and place you into immediate custody." We looked at Jeff and
he looked at us as the guards led him out the back door and into the
prison system. Jeff was taken first to Cook County Jail and then sent
to the federal maximum-security prison in Springfield, Illinois. He
was later transferred to a minimum-security federal prison in
Safford, Arizona, where he served the remainder of his four-year
sentence.

An entry in my FBI file refers to the revocation of Jeff's bond as
one of the effective actions of COINTELPRO and recommends that

similar actions be taken wherever possible. Interestingly, this information was not in the FBI files released to Jeff Segal. My file has the following:

> The Chicago Office [of the FBI]...determined that ▓▓ had been arrested both in California and New York while participating in anti-draft activities. This information was immediately furnished to [the US Attorney's office who] filed a motion with US District Judge James B. Parsons, Chicago, to revoke ▓▓▓ appeal bond based on the fact that ▓▓ had left the jurisdiction of the court without permission....Judge Parsons revoked ▓▓▓ appeal bond and ▓▓▓ was ordered into immediate custody on May 27, 1968, to begin serving a four year prison term."

Memorandum

TO · DIRECTOR, FBI DATE: 5/29/68

FROM — SAC, CHICAGO (100-45316)

SUBJECT: COUNTERINTELLIGENCE PROGRAM
 INTERNAL SECURITY
 DISRUPTION OF THE NEW LEFT

Appropriate recommendations regarding any informant found possessing the requirements suitable for his utlization in the New Left movement on a full-time basis will be submitted under the individual case captions of the informants.

Recommendations

Experienced agents of the Chicago Office who have conducted investigations in the New Left movement since its inception recommend the following counterintelligence Program:

1. That the Chicago Office continue in every possible way to see that quick and decisive prosecutive action is taken against all members of the New Left for all violations of law. It is believed that prosecutive action is most effective in accomplishing the desired disruption of the organized activity of these groups.

Chicago will continue to follow closely the activities of all individuals engaged in the New Left movement to uncover any possible violations of law committed by these individuals. Particular attention will be given to possible violations of the Selective Service Act and any violations of local law concerning which the police may take action.

With respect to the above, the Bureau is requested to note that during the latter part of 1966 ▓▓▓▓▓▓ (BUfile 100-439955,CGfile 100-39357) was convicted for violation of the Selective Service Act and subsequently was released on appeal bond. The Chicago Office in closely following this case, especially ▓▓▓▓ day-to-day activities, recently determined that ▓▓▓▓ had been arrested both in California and New York while participating in anti-draft activities. This information was immediately furnished to AUSA DAVE HARTIGAN, USA's Office, Chicago,

who in turn filed a motion with U.S. District Judge JAMES B. PARSONS, Chicago, to revoke ▓▓▓ appeal bond based upon the fact that ▓▓▓ had left the jurisdiction of the court without permission.

In view of the above, Judge PARSONS revoked ▓▓▓ appeal bond and ▓▓▓ was ordered into immediate custody on May 27, 1968, to begin serving a four year prison term.

FBI document about a successful COINTELPRO operation against Jeff Segal.

As the FBI tried to come up with a special COINTELPRO program to disrupt the national office and the key activists, they decided that they needed live informants in the office to work with us and gather information first hand. An FBI memorandum dated May 17, 1968, says:

> Chicago continues to remain alert for imaginative and resourceful techniques to provide coverage of the activities of SDS leaders consistent with the ultimate goal of prosecutive action. Chicago believes that such coverage at this time can best be obtained through the use of live informants.

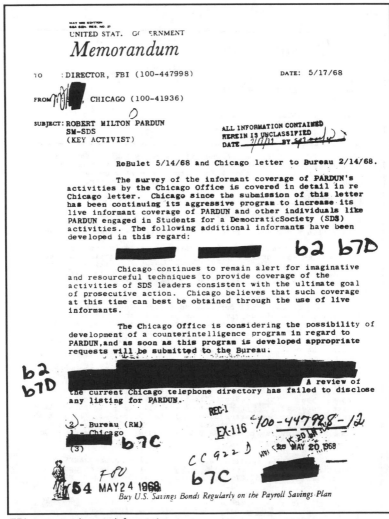

FBI memorandum on informants.

UNITED STATES GOVERNMENT

Memorandum

TO : DIRECTOR, FBI DATE: 5/29/68

FROM : SAC, CHICAGO (100-45316)

SUBJECT: COUNTERINTELLIGENCE PROGRAM
 INTERNAL SECURITY
 DISRUPTION OF THE NEW LEFT

 ReBulet to Albany 5/10/68.

 Analysis of Potential Counterintelligence
 Against the New Left

 (3) That the Chicago Office be authorized to contact
Internal Revenue Service (IRS) on a local level regarding the
income tax returns of key activists in the Chicago Division
to determine if they have submitted federal income tax returns
and if so have made any fraudulent entries as compared with
known background.

 The following key activists are located in the
Chicago Division:

b7C BUfile 100-447549
 BUfile 105-157629
 BUfile 100-443916

b7C BUfile 100-440138
 ROBERT MILTON PARDUN, BUfile 100-447998
 BUfile 100-447957

 It is noted that all of these individuals have been
active in the leadership of New Left organizations and that they
have been involved in the financial transactions of these groups.
It is not believed that their financial records will bear close
scrutiny and the possibility exists that they may not have
filed any tax returns in recent years.

 The IRS is already conducting a searching examination
of the financial records of SDS and it is believed that IRS would
be happy to extend its examination to include the income tax
returns of the above mentioned key activists.

 If the IRS could uncover violations of the law in the
tax returns of these key activists any legal action brought
against them would disrupt the New Left movement because these
individuals are the driving force in the organizations with
which they are affiliated.

 The Chicago Office can assure the security of this
IRS contact if approved.

Chicago FBI plans to use the IRS in its attack on the SDS national office.

The FBI tried many different ways of stopping us, most of which
involved breaking the bonds of trust that were so important to the
movement. They encouraged factionalism, created divisions where
none existed, and exploited existing divisions by sending anonymous
letters, handing out phony leaflets, and even creating cartoons to
satirize New Left members – all supposedly from students or other
members of the New Left.

The FBI launched rumor campaigns to destroy potential
coalitions and gave information to university administrations that

they hoped would result in the firing of leftist professors. They sent people death threats to scare them into inactivity. They contacted landlords, employers, and parents. They arrested people on trumped up charges. They called people to testify before grand juries and then tried to create the impression that the person had either given information or was an agent. FBI agents were encouraged to exploit divisions between organizations, in particular the rift between Progressive Labor and SDS.

The FBI, however, was capable of far more than rumor-mongering. They sent people into the movement to disrupt meetings and to act as provocateurs by advocating violent action at meetings or encouraging violence at demonstrations. In several situations they offered to show people how to use explosives and even provided access to the materials needed. The FBI gloated that their attempts to provoke violence between black organizations had been successful and resulted in black activists being killed.[173] They had no qualms about killing black activists or jailing them on false charges, and they worked closely with local and state police departments, encouraging them in their efforts. Because the FBI has refused to release the details of its activities as they attempted to stop us, we may never know the extent to which the history of the movement was changed by their actions.[174]

The FBI also wanted to see if they could get national leaders, including me, for tax evasion. After a careful audit, the IRS told them that during my year in the national office I had made less than $200 and didn't owe any taxes.

As the FBI consolidated information about me into the Security Index, they went to my draft board to see if there was any way to charge me with draft evasion. They must have found the report from my pre-induction physical in which I was given a 4-Y psychological deferment because, "Pardun smokes marijuana once every month or two, is definitely not an addict." They reworded this to read, "PARDUN SHOULD BE LISTED AS DANGEROUS IN VIEW OF DIAGNOSED DRUG USE AND PSYCHIATRIC STATUS" and from then on the FBI put that statement – in capital letters – at the top of each of my file entries. I'm sure that this put me in some danger of being shot by an FBI agent, afraid that he would be attacked by a drug-crazed radical.

Late in May, SDS staff member Tim McCarthy and I pulled into a gas station in my old Austin A-40. As I got out of the car, two men who looked like plainclothes cops got out of the car behind us. They

quickly approached with their suit coats pulled back as if they were ready to go for their guns. One of them grabbed me, threw me up against the car, and patted me down for weapons. The other one ordered Tim out of the car, searched him, and then crawled into the back seat to look around. After a minute or so he got out and the two of them walked away as if nothing had happened. I walked over to the one who had grabbed me and demanded, "What the hell was that all about?" He just glared at me as he and his partner got into their car. As he drove away he leaned out the window and said, "There was a bank robbery and your car fit the description of the get-away car." In all my travels around the country, I had never seen another Austin A-40. After they left, I searched the back of the car to see if they'd planted drugs or left a bug, but I couldn't find anything

By the summer of 1968, COINTELPRO was in full operation. The FBI office in Chicago, aware that the SDS national convention was approaching, made a proposal to J. Edgar Hoover about a way to disrupt it. My FBI file contains the following:

> Experienced agents of the Chicago Office, who have conducted investigations in the New Left movement since its inception, recommend the following counter-intelligence program....

> That the Chicago Office institute action to disrupt the SDS national convention scheduled to be held at Michigan State University, East Lansing, Michigan, June 10-15, 1968, by attempting to insure that one or two leaders of the SDS are unable to attend the convention. The individuals who would undoubtedly play leading and significant roles at this convention and in any programs adopted at the convention are:

> ██

> ROBERT MILTON PARDUN, Internal Education Secretary of SDS

> ██

> The absence of one or more of the aforementioned individuals is certain to create confusion at the SDS national convention.

They considered arresting Mike Spiegel, Carl Davidson, and me on trumped up charges, but apparently either dropped the idea or were unsuccessful since we all got there safely. The "Director," J. Edgar Hoover, had to approve all such actions personally and he may have been concerned about the repercussions if it got into the press.

Memorandum

TO : DIRECTOR, FBI DATE: 5/29/68

FROM : SAC, CHICAGO (100-45316)

SUBJECT: COUNTERINTELLIGENCE PROGRAM
 INTERNAL SECURITY
 DISRUPTION OF THE NEW LEFT

--

 (2) That the Chicago Office institute action to disrupt
the SDS national convention scheduled to be held at Michigan
State University, East Lansing, Michigan, June 10-15, 1968, by
attempting to insure that one or two leaders of the SDS are
unable to attend the convention. The individuals who would
undoubtedly play leading and significant roles at this convention
and in any programs adopted at the convention are:

67c

 ROBERT MILTON PARDUN, Internal Education Secretary
 of SDS

 The absence of one or more of the aforementioned
individuals is certain to create confusion at the SDS national
convention.

 The Chicago Office is currently conducting an intensive
review of pertinent laws and statutes of the State of Illinois,
Cook County and the City of Chicago to ascertain if the SDS
National Office or the aforementioned individuals may be in
violation of any regulation which could permit the issuance
of a subpoena to one or more of these individuals requiring
that they appear at a hearing within the State of Illinois
during the period of the SDS national convention June 10-15, 1968.

 The Bureau will immediately be advised of the nature
of any law which could be utilized for the above described
purpose.

 In addition, as the Bureau is aware, the Chicago
Office continues to enjoy excellent relations with the Chicago
Police Department.

67c
67D

 One of the broad
provisions of City Ordinance 193-1 proscribes "Any unreasonable
or offensive act, utterance, gesture or display which under the
circumstances creates a clear and present danger of a breach of
peace or imminent threat of violence."

Chicago FBI ideas about how to neutralize the SDS national officers.

The convention was in East Lansing, Michigan, and the first
night a group of us were driving around looking for a place to eat

when the local police stopped our car. The cop walked up to the car, shined his light in everyone's face and called me by name as he welcomed us to East Lansing. What else the FBI may have done to sabotage the convention is still unknown since getting the FBI to release files from their COINTELPRO-NEW LEFT file has been extremely difficult.

Eight hundred people came to East Lancing, Michigan, for the 1968 national convention, almost three times as many as attended the National Council meeting only a few months before. In the year since I was elected a national officer of SDS, the number of chapters had gone from 250 in June 1967 to 400 in June 1968 and the number of members was estimated at perhaps 100,000.[175] The number of campus based demonstrations jumped eight fold from 400 during the school year 1966-67 to 3,400 in 1967-68.[176] New chapters were being organized every day and many of them were in high schools and community colleges in places like Wichita, Kansas; Aptos, California; Pueblo, Colorado; and Gresham, Oregon. A survey by *Fortune* magazine in the fall of 1968 found that 368,000 students identified themselves as revolutionaries. There was a growing sense among students that the only way to bring about real change in America was through revolution.[177]

The convention represented all the different styles of the political/cultural rebellion that coexisted within SDS and symbols of revolution were everywhere. This convention reminded me of a carnival, complete with red flags, black flags, red armbands, Chairman Mao's little red book, the little red IWW songbook carried by the non-centralist/anarchist faction, and the serious clowns known as the Up Against the Wall, Motherfucker! chapter from New York's Lower East Side. As Carl Davidson put it, "We have within our ranks communists, socialists of all sorts, three or four kinds of anarchists, social democrats, humanist liberals, libertarian laisez-faire capitalists, and, of course, the articulate vanguard of the psychedelic liberation front."

I considered this convention to be critical to SDS's survival. SDS was a loose confederation of local chapters with national policy set by its National Council. But with increasingly large numbers of people attending these national meetings, they had become unwieldy and almost dysfunctional. It had become nearly impossible to decide the direction of the organization or how to reach new people. We needed to make National Council meetings smaller and more

directly responsible to the local chapters. Solving these problems was especially critical since the repression against us was increasing. I addressed these problems in a speech at the beginning of the convention and urged people to take the task before us seriously. I finished by saying, "If we don't get our shit together, we'll be wiped out in two years."

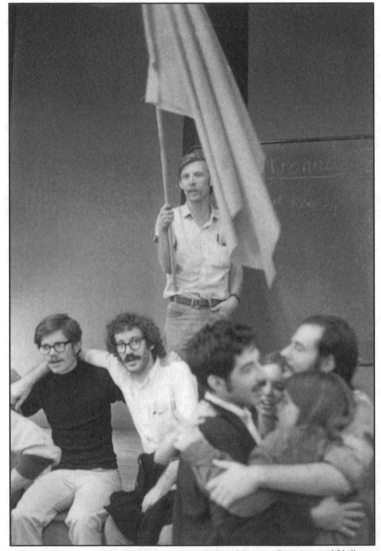

SDS convention, June 1968. Me with red flag. Morgan Spector and Neil Buckley seated. Gerry Tenney, Sue Jankowsky, and Thorn Dreyer.

Before the plenary sessions began we held a number of workshops designed to help clarify the issues before us. One of them, the "sabotage and explosives" workshop was specifically designed for the agents who we knew were spying on us. Apparently it worked. An agent from the sheriff's office in Jefferson Parish, Louisiana later testified before a Senate Committee that "everyone who didn't fit the mold, who appeared to be agents, undercover workers, Federal Bureau of Investigation, or local police intelligence units, all went to the sabotage and explosives workshop."[178] The workshop leaders had fun showing the agents how to put super-glue in door locks and other "terrorist" actions.

I attended a workshop to discuss a proposal that would change SDS's structure and found that PL members were there in force to make sure that their position was heard – over and over. The purpose of the proposal was to create regional councils that would add a level between the chapters and the National Council. The chapters would elect representatives to regional councils, which would then coordinate activities of the local chapters. Representatives from the regional councils would then form the National Council, which would be smaller and more functional. PL's membership was concentrated in Boston and New York and they realized, as did I, that forming regional councils could make it more difficult for them. Not only would the number of PL delegates be reduced, but delegates from the regions would be more likely to have strong chapter ties, and so PL's accusations about the "national office cadre" would be less likely to work. That didn't mean they couldn't use that kind of argument to oppose the proposal – and that is precisely what they did. They argued that the "national office cadre" would take over the regional councils to the detriment of the chapters. To many of the new members, who were wary of top-down control, PL sounded as if they were valiantly defending the local chapters from the "out of touch national office cadre." When I compared notes with other workshop leaders, they all said the same thing had happened in their groups – PL packed the meetings and controlled the debate by creating a dynamic in which their ideas were at the center.

At the plenary session, Bernardine Dohrn, Tom Bell, and Steve Halliwell proposed a program that called for "changing the emphasis from *building* revolutionary movement to *using* radical movement in the work of making revolution." They wanted SDS to begin the process of building revolutionary organizations in larger cities,

perhaps based on the campuses, but reaching outside to high schools, community colleges, welfare mothers and young workers in order to start laying the "groundwork for a New Left revolutionary organization." PL was totally opposed to this concept because it had a very narrow view of SDS's role. They wanted SDS to become the mass student organization for their Worker-Student Alliance. Since PL considered itself to be the "vanguard of the revolution," they opposed any proposal that would move SDS off the campuses.

PL also launched an attack on the "new working class" ideas that were part of the proposal. As in the workshops, their strategy was to convince the new people to vote against the program because it came from the national office and its supporters who were trying to take control of SDS. Every time a PL member or someone from the Worker-Student Alliance, which included non-PL members, got up to speak, you could almost hear the tape recorder running as they said in slightly different words what the previous PL speaker had said. Because of their adherence to the positions they had previously agreed upon in their closed caucus, it was impossible to get them to compromise. After a long debate, the Dohrn-Bell-Halliwell proposal failed.

The restructuring proposal, authored by Jeff Segal, now in prison for draft refusal, and Neil Buckley, was also defeated after a frustrating debate that lasted ten hours and was a re-run of the workshop arguments. It took a two-thirds majority to change SDS's structure but there weren't enough votes to do it. After days of debate, PL had managed to frustrate every attempt to develop programs they opposed.

Each of the outgoing officers had an opportunity to address the body before the election of new officers. After talking with other people, I decided to confront PL head-on about how they functioned within SDS. Their working class oriented politics wasn't the issue because we shared many of the same concerns. The real problem was that by functioning as a monolithic block to oppose ideas and programs they didn't agree with, and by constantly trying to drive a wedge between the national office and the chapters, they set up a destructive dynamic.

PL members, while calling themselves SDS members, were loyal to the Progressive Labor Party and to its hidden leadership that wasn't in SDS at all – and that many in SDS didn't even know existed. Their purpose was to transform SDS into an organization that would become the base for their Worker-Student Alliance

program and they opposed any programs that didn't support their agenda. Democratic centralism, by its endless repetition of one pre-determined position, focused the debate on their "correct line" while other important issues were pushed to the sidelines.

PL functioned in a way that was almost the definition of opportunism. The same PL members who came to the defense of the chapters against the supposed SDS national office cadre, were at the same time reporting and submitting to the top-down leadership of PL. With PL in control of SDS, the membership wouldn't even know who was making the ultimate decisions.

PL's way of manipulating the content of debate was so diametrically opposed to SDS's ideal of participatory democracy that we didn't know how to respond to it at first. We had hesitated to confront PL earlier because of our anti-anti-communism and because we knew that their response would be to accuse us of "red-baiting" them because they were communists. I wanted to make clear that the issue was what they were doing within SDS, not their politics. I began by talking about how "cadre groups," groups organized around a particular project or ideology should function within SDS. After talking about groups that formed on the local level within SDS, I talked about organizations that came into SDS from outside.

> We must demand that external cadre operate in a principled fashion. It's simply not principled to move into SDS in order to recruit members for another party. Your function should be to bring in ideas. It's not principled either to pack meetings in order to manipulate acceptance of a line or to tie up valuable time discussing issues that the collective does not wish to discuss.[179]

I looked out at the delegates and said, "Let's be honest here. I'm talking about Progressive Labor." There was a long pause, like the taking in of a deep breath of air. This was the first open denunciation of PL at a national meeting by a national officer and it was cathartic to finally bring forth the frustration that had built up. People began getting up to speak about the rigidity of PL's politics and to denounce their simplistic Marxism. Finally, Tom Bell, originally from Cornell, who had forged one of the strongest draft resistance unions in the country, got up to speak. Tom was not a person who spoke often, but now he was angry because the convention had accomplished nothing. He picked up where I had left off and told the delegates that he had come to the convention with hopes that there would be open, productive debate leading to

passing proposals that would make SDS more effective in the difficult period ahead. He accused the PL people of obstructing every move with their unchangeable line and their inability to listen to any point of view but their own. They had bogged down every proposal with the result that the entire debate led nowhere. "It isn't possible to have a debate on the floor because of the organized opposition of PL, and unless SDS does something about it the organization will surely collapse."

Someone from PL got up and accused Bell of red-baiting them because they were communists. Bell, very angry by this time, yelled into the microphone "Red-baiting! *Red*-baiting!? *I'm* the communist here not you guys from PL." Then he did what was on a lot of people's minds, he yelled "PL OUT!" Pandemonium descended. People began shouting "PL OUT! PL OUT!" and banging on chairs, clapping, and dancing around. The PL people just sat there and finally Tim McCarthy, who was chairing the meeting, called for a special session to deal with this issue. In the nearly three-hour session that followed, almost every non-PL speaker punctuated their statements with remarks about PL's rigidity, inability to change their minds, divisiveness, and blind adherence to the "working class."

My intent in bringing the issue to the floor was not to force PL out of the organization but to persuade them to recognize the diversity of ideas that made SDS strong. They didn't get the message. Following the convention, Jeff Gordon of New York PL blamed the growing frustration within SDS on the ideology of the "national office/New Working Class" that was weak and incapable of combating true anti-imperialist/working class theory and had therefore resorted to anti-communism to attack PL. He concluded that it was necessary to continue to push the "correct line" to strengthen SDS. With the arrogance of those who know the "truth" he concluded, "The future of SDS as a positive factor in the American revolution is at stake."[180]

After everything finally calmed down it was time to elect the new national officers. Anticipating that PL would put up candidates, a anti-PL slate was put forth, consisting of Bernardine Dohrn for inter-organizational secretary, Mike Klonsky for national secretary, and Les Coleman for internal education secretary. PL didn't nominate anyone, probably because they knew they would lose, so the Up Against the Wall, Motherfucker chapter from New York's Lower East Side nominated a trash can to run against Klonsky.

People opposed to the concept of a slate of candidates nominated Fred Gordon (no relation to Jeff Gordon) to run against Coleman.

I had first met Bernardine in the spring of 1967 when she had shared an apartment with Jane Adams. She was a law student and had worked with Martin Luther King's civil rights organization in Chicago. She always struck me as somewhat of a contradiction. She had co-authored a paper, "The Look is You," which talked about how capitalism turned women into commodities, and yet she wore all the women's clothing styles that were designed to make women into commodities. When asked at the convention if she considered herself a socialist she replied, "I consider myself a revolutionary communist!" This was a good example of how much the rhetoric had changed in the past year.

Mike Klonsky was an active organizer from Southern California who described himself as a communist with a small "c," meaning that he believed in the ideas of egalitarianism put forth in the early philosophical writings of Marx and Engels.

Les Coleman and I worked together in the national office. He was a methodical organizer who knew that the changes in America were going to take a long time. I often relied on him for ideas and understanding, but on a personal level I could never figure him out. Whenever I asked him about his background, he always avoided the issue, saying just enough to make a point and no more.

I didn't know Fred Gordon personally, but he was seen as being less antagonistic to PL than the other candidates. In the election Bernardine won easily, Mike beat the trash can, and Fred Gordon beat Les by one vote.

Following the convention, I returned to Chicago because I had promised to stay until the end of the summer to help the new officers. I was burning out fast, however, and one day, as I was walking to the office, I caught the smell of cottonwood trees blooming. It brought back memories of Pueblo, blowing cotton, sweet air, sunshine and trees. I talked to the new officers about how the transition was going and was assured that everything was under control. I left for Austin the next morning.

As I drove south I tried to put the year I had spent in Chicago in perspective. The antiwar movement was growing and challenging the ability of the government to maintain peace at home as long as it continued the war in Vietnam. The American people were turning against the war although they were also critical of the antiwar movement. The counter-culture was growing rapidly and was

challenging the underlying assumptions of the old culture with new values based in community. It was an exciting time of change, growth, and experimentation. I thought about how much my understanding of America had changed since I first arrived in Austin. America had gone from being the "land of the free and the home of the brave" to being Amerika[181], the greatest purveyor of violence the world had ever known. I had gone from being an alienated graduate student to being a national officer of the largest student organization in the US.

As I drove back to Texas, SDS was under attack from both the government and Progressive Labor. I wondered how long SDS could survive.

— 16 —

Things Fly Apart
Summer 1968 – Summer 1969

"Praise be to Nero's Neptune. The Titanic sails at dawn. Everybody's shouting, "Which side are you on?" Ezra Pound and T.S. Eliot, fighting in the captains tower, while calypso singers laugh at them and fishermen hold flowers."

Bob Dylan, *Desolation Row*

When I got to Austin, it felt as if I had been gone for a lot longer than just a little over a year. So much had happened that it felt as if time had been stretched thin. I found a place to stay and looked up Linda Kerley, who I had first met at a National Council meeting during the spring. She had been working in New York and Jeff Shero and Alice Embree had convinced her to visit Austin. It had taken only a few days of Austin hospitality to convince her to stay. We had been corresponding while I was in Chicago and now we began seeing each other regularly.

Linda had become friends with a group of professors, graduate students, and artists, who got together regularly at Arnie and Judy Binder Kendall's house. I knew many of these people before I went to Chicago, so joining the group was easy. Arnie was a drama instructor at the university and Judy was an artist and dancer. They had come to Austin from Ann Arbor, Michigan, where Arnie had directed one of Carl Oglesby's plays and Judy had done a series of antiwar drawings that had been used as illustrations for SDS publications. Larry Caroline had come to Austin in 1967 as a philosophy professor and had spoken at an antiwar rally soon after his arrival. During his speech he used the word "revolution" and said, "the whole bloody mess has got to go." The press jumped on this, labeling Larry a "corrupter of youth" who advocated "bloody revolution." This incident put Larry at odds with the head of the philosophy department, John Silber, who considered Larry unfit to teach. Dena Caroline was in graduate school. Bobby Minkoff was working on a Ph.D. in psychology and his wife, Trudy, was

illustrating for the *Rag*. Donny and Kathy Gross were both artists who did metal sculpture, jewelry, and ceramics. They taught me how to do lost wax metal casting and I used the skill to make rings, which I then sold to support myself.

In August, as the Democratic National Convention approached, we discussed whether or not we should go. Nobody knew what was planned, although we expected the worst since Mayor Daley had refused to negotiate with the people planning the protest. and the Chicago police had a reputation for violence. Although several SDS members were involved in organizing the event, the SDS National Council had discouraged going to Chicago on the grounds that electoral politics had lost its legitimacy and it didn't really matter who won. Martin Luther King and Bobby Kennedy had both been assassinated and it appeared that the pro-war forces would stop at nothing to keep the war going. Eugene McCarthy continued to wage a symbolic but futile battle against Hubert Humphrey, who was so afraid of President Johnson's wrath and political power that he kept his own antiwar feelings hidden. Most people never knew that Humphrey opposed the war.

Steve Fox, an antiwar vet who was now a student at UT, wanted to go to Chicago and tried to convince me to go with him. I thought it over and decided that I didn't really want to confront violence and chaos in the streets of Chicago. Steve went anyway and called back daily with information about what was happening. We also watched the television coverage of policemen wading into crowds of demonstrators with their clubs flying. Demonstrators who got too close to the convention site were pushed back with jeeps with rolls of barbed wire on the front and with horses. The police and soldiers seemed to enjoy surrounding the demonstrators, Eugene McCarthy supporters, innocent by-standers, and journalists and then gassing them and beating them to the ground while people chanted, "The whole world is watching!" The scene on the convention floor was almost as chaotic as it was in the streets. Senator Abraham Ribicoff denounced the "Gestapo tactics" of the police and the camera turned to an angry Mayor Daley who couldn't be heard but who's lips seemed to be saying, "Fuck you, you Jew son of a bitch, you lousy motherfucker, go home."[182] Daley's "security forces" man-handled reporters on the convention floor who tried to interview antiwar delegates. This upset news commentator Walter Cronkite so much that he called Daley's men, "thugs," on national television. By

the time the convention was over more than a hundred people had been sent to local hospitals and nearly 700 people were arrested.

At almost the same time as the Democratic Convention in Chicago, things were coming to a head in Czechoslovakia where students demanded more democratic control of the country. There had been demonstrations and meetings and the government had begun to make concessions when, on August 20, the Soviet Union put an end to all that by sending tanks into Czechoslovakia and crushing the movement. The similarities between the demands being made in Czechoslovakia and Chicago and the military style reaction to it was summed up in a protest sign at the convention that read, "Welcome to Czechago!"

Public opinion polls taken after the Democratic Convention told us that more people opposed the war than supported it, but they also showed that a majority of Americans supported the police because they thought the demonstrators had caused the violence. A majority of the American people opposed the continuation of the war – but they didn't approve of chaos in the streets. The fact that Mayor Daley had precipitated the chaos by refusing to grant permits for peaceful rallies and marches became known to the public only later when an investigative commission labeled the violence a "police riot." That information didn't change the opinion of most Americans, who were increasingly responding to calls for "law and order." Linking the movement to violence was a way to discredit us even though in reality it was the police attacking us and not us attacking the police.[183]

To no one's surprise the Democratic Party machine nominated Hubert Humphrey as the party's candidate for president. But he was in a bind. We now know that he had quietly opposed the war while vice-president, but as President Johnson's pick for the Democratic nomination, Humphrey was expected to represent the pro-war line. His support among those Democrats who had voted for "peace candidates" in the primary elections was at best lukewarm.

On October 31, 1968, a week before the elections, President Johnson ordered a bombing halt and tried to get peace negotiations started with the participation of the US, North Vietnam, South Vietnam, and the National Liberation Front. Richard Nixon, who told the American people that he would bring peace to Vietnam, had been leading Humphrey in the polls, but with the possibility of peace at hand, he watched his lead evaporate. We now know that Nixon,

through Republican vice presidential candidate Spiro Agnew, secretly contacted South Vietnam's President Thieu, whose government depended completely on US support for its existence. Thieu suddenly refused to participate and the peace talks fell through. Because of illegal wiretaps, LBJ knew about this potentially illegal interference in the security affairs of the nation, but he concealed the information. Clark Clifford, the Secretary of Defense, quotes President Johnson as saying, "It would rock the world if it were said that Thieu was conniving with the Republicans. Can you imagine what people would say if it were to be known that Hanoi has met all these conditions and that Nixon's conniving with them kept us from getting [peace talks]?"[184] Nixon was elected President by a margin of less than one percent of the vote and extended the war for another six years. This cost Vietnam, Cambodia, and Laos more than a million lives.[185] Of the nearly 58,184 American deaths in Vietnam, 23,957 were killed after Nixon was elected. This is the level of power and morality we were up against.[186]

Thorne Dreyer and I drove to Boulder, Colorado, for the fall National Council meeting. I had been out of touch with the national office since I left in June and it was apparent from the opening meeting that the national officers, except for Fred Gordon, and other organizers from around the country were on the offensive against PL. They were developing a program that recognized that the left around the world was surging and that young people were in the lead. There were growing youth movements in France, Japan, Mexico,[187] Greece, Czechoslovakia, and England, and revolutionaries were challenging colonialism all over the world. To become part of this worldwide movement, it was imperative to move now and to sow the seeds of revolution by building an explicitly anti-imperialist, anti-capitalist movement of young people, a "Revolutionary Youth Movement," (RYM). A basic part of the program was the notion that "action builds consciousness;" that through militant action young people learn that *they* can be agents of social change.

PL presented a modified worker-student alliance program called the Student Labor Action Project. The emphasis was on linking up with campus workers, doing strike support, supporting the summer work-in and the black rebellions, and educational work on campus. The anti-PL people pointed out that there were no workers in the worker-student alliance, a fact that PL had discussed internally but didn't openly admit. The vast majority of students who took part in

the summer work-ins had no intention of continuing to work in factories as full-time organizers.

The RYM people advocated reaching the industrial working class by organizing their children and proposed a national student strike on university and high school campuses at the time of the November elections with the slogan, "No Class Today, No Ruling Class Tomorrow!" PL countered with a proposal for a march on Washington on Election Day. The student strike proposal passed and PL's proposal was voted down.

I came away from the meeting wondering if and how I wanted to participate in SDS on a national level. I identified with the people around the national office, but I was concerned that the attempt to fend off PL was polarizing SDS. I was bothered by slogans such as "action builds consciousness," that appealed to young inexperienced members and could lead to actions that would alienate potential allies. I wasn't opposed to action, but I saw it as a tactic that needed to be mixed with education and organizing as I had emphasized so often when I was in the national office.

Back in Austin, I tried to plug into the SDS meetings, but they were impossible. The polarization that was happening nationally was also happening in Austin. The first meeting of the year drew several hundred people, but it rapidly turned into a recruiting war between the PL supporters and their opponents. As the meeting descended into a haze of rhetoric, two-thirds of the people drifted away. After a few weeks the number of people attending SDS meetings was down to 25. Most of my friends avoided these meetings like the plague and were working in smaller groups outside of SDS, where they didn't have to deal with the "correct line" and the animosity that characterized the SDS meetings. There were a lot of these groups, and the old Austin SDS community spirit was alive and well in the way they worked with each other. They were similar to the "affinity groups" or "cadre groups" that I had written about while in the national office. The difference was that these groups no longer saw SDS as the organization that unified them. In fact, as sectarianism tore SDS apart, they saw it as increasingly irrelevant.

The community of people who identified themselves as part of "the movement" was growing everywhere, and a whole culture reflecting our values was taking form. In Austin this community was a mixture of political people with counter-culture tendencies and counter-culture people with political tendencies and it was hard to tell the two groups apart. There was a small group trying to organize

a chapter of Movement for a Democratic Society (MDS) to meet the needs of non-students. Another group of several dozen people was starting Greenbriar School with a mission of helping children learn cooperatively and at their own speed. The goal was to raise children to be curious about many things and to believe they could do anything they wanted. Judy Kendall, a ballet dancer, set up a stage in a public park so that she could do ballet for the people. Small businesses were also springing up. These ranged from our local head-shop, Oat Willie's Campaign Headquarters, to food co-ops supplying whole grain flour, natural peanut butter, and organic food. Several stores sold clothes, jewelry, and other hand-made items, some of it produced in Austin.

Linda Kerley joined a group of actors, artists, and assorted other free spirits who were forming a traveling circus/vaudeville show to carry the antiwar message to small towns around Austin. One of the members was a business major and had been assigned by his advertising class to come up with a jingle to sell a product. He took the lyrics by Country Joe and the Fish, "If you're tired and a little run down, can't seem to get your feet up off the ground, maybe you ought to try a little bit of LSD. Shakes your head and rattles your brain, makes you act just a little insane, maybe you ought to try a little bit of LSD" and changed the word LSD to Mother's Grits. He got an "A" in the class, it was a catchy jingle, and became the theme song of the troupe when it went on the road as "Mother's Grits Anarcho-Terrorist New Left Beatnik Evangelical Traveling Troupe." In typical counter-culture style, the name tried to incorporate every epithet that could be used to discredit it. They traveled to small towns, set up and performed plays, ballet, poetry readings, and gave antiwar speeches. The goal was to bring young people into the movement by bringing the movement to them. Often, before the performance began, local guys would threaten the performers with something like, "Right after the show we're gonna cut all y'all's hair off." But after the show they'd often come to talk about the war and find out what it was like in Austin.

The collection of all these groups formed a community, a counter-culture, where people worked together, shared housing, occasionally made a little money doing odd jobs, bought or traded for needed items, and just had fun. This community was much more exciting than the SDS meetings and also a lot more productive.

During the Democratic Convention, forty-three black soldiers from Fort Hood, Texas, had refused to go to Chicago to suppress the demonstrations. The government was very concerned about the growing antiwar sentiment within the military and the connections that were being made with the New Left. The Oleo Strut in Killeen, near Ft. Hood was one of a number of antiwar coffeehouses, located near military bases around the country. People from Austin went there regularly to talk with the GIs, and an increasing number of GIs came to Austin and joined in antiwar rallies. I joined the volunteers and went a number of times to talk with the GIs. What I learned from the returning soldiers was even more horrendous than what I already knew.

I talked with combat vets who described what it was like to fight against a guerrilla army that blended in with the people and had widespread popular support. Any Vietnamese was a potential enemy so when the GIs ran into resistance around a village they often retaliated by burning the houses, killing all the farm animals, and burning all the food. Several soldiers told me that they had witnessed massacres of unarmed men, women, and children who were lined up and shot. About a year later we, the public, officially learned about the massacre at My Lai where between 350 and 500 old men, women, and children were systematically executed by US troops under the command of Lt. Calley, who was acting on orders from above. From what I heard at the Oleo Strut, it sounded as if such massacres were fairly common.

Many of the GIs returning from Vietnam were against the war and some of them were joining our protests. Every fall and spring there were national demonstrations coordinated by the National Mobilization Committee and the first week of November 1968 was designated as "GI Week." Mariann Vizard and I, together with other Austin volunteers at the Oleo Strut, worked on incorporating GI-Week into the antiwar activities in Austin. The FBI learned about my involvement when Jody Bateman, my friend from the Oklahoma SDS chapter, received a letter from someone at the Oleo Strut, but then lost it. Whoever found it turned it over to the FBI.

> We are now in the midst of planning a pan-Texas GI antiwar rally, to be held in Austin on November 2nd, with soldiers and movement people from all over the state in attendance. BOB PARDUN and MARIANN VIZARD are taking care of the civilian-organizing end of things. It looks as though it will be big, very big. Don't put that out in public yet, OK?[188]

On the day of the mobilization we held a rally and a large peaceful march into downtown Austin. The demonstrators included students, professors, people from the community and about 150 military personnel. At a recent demonstration groups of pro-war men had followed behind the marchers, throwing rocks and bottles, but this time we were prepared. When a group of men in military uniforms – possibly ROTC – came up behind the demonstrators a large group of us fell back and chased them away. GIs from bases all across the country participated in the national demonstrations. In San Francisco 500 military personnel marched with 15,000 civilians to show their opposition to the war.

Even though I rarely went to the campus any more, I kept up with events there. In November 1968, the Student Union Board voted to require a student ID card to get into the cafeteria as a way of keeping non-student "agitators" off campus. The next day, the Austin police came into the Chuckwagon cafeteria and arrested a young run-away girl. When a group of students asked what authority the city police had to do this, one of the policemen drew a pistol and announced that he had all the authority he needed. Four students went to the police station to file a complaint, and were promptly arrested for disorderly conduct. A few days later, Paul Spencer, an SDS member and recent graduate of UT, went into the cafeteria and refused to show his ID. The police were called and he was arrested for disorderly conduct and assaulting a police officer. The next day, five hundred students and non-students marched into the cafeteria without showing ID and sat down. Again the police were called but when they arrived they found a thousand people blocking the entrances to the building to keep them out. The police attacked with clubs and gas and most of the students ran, but a fairly large number surrounded the police cars, slashed the tires, and liberated the prisoners by pulling them away from the police. The police only arrested eight people at the time, but in December, based on police photos of the demonstrators, they arrested twenty-two students for conspiracy to riot.

In the spring of 1968, while I was in Chicago, the FBI had put me in Category I of the Agitator Index with the instruction that, "Pardun must be neutralized within SDS." The Chicago agent who was keeping track of me was supposed to report my location on a weekly basis, but he apparently lost track of me when I returned to Austin during the summer. There is a note in my file stating that I had been seen in Austin in July but that it was assumed that I would

return to Chicago soon. It appears that both the Austin and Chicago offices thought I was in the other's territory and neither worried about me until September when the Chicago police were notified that the staff apartment, where I had lived, had been vacated. When the FBI realized that I had been missing for several months, they began a nation-wide search to locate me. Since I had obtained a passport, the CIA checked to see if I'd gone to Europe or perhaps Cuba.

I don't know why the FBI had so much trouble finding me. I had been openly involved in political work in Austin and had attended some SDS meetings. I was in contact with all my old friends but apparently none of them told the FBI where I was because it took the FBI until January 1969 to confirm that I was in Austin. Of course, I didn't know any of this when the FBI came to my house and left a message that they wanted to talk to me. I decided to visit their office because I hoped to discover information about what they were doing to us. (NOTE: I don't advocate this, particularly after having seen my files. There is no way to know what they are looking for or what they will do with what you tell them. One of the ways the FBI "neutralized" people was by creating distrust, and the mere fact that I went to talk to them could have been used to create suspicion and to isolate me).

The agent wanted information on the demonstrations at the Chicago Democratic Convention and knew that I had been at several meetings to plan this action. He wanted to know if people had decided what they were going to do at the convention before they got to Chicago. I told him that the groups of people and organizations at the meeting I attended were incapable of working together, let alone planning anything together. I also made it clear that I believed that the government was trying to suppress the antiwar movement and that this interview was part of that effort. After I left, the agent put a memo into my file stating that I would not be re-interviewed because, "he was not very cooperative, because of his apparent fanatical adherence to the SDS program and because of his statements alleging governmental suppression of the resistance movement. An interview with Pardun could result in embarrassment of the bureau." In hindsight it's clear that the FBI was gathering evidence for the conspiracy case against the Chicago Eight which went to trial in the fall of 1969.

The FBI sent information about me to the Secret Service in case
I should want to attend President Nixon's inauguration. My
"Succinct Profile," that gives me more credit than I deserve, says,

> Pardun has been active in SDS since 1964 and has served as internal
> education secretary and on the National Executive Committee. He has
> organized numerous SDS chapters in high schools and colleges
> throughout the US, lectured, and written articles for "New Left Notes."
> In 1965 he said, "I support the Cuban revolution. I am completely
> opposed to the war in Vietnam. The United States is the aggressor and
> should get out." He has frequently advocated taking radical action to
> develop "student power" to be used in changing today's society.[189]

In the spring of 1969 I took a job on a construction crew in
Austin, partly because I needed the money to live on and partly to
find out how non-student, non-SDS people viewed the war and the
antiwar movement. At the beginning I worked on a concrete crew
and found that most of other workers thought the war was a mistake
and didn't support it. They didn't support the antiwar movement
either, although the younger guys were more sympathetic than the
older ones. Even the people who didn't like the antiwar movement
were willing to talk to me when they found out I opposed the war.

I had been on the job a couple of weeks when I was moved to a
new job site – a big empty field with a few stakes in the ground and
a couple of guys surveying. The foreman took me to a spot far from
anyone else and told me to dig an L-shaped hole. He emphasized
that the location and dimensions had to be exact and said he'd be
back later. I was completely isolated from the other workers and
wondered if the police or FBI had told the construction company
who I was. The next time the foreman came around he told me that
the hole was in the wrong place and needed to be moved. As he was
leaving he told me to put my shirt on before I got sunburned. I told
him that I was already tan and he left. Over the next few days the
foreman told me to move the hole several more times and each time
he told me to put my shirt on. I always asked for a reason and every
reason he gave didn't apply. One time he told me it would protect
me if something fell on me and he laughed when I reminded him
that I was working all alone in the middle of an empty field. This
went on for several days until a young guy wearing fancy boots and a
leather jacket walked up to my hole with the foreman. He looked
down at me and said, "Put on your shirt!" I was getting tired of this
game and asked why. He replied, "Because I *told* you to, that's why."
I'd had it with moving this hole around and replied, "That's not a

reason! I quit." He smiled and said, "I hoped you'd say that because state law says that if we fire you, we have to pay you off before you leave the job site, but if you quit we can make you wait ten days. Get off the property and if you come back before ten days we'll have you arrested for trespassing." It was obviously a set up but I never found out who did it. Having read some of the petty things that the FBI did to harass people, I've always wondered if this was part of their Counter-Intelligence Program, COINTELPRO, or just some kind of surreal joke.

President Nixon was inaugurated in January 1969, and his policies were beginning to be felt. Like the Johnson administration, the Nixon administration gathered people as advisors whose political blinders obscured the truth of what was happening in Vietnam. Roger Morris, senior National Security Council staff member during the Nixon administration, recalled:

> It was just one great ongoing sort of crap game of fraud that was being perpetrated on Washington....It's really true that the truth wasn't in us. We had been lying to ourselves and others for so long about that problem that you just couldn't get decent, open analysis....The American government was saying to itself the same kind of horseshit that it was peddling on the outside.[189]

Nixon told the American people that he had a peace plan and he expanded the peace talks to include both the South Vietnamese government and the National Liberation Front. In a process called "Vietnamization," he proposed the withdrawal of both US and North Vietnamese troops from South Vietnam. To show he was serious, he withdrew 25,000 US troops in May 1969 and another 25,000 on June 8. While he told the American people about these actions, he didn't tell them about the expansion of the air war into Cambodia and Laos. Beginning on March 18, 1969, American bombers began the secret bombing of supposed Viet Cong bases in Cambodia. This bombing campaign lasted until 1973 and killed three-quarters of a million Cambodians. At the same time, he increased the intensity of the bombing of North Vietnam and also extended the bombing into Laos where, "by September (1969), the society of fifty thousand people living in and around the [Plain of Jars] no longer existed. History had conferred one last distinction upon it: the Plain of Jars had become the first society to vanish through automated warfare."[190] If the increase in the bombing didn't get the desired results, Nixon had another card up his sleeve – he

tried to convince the North Vietnamese that he was crazy enough to use nuclear weapons if they didn't cooperate.

Another part of Nixon's plan that the American people knew very little about was the destruction of the antiwar movement. During the spring of 1969 regional offices of SDS were broken into and destroyed. Hundreds of bills were introduced and passed by state legislatures supporting police activity against the New Left. The FBI placed phone taps and broke into movement people's homes looking for information. The government indicted people on felony charges and held them in jail with high bail. Grand juries investigated people and organizations and the FBI and local police sent provocateurs into demonstrations to provoke violence and justify police action. The number of agents assigned to "infiltrate, provoke disturbances and spread lies" was increased to over 2,000.[192] Richard G Kleindienst, US Deputy Attorney General, said,

> If [SDS] or any group was organized on a national basis to subvert our society, then I think Congress should pass laws to suppress that activity. When you see an epidemic like this cropping up all over the country – the same kind of people saying the same kinds of things – you begin to get the picture that it is a national subversive activity…[SDS and other New Left activists] should be rounded up and put in a detention camp.[193]

Early in 1969, the Justice Department established the Panther Task Force and the FBI was busy compiling hundreds of reports entitled "Racial Matters-Smith Act." The Smith Act was a World War II era law making it illegal to conspire to teach or advocate the violent overthrow of the US government. By June the FBI was investigating all 42 Black Panther chapters and their approximately 1,200 members and sympathizers "to obtain evidence of *possible* violation of Federal and local law."[194] In 1969 alone 348 Panthers were arrested for murder, armed robbery, rape, bank robbery, drug trafficking, burglary, and dozens of other charges. Twenty-one members of the Panthers in New York were charged with conspiring to blow up five downtown department stores; bail was set at $1,400,000 so that the accused sat in jail as their case got postponed over and over again. Although it is difficult to establish an accurate number, it appears that at least a dozen members of the Panthers were killed in 1969 by police or by FBI inspired violence between black organizations.[195] There is a notation in my FBI file instructing the local agents to try to find evidence to prosecute me under the Smith Act or the Alien and Sedition Act, both of which have to do with treason. Of course, at the time we didn't know the

details of what they were doing, but everything was becoming more chaotic and seeds of distrust were being sown everywhere. There was serious discussion about what to do if the police started rounding us up to put us in detention camps and a few people were talking about buying guns for self-defense.

In the spring, Jeff Shero and Alice Embree returned to Austin from New York, bringing news about the movement there. They had moved to New York about the same time I went to Chicago. While there, Jeff had started an underground paper that he called the *RAT* because the rat is the only animal that not only survives in the underground but also prospers there. Alice helped at the *RAT* but mainly worked for the North American Congress on Latin America (NACLA), a New Left power structure research organization. Linda also worked for NACLA and met Alice there. Both Jeff and Alice had been involved in the rebellion at Columbia University and the *RAT* had published documents proving that the university was working with both the CIA and the Pentagon. Whenever Linda and I got together with them in Austin, they seemed to be looking over their shoulders to see if anyone was following us. They had been under heavy surveillance in New York and back in Austin they refused to talk about anything sensitive unless they were outdoors in a crowd and walking. They worried that they might still be under constant surveillance and that someone using a directional microphone could hear our conversations. This kind of fear of being watched and distrusting anyone you didn't know well was taking its toll on the movement.

During his presidential campaign, Richard Nixon had run on a law-and-order platform, which we interpreted as anti-demonstrator and anti-black. Nixon had something specific in mind. Two months before the elections he told a rally of Republican supporters, "As I look over the problems of this country, I see one that stands out particularly. The problem of narcotics." He went on to say that drugs were like a plague decimating a generation of Americans and that his administration would initiate federal action to stop it. After the election H.R. Haldeman, one of Nixon's advisors, noted in his diary that, "[Nixon] emphasized that you have to face the fact that the whole problem is really the blacks. The key is to devise a system that recognizes this while not appearing to." Nixon couldn't make it illegal to protest against the war or to be black, but the antiwar movement, the counter-culture, and blacks had something in

common – the use of illegal drugs. Thus began the "drug war" – a war against blacks, other minorities, and the political left that continues to this day.[196]

Arresting political people on drug charges was not new. The JOIN project in Chicago had been raided for drugs in 1965, but those arrested got off for lack of evidence. Lee Otis Johnson, a SNCC organizer at Texas Southern in Houston, was arrested and convicted for passing a lit marijuana cigarette to an undercover policeman. He received a sentence of thirty years in the state penitentiary, where he served seven years before being released. In Dallas and Houston the police raided the offices of the local underground newspapers numerous times. Each time they claimed to be looking for drugs and in the process they destroyed or took equipment.[197]

SDS picked Austin as the location for the Spring National Council meeting in early March. A week before the meeting, under pressure from the Board of Regents and the Texas legislature, the university withdrew its permission to use campus facilities. With some frantic last minute arranging SDS found an alternative location. I think that the national officers hoped that holding the National Council meeting away from the Northeast would reduce the number of PL delegates. It didn't work. Some 1,200 people came to Austin for the meeting and PL was there in force – the rumor was that PL had paid for plane and bus tickets for their delegates.

At the time of the National Council meeting I was working in an industrial plant as a welder. My interest in metalworking had evolved from working with silver, gold, and brass to making welded steel sculpture. I had bought a cutting torch and taught myself how to use it and then had taken a class in arc welding. Welders were reasonably well paid so I began taking welding jobs. I worked during the day, but I planned to attend the National Council during the evening sessions. When I got home on the first day of the meetings, I called a number of friends to see what I had missed. Everyone I talked to was angry because SDS had become the battleground for the Revolutionary Youth Movement and Progressive Labor and there was no room for debate around any other issues. In frustration, a group of Texas SDS people, including Greg Calvert and Carol Neiman, took the microphone to speak to the delegates.[198] When they were ignored, many Austin SDS members walked out in protest and began boycotting the meetings. They encouraged me to do the

same. I didn't attend the meeting that evening, but decided to wait and see about attending future meetings.

PL's tactics of voting as a block, controlling the direction of debate, and attacking the leadership of SDS, as if that leadership was an organized faction working against the chapters, created a destructive dynamic within SDS that led to the formation of just such a faction to oppose them. During the fall of 1968, the national officers, members of the Action Faction from Columbia, and others opposed to PL began to develop the ideology of the Revolutionary Youth Movement. There were serious disagreements within RYM, but they were unified in their opposition to PL. As the RYM people tightened their ranks against a growing threat, debates at the National Council meetings became polarized around the differences between PL and RYM. Other important strategies for organizing, such as the Movement for a Democratic Society, the new working class, and traditional campus organizing, were increasingly squeezed out of the debate. Meanwhile new people continued to pour into SDS and the National Council meetings became battlegrounds as each side tried to muster support. All this took place in the superheated atmosphere of bombs falling on Vietnam, body bags coming home, increasingly violent attacks on the movement, and the murder or imprisonment of the black leadership. The luxury of time for clear thinking had passed.

Returning to Austin and stepping back from the political whirlwind that surrounded the national office had changed the way I saw SDS and the political battles going on within it. Working as a welder and being in constant contact with working class men, mostly Chicanos and mostly older than I was, added another dose of reality to the mix. Almost all the workers agreed that the US should end the war as soon as possible. They were curious about the antiwar demonstrations but none of them had ever taken part in one, partly because the demonstrators were mostly white students. The workers my age or younger were interested in the counter-culture because it was opening the way for more diversity. None of these people were attracted to militant confrontation, but they were open to our ideas. All the articles I had written about resistance and the need for education and outreach were still true.

The cultural radicalism that many of us foresaw in the early 1960s was now spreading across the country and people were experimenting with alternative life-styles based on cooperation for the common good instead of on the rugged individualism and

competition of capitalism. This was potentially revolutionary in the anarchist sense of building the new society within the shell of the old.

The second evening of the National Council meeting, Bernardine Dohrn and several other RYM people came to my house to ask me to help in their fight for control of SDS. That meant supporting either RYM or PL – but I wasn't interested in being part of that battle because I didn't agree with either side. After they left, I thought they considered me to be a "sell-out." But that was part of the problem. The way they saw it, I was either for them or against them and I didn't like the kind of politics that went with that mentality. After they left I decided to boycott the rest of the National Council meeting along with my Texas SDS friends.

One of PL's strong points for recruiting people to the Worker-Student Alliance was that its political positions supposedly lay on a firm foundation of analysis and theory. But in practice their "correct line" was often subject to change. PL moved from supporting the Vietnamese to condemning the National Liberation Front and the North Vietnamese government because they were willing to negotiate with the US. When PL's central committee decided that "all types of nationalism including black nationalism" were counter-revolutionary, the local PL and WSA members suddenly found themselves in opposition to positions they had recently supported. On campuses where PL had been working actively for black studies programs, affirmative action, and black student strikes, they switched sides over night and began working against these same positions. In some cases, they were actually breaking through picket lines that they had helped organize. RYM capitalized on PL's inconsistency and pushed a proposal that declared the Black Panther Party to be the vanguard of the revolution, and urged the formation of a "white fighting force capable of giving real support to the black liberation struggle." This was passed, overturning a PL resolution from the December National Council condemning all forms of nationalism including black nationalism.

The day after the National Council ended, a man knocked on the door of the downstairs apartment and asked for me. My neighbor came up and said that someone who looked like a cop wanted to talk to me. I went down and found a clean-cut guy who looked like he was in his mid-twenties. He told me that he was AWOL from the army because he opposed the war. He said that he had met some

people in the university cafeteria who told him that I could get him into the "underground railway" to Canada.[199] I knew that ways to get people to Canada existed but I had deliberately not learned anything about that since I didn't need that information.[200] I had never talked to anyone in Austin about it. None of my friends would ever have sent someone to my house without contacting me first. I pressed him for names, descriptions, and exactly how my name and address had come up. He didn't remember any names and his descriptions were so generic they fit half the people at the university. He looked too old to be a draftee and I agreed with my neighbor – he looked like a cop.

I told him that, no matter what he had heard, I didn't have connections to the railroad and couldn't help him. He insisted that he needed help and that he knew for a fact that I could help him. The more he pressed me, the more convinced I became that this was a set-up and so I decided to try to get rid of him. I asked where he was staying so I could contact him later. He didn't have an address or phone number and said he'd come back whenever I told him to. I gave him two hours and immediately called a friend on a safe phone and explained the situation. He agreed that the whole thing sounded like a trap and we decided to get the guy out of town without doing anything illegal.

When the guy returned, I told him that I could get him out of town, that he was leaving immediately, and that if he needed to make a phone call or get anything the deal was off. We walked a few blocks to a busy corner while I kept my eyes open for anyone following us. It appeared we were alone, so I told him to stand at the light until a car drove up and the driver said, "Hey buddy, you need a ride?" He was to get in the car, do what the driver said, and not talk at all or he would immediately be put out. My friend drove up and asked if the guy needed a ride. He got in, and they drove away. A few hours later I got a call to tell me that the guy had been dropped off on one of the little used county roads and told to wait for his next contact who would say, "Hey buddy, you need a ride?" We never heard from the guy again and I've always believed that it was a set-up, although I can't be sure. My FBI files have deleted any reference to what they actually did to neutralize me but there are recommendations that the agent find a crime to arrest me for. This incident certainly fits that pattern.

Late in the spring of 1969 we got both good and bad news from California. The good news was that the seven people, including my

friend Jeff Segal, who had been indicted on conspiracy to commit sundry misdemeanors during Stop the Draft Week at the Oakland Induction Center in October 1967, were acquitted. The major witnesses against the defendants were undercover police who had taken part in the planning. In addition, the prosecuting attorney had made the mistake of playing an excerpt from a campus rally before the demonstrations began and the defending attorney then demanded that the entire tape be played to put things in context. The tape contained good speeches against the war and some of the members of the jury laughed at the anti-LBJ jokes and quietly joined in when people chanted "Hell No, Nobody Goes." In the end the jury acquitted everyone.

The bad news was that the Berkeley police had opened fire on student protesters, killing one, blinding another, and wounding at least fifty others. The confrontation was over an unused vacant lot on university property that had been turned into a "people's park" by local movement people. The university wanted to make the area into a parking lot and had bulldozed the park. It was during the demonstration that followed that the police fired on the crowd. Governor Ronald Reagan sent in 3,000 National Guardsmen to take military control of the area. During the next week a thousand people were arrested and the National Guard used helicopters to disperse crowds by covering the Berkeley campus with tear gas.[201]

While the war and the repression swirled around us, Linda and I were having a good time together and decided to celebrate the fact that we were together. We held a party with lots of friends, a ceremony of poems and readings, and quite a lot of psilocybin. Following the celebration we decided to take a break and go to Mexico for a few weeks. Jeff Segal was now serving his sentence for draft evasion in a federal prison near Safford, Arizona, so we decided to enter Mexico at Nogales, Arizona, and to see him on the way. It never occurred to us that a federal prisoner might not be home, but when we got to Safford we found, to our surprise, that Jeff was off fighting fires to accumulate "good time" for early release. We left word that we would be back in a few weeks, drove on to Nogales, and took a bus to Guadalajara.

We spent two weeks in Guadalajara and on Mexico's west coast and then returned to Safford to see Jeff. This was a minimum-security prison used to hold convicted draft resisters and other non-violent criminals. We met Jeff in a large visiting room with chairs

and couches. Other prisoners and their visitors were sitting around tables or on the floor. One couple was quietly making love behind a curtain in the corner. Jeff told us that he worked in the kitchen and was organizing an IWW union there. He volunteered for work outside the prison whenever possible because it shortened his jail time and relieved the boredom. This prison was much different from the maximum-security prison in Illinois where Jeff had initially been sent. When I had visited him there in the spring of 1968, it was a totally controlled situation with security doors, guards, and constant surveillance. Safford was much more open, but even though it was minimum security, it was still a prison.

———————

In June 1969, while we were in Mexico, SDS held its annual convention in Chicago. There were 1,500 delegates, many at their first national SDS meeting, with about a third of them from the Revolutionary Youth Movement, another third from Progressive Labor, and the last third from neither faction. The convention got off to a rocky start with accusations flying in both directions and went downhill from there. The conflict between RYM and PL had now reached an explosive mixture and in the heat of the battle Bernardine Dohrn seized the microphone and announced that everyone who wasn't with PL should follow her into a closed meeting in another room. PL members were stunned by the announcement and tried to get RYM to stay, but it was too late. When the RYM caucus returned, after meeting for many long hours, they announced that all members of PL and of the Worker-Student Alliance were no longer members of SDS. They then marched out of their own convention to meet elsewhere.

Before the split, a long paper, "You don't need a weatherman to tell which way the wind blows," named for a line from Bob Dylan's *Subterranean Homesick Blues*, had been presented to the convention. This statement argued that the war in Vietnam was one part of a worldwide anti-imperialist struggle that included the "black colony" within the US. The role of white revolutionaries was to support the black movement by using "revolutionary action" to inspire "revolutionary youth" to become an "anti-imperialist, anti-racist, white fighting force." It went on to say that, although almost all Americans were part of the working class, they were hopelessly bought-off by the benefits they received because of their "white skin privilege."[201]

After the walkout, the RYM people elected Bill Ayers, Jeff Jones, and Mark Rudd as the national officers and a National Organizing Committee was elected to plan a week of protests in Chicago during the fall.[203] But there were major political disagreements within RYM about the "Weatherman" paper and without PL to force them together, RYM split. Supporters of the Weatherman paper first became known as RYM I and then simply as the Weathermen. This faction included all the new national officers and all of the members of the organizing committee except for Mike Klonsky, who left the committee to form another group called simply RYM II. Both groups began preparing for the fall demonstration, but in very different ways. The Weathermen prepared to fight the police and RYM II began planning a more traditional demonstration that would appeal to the working class.[204]

The PL group opened a new "SDS" office in Boston, but they had neither the SDS mailing list nor the loyalty of most of the membership and they quickly lost contact with most of the chapters. PL now had an organization with the correct line, but they didn't have the spirit of SDS. The leaders of PL/SDS reported and submitted to the leadership of PL, a group of people who worked behind the scenes and set the PL line. Later that summer, two of the PL/SDS leaders, Jared Israel and Jeff Gordon, were called before the leadership of PL and told to forget the war and to focus on the Worker-Student Alliance. Jared later said he knew that switching the emphasis would destroy PL/SDS, but he followed orders.[205] There were a few PL/SDS chapters, but they had their own splits and changes of direction and PL/SDS withered away. At the first Austin SDS meeting in the fall of 1969, a resolution was passed dissociating the Texas chapter from PL, the Weathermen, and RYM II.

Heading for the Hills
Fall 1969 – Spring 1971

"Take me to the mountains if you please. I would gladly trade the cement for the trees. Take me by the hand, take me to the land. It's the only thing I really understand."

Shiva's Headband, *Take Me to the Mountains*

"The land you bought ain't the land you bought, but the land you bought is nice!"

Lance Gurel, calling from Arkansas

On September 3, 1969, Ho Chi Minh died in Hanoi. He had spent his life fighting for the independence of Vietnam and had stood up to the Japanese, the French, and the Americans. Ho Chi Minh wrote beautiful poetry expressing his understanding that the struggle for freedom was ongoing and perpetual. It was sad that he died before seeing the liberation of his country from the aggression and destruction wrought by the nation whose founders had written the Declaration of Independence and the Bill of Rights. I thought Ho Chi Minh carried on the legacy of the American Revolution far better than Johnson or Nixon.

Following the Tet Offensive in Vietnam and the refusal of President Johnson to run for re-election, it had seemed that the war would end relatively soon. With the election of Richard Nixon our optimism died. He was one of the original cold warriors and the rhetoric coming from the White House made us wonder if fascism was just around the corner. To make things worse, the House of Representatives held hearings that fall on SDS and the danger it presented to the nation. Part of their evidence was a large chart showing the structure of SDS with my name and picture listed with the "key activists." Later my name was read into the Congressional Record as one of five people responsible for *all* the student unrest in the state of Texas. The government's anti-movement rhetoric encouraged attacks not only by the FBI and local police but also by violent right-wing paramilitary groups, such as the Minutemen and

the Legion of Justice.[206] The knowledge that we were in danger spread throughout the movement and many of us began looking for ways to survive. My fear that the government was out to get me wasn't simply paranoia. My FBI files indicate that I was under surveillance and that they were considering indicting me under the Smith Act that made it illegal to advocate the violent overthrow of the US government. They were also interested in whether or not I was leaving Austin to organize, probably hoping to arrest me for some kind of conspiracy.

Sharing houses to keep the cost of living down had been standard practice for years, but as the counter-culture grew, people began to think about forming communities that were more like a family rather than just house-mates. This idea quickly expanded to include moving to the country and living on a piece of land where we could also raise our own food. We reasoned that if we raised our own food, schooled our own children, and lived simply, we could create a model and show the world that communities of people who loved and cared for one another could sustain themselves economically and provide an alternative to the American rat race. We needed information about country living and the *Whole Earth Catalog* became essential reading for anyone in this "back to the land" movement. It not only listed tools and books for sale, but also included hundreds of pages of information about everything from organic farming to how to generate methane from manure.

I remembered my dad's warning that I might not be able to get regular work, so I decided to learn skills that would always allow me to make a living. I had learned how to weld and had worked in a number of shops before I met a young woodworker named Tony, who asked if I would make metal components for the furniture that he was building. Tony also made money doing odd jobs and needed help so I went to work with him. We did everything from leveling houses and putting on roofs, to appliance repair. It was a great way to learn to do all kinds of repairs, a skill that always has a market.

Linda and I were talking about buying land and Tony was also interested so we decided to all go to work and save as much money as possible before the next summer. We hoped that we could find a place that was inexpensive but located in an area where we could also make money from things we produced such as handmade furniture. We spent hours looking through the *Whole Earth Catalog* for ideas and through the *United Farm Catalog* for land. The cheapest farms were in Minnesota and Arkansas, but Minnesota

sounded much too cold, so we decided that when we had the money we'd see what we could find in Arkansas.

Meanwhile, in Chicago the government had indicted eight people on conspiracy charges for organizing the demonstrations at the Democratic Convention.[207] On the opening day of the trial in September 1969 the Weathermen staged a violent demonstration outside the courthouse resulting in nineteen multiple felony arrests of Weathermen. On October 6 a bomb destroyed the statue of a Chicago cop in Haymarket Square. The statue was a memorial to the policemen killed when they attacked a rally of workers in Haymarket Square in 1886. I had fantasized about blowing it up myself, as I'm sure many other movement people had, because it commemorated police repression of legitimate protest. The Weathermen's "Days of Rage" was scheduled for two days later, and we all assumed that they had blown up the statue.

The Weathermen leadership had hoped to bring thousands of people to Chicago for this militant action but the actual turnout was much smaller. Only a few hundred demonstrators gathered in Lincoln Park, but they wore helmets, carried clubs, and were prepared to fight the police – to be the "white fighting force" they had talked so much about. After building up their courage they headed for the rich neighborhood along the lake and roamed the streets for a few hours trashing cars, breaking windows, and fighting back when the police tried to stop them. By the end of the demonstration six Weathermen had been shot, many seriously injured and many more taken to jail. The next morning members of the "women's militia" attacked a line of police and several days later a demonstration in Chicago's Loop resulted in broken windows, smashed cars, and the arrest of many Weathermen activists on both local and federal felony charges.[208] Following the Days of Rage, many of the participants pulled away.

The Weathermen were not alone in attacking institutions complicit with the war. The Justice Department reported that there were 35,000 bomb threats in 1969.[209] As the possibility of ending the war seemed increasingly remote, small groups of people across the country began to turn to symbolic violence. Usually the intention was to destroy property that was in some way linked to the war while trying not to hurt anyone.[210] There was increasing news of bombings and arson attacks on Reserve Officer Training Corps (ROTC) buildings and other targets. ROTC, present on almost all

campuses, produced over 50 percent of the Second Lieutenants being sent to Vietnam and was an obvious target. Over the next few years the number of bombings increased as the war went on and on.

There were two demonstrations scheduled for the fall of 1969 – the Moratorium in mid-October and the Mobilization in mid-November. At the time no one knew just how important they would be. In July, before Ho Chi Minh died, President Nixon had sent a secret ultimatum to North Vietnam warning that unless there were serious breakthroughs in the peace negotiation, the US would be forced to use "measures of great consequence and force." He threatened to bomb the population centers including Hanoi and Haiphong, mine the rivers and the ports, bomb the dike system that protected the people from flooding, invade with ground troops, and possibly bomb the supply routes into the South with nuclear weapons. To make his point clear, Nixon warned the Soviet Union that he was putting the Strategic Air Command on full nuclear alert while he and Henry Kissinger, his national security advisor, prepared to deliver a "savage punishing" blow being planned under the code-name, "Duck Hook." No one outside the government knew anything about it at the time.[210]

On October 15, millions of people across the country demonstrated against the war, including a half million in Washington DC. There were now groups carrying signs like, "Teachers Against the War," "Social Workers Against the War," "Teamsters Against the War," and "Vietnam Veterans Against the War." In Austin a coalition of SDS and people from several other organizations set up pickets at the entrance to campus and asked people to stay away from class. There were teach-ins and discussion groups all over campus as well as guerrilla theater and a big rally in front of the tower at the center of campus. From there 10,000 people marched to the state capitol.

In reaction to these demonstrations Nixon appealed to the "silent majority," those white, middle class, god-fearing, law-abiding, demonstration-hating Americans who supported him in his efforts to crush the antiwar movement. Nixon was a shrewd politician and knew that although a majority of Americans opposed the war, there was also a majority who opposed the antiwar movement and said in opinion polls that they would support restrictions on free speech if that would stop the demonstrations. When we were a small minority, we organized to turn more and more people against the war so that the government would be forced to end it. Now the majority of the

American people opposed the war, but rather than end it, Nixon appealed to the "silent majority" to support his actions against the antiwar movement.

Two days before the November 15 demonstration we learned about the My Lai massacre in Vietnam. This execution of unarmed women, children and old men by the US Marines at the village of My Lai had occurred a year earlier but had been covered up by the military. The issue of war crimes began to appear in the press, and public support for Nixon's war policy was losing ground. Articles against the war appeared in the daily press and eleven antiwar resolutions were introduced in Congress. Well-known respectable people were beginning to speak out against the war and even family members of senior officials were in the streets marching against the war.[211] Nixon decided that going through with Operation Duck Hook would be political suicide, so he backed down on his ultimatum to North Vietnam.

Meanwhile, back in Austin, Regent Frank Erwin was preparing to cut down forty beautiful old live oak trees along Waller Creek so that the football stadium could be expanded to hold 15,000 more people. Ecology was not a commonly used word at the time, but people knew the difference between a live tree and a concrete stadium. Waller Creek was by no means pristine – companies upstream used it as a sewer – but it provided a place to sit under the huge old spreading trees on a hot afternoon. The trees were a symbol of the life that was being sacrificed everywhere in the name of progress. These beautiful trees would be sacrificed so that people could sit in a concrete stadium and watch a football game. When the cutting crew arrived, students had climbed into the trees to stop the cutting. Regent Erwin went to court, got a restraining order, and then ordered the police to remove the students so that the bulldozers could level the area. Twenty-seven students were arrested on county charges under a new law making disruptive activities a crime. Every time a tree fell, Erwin clapped his hands. A thousand students, including members of the Young Democrats and Young Republicans, gathered on the main mall to show their displeasure. Trying to save this area was one of the first environmental actions in the city of Austin.

By the fall of 1969 the movement everywhere was heavily infiltrated by agents and informants, and the FBI's attempts to sow discord and break up alliances was having a serious effect. Local

police had killed a number of Panthers, but now the FBI was actively involved. Fred Hampton was a very charismatic and respected leader of the Black Panther Party in Chicago. The Panther office was not far from the SDS office, and many Chicago SDS activists regarded him as a colleague and friend.

On December 4, at four in the morning, members of the Chicago police attacked Fred's apartment and killed him and fellow Panther Mark Clark. An FBI informer had supplied detailed plans of the apartment, including the exact location of Fred Hampton's bed, and that information was passed on to the Chicago police. Before the attack the informer put a strong sleeping pill in Fred's drink so that he was asleep when the police attacked with shotguns and a machine gun. They fired nearly a hundred rounds through the walls at Fred's bed hitting him three times. They then shot him twice in the head at point-blank range. The only shot fired by the Panthers was a single round into the floor as Mark Clark, head of the Peoria, Illinois, Black Panther chapter, fell to the floor dead of gunshot wounds. Seven others, three of them wounded, were beaten and charged with attempted murder of the police. The police claimed that they were looking for illegal weapons and that the Panthers had opened fire on them, but a Senate investigation showed the police story to be untrue and proved that the FBI and the Chicago police had planned the attack.[213]

This decision to murder the Panther leaders was not limited to Chicago. Between April and December 1969, police also raided Panther headquarters in San Francisco, Salt Lake City, Indianapolis, Denver, San Diego, Sacramento, and Los Angeles. The attack in Los Angeles took place only four days after the Chicago raid and used the same plan to kill the Panthers while they slept.[214] The LA Panthers, however, were prepared for the assault. Geronimo Pratt, now known as Geronimo Ji Jaga, the Deputy Minister of Defense and a decorated Vietnam veteran, had fortified the building and there were armed guards protecting it. The police assault was turned back and a four-hour shoot-out followed during which the police surrounded the building and actually dropped a bomb, which didn't go off, onto the roof. The Panthers refused to come out until the press arrived to provide them with protection from being shot down in the street. A jury later acquitted the Panthers because the police warrant was based on false information provided by the FBI. The Los Angeles Police Department and the FBI were determined to get Geronimo Pratt and later set him up on a murder charge. He was

sent to prison in 1972 where he remained for sixteen years until his conviction was overturned in 1998.[214]

The murder of Fred Hampton deeply affected many of us, including many of the people who would later become central to the Weathermen. It was apparent that the Chicago Police would resort to anything to destroy the Panthers and, with the SDS office just down the street, it soon became clear that SDS was also a target.

Beginning in early 1970, the Weathermen started dispersing and going underground. In late February they closed the national office in Chicago after arranging for all the records and documents to go to the University of Wisconsin historical archives. On March 6, 1970, members of a Weatherman collective in New York were building a powerful bomb in the basement of a Greenwich Village townhouse when they accidentally closed the circuit and the bomb exploded. Terry Robbins, Diana Oughton, and Ted Gold were killed and two others, who were upstairs at the time, barely escaped. After the explosion, most of the Weathermen went underground and immediately became the subject of a nationwide hunt by the FBI.[215]

On April 30, US military forces invaded Cambodia in a expansion of the war. This outraged us – not only was President Nixon not ending the war, he was expanding it into other parts of Southeast Asia. Students all over the country reacted with demonstrations, student strikes, teach-ins, and other activities. During the first week of May, thirty ROTC buildings across the country were either bombed or burned.

At Kent State in Ohio, where SDS had a strong chapter, there were demonstrations and the ROTC building was burned. The National Guard was called in and on Monday, May 4, for no apparent reason, they opened fire on a group of demonstrators. Sixty rounds were fired into a crowd of perhaps 200 students that was a hundred yards away. Four students died immediately and nine others were wounded. The war had finally come home.

As word of the Kent State killings spread across the country students went into the streets. Three hundred and fifty schools went on strike, 536 schools were shut down for some length of time, half the colleges in the country had demonstrations of some sort and 60 percent of the students – over 4,350,000 people – took part. In Austin, Nixon was burned in effigy and 8,000 students met on the main mall and headed off campus to protest the war. The organizers of the rally had planned to march around the university as a challenge to the city council's policy of not issuing parade permits.

To keep the police from knowing their plans, they kept the parade route secret. As a result, the demonstrators didn't know the plan either and before anyone could stop them, they all headed downtown. The police tried to block the street, but the demonstrators split up and went around the police on side streets. The police regrouped but they were so outnumbered that they finally resorted to tear gas to drive people back to campus.

I was working as a welder when the demonstrations began and decided not to take time off until the big demonstration on Friday. The guys I worked with were predominantly Chicanos who knew my views on the war and wanted to know what was going on, so we talked about the war and its history on breaks and at lunch. I told them that there was a big demonstration planned for Friday and that I wouldn't be at work that day. On Thursday at lunch they wanted to know what I meant when I talked about imperialism. We cleaned off a big steel table and I used welders chalk to draw a map of what used to be Mexico and showed what had happened to it as Texas and California were taken by the United States using military force. Then I drew a map of Vietnam and we talked about France and what the war was really about. Everyone listened and talked about what it felt like to be treated as part of a conquered nation. One of the guys, an ex-Navy welder, was very interested and we both took Friday off to march in the demonstration.

While I was at work, 10,000 students met on campus and demanded that the university be shut down. The police were on full alert and we heard that they had snipers stationed on the university tower and on other buildings with orders to "shoot to kill" any student demonstrators who headed downtown. On Thursday, some students went from class to class urging their fellow students to join them and the university went out on strike while the faculty urged the administration to negotiate with the students. A group of law students put together a case challenging the city council's right to deny a parade permit for Friday's march and went to court.

On Friday, I called in sick and went to the campus where a huge number of demonstrators had gathered. People began to leave the campus and head downtown on the sidewalk, but after a few blocks the word came that we had won our challenge to the city council's ban and the permit was granted. The people surged into the street and filled it from curb to curb for thirteen blocks from the university to downtown and then back past the State Capitol. It took three hours for everyone to make it around the parade route. I looked up

the street toward the university from downtown and saw a solid river of people. It was absolutely amazing to realize that this demonstration of 25,000 had started with demonstrations of two or three people when I first arrived in Austin seven years before.

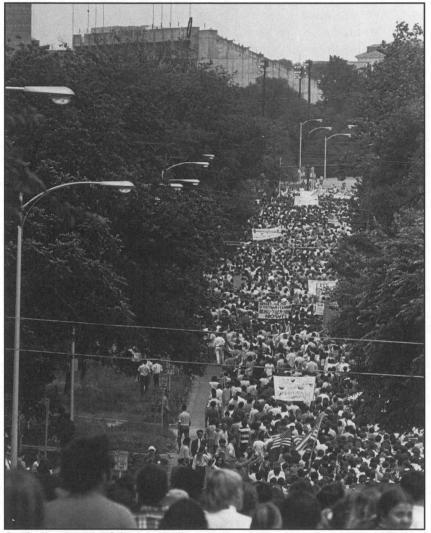

Austin demonstration following the killings at Kent State.

There is a notation in my FBI file that I was one of the primary organizers of this demonstration and perhaps that's true – if you consider that I worked on it for six years. The reality, however, is that I was simply a convenient person to blame. Many people believed there would have been no civil rights movement or antiwar

movement without outside agitators. They believed that most people were too dumb to do anything on their own. They really didn't understand the extent of the anger and antiwar feeling that had become widespread by 1970.

On May 14, ten days after Kent State, two students were killed and twelve wounded when police in Jackson, Mississippi, opened fire on students at Jackson State College during an antiwar demonstration. Jackson State was an all-black college and, like the deadly police attacks on black schools in Houston and Orangeburg in 1967, it was not widely covered by the press.

Following Kent State and Jackson State isolated groups of people across the country continued to attack local targets, often ROTC buildings, either burning them down or blowing them up. A government agency estimated that there were nearly 41,000 bombings, attempts, or threats during a fifteen-month period beginning in January 1969.[217] In late May, the Weathermen bombed the New York Police Department headquarters and the National Guard Headquarters in Washington DC as they continued their attacks on political targets. As usual, they issued a communiqué following the action to claim responsibility and explain the target to the public.

In mid-July 1970 the attack on the movement in Houston again turned deadly when Carl Hampton (no relation to Fred Hampton in Chicago) was shot and killed by snipers as he walked down the street. Bartee Haile, who I had recruited as a regional traveler in 1967, was wounded twice when he went to help Carl. Bartee and Carl had been organizing a white-black coalition and the Houston police had repeatedly arrested them and members of the coalition on numerous trumped-up charges ranging from illegal weapons possession to rape and murder. The snipers continued shooting at other blacks on the streets, wounding many. While all this was happening, the Houston police were nowhere in sight. When 500 Houston police finally arrived they ignored the snipers and went on a rampage through the black neighborhood, beating and arresting people. The snipers were never identified although it was assumed they were from the police or the Klan or both. Bartee was charged with attempted murder, although he was later acquitted by a hung jury.[218]

At the University of Texas the attack on the movement wasn't deadly, but it was still destructive. The FBI was targeting antiwar professors and pressuring universities to terminate their contracts.

Larry Caroline, who had come to Austin in 1967 as a philosophy professor, had angered the department head, John Silber, by speaking out against the war. The animosity increased after Larry Caroline sponsored Larry Jackson, a local SNCC organizer, for admission to the university. When Jackson dropped out and accused the university of being racist, Silber took it personally and blamed Larry Caroline. When Larry's contract was up for renewal in 1970, the philosophy department voted to retain him, but Silber used his power as Dean of the School of Arts and Sciences to block the appointment. About the same time, Arnie Kendall's contract in the drama department was not extended, probably because he was producing controversial plays. The Kendalls and Carolines were leaving to find work elsewhere and they were not alone. In the spring, my friends, Bobby and Trudy Minkoff, who had been helping with Greenbriar School and the *Rag*, moved to Santa Fe, which was becoming a gathering place for people on their way to communes. They wrote back to say they had found an alternative school in the formative stages and were living outside of Santa Fe with about a dozen of the other teachers. Mariann Vizard (now Wizard) was also planning to leave to join Larry Waterhouse in California. She and Larry had begun a relationship the previous summer and then Larry had been drafted out of graduate school. He was stationed at Fort Ord – and was working at an antiwar coffee-house nearby in his free time. He and Mariann were also writing a book about resistance within the military entitled *Turning the Guns Around*.

The loss of these friends meant that there was even less to hold us in Austin, so Linda, Tony, and I prepared to make an exploratory trip to Arkansas to see about buying a farm. Linda and I had saved up $1500 and Tony had about the same so we decided to look for land in the Ozark region of Arkansas and southern Missouri, where land was still cheap. We took Tony's van and camping gear and traveled through the hills of southern Arkansas and then north through the Arkansas Ozarks and into Missouri. The Ozark Mountains in northern Arkansas were the least settled and the most beautiful so we turned back south to search that area. After finding that we could buy 40 acre parcels for about $4,000 we headed back to Austin to figure out how to earn enough money to pay off the land, buy needed equipment, and still have a cushion to live on while we got established.

Back in Texas we decided that since wages were low in Austin we would move to Denver where we could accumulate the money we needed more quickly. I sold my 1948 Chevy to Dickie Magidoff, an old SDS friend from Cleveland who was passing through Austin on his way to California, and bought a 1951 International Harvester pickup that had large toolboxes along the sides where we could keep our belongings. The truck was old but ran well and I was confident that I could keep it running. We built a canvas camper on the back and Judy Binder Kendall painted a wonderful angel on the hood to protect us on our journey. In late July, Linda and I and Tony and his new wife, Alicia, headed toward Santa Fe on our way to Denver.

Portrait of me done by Judy Binder Kendall in 1969.

The Minkoffs had sent a map so we could find where they were living in Apache Canyon. After several days of driving, the last part over dirt roads, we came over a hill and looked down into a valley

with teepees, tents, and a large garden. It was late afternoon and, as we drove down into camp, people walking from the garden to the communal tent for supper greeted us and invited us to join them. We spent the evening talking and smoking, catching up with the Minkoffs and getting to know everyone else.

There were a dozen or so people living in Apache Canyon. New Mexico was one of the places in the country where the "back to the land" movement focused, and many political and counter-culture people were coming to Santa Fe from all over the country. People were on the move for a lot of different reasons. Political repression, including firing of antiwar professors, indictment of activists on conspiracy charges, and drug busts, had taken its toll. It seemed as if there was a general scattering of the movement as people all over the country tried to figure out what to do next.

The formation of intentional communities, or communes, was a logical step as we tried to create a space where we could build something positive and alive in Amerikkka, which seemed increasingly negative, dead, and beyond hypocrisy. Part of this was a desire to simplify our lives by growing our own food, building our own houses, and living as cheaply as possible. We didn't want to have any part of supporting a system that was killing people all over the world. We hoped that if we got out of the cities we could create an alternative to the cycle of selling our labor and supporting the system in order to live. We wanted to educate our children as part of the natural process of growing up rather than sending them to be taught by people who didn't share our values. We wanted to live with nature instead of conquering it.

The concern with ecology has its roots further back than the sixties, but it got a significant boost during that era for several reasons. We were very aware that the US military was using defoliants and herbicides in Vietnam on a large scale. Hundreds of thousands of acres of cropland were sprayed with herbicides to deny food to the people and millions of acres of forest and swamp were being killed with Agent Orange in order to expose the enemy. This information made us much more aware of our own environment and the use of chemicals on our own food supply. Another, and possibly more significant reason, was the use of psychedelic drugs that erased, at least temporarily, the boundaries between the user and the rest of creation. As a friend of mine once said, "It's harder to cut down a tree after you've had a conversation with one." A big part of the counter-culture was the desire to have our own lives be

of one piece rather than being divided into separate and often independent parts called, work, family, and recreation. This extended to living cooperatively with the earth as well.

The farm in Apache Canyon stretched for a quarter mile along Apache Creek and here and there people had set up tents or were living in VW buses or campers. A parachute spread out like a big awning was used as the central gathering place. A large garden produced fresh vegetables. People worked in the garden during the morning and evening and took naps or did crafts during the heat of the day. All activity appeared unplanned, yet the work got done, the meals got cooked, and the dishes got washed. Linda, Alicia, Tony and I helped wherever help was needed and talked to people about our goal of raising enough money to buy land in Arkansas.

We stayed for several days and were getting ready to leave when Bobby asked us to come to a meeting under the parachute. Their group was only staying in Apache Canyon for the summer and they were looking for someplace more permanent. They wanted to know if we would be interested in putting our money with theirs and finding a place in Arkansas where we could all live. By combining our money we would have enough to buy land. The four of us talked it over. Linda and I were in favor of the idea. Tony was willing, but Alicia wasn't interested in living with a large group of people, which was one of the factors that appealed to me. Before we left Austin, Tony and Alicia had considered moving to a piece of land near Austin that belonged to Tony's uncle, but they had decided to come with us instead. After much discussion and soul searching, Tony and Alicia decided to go back to Texas. Linda and I joined the Ganja Boogie Band, which is what the Apache Canyon people called themselves.

Bobby, Trudy, Andrew, and Linda and I were delegated to go to Arkansas to buy the land. The rest of the group, Jonga, Phyllis, Carol, Lance, and Kenny, wanted to spend that time visiting friends around the country. We found an old school bus in Santa Fe that Ken Kesey and the Merry Pranksters had driven around the country in the mid-1960s as they passed out LSD and promoted the "psychedelic revolution." Every inside surface looked as if people tripping on acid had decorated it. There were beds, a table, and a wood stove for heating and cooking and it was sound mechanically, so we bought it. We then spent a few days gathering supplies for our cross-country journeys and getting ready to go.

The day after the Weathermen's Days of Rage, Charles Manson was arrested in California for the grotesque murder of several people. Because Manson had lived on what some described as a commune and he and his followers used lots of drugs, the media presented him as an example of how dangerous drug users were. In the surreal atmosphere of the time, the Weathermen and the Manson murders were used to brand the entire movement and counter-culture as violent and dangerous. We had also heard about police attacks on the Panthers as well as on underground press offices and GI coffeehouses. In this hostile atmosphere it felt as if we could be attacked at any time, if not by the police then by some right-wing crazy, so I decided to arm myself. I had no illusions about being able to fight off the police, but I also didn't want to be completely defenseless. I went to the New Mexico motor vehicle department in Santa Fe and told them I'd lost all my identification and needed a new driver's license. I applied for one under the name Robert James and was told to come back in the afternoon to pick it up. I wondered if they were using the time to contact the FBI but nothing happened. The next day I went to Albuquerque and bought a rifle using my new identification.

In August, our group headed north out of Santa Fe in a caravan led by the psychedelic school bus, followed by our old International truck with an angel painted on the hood and the Minkoff's VW Bug. Our first stop was at an abandoned hot springs that had once been a resort but now belonged to some people who hoped to turn it into a health spa and commune. From there we moved on to Westcliffe, Colorado, about sixty miles west of Pueblo. I had been to this area many times on fishing trips and knew about an isolated campsite where we could stay for a few days. At sundown several pickups pulled in and a half-dozen young guys got out and stood around their trucks looking at us. As it got darker they started yelling insults and threatening us if we didn't leave. We talked the situation over and decided that Jonga (also known as John Ganja) and I should go out and talk with them. John was from Arizona and had grown up on the rodeo circuit with his dad. He had become a bronco rider when he was in high school. He and I thought we could relate to these "cowboys," so we walked out and talked to them. They told us that they didn't want "hippies" moving into their area. We explained that we were just passing through and needed a place to camp for a couple of days and then we'd be on our way. We invited them to come over to the bus to meet everybody. They stood outside the bus

for awhile and then came inside to talk. As they got to know us their hostility dissolved and when they left they said they'd tell other people not to bother us. The next day they brought some of their friends to meet us, and before we left they told us it was all right if we moved into the area but that we shouldn't tell other people about it.

We all planned to meet back in Santa Fe to spend the winter because we didn't expect to find a place with a livable house in Arkansas and because both Linda and Trudy were pregnant. Our two groups parted ways in Colorado. The bus headed toward the East Coast, while Bobby, Trudy, Andrew, Linda, and I drove across eastern Colorado and Kansas and into the Ozarks in northern Arkansas. We went from small town to small town talking to real estate agents and local people about land. Bobby was short with black curly hair that he wore in a big afro. Andrew had just returned from India and was wearing an outfit that looked like a white cotton dress. I still had short hair and a mustache and was the "straight" guy in the group. Everyone we met was very friendly in spite of being a little taken aback by our appearance. In Russellville, the United Farm real estate agent thought awhile and then said that he had a piece of land that fit our description but that he'd have to check on it since no one had asked about it in ten years. He called the owner and was told it was still for sale. The land was forty acres bounded on three sides by national forest, with an old log cabin, an everlasting spring, and five acres of tillable land. The price was $4,000, but he knew we could get it for $3,500.

He drove us about forty miles up onto the Ozark Plateau to Nogo, which consisted of a single building that doubled as a church and community center. We turned in at the farm of Claudie and Loreen McDonald but no one was home so we drove past their house and into the woods on a rocky, one-lane road that was more suited for a truck than the realtor's car. We soon came to a fork in the road where the agent, who hadn't been there for ten years, hesitated, then decided to go left. We drove for a couple of miles, ending up in a large field with a pond and the remains of an old house that had been bulldozed. He looked puzzled and said that he remembered the house as an old log cabin and that it was standing when he saw it. He didn't remember the pond and said several times that he sure hoped it was the right place. He took us down an old logging road, hoping to see something that looked familiar, but the road just seemed to go off into the forest. The agent decided that we

had to be at the right place. It fit the description of what we wanted, so when we got back to Russellville we made an offer of $3,500 with $1,500 down. When the offer was accepted, we filled out the paperwork, made the down payment, and headed back to New Mexico – the proud owners of forty acres at Nogo, Arkansas.

We found a small house to rent for the winter north of Santa Fe in the foothills above El Nido Ticolote, the owl's nest. One of Bobby's friends, Barry, lived in Santa Fe and was our telephone contact with the rest of the group. Lance and Kenny, who had left the bus and were hitching around, called in and asked for directions to the Arkansas land. In November they called Barry and left a message, "The land you bought ain't the land you bought, but the land you bought is nice." They said they'd call again after lunch. When they called back they told us that they had gone to the land using our instructions and set up their tent by the pond. After a couple of days, Claudie McDonald drove up and told them that it was all right to camp on his land, but that to get to the land we bought they needed to take the right hand fork of the road. Since they were on foot, he told them to go down the old logging road about a quarter of a mile. It turned out that if we had walked down that road another hundred yards, we would have seen the place. The farm we had actually bought was land the McDonald family had originally homesteaded. We had bought the land from Bill and Clarie Thomas, who had bought it from the McDonalds, who had sold it to raise money to get Claudie's dad out of jail after the revenuers caught him making whiskey during Prohibition.

As winter approached we settled into New Mexico. Bob Ellenburg, known affectionately as Coach Bob or simply Coach, had stayed in New Mexico while we looked for land and he and his partner Belle and her daughter Tasha lived with us. The house we lived in had a couple of pot-bellied stoves that had been salvaged out of the cabooses of trains and we made numerous trips with the pickup to the ranches around Santa Fe to cut piñon pine for firewood. Linda worked with a drama group and I did odd jobs. When I discovered that Frank Turley, a blacksmith in Santa Fe, had a school to teach people how to forge iron, I went to talk with him. We agreed to a trade – in exchange for teaching Frank how to arc and oxy-acetylene weld, he would teach me blacksmithing. I learned how to use the hammer and anvil to make a pair of tongs for holding the hot iron, and then he showed me how to take a horseshoe, forge weld it into a small iron bar and then turn that back

into a horseshoe. After I had accomplished that, he asked, "What do you want to do next?" I spent the next six months learning to forge tools and making flowers and animals out of iron.

During the late fall Bobby, Linda, and I headed off into the mountains to find Ben Morea and other members of the Up Against the Wall, Motherfuckers chapter of SDS from the Lower East Side of New York. They had come to New Mexico and bought horses so that they could journey through the mountains, living off the land along the way. Bobby knew their approximate location, so we drove in as far as we could and walked in the last few miles. We found about a half dozen men and women all wearing buckskin clothing and living in tents and teepees in the forest. They were in mourning because a week or so before, one of the men had been thrown from his horse and died a few hours later. They had buried him in the forest and set up camp nearby while they mourned his passing. They were now preparing to move on toward Colorado. We stayed with them for the day, discussing our plans for the farm in Arkansas and their plans to journey to Canada. A few years later I heard that the Motherfuckers had successfully made it as far as Colorado.

In November, Trudy gave birth to Sadie Grace about two months prematurely. Sadie had to be kept in the hospital for a month, but was home by Christmas. Soon the people in the bus arrived to spend the rest of the winter and our friends Donny and Kathy Gross came from Austin to visit. We had over a dozen people crowded into a house with only two large rooms, each with its own potbellied stove. When I needed some time alone, I would climb up into the foothills of the Sangre de Cristo Mountains that rose up behind the house. The view of the valley was magically beautiful except for one small area on the horizon – Los Alamos, the home of the atomic bomb.

The general scattering of the movement between 1969 and 1971 caused enormous problems for the FBI as they tried to find the Weathermen and keep track of people like me. There were communes springing up all over the country, many people were on the road with no permanent address, people were using made up names, and people's appearance changed as they let their hair grow. In New Mexico the FBI went from postmaster to postmaster trying to figure out who was where. Although they were supposed to know where I was at all times, by the time they found me I had been gone from Austin for three months. The agent in charge of my case was severely criticized for letting me get away. It appears that they

thought I had gone underground with the Weathermen because my name appears on a long list of fugitives, mostly Weathermen, who are "to be considered dangerous." In mid-October they received word that I was living in a canyon outside of Santa Fe with Bobby Minkoff, who also had a file, and in December they were still trying to figure out whether I lived in Austin or New Mexico. In February they decided that I was somewhere in New Mexico and sent all my files to Albuquerque. In March they found a letter to me in the Santa Fe post office addressed to General Delivery with no return address. In a memo dated April 4, 1971, a week before we left Santa Fe to move to Arkansas, they were still trying to figure out where around Santa Fe I was living. In June they found a letter in General Delivery from Coach Bob with a postmark from Hector, Arkansas, and a return address of North Star Route. The postman confirmed that we had all moved to Arkansas so my files were transferred to Little Rock.

While we were in New Mexico the war and the protests went on. In January, the South Vietnamese army invaded Laos with US support. In March the Weathermen bombed the US Capitol building in opposition to that invasion. In May the antiwar movement went to Washington DC for two weeks of protests. The Nixon government declared martial law and arrested over 12,000 people. Nixon was in the process of switching the war into Vietnamese hands by withdrawing American troops and increasing the bombing. By the end of 1970 there were 280,000 US troops in Vietnam, down from a peak of more than 500,000. By the end of 1971 there would be only 140,000

In February everyone left for Arkansas except for Linda and me and on March 18 our daughter Jody was born. We waited for another month before heading for Arkansas, stopping in Pueblo to show my parents the new baby before heading east. Before we moved to New Mexico I had fairly short hair and a mustache because I had made a conscious decision not to stand out due to my looks when I was organizing. Now that was no longer necessary and I had a full beard and a braid down my back. When we stopped for gas or to get something to eat people were very friendly and everyone wanted to see Jody. When they saw our blue truck with the angel on the hood and the canvas camper on the back, they wanted to know where we were headed. We'd tell them about the farm, which always started a conversation. Many people said they would

also like to do that. After a few days on the road we drove up into the Ozarks, past the Nogo community center, and turned in at the McDonald's farm. We took a right at the fork instead of a left, drove over two miles of bad road, and arrived at the log cabin and the farm that we had never seen. Leaves were on the trees and the flowers were blooming. The Ozarks and the farm and the people were beautiful.

— 18 —

The Ganja Boogie Band Commune
1971-1976

"The world is made of plumbing. The world is made of pipe. It's breaking while you're fixing it. The end is just in sight. The wind that's whistling through here gets colder every day. But we'll hang on for a little while. Things may come our way."

Bobby Minkoff, Ganja Boogie Band poet

We got out of the truck and went into the log cabin, the ten by fifteen foot structure where our neighbor Claudie McDonald had been born. A large room made of sawed lumber had been added at some time in the distant past, but it wasn't much protection from the weather since sunlight streamed in through cracks and holes everywhere you looked. There was a front porch looking out at a huge old cottonwood tree and an old car body that someone had shot full of holes. This was the only structure on the land and sleeping bags, blankets, bags of grain, and other things that needed to be kept dry were piled everywhere. Two wood stoves stood at either end of the room – one for cooking and one for heat. A huge wooden table with a grain grinder at one end served as a food preparation area. While we waited for supper, we shared stories of what had happened since we had last seen one another. We were happy to hear that several of the neighbors had come to greet the newcomers and that everyone was friendly because some of the people we knew in New Mexico had been greeted with hostility by their Chicano and Native American neighbors.

Since the house was drafty and cold, we ate in the "greenhouse," a large plastic tent behind the cabin. Most of the tent was filled with pots of sprouting plants for the garden, but there was also a long wooden table big enough for everyone to sit and eat. Before eating we formed a circle around the table, held hands, and OM-ed, which is just what it sounds like. Everyone took a deep breath and then made the sound OMmmm as they slowly let the breath out. OM

represents the sound of all things in the universe together – the cosmic background noise – and this ritual before meals reflected our sense that all life, in fact all creation, is bound together.

The next morning Linda and I looked the place over. The McDonald's land joined ours on one side and the Ozark National Forest bounded the other three sides, giving us access to several million acres of land for walking and exploring. Seven acres had been cleared sometime in the past, but this area was now overgrown with sage grass, small persimmon trees, and sassafras sprouts. Five acres of this had deep soil with very few rocks and a small part of it near the house had been hand-spaded to make a garden. The other two acres were too rocky to farm, but would make a good pasture. One of our first projects would be clearing off the brush so that we could begin the long process of making the land fertile again.

The house as we found it, with the old log cabin on the right end.

The "spring hollow" started just behind the cabin and a steep trail led down to a muddy spot where water slowly seeped out of a dirt bank and collected in a couple of shallow pools before becoming a small creek. The water was clear and cold but it didn't look like it should be used without boiling it first. Although the spring just seeped out of the hill, the McDonalds assured us it had never gone dry, "even during the drought in 1933-34 when the trees died."

Civilization was just beginning to get to this part of the Ozarks. The road from Hector, the nearest town, twenty miles away, had been paved since we bought the farm. The McDonalds had only had electricity for five years, and the nearest phone was still ten miles away at a little store in the next county. For us to get electricity at the farm would have required clearing a two-mile right of way through the forest and then paying a hefty fee for poles and wire. We never considered it and quickly adapted to kerosene lamps, wood heat, and muscle power for everything from splitting wood to grinding grain.

Although Arkansas is part of the South, the mountain people were distinctly different from the southern culture associated with slavery. They spoke with a different accent and used the word "youenzes" for the plural form of you instead of "y'all." When settlers moved into the Ozarks in the early 1800s, they cleared the flat areas on the ridges for farming and considered the steep rocky forested areas between the clearings to be communal land where they grazed their pigs and cattle part of the year. That all came to an abrupt halt during the 1920s and 1930s when the Federal Government decided to turn the communal lands into National Forest, made grazing in the forest illegal, and confiscated any farm animals they found there. In order to keep the animals out of the forest, the people needed strong fences and extra feed, but that cost money, something most of these subsistence farmers lacked. To make money, some of them turned to a traditional product – whiskey. But whiskey was illegal due to Prohibition, and farmers who got caught often had to sell their land in order to pay the fines. The forty acres we bought had been the original McDonald homestead recorded in 1828. When Claudie's father was caught making "wildcat liquor," he sold forty acres to Bill Thomas, a prosperous farmer down in the valley near Hector, paid the fine, and kept the remainder of his land. The Forest Service was always ready to buy the land, and the local farmers still resented the Forest Service because they believed that it used prohibition as a way to steal their land. More than one local farmer asked us not to sell to the Forest Service if we left. The fact that the local people had been "outlaws" made me feel more secure since I also felt like an outlaw.

As word got out to old friends and acquaintances, they began to come to visit and some stayed. The early settlers at what came to be called the farm, the "plantation," or the "Ganja Boogie Band" included: Bobby and Trudy Minkoff and their daughter Sadie Grace; John, known as John Ganja or Jonga; Bob Ellenberg, known as

Coach, and his son Miguel; Ken Dubie, Lorraine, and their two children, Jennifer and Robin; Donny and Kathy Gross and their son Aaron; Joanne, who later named herself Aunt Crabby; Eloise; Phyllis; Kenny Wildebeest; Lance Gurel; Peter Levine; Andrew; Scott Pittman and his brother, Wayne; David; Dona; and Dick.

Our group was a strange mixture; some had no experience with building or repairing things and others had grown up on farms or at least around them. We held regular, often daily, meetings to decide how to allocate our limited amount of money and to set priorities. There were several urgent projects and we took them on eagerly as we began to transform the land into a place to live. These early meetings were like the early SDS meetings that I had liked so much. Every project had its advocates and different groups of people set about planning each task. Many hands make light work and most of our projects were carried out by groups of people who enjoyed working together.

Creating a supply of clean water was our first priority. A group of us dug back into the hillside until we exposed the layers of rock where the spring water seeped out. We built a large concrete holding tank around the water source and covered it to keep animals out. We bought an old hand-operated pump with a long handle that made it relatively easy for two people to pump water up the hill and fill a fifty-five gallon barrel in about five minutes. This was a lot easier than hauling water up the hill in five-gallon buckets. Later, we bought a 1,000-gallon tank and set it up next to the log cabin to catch all the water that fell on the roof. It quickly filled to overflowing and gave us a source of cooking and drinking water that lasted until summer

Our second priority was to clear the garden and pasture areas. We sent Scott off to buy a tractor, and he returned with a huge one designed for plowing a flatland farm rather than a mountain garden. We used it to clear and plow the garden area and began the process of enriching the soil by plowing in organic material. The soil was deep and had very few rocks, but it had been depleted by a hundred years of growing corn and sorghum. We cleared and fenced the pasture area and bought a young Jersey milk cow from a local farmer. We named her Nadine and she became like a large pet. When I scratched behind her ears she would rub against me and purr — I think that's the sound referred to when they say, "the cattle are lowing." A neighbor had a flock of chickens for sale and we bought them as another source of protein. I built a chicken house

and pen and soon we had little yellow chicks wandering all around the pasture.

We bought an old three-ton truck and crews went regularly to the big farms around Hector to clean out barns and stalls in return for the spoiled hay and manure. We picked up rotted hardwood sawdust and truckloads of hay bales that had been rained on and were decomposing in the fields. Truckload after truckload was spread on the land and plowed under or made into piles and composted. We also planted "green manure" crops such as buckwheat and legumes and plowed them under as a way of building the soil. We bought hives of bees to pollinate the crops and to supply us with honey. When we moved to the farm, the weeds in the garden area grew only a few inches tall, but after a few years the soil had improved to the point where we could grow corn, azuki beans, peanuts, potatoes, and all the other regular garden crops. With many hands it was possible to grow a substantial amount of food, cut firewood for all the houses, and generally keep things going without much money, but we still needed some capital to buy what we couldn't grow and to buy gasoline, kerosene, and building supplies.

Soon after we bought the truck, Claudie asked if we could help him get his hay bales into the barn before it rained. We sent the truck and a large crew and quickly got the bales out of the field. Word quickly spread that we had a good crew and we began to get requests from farmers in the valley twenty miles away to help them get their hay in. We used this as a source of cash and often also took part of our payment in hay for Nadine the cow.

By late summer there were a number of small houses or sleeping spaces scattered around the farm. There was a small local sawmill nearby that gave us free "rough-outs" – the slabs cut off to square the tree before the lumber is cut. These rough-outs are flat on one side, and with the bark removed and some trimming they made useable lumber. Using these and regular lumber, Donny and Kathy built a house with a couple of rooms and a big stone fireplace. Ken Dubie was finishing a single room house with a sleeping loft, and Dave and Dona built a small house using a large tree as one of the corner posts, which caused the whole house to move a little when the wind blew. Jonga and several other people set up a teepee next to the garden. Linda and I built a canvas yurt about twenty feet in diameter with an eight-sided, hand-hewn, oak floor made of rough-outs that radiated out from the center. We insulated the yurt with another layer of canvas and carpet padding that we got for free, put

in a pot-bellied stove, and hoped for the best come winter. It was waterproof, but when the stove went out it got cold very quickly.

Relaxing at the commune.

Kenny wanted a quiet place to do yoga and built a grass hut several hundred yards down a steep hill behind the garden area. He tied thick bundles of grass to a frame made of branches set on top of a wooden platform made of rough-outs, and when he was done the walls were about eighteen inches thick. I welded together a small steel stove and his grass hut was quite dry and warm until one evening when the grass caught fire while he was doing yoga. He then joined with Bobby, Trudy, Coach, Peter, Lance, and some others who were re-assembling an old log barn that a farmer down the road had given them. They numbered all the logs, took the barn down, brought it to our farm, and put it back together. Since it had been a barn, it was not built very tightly and required a lot of concrete chinking between the logs to keep out the wind.

Because there was so much to do, it was possible to work all day, every day, so at one of our meetings we decided to set aside one day a week when no one was expected to work. David, a friend from Austin, had recently returned from school in Israel and since he celebrated the Sabbath, from sunset Friday to sunset Saturday, we all decided to do the same. Sometimes this day was used for discussions of religious texts ranging from Yoga to Native American beliefs, Sufi parables, Hindu, and Buddhist texts. People were seeking a new way of looking at life and were hoping to find a non-violent, cooperative path in eastern religion. Personally, I thought all the different traditions were too complicated and preferred the simplicity of walking in the woods or sitting by the creek.

On several occasions we fasted from food for the day, with some people extending it to a week or more. We also tried fasting from words and I found that to be more difficult. For one whole day no one spoke and we only wrote things that were absolutely necessary. It was interesting to learn that most of what we say during the course of a day is for social connection and that very little is to communicate important information.

Our farm was about twenty miles from the small town of Hector with its grocery store, mechanic shop, café, and several different Protestant churches. We quickly became friends with John Branch and Tim McElfish, the local mechanics who ran the gas station and repaired farm equipment. John and Tim introduced us to Earl and Ruby McElfish, a couple in their sixties who headed an extended family that included their children and their families. They functioned somewhat like a Christian commune based on a mixture of Pentecostalism, Seventh Day Adventism and Earl's interpretation of the Bible. Earl was interested in us because he had seen a vision in which the hand of God touched the earth and communes grew up everywhere his fingers touched. When we moved to our farm and other communes followed, Earl figured we were part of his vision. There was an open invitation for any of us to drop in at Earl and Ruby's house when we went to town and we often stopped by to discuss everything from sharpening saws and organic farming to religion. Earl would sit and talk about the Bible as long as we were willing to listen, and he listened to our ideas in turn.

The Ozarks were formed from a seabed that was gradually tilted up at the north, causing water to run south toward the Gulf of Mexico. The running water created long ridges separated by river valleys. Our ridge had the East Fork of the Illinois Bayou on one

side and the Middle Fork on the other. Water making its way from the ridges to the rivers below cut steep canyons, called "hollows" or "hollers," that divided the ridges into a series of relatively small flat areas separated by steep rocky hillsides. Our forty-acre farm consisted of about seven acres of flat ground, surrounded by steep hillsides and hollows going down on both sides. An old wagon road leading to the Arkansas River went through our farm and down the ridge to the East Fork, where we went swimming on hot summer days. These north-south valleys and ridges made east-west travel difficult. In the early 1800s, a team surveying the area was stopped by high cliffs along one of the creeks to the east. Because they couldn't establish the section corner they marked the ridge as "lost corner" and since they couldn't go on, they marked our ridge as "no go." The names stuck and our farm was located in Nogo, Arkansas.

I only went to town when it was necessary and preferred to spend my time working on projects or exploring the woods. The forest surrounding the farm was very wild and Kenny and I explored it in every direction. The Ozarks fascinated me because every creek bed and every hillside was different and fun to explore. There were waterfalls, deep pools, and shallow caves. The hardwood forest contained many different kinds of trees, plants, and animals. There were bears, deer, and many kinds of snakes including copperheads, water moccasins, and six-foot-long timber rattlers. The local people were very afraid of the snakes and killed every one they saw, but I always respected them and found that they were not aggressive if left alone. I explored all the surrounding hollows and woods but never ran into another person.

I enjoyed the exploring but I was also always looking for places where we could hide people. Kenny and I found one large dry cave on the McDonald's land that was so well hidden that even Claudie didn't know it was there. I hadn't been in contact with the Weathermen since before they went underground, but I was constantly reminded of them because their pictures were posted in the Hector post office among the people wanted by the FBI. I disagreed with them politically, but I always cheered when they blew up another symbolic target and sent a communiqué explaining their reasons for choosing it. I didn't expect them to come to our farm, but it was always possible that some of them might need a place to hide in an emergency and I wanted to be able to protect them if necessary.

J. Edgar Hoover had sent a memorandum to all field offices on April 17, 1970, ordering the agents to obtain "informant coverage" of every "New Left commune." We knew that we were under surveillance because our mail was routinely opened and sloppily resealed. It must have been very frustrating for the FBI as they tried to keep track of everyone on their lists. There were over 3,000 communes scattered across the country and thousands of people traveling from place to place. The use of made-up last names was so common that I never knew the real last names of some of the people I lived with in Arkansas.

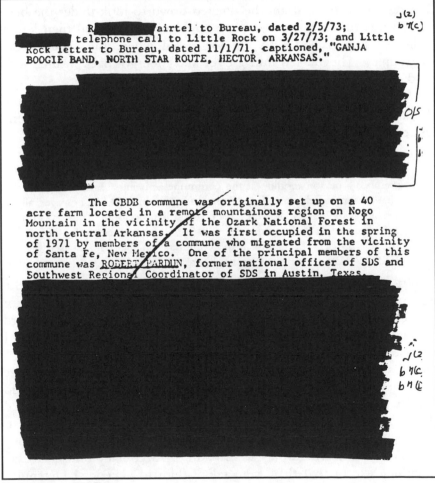

Page from my FBI file.

Early in the morning of August 24, 1971, two cars of FBI agents stopped at the McDonald's house to tell them that they were on

their way to our farm to capture a "draft dodger" named Lance. Loreen McDonald sent her son, Terry, out the back door to run through the woods ahead of the cars and warn us. The road was so rough that Terry arrived at our farm a full five minutes ahead of the FBI and Lance disappeared into the woods. When the FBI arrived, they flashed a search warrant and, using topographical maps, spread out across the farm as quickly as possible. I was in the yurt and had been warned that they were on the way but decided to just stay where I was and see what would happen. After a few minutes there was a knock on the door. I opened it and an FBI agent said, "Oh, hello, Robert. We wondered where you were. Can I come in?" When I asked to see his warrant, he ducked down to look under the bed, which was the only place anyone could be hiding, and then left. I followed him back up to the log cabin where the agents were regrouping. They talked things over and then got back in their cars and drove away.

The FBI agent who came to the yurt obviously recognized me because he called me by name, but the official report in my file states:

> It should be noted that Special Agents of the Little Rock Office visited the commune near Hector, Arkansas, on 8/24/71, to verify or eliminate a person residing at the commune as being a Bureau fugitive. That person was eliminated as a Bureau fugitive on 8/24/71, however, all persons at the commune were observed on that occasion. There was no one observed at the commune on 8/24/71 who resembled ROBERT MILTON PARDUN. Persons at the commune on that date advised that ROBERT PARDUN was not residing there.

In the early afternoon we spotted the FBI in Claudie's field, spying on us through the trees with binoculars. Kenny went to warn Lance to stay where he was and I headed down the road toward Claudie's field to get a better view of what the FBI was doing. As I crossed the hollow that separated the McDonald's land from ours, I saw Lance walking up the creek bed toward the road. This was the worst place that he could possibly have come out of the woods, and as I watched, two FBI agents walked down the hill and captured him. As they led Lance up the hill toward their car, I ran around to the field where the agents were and demanded to know what they were doing and where they were taking Lance. They refused to say anything except that they were taking him to a Federal Detention Center in Little Rock because he had not appeared for military induction. Lance actually had a letter from his doctor stating that it was impossible for him to wear boots because of a foot condition,

but he never went to the induction center or bothered to show the letter to his draft board. After his arrest it took about a month to get it all straightened out, but by late September he was back at the farm.

As the first winter approached we had accomplished quite a lot. The garden area had been plowed and tons of organic material added. We had a chicken house and pen. The pasture had been fenced, plowed, and planted in good pasture grass for our Jersey cow, Nadine, to eat. There was a root cellar down by the spring box where it was cool so we could store fresh vegetables like Chinese cabbage, carrots, and potatoes for the winter. The small houses we had built, along with a teepee, the old school bus we bought in New Mexico, and a loft in the old log cabin, gave everyone a dry and reasonably warm place to stay.

Winter brought the rain and it seemed like it rained every day for months. We watched in horror as the water running from the plowed ground washed away good soil and the material we had labored so hard to plow into it. We used the running water to show us where to dig level lines so that the field could be contour plowed and terraced in the spring. By the end of the winter we were all tired of eating cabbage at every meal and were delighted when the wild Poke Salad plants began coming up. Poke is said to be poisonous when it is mature, but the young leaves are delicious, especially after a winter of cabbage.

In the spring of 1972, two children, both girls, were born on the farm. Eloise gave birth to Desha and Joanne gave birth to Yana. We were all there for the births; some people inside helping and singing, others outside looking in through the windows to witness, in amazement, new life coming into the world. From the beginning there were quite a few children at the farm ranging in age from Jenny, who was about ten, to Miguel and Robin who were six or so, and then Jody, Sadie Grace, Aaron, and Willie who were babies. We tried to let the children be involved in whatever we were doing, and they helped us plant and harvest, gather the eggs, and milk the cow. Jody made friends with one of our chickens and would walk around with it under her arm. The children were often nearby while we were working and, of course, they went to the river with us when it got too hot. Having the children grow up with us was one of the reasons we moved to the farm.

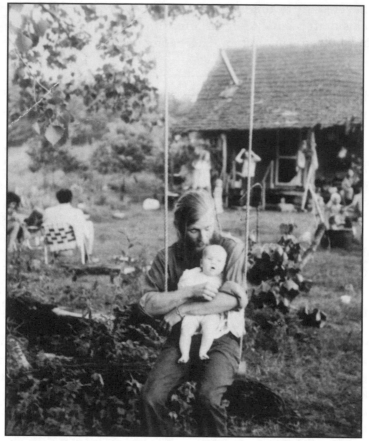

Me and Jody.

Spring brought more projects. Peter had inherited some money and we paid off the balance that we owed on the land. We allocated money to have a well drilled in the middle of the garden, and we took down the old room that had been added to the log cabin and replaced it with a much larger room. The "Big House" as the addition was called, wrapped around the log cabin on two sides and had room for a kitchen, a big dinning table, chairs, a sofa, and a large wood-burning stove for heat. I don't remember how we got a piano, but we did and it was wonderful when Peter played his cello and Kenny played the piano. The big house was the main gathering place for meals, meetings, or just hanging out and it seemed that no matter how many people showed up for supper, there was always enough food left for the unexpected guest. After every meal, Ken Dubie would declare it the "best meal ever" and he was always serious. After supper we would sit around the stove, with peanuts roasting

on the hot iron top, perhaps passing a pipe and talking, drumming, or singing.

The spring also brought an influx of new people to our part of the Ozarks. A group of people who had lived communally in Michigan bought 80 acres at Lost Corner on the ridge to the east of us. They were about ten miles away by road or about five miles if we walked down to the river and up the next ridge. We called them the Michigan Gang and the name stuck. They had obviously planned this move carefully and had decided to keep the level of technology simple by using animal and human power as much as possible. After they bought the land, they returned to Michigan, bought a big, enclosed truck, loaded it with tools and supplies, and returned to Arkansas. They built a tight shed, unloaded the truck into it and moved into the truck for a year, while they lived on the land and planned what to do. They had two ponds dug up on the side of a hill, one to water their animals and the other to water their garden. They bought a working team of two-year-old mules and old farm equipment, which they rebuilt and painted so they were like new. They later disassembled a school that was scheduled for demolition and turned the salvaged material into a two-story house to live in.

They had a well drilled next to the house and mentioned that they would like to get a wind-powered pump, commonly called a windmill. I called my uncle Bus in Iowa, where windmills were common, to see if there were any for sale. Bus told me that we could have all the windmills we wanted for free if we took them down because everyone had switched to electric pumps. A small crew of us drove to Iowa and had a wonderful time with my aunt and uncle, who were genuinely interested in our experiment with living on the land. We worked for a week taking down three complete mills, one of which was set up at the Michigan farm. Shortly after that one of the members of the Michigan gang was given an almost new wind-powered electric generator that they set up next to the windmill. With all this "modern" machinery they had a state-of-the-art 1920s farm.

Alice Embree, Gary Thiher, Char Pittman, and several others from Austin moved onto a river bottom farm in the valley beyond Lost Corner, and a group of oil field counter-culture divers and welders from Morgan City, Louisiana, affectionately known as the Louisiana Gang, moved onto the ridge east of them. When we wanted to visit the other communes we would often walk rather than take the truck. From our farm down to the East Fork, then up

to the top of Lost Corner and down to the river, where Alice lived, was about eight miles and a nice walk through the forest. It was nearly twenty-five miles by truck, part of it over a very rough road. Individuals, couples, and small groups that weren't really communes but were part of the movement were also moving into the area. Steve Fox, the Vietnam vet I had known in Austin, bought a few acres about ten miles from our farm.

As the community grew, we held Full Moon Boogies. People from all the communes would meet at one farm on the full moon to work, eat, and have fun. On one farm we built the frame for a barn and when people came to our farm they hoed and weeded our five-acre garden. These parties were a time for people to get to know one another and to share information. There was always a huge evening potluck meal and lots of music and singing. These full moon gatherings usually took place in the warmer months but I remember one at the Michigan gang's farm in the winter when we tried out their sweat lodge. They had erected a small tent near the dock going out into the pond. We heated up a large piece of iron until it was red-hot and put it in a pit inside the tent. Five or six of us took off our clothes, went into the sweat lodge, and sprinkled water on the hot iron to fill the tent with hot steam. As the lodge got hotter and hotter, one person at a time left the tent, ran out on the dock and jumped into the pond at a place where we had broken the ice. After scrambling out of the icy water, the heat of the sweat-lodge was very inviting so the process would repeat a few times before the lodge was turned over to other brave souls.

Living twenty miles from town, without electricity, meant that on any given day we didn't know what was happening in the rest of the country or the world. We had a few battery-powered radios but replacement batteries were many miles away. We kept up with the news, although we often learned of events some time after they happened. Visitors who came to spend a few days brought news of what was happening in the world with them. We knew that the Weather Underground was still bombing symbolic targets and that they had gotten Timothy Leary, the LSD guru, out of prison and into the underground. We had heard that Chicanos, Puerto Ricans, and Native Americans were forming their own liberation organizations and that the Los Angeles police had opened fire on a demonstration of Chicanos, killing one and wounding thirty-four. I paid particular attention to the prison rebellion in Attica Prison in September 1971, because New York Governor Nelson Rockefeller's

response was so outrageous. After refusing to negotiate with the prisoners, he ordered a military-style attack that killed thirty-one prisoners and nine of the hostages. I recalled that another member of the Rockefeller family had called in the troops to gun down striking workers and their families at the Ludlow massacre near Pueblo in 1914, so I cheered when the Weather Underground bombed the New York Corrections office in Albany, New York, in retaliation.

In June 1972, part of the war in Vietnam came home to Arkansas. Agent Orange, a mixture of two defoliants, 2,4 D and 2,4,5 T, was widely used by the US military in Vietnam to destroy the forest there. The Forest Service was using a similar concoction in the Ozarks to convert the south-facing slopes from hardwood forest to pine forest. They used helicopters to spray the oaks and hickories and then dropped pine seeds in hopes they would grow. The US government had excess defoliant on hand, probably a result of the winding down of the Vietnam War, and the Forest Service offered it to the local farmers as a new and wonderful way to convert forests into pastures.

Information had been filtering back from Vietnam about the effects of Agent Orange on the GIs and on the Vietnamese and we read a detailed article about it in *Atlantic* magazine. Particularly frightening was the evidence of birth defects and miscarriages associated with dioxin, a contaminant found in Agent Orange. The Forest Service held meetings to convince the local farmers that the defoliants were safe to use because they only affected plants and were harmless to people. When we presented our information that questioned the safety of the defoliant, they admitted that dioxin was toxic but told everyone that once it landed on the soil it didn't move and that soil organisms destroyed it within a few days. They warned people not to use the trees killed by the spray for firewood, since the heat might create dioxin, but they assured everyone that burning the wood was the only danger. Their claims about dioxin were at best wrong and at worst lies. Dioxin is very toxic, very persistent, and moves easily in the water supply. We argued our case as best we could because Linda, Joanne, Kathy, and Loraine were all in the first months of pregnancy and any spraying uphill from our spring would probably end up in our water supply. We understood why the local people were interested in spraying to kill the trees and create pasture. They were poor by anyone's standards, and creating pasture meant that they might be able to raise enough cattle to make a living off the

land. It was common for families to leave for months at a time to do seasonal work so that they had enough money to improve their land. Claudie drove a log truck, which was taking its toll on him physically, and that, combined with the income from his farm, was still far below the poverty level.

Many of the local farmers, who thought the government was lying about everything else, decided to believe them on this one. When Claudie decided to defoliate one area an eighth of a mile uphill from our spring, the Forest Service assured him that it wouldn't affect us. In June the helicopters came and sprayed the trees, and it was July and August before the leaves turned brown. I could imagine what it was like to be a Vietnamese farmer and watch as US planes killed all the trees around the village. It was later in the fall that Lorraine had a miscarriage. Soon Joanne began to feel sick and went to Texas, where she delivered two severely deformed, dead babies. Kathy and Donny's child was born normal. It is impossible to tell whether or not the spraying caused the miscarriage and the deformed babies. The Forest Service, however, was concerned enough about it that they later produced a short film that made it look as if the problems were caused by our life-style. The McDonalds didn't know about any of these pregnancy problems when they decided not to spray any more land. Their son, Terry, who had been looking for a good excuse to drop out of high school, began clearing more land for pasture by hand.

Later that winter, Linda went into labor very suddenly. We tried to make it to the hospital in Russellville but only made it as far as Hector before it was obvious we weren't going any further. The McElfishes weren't home but had left us a key for just such an emergency. We laid out a clean sheet, boiled up pans and pans of water, and Eloise and I delivered Rachael Joy. The next morning we went to the clinic in Conway, where the doctor paraded Rachael up and down the hall, proclaiming the joys of natural childbirth and declaring Rachael, "perfectly healthy."

By the late summer in 1972 it was becoming clear that we needed to re-evaluate how things were going at the farm. We had been experimenting with different levels of technology as we tried to find a balance between living simply and not spending all of our time doing it. As we tried to become self-sufficient for food, we planted a vegetable garden and then planted the remaining part of the five acres in corn, peanuts, sweet and regular potatoes, sesame, and azuki

and other dried beans. We had sold the huge tractor, because it wasn't suited to the kind of intensive farming we were doing, and had tried to use first a donkey and then a horse to cultivate, but neither worked out, so we were back to doing it by hand. To maximize production of peanuts and potatoes we needed to almost bury the plants with dirt several times during the growing season, and at harvest time all the potatoes and the peanuts had to be dug out of the ground. As the ground became more fertile, the weeds got bigger and trying to weed five acres by hand was a constant struggle. We had experimented with a half-acre of wheat to see what it was like to harvest it by hand. Beating it with sticks to separate the seed from the plant and then putting it on a tarp and throwing it into the air to let the wind carry away the chaff was very time consuming and after a week's work by several people we had thirty gallons of wheat.

While it was fun working together, it was clear that most of us wouldn't want to do this every year. Doing all this work by hand was very time consuming and we were growing crops we couldn't adequately cultivate or harvest. Since I did most of the repair and maintenance of whatever equipment we had – and I knew more about keeping engines running than about taking care of horses – I suggested that we buy a small dependable garden tractor. With the right tools we would be able to plant, cultivate, and harvest our food crops. We could use the tractor to plow under the cover crops that we grew to enrich the soil and we could also use it to power a seed separator that would separate the beans, wheat, or other seed crops that were so time consuming to process.

Because of our inability to harvest our own crops, we bought most of our grains and beans in bulk and, to save money for building projects, we applied for Food Stamps. Although everyone at the farm was eligible, we only applied for the number of people that would give us enough stamps to buy what we couldn't grow. Bobby and I had to go into Russellville every month to talk with a skeptical government official who always insisted that a psychologist and a mathematician shouldn't need Food Stamps because there were jobs available. We explained that we lived 40 miles away over bad roads and that we had tried to find jobs around Nogo but nothing fit our job descriptions. Every few months a government bureaucrat from Little Rock would come to intimidate us. They asked lots of questions about the farm and insisted that we should move to a location where there was work. We reminded them that as Americans we had the right to live where we wanted and that it was

the Communists who told people where to live. We always got the stamps, but I never liked having to "negotiate" with the government like this and wished we could become self-sufficient more quickly.

A small group of us had been talking about finding seasonal work to earn money to get the farm through the winter and to buy equipment. There was serious opposition to the idea and the controversy exposed a conflict of visions about what it meant to live at the farm and why we were there. Those of us who wanted to take outside work argued that we needed a source of money so that we could buy the equipment and tools we needed to improve the land and to become more self-sufficient. Our vision of the farm was that it could supply most of the food for the people who lived there if we invested in machinery that could do easily what we couldn't or didn't want to do by hand. If we had the tools to take care of our food and housing needs it would create a space for us to decide what else we wanted to do. If this meant going out to earn money, then I was willing to do that so that I could live on a working farm later.

Those who opposed leaving the farm to make money did so on the grounds that it violated their whole reason for coming to the farm in the first place. The farm was supposed to be a model of the society we wanted to live in, a place where we lived and worked together and didn't leave home every day in order to work for money, as most Americans did. This conflict also involved work at the farm as well as outside. We all said that we believed that "we should do what our hands find to do" but some people found less to do than others. Those who found more to do wished the others would be more helpful, while those who did less thought the reason we had moved to the country was to get away from the work ethic and that working all the time was destructive to the worker. They refused to feel guilty because they were more "laid back." When it came to going outside to make money to keep the farm functioning they refused to have any part of it, saying that it violated their principles. I sympathized with their point of view, but I worried that if we didn't take positive steps toward self-sufficiency we would end up working long hours doing things that a simple machine could do quickly and easily. I didn't think that would last for long, and people would leave because they wanted to do other things with their time than shell beans by hand and thresh wheat and winnow it in the wind. It was finally decided that those of us who wanted to go would go, and the rest would stay at the farm and no one would feel guilty about it.

Those of us who were willing to work outside had two money-making schemes going. One of our neighbors went to the Red Gold tomato cannery in Indiana every year and he was recruiting workers for the coming season. We were told that it would last about six weeks, during which we would work twelve to fifteen hours a day, make a lot of money, and be eligible for unemployment in the spring. The other scheme was to go to Missouri to pick apples. Dave, Scott, Dick, and I decided to go to the cannery and Linda, Lance, and Sally decided to go to pick apples with a crew from the McElfish clan in Hector. Both crews headed north in September.

Working conditions at Red Gold fit the description of a migrant labor camp. The two-room "apartment" where six of us lived had six bad beds, a small kitchenette with a hot plate and refrigerator, no bathroom, and cost us $120 a month. By comparison, Linda and I had rented a two-room house with a stove, refrigerator, and bed for forty-five dollars a month in Austin. The communal bathroom had toilets along one wall, showers along the other, and no privacy at all.

We were probably the first hippie/political crew that Red Gold had ever seen and they assigned most of us to the area where the cans were labeled, boxed, and put on pallets to be shipped. We watched for crooked labels, ran the boxing machine, stacked pallets, and made sure the cooling conveyors didn't jam and spill hundreds of cans onto the ground twenty feet below. We worked a split shift that went from eight in the morning to four in the afternoon and then from nine at night until three or four in the morning, Monday through Saturday. We never got to sleep more than three or four hours at a time, and after a few day we were all past that point of exhaustion that is almost like taking drugs – we had lots of energy, but everything seemed surreal.

The company assigned each of us to a specific job, but that didn't make sense to us because some of the jobs were much more difficult than others. Because we were used to working together our immediate response was to run our area as a democratic collective and rotate the jobs. Running the boxing machine was the hardest job because the operator had to stoop over and use both his hands and feet to operate the controls. With our rotation system, when the boxer called "shift" everyone moved to a new job. The boxer went to stacking pallets, which helped stretch out the tired muscles. One of the labelers went to the boxer. The person on the catwalk came down to the labeler, and the person stacking pallets went to the catwalk. Our system worked well, but the company hated it because

our group was like a ready-made union. When they sprayed insecticide in our area we demanded that the spraying stop and when they ignored us we all walked out, leaving the cans to pile up all over the place and requiring the plant to stop production for an hour while we cleaned up. When they speeded up the flow of cans, I sabotaged the cooling conveyor, causing another shut-down. I'm sure they knew what had happened, but they couldn't fire one of us without all of us leaving so they slowed the line down again. About two weeks before the end of the season, Scott got so tired he caught his arm in the boxing machine and went home early.

When we arrived back at the farm, we set aside some of the money we had earned for a tractor, but we still needed more. Since I had welding skills that could be used locally, I volunteered to go to work in town for the winter to earn money. Again there was a lot of resistance, but Linda and I decided to do it anyway. Bill and Clairie Thomas, the people who had sold us the farm, had an old two-room house on their land in Hector where they stored hay. They told us that we could live there for free if we made it livable again, so we turned it back into a house and in February 1973, Linda, Jody, Rachael, and I moved in. I commuted about twenty miles to Russellville to work in a welding shop.

I had been working for a month when I got an emergency call – Rachael Joy was dead at the age of five months. I rushed home in a fog. We took Rachael into Russellville to the coroner who determined that she had died of Sudden Infant Death Syndrome. We then drove up to Nogo to tell the people at the farm and to ask Claudie what we had to do to have Rachael buried in the cemetery next to the Nogo community center. He said that he would take care of it and several local men built a small wooden casket and dug the grave. Rachael was buried at Nogo after a brief ceremony by Earl McElfish. Everyone from the farm, all the local people from Nogo, and all the McElfish family came.

We stayed in Hector for a month after Rachael died so that I could finish paying off the small, very old tractor that we had bought. After we moved back to the farm, I refused to go to town at all for the next six months. I stayed on the farm repairing machinery, working in the garden or going for day-long walks in the forest to sit by the rivers and waterfalls and watch the animals. We used the tractor to pull our old horse-drawn farm equipment. It was still hard work for the person walking behind the plow or cultivator but it

made cultivating and piling dirt on the potatoes and peanuts much easier and quicker.

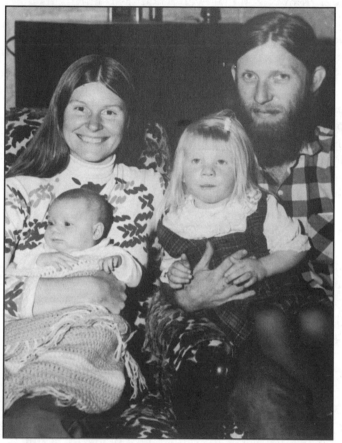

Linda, Jody, Rachael, and me

In August 1973 the government let us know that they were still watching us. We were all in the big house having lunch when the sound of very low-flying jets shook the house. We ran outside, but there was nothing to be seen. Suddenly three fighter jets appeared just above the treetops heading straight for us. The one in the center swooped down in a practice Napalm drop and the two behind followed in a practice strafing run. They passed over us at an elevation of about a hundred feet and disappeared over the trees behind us all in a matter of seconds. If we had been Vietnamese we would all have been incinerated or shot on the first run, the one that we didn't even hear until they had passed over the house. Before we could do anything they appeared again just above the treetops and

repeated their practice bombing run. A little while later, they flew over very slowly and waved their wings in unison. I guess it was just a reminder from Nixon that even Arkansas is in Amerika.

During the summer, most of the people who were putting up the resistance to going outside to work decided to move to West Virginia to join a commune there. Many of the people from New Mexico who had lived in Apache Canyon were part of this group. I was disappointed because I wanted the farm to work as a community and knew that it needed a critical mass of people for that to happen. We could live with little money if we had enough people to do the necessary work. I had hoped that we could keep the farm functioning until we accumulated dependable machinery to ease the workload, but half the population was leaving and that would make it more difficult.

That winter a number of other people also moved away, leaving about a dozen people at the farm. Some people had never intended to stay very long and left to do other things. Others just burned out on trying to live on a farm with no electricity, no running water, and an abundance of ticks. They left to make a life elsewhere. When the people left for West Virginia, Linda, Jody, and I moved into the log cabin that they had reassembled at the farm. It had one large room downstairs and a half-loft the length of the building. It was easier to keep warm than the yurt and was also larger.

During the first couple of years at the farm most of the visitors were people we knew or friends of someone we knew. Most of them stayed only a few days and helped with the on-going work. That changed when someone put our address in the *Spiritual Community Guide* and people began to wander in looking for a guru. Another kind soul put a message on the back of a billboard on the freeway out of Los Angeles saying, "If you're looking for a really great place to go and hang out, go to..." along with directions on how to find us. The visitors who came to the farm because of those two "advertisements" were usually not there to work and we weren't interested in people who just wanted to "hang-out" so we set a three-day visiting policy for those we let stay at all. One visitor, for unknown reasons, took all the books out of the library and put them outside. Another group ate all the ripening peaches. This was our first crop of farm peaches and we had been patiently waiting for them to ripen when we discovered that they had been eaten by visiting locusts.

Other visitors were more helpful. One afternoon, I was in the garden trying to start a borrowed rototiller when a blue Cadillac convertible drove in. A woman with bleached blond hair and a lavender mini-skirt, and a man wearing a polyester leisure suit got out and went into the house. I had spent most of the morning trying to start the tiller and was pulling the starter-rope and cursing when the guy in the leisure suit walked up, watched me for a minute or so, and then said, "It's your carburetor." He unscrewed the wing nut and removed the air cleaner. "Right here. This jet has to be screwed all the way in or it'll never start." He took a screwdriver out of his pocket, screwed the jet in and said, "Try it now." I pulled the rope and it started instantly. "I know all about carburetion; I hold the world's speed record on the Bonneville Salt Flats." He wished me a good day and walked back toward the house. The woman met him at the car and they drove away. I found out later that the woman had washed all the dishes. Earl McElfish used to tell us to "beware how you treat strangers, because they may be angels in disguise." Who would have thought they would wear polyester.

Our son Jesse was born in December 1974. We went to the hospital in Clinton, Arkansas, because we didn't feel we had a good enough support network at the farm for a home birth.

The number of people at the farm continued to drop. Donny and Kathy had gone back to Austin, and Dick had gone to California. Scott and Wayne headed back to Texas and then to New Mexico, Jonga had moved back to Arizona, and Joanne had left with a crazy Cajun. We were down to Linda and I, Dave and Dona, SueJan, from Austin SDS, and Vera, who had moved over from the Michigan farm.

As people left, the communal nature of the farm crumbled. Linda accepted this before I did and wanted to set up a kitchen in our log cabin instead of having everything happen at the Big House. I resisted because it meant that the group would no longer get together over meals and that was another step toward abandoning the idea of communal living. Linda insisted that our family was our commune and that if we didn't try to make it work, it too would stop working. I got the point and we set up a regular family household.

In 1975, Ernie and Sandy from Florida came to the farm with their daughter Dawn. I had always known that in order to get by with little money, the commune had to rely on its human capital. As the number of people dropped, this balance became critical. Ernie

was from rural Florida and knew about working on a farm and I was glad to have his help.

During the spring and summer of 1975, I worked around Hector, mainly for Bill Thomas and Charlie Caudle. Charlie had a thousand acres of river bottom pasture and big commercial chicken houses with hundreds of thousands of chickens. I repaired broken machinery, prepared fields for pasture, and did any other farm work that he needed done. Bill needed someone to clear his fields of the small trees that sprouted every year. I would run the tractor all morning, eat lunch with Bill and his wife Clarie, and then go back to work until mid-afternoon when Bill would come out and tell me to get into his pickup. He'd look through the five or six dried out chaws of tobacco on the dashboard, pop the best one into his mouth, and we'd head off for the back forty. He'd drive around and then pull up next to a rock or a stump or an old log and I'd get out and find the gallon jug of wildcat whiskey that I knew was there and we'd each take a swallow or two before I returned to work. As I got to know other local farmers, I found that they all hid their whisky the same way that Bill did. One of the reasons we got along with the local people was that we shared the reality of having been made into criminals by the government – us for marijuana and opposition to the war and them for wildcat whiskey.

In early 1976 Linda went to visit her parents and they gave her a car so she would have a way to commute to the college in Russellville where she began taking education classes. I continued to work for Bill and Charlie. We still had a huge garden and the weeds that grew only six inches high when we moved there now grew six feet high because of all the organic material we had plowed into the land. We couldn't keep ahead of them. The tractor was sitting in the field for lack of an expensive part and there wasn't enough money to fix it, so Ernie and I took turns driving an old Dodge Power Wagon through the field while the other walked along behind guiding a piece of equipment designed for use with mules. With too few people and not enough money, things were heading downhill.

We heard the news sporadically. When Richard Nixon and Spiro Agnew were elected president and vice president, I knew instinctively that they were both crooks. I wasn't surprised when news of Senate hearings in 1973 implicated Nixon in burglarizing the Watergate Hotel offices of the Democratic National Committee in June 1972. It also seemed totally in character when Spiro Agnew

was indicted for extortion, tax evasion, and bribery in Baltimore and resigned as vice president in October 1973. I was elated when Nixon resigned in August 1974.

One piece of news arrived special delivery – the news that the war was over. A friend of ours in Hector heard about the fall of Saigon to the liberation army on April 30, 1975 and drove his tractor all the way to our farm to tell us. After he left I went for a long walk in the woods and cried and laughed and sang. The Vietnamese had beaten the most incredible military machine in the history of the world. I thought about what the war had done to me and my friends and the numerous people who were casualties. Some were dead, some in prison, some underground. Some, like me, were disillusioned and emotionally disconnected from America and didn't know how to fit into it again. The fabric of America had been torn in a way that can only be matched by looking at the Civil War. The people responsible for mass murder in Vietnam, who destroyed the people's trust in the government by wrapping themselves in the flag as they shredded the Bill of Rights, were still in power. These people lied to Congress, the press, and the American people about a war in which millions of Vietnamese died, more than half a million South Vietnamese women became prostitutes, and half the population of South Vietnam fled to the cities to escape the Napalm, poison gas, and bombing of the US military. The war took away much of the funding for domestic programs and poor people all over America suffered because of it. In the face of this moral tragedy, the government tried to shift the blame onto those of us who protested what they were doing by saying that we were the ones who had destroyed the moral fabric of America with sex, drugs, rock and roll, and disrespect for authority.

In the spring of 1976, Dave and Dona left to go back to California and Vera headed for Michigan to work in a Montessori school. Ernie's brother from Florida came to live at the farm and he and SueJan paired off. Linda continued in school and I was still working for the local farmers in Hector. Linda was pregnant again, which was a surprise to both of us. Jesse's birth had been so easy that we decided to have another home birth. This decision was made easier because an obstetrics nurse from Chicago, who had delivered thousands of babies, had moved into our area and was available to help. Heather was born on August 28 with her eyes wide open and a smile on her face.

We had decided earlier in the summer to leave the farm, at least for a while. I was hesitant because I felt the world outside was hostile – but staying at the farm didn't seem to make sense anymore. I was working more in town than I was at my own farm, and the reality was that during the first six months of 1976, working almost every day in Hector, I had earned about $600. At the end of August we left for Louisiana with Lance and Sally, leaving Ernie, Sandy, SueJan, and Ernie's brother at the farm. In the fall we received a newspaper clipping from Ernie. The Russellville paper had interviewed him about the state of the Nogo hippie commune. The headline was "Send us no hippies. We are no commune."

Back To America

"Teach your children well, their father's hell did slowly go by. And feed them on your dreams, the one they fix, the one you know by."

Crosby, Stills, and Nash, *Teach your Children*

Moving back to America was not easy for me. I had moved to the commune because I had hoped to create an alternative way of living with a community. I didn't want to be complicit with what America had become. Tens of thousands of people had joined in the "back to the land" movement and thousands of communes were created across the country as "liberated zones" where people could experiment with living in non-violent, cooperative communities. As the war wound down, however, people slowly returned to the cities, for a variety of reasons. By the end of the 1970s most of the farm communes were gone.

I had felt like an outlaw on the run before moving to the commune, because of the extent of the government's attack on the movement. Although I had done nothing illegal, my FBI files reveal that I was not just paranoid, they really were out to "neutralize" me. By the time we left Arkansas in August 1976, it felt as if the repression against the movement had worked – we had been neutralized. The war in Vietnam had split the country in a very profound way. Now that the war was over, I didn't know what reaction to expect from people, so I decided to keep my past to myself. I had lost track of most of my friends from the movement, so when people left the commune I was left without a home or a community. Going to southern Louisiana, where I had found work before, made sense.

Moving back into America from a rural commune in Arkansas was like moving to another culture. Even though I could pass for an American, I felt like a stranger in a strange land. We had missed most of the popular culture of the 1970s by living without electricity, radio, or television for five years. When people referred to movies or

TV shows, advertising jingles or popular music, I didn't know what they were talking about. I considered going back to school, but we had three little children and no money, so I created a job history to cover the years from 1963 to 1976 and went to work in the Louisiana oil fields. The pay was good and nobody asked questions.

Lance and Sally came to Louisiana with us and we moved into a trailer park in Cat Bayou, south of Morgan City. I got a job with a company that did service work for the oil industry out of Morgan City. I was good with a cutting torch and spent a few weeks cutting up scrap steel while waiting for the opportunity to go offshore. ARCO needed a crew for one of their offshore platforms in the Gulf of Mexico and I was told that I could go out if I cut my hair and beard. ARCO didn't hire hippies. I decided to do it, and that job opened up other opportunities to go offshore. I soon became a member of a crew that pulled the anchors when a drilling platform was to be moved to a new location. Our work-boat went out to the anchor buoys, pulled the anchors out of the mud, and then let the platform reel us and the anchor in. When all the anchors were up, they moved the platform and then we pulled the anchors away from the platform and let them back down into the mud. Most of the time we were just waiting, but for the fifteen minutes when the ten feet in diameter anchor buoy was rolling around on the deck it was very dangerous. Offshore work paid well and I worked steadily until winter weather made working in the Gulf impossible.

As work became harder to find, I heard about a Comprehensive Employment and Training Act (CETA) welding school in nearby Franklin and decided to apply. I had taken an arc-welding course in Austin and had worked as a welder in Austin, Arkansas, and Louisiana, but oil-field welding required welds of x-ray quality and I couldn't do that. CETA was part of President Johnson's War on Poverty and this welding school sounded too good to be true. The instruction would be six hours a day for six months and, if I got in, I would be paid by the hour like a regular job. The program director said that the teachers were excellent and then he casually mentioned that the instructors and all the other students were black. When I didn't flinch, he signed me up. The school was as good as I had been told it was. The instructor knew from experience that black welders had two strikes against them to start with, so his goal was to train his students to be the best welders around.

When I graduated six months later I applied for work in the Avondale shipyard at Bayou Black, south of Morgan City. The

booths for the welding test were all occupied so I was asked to bevel a piece of pipe so that it would fit perpendicular to another pipe. When they found out that I was good with a torch and could cut pieces so they fit correctly, I was hired as a fitter. This was the beginning of my becoming a journeyman steel fabricator. I learned how to turn the blueprint into a finished product by preparing the material, fitting the pieces, welding it all together and installing the machinery. My way of learning the trade was to keep a job as long as I was learning new techniques and then to move on. During the years that I worked in the shops I helped build everything from simple frames to complex machinery including cranes, offshore oil platforms, and vibratory conveyors. I had always enjoyed making things with my hands and this was just a higher level of doing that. It was hard, dirty work but it was usually interesting – and nobody asked any questions about what I'd been doing for the past twelve years. It also paid well, and I had a family to support.

During the time that I was at the welding school, and later when I rode in a car pool with all black workers going to Avondale, no white person ever asked me about the fact that I spent a lot of time with black people. I knew that civil rights workers had considered southern Louisiana to be a very dangerous place to work during the sixties, but during the late seventies the situation seemed to have changed dramatically. The economic boom in the oil industry had changed the economy from one based on sugar cane and black labor, to a more industrial economy with its need for skilled workers. When I first went to work in Louisiana in 1974 and asked why there were no black welders in the shop, I was told, "There ain't no such thing as a good nigger welder." In 1977, there were black welders in many of the shops in the oil fields and the social structure that kept blacks in the sugar cane fields had given way to more economic equality.

I enjoyed working in Louisiana because of the people, the food, and the music. The Cajuns were a lot of fun and if it had been cooler I would have considered staying. When I found myself repeating "Mad dogs and Englishmen, out in the noon-day sun" as I slowly became delirious while working on a steel deck under the glaring sun, I knew it was time to move to a cooler climate. We had decided not to go back to Arkansas, so we moved to Pueblo to see if we could help my dad take care of my mother, who was suffering from advanced Parkinson's Disease. The war had strained my relationship with my parents and I also hoped I could get to know them again.

We stayed in Pueblo for about four months but there was no permanent work and we again began looking for a place to settle in. Linda's parents had retired to Portland, Oregon, and when they heard that we were leaving Pueblo, they offered us a free place to stay in a house they owned in Portland's small black neighborhood. I was hesitant to move near Linda's parents but we needed a place where I could get work and where we could get our feet on the ground, so in February 1978, we moved to Portland.

As we settled into Portland, we tried to carry through with the ideals we had brought with us from the farm. I didn't want to be a dad who got home exhausted and never had much time to spend with his children. I wanted to be with them as they grew up. I took jobs working the late afternoon to midnight shift so that I could spend most of the days at home. We decided not to get a television and I sabotaged the one that Linda's mother gave us because she didn't want the children to grow up "culturally deprived" and "out of the mainstream of modern America." We wanted our children to draw, to read, to do things that came out of their own imaginations. We wanted to teach them that learning was much more than the memorization of facts. I bought metal working equipment and created a shop in the garage, where I could do ornamental ironwork, make jewelry, do house repairs or any other projects that came to mind. I encouraged the kids to help me with my projects and in the process they learned that they could do creative things and design projects of their own. As the children grew up they all became artistic, independent thinkers with lots of interests and abilities.

Before we left Pueblo, Linda had heard about a church in Portland that was described as being a community and she began attending it not long after we arrived in Portland. I had no intention of being any part of a church, but Linda finally convinced me to come to a service with her and I was impressed by the way it was organized to take care of its members. The church had about 2,000 members and there were groups of young people, retired people, single adults and others that met regularly to make friendships and to help one another with common problems. The basic support network was made up of small neighborhood groups that met every couple of weeks. Members of these groups lived close to one another and looked out for each other by providing help for the sick, unemployed, and elderly. People were very friendly and welcomed us into their groups. The pastor was a genuinely compassionate man and the congregation, while mostly white and

working class, also included a significant number of blacks, Latinos, and other minorities. We had not been there very long when the pastor gave a very strong sermon against racism and we discovered that he was well known in Portland for his strong anti-racist position. The facts that the church was organized to take care of its members and was actively anti-racist were important factors in my becoming a member of the church.

As we became involved in the church, we learned that it had grown from fifty or so members in the early sixties to some 2,000 members by the late 1970s. As the church grew, the pastor brought in a dozen or so elders who now helped run the church. The pastor was a registered Democrat but most of the elders were Reagan Republicans, and as the political religious right began to emerge during the eighties, the sermons given by the elders began to take on a political edge. They began by telling people that it was their religious duty to vote, and over the course of several years, that turned into an endorsement of the Republican Party and the growing religious right. The move to the right was gradual but it coincided with other events that made us question our relationship to the church. We watched as the elders helped the religious right take-over the Oregon Republican Party, using tactics that reminded me of how Progressive Labor had functioned within SDS. Shortly after that, Ephraim Ruizmont, the "born-again Christian" president of Guatemala, who had been named by Amnesty International as having the worst human rights record in Guatemalan history, was invited to speak at the church. This move to the right convinced us that we were in the wrong place, so we left the church.

At the same time that this was happening I made contact with Helen Garvy, who I had first met in 1964 in the SDS national office in New York. She was living in California, and urged me to attend an SDS reunion she was helping to organize. It had been nearly twenty years since I had been in contact with SDS people and the last memories were of splits and acrimony, but after much soul searching, Linda and I decided to go.

We flew to New York and by the time we got out of the city and to the reunion site upstate it was dark and the building where the meeting was being held was just a light on the other side of a big field. We made our way to the back door and walked into a room full of people out of the past. It was like going home after a long absence – and I realized how much I had missed this community of people and how isolated I had become. There were several days of

meetings and discussions, but mostly it was a time to catch up on what people had been doing. As with National Council meetings, most of the important gatherings took place out on the grass. It was great to see old friends and to find out what they had been doing. It felt good to be in touch with my community again.

Carl Davidson, me, and Mike Spiegel at the 1988 SDS reunion.

When we first moved to Portland I had looked around at the political organizations of the left and didn't find anything I felt like joining. There were lots of groups, but they were all very small and too narrowly focused on single issues. During the late 1980s I became involved with the Columbia-Willamette Greens because they were the first group I had seen which tied different issues together in the way that SDS had. Following the reunion I took a class called Vietnam Literature at a local community college, and met several people who had been in the antiwar movement and a number of Vietnam veterans who had seen heavy combat. It didn't take long for the Vietnam vets and the antiwar vets to become friends and I found it interesting that we all shared some important things in common. We had all taken the class so that we could talk about experiences that we hadn't felt comfortable talking about in public before. Both groups felt marginalized by American society;

the vets were "baby killers" and the antiwar people were "traitors." We all shared an instinctive distrust of the government. The Vietnam veterans felt that the government had lied to them, used them, and then abandoned them when it came to Post Traumatic Stress Disorder and the effects of chemicals used in Vietnam, such as Agent Orange. Through these veterans I made contact with the Vietnam Veterans Against the War (VVAW) and met men and women who had lived through the carnage which I had tried to stop. Some of these decorated veterans had returned home and thrown their medals onto the White House lawn to show their disgust with what the US was doing in Vietnam. Making contact with veterans was very important to me because I had worked hard during the war to bring them home alive. I attended several VVAW meeting and at one of them I was introduced as a veteran of the antiwar movement and was voted in as an honorary member.

With two other steel fabricators, in front of a large vibratory conveyor we built.

When President George Bush decided to use massive force to push the Iraqi army out of Kuwait, I found out how large the community of people with ties to the sixties was. The first antiwar rally in downtown Portland drew over 9,000 people on short notice. When I arrived at the rally I found that my children and their friends were already there. I remembered how much work it had taken and how many years had been spent getting that many people out against the Vietnam War. It felt good to be marching with people of all generations and to know that, in some sense, my work over the years had helped organize this demonstration.

In 1991, after working as a steel fabricator, ornamental blacksmith, and sales engineer selling the equipment that I had formerly built, I finally went back to graduate school to complete my master's degree in mathematics.[219] It had been 28 years since I dropped out of graduate school at the University of Texas. One of my professors told me that sixty-five percent of all mathematics had been developed since 1960, so I had a lot of catching up to do. I taught for several years at a community college near Portland, but while I really enjoyed working with the students, I felt increasingly at loose ends. In 1993 I was diagnosed as having Parkinson's disease and now that my children were grown I was re-thinking what I was doing with my life. In 1996 Linda and I divorced and I moved to California to be with Helen Garvy, who was in the beginning stages of making a feature-length documentary film about SDS – *Rebels with a Cause*. We live in the Santa Cruz Mountains where I have a garden and do metal sculpture. As we have traveled around the country with the film, we have had an opportunity to talk with many activists, including young people, who are organizing today. The struggle for social and economic justice goes on – and I am still proud to be a part of it.

— 20 —

Looking Back

"Whatever the weathermen did, and I don't want to make excuses for them, we've got to remember that the whole weatherman episode didn't equal the Napalming of one Vietnamese village – in its intensity or in its mistakeness – and keep our eyes on who the real criminals were."

Steve Max in *Rebels with a Cause*[219]

Politicians will go whichever way the wind blows. We were the people making the wind blow."

Alice Embree in *Rebels with a Cause*

America has changed since the sixties in ways that are truly profound – and much of that is the result of the movements for political and social change of that decade. Segregation is no longer legal, and blatant racism is no longer accepted as normal. Restaurants, hotels and motels, theaters, schools, housing, and universities can no longer legally discriminate on the basis of skin color, religion, or sex. Because of the struggles of people from many generations, life for blacks and other minorities has significantly changed. In the South, where many black people lived in near slavery and were relegated to menial jobs into the 1960s, there are now many black public officials and economic conditions are improving.

Women are no longer expected to stay at home, cook, clean, and raise the children. The "women's section" of the want ads has disappeared, and women hold influential positions in universities, the professions, business, and government. The women's movement brought a redefinition of gender roles and demands for equal opportunity, equal pay, and affordable child-care. A similar shift has happened for homosexuals. Before the gay liberation movement, homosexuality was a crime in every state and gay bashing was almost considered a legal sport. Today many gays are out of the closet and accepted in society.

The Vietnamese people's refusal to give up, combined with the antiwar movement here at home, finally did force the US to get out of Vietnam. We showed that education could change public opinion and that massive opposition could eventually create such havoc that continuing the war wasn't politically feasible.

The cultural rebellion of the sixties challenged the rules and assumptions of America – and also proved that "the personal is political." We rejected the values and behavior that led to bureaucratic authoritarianism, racism, and the Vietnam War – and tried to live by other rules. As we searched for ways to liberate ourselves from what Bob Dylan called "society's pliers," we emphasized community and personal liberation – the right of individuals to pursue their own dreams. By questioning authority, we legitimized asking questions about the actions of those in positions of power. The cultural rebellion, together with political action, played a part in changing American consciousness away from white supremacy and male dominance and toward a more multi-cultural and tolerant society.

Counter-institutions flourished during the sixties as we tried to make the world a better place. We started alternative schools, free universities, medical clinics, and cooperatives for everything from buying food to fixing bicycles. Recycling and organic farming are now part of main stream thought rather than just the crazy ideas of the counter-culture. Alternative institutions continue to flourish to this day, while many of the ideas that spurred them have been incorporated into main stream institutions.

This is not to say that the battles we fought have all been won. Poverty is still with us, as are sexism and homophobia. Policy manifestations of racism still abound. Racial profiling is common and affirmative action is under attack. Many schools are still largely segregated, either because of the racial make-up of neighborhoods or because white children now attend private schools. The prisons are filled with people of color in proportions that are far beyond their numbers in the society.

The US continues to use its military might to police the world, and uses its powerful economy to bludgeon small countries into compliance with our needs. Although we had hoped to organize a movement that would prevent future wars, we have seen US interventions in Nicaragua, El Salvador, Panama, Grenada, Iraq, and Columbia. The experience in Vietnam – and the opposition at home

– has limited what the military can do, however. Nobody wants "another Vietnam."

There is still plenty of work to do. While the threat of nuclear war among the advanced nations has decreased somewhat, the threat of committing environmental suicide has increased. Stripping the resources from the land, using chemicals and poisons to grow crops, and dumping waste material into the atmosphere, the soil, and the water are all short-sighted. Stopping these practices is an uphill struggle because capitalism is by its nature short-sighted. It exploits whatever will make a profit today and then takes advantage of the disaster it has created to make another profit tomorrow. The concept that the unbridled greed of a few leads to the social good for the many needs to be continually challenged.

As we go into the twenty-first century, unregulated international capitalism is moving jobs wherever wages are lowest. CEOs are paid multi-million dollar bonuses for closing down factories and many receive salaries that amount to hundreds of times what they pay their workers. Working people and the poor increasingly find themselves cut out of the political process, as money from corporations and the rich buy the elections. Real wages are dropping at the lower end of the pay scale while material consumption increases on the upper end. The rich are getting richer and the poor are getting poorer.

The attack on the movement begun by President Johnson and accelerated by President Nixon was to some extent successful. By the end of the Vietnam War, the political left in America was in disarray. Internal conflicts combined with repression shattered the movement and left many activists scarred and weary. Although political activism continued, it became localized and fragmented into isolated single-issue groups. The attack on us didn't end when the war was over but continued into the 1980s and 1990s as the political and religious right consolidated its political power by running against the supposed moral breakdown of the sixties generation. But that distorts our values.

The *Port Huron Statement* of Students for a Democratic Society began with a statement of values that both reflected our personal understanding and influenced the way we worked. We believed in justice and equality. We believed that all people have the potential for meaningful and fulfilling lives and that all people – including blacks, other minorities, and the poor – have the right to help make the decisions that affect their lives – economically, socially, and politically. The value of organizing people to collectively make their

voices heard was part of the vision of the future that was at the heart of the movement of the 1960s. People can make big changes if they work together, but to do so they need a vision of a just world and knowledge about how the issues are interconnected. Now is the time to think and to dream, to plan and to act.

The history of the sixties generation isn't finished yet. We are still very much present and working to change the world in many different ways. There is a growing international movement for justice and equality – and the number of people active today is larger than it was during the sixties. The difference is that, in the absence of overriding issues, there is little unity among the organizations. It is only when people see the issues as connected that they begin to see how the system works and how to make it work for them. People everywhere are trying to build a better more just world. I am proud of what I did during the sixties and look forward to continuing to work for a better world with people of all generations.

Appendix
Lest We Forget

As the war continued year after year, it was apparent to those of us who opposed it, that the US was destroying Vietnam in the name of freedom and democracy. Now that the war is over, we can look at the results.[225]

Over 58,000 young American men, and some women, were killed in Vietnam and another 365,000 were wounded and live with the consequence. It is estimated that 3,500,000 Vietnamese and another 2,000,000 Laotians and Cambodians were killed. For every GI killed, nearly a hundred Southeast Asians died – most of them civilians.

Many Americans who came home without physical wounds bore other scars. Young men were taught how to kill and then sent into situations where they couldn't tell the enemy from the people. Many Vietnam veterans came back carrying a heavy burden of what they had seen and done in Vietnam. One result is that a disproportionate number of Vietnam vets never re-entered the American mainstream and many are homeless. It is estimated that by 1992, the number of Vietnam veterans who had committed suicide surpassed the number of US soldiers killed in Vietnam.

The US strategy was to deprive the enemy of protection either in the villages or in the jungle. Destruction of the environment and forcing the people to flee to the cities were major parts of this strategy. The U.S. sprayed nearly 19,000,000 gallons of herbicides on food crops, the jungle canopy, and mangrove swamps in order to deny food and cover to the National Liberation Front. Eight percent of the croplands, fourteen percent of the forests, and fifty percent of the mangrove trees in the vast coastal swamps were killed. The long-lasting ecological effects are widespread erosion, dust storms, major declines in freshwater and coastal fisheries, and severe losses of wildlife Of all the herbicides used, 11,000,000 gallons was Agent Orange, contaminated with dioxin, an extremely toxic chemical that causes birth defects in doses measured in micrograms. Over 170 kilograms of dioxin were spread across Vietnam and the health problems caused by it continue into the present.

When U.S. troops went through the countryside searching for the enemy, they called in air strikes, artillery, and attack helicopters against villages where they found resistance. In addition to bombs, the planes dropped Napalm, which exploded in a huge burning ball of sticky plastic. People were killed or seriously burned – or suffocated in the tunnels where they hid. Some 400,000 tons of Napalm was dropped on villages and enemy positions in South Vietnam. Cluster bombs burst into thousands of high velocity pellets, killing and maiming anyone in range. Laser directed, high-speed machine guns, capable of firing 18,000 rounds per minute, were turned on anyone who hid or tried to run away. B-52 bombers dropped bombs from an altitude of nearly nine miles on unsuspecting military and civilian targets in North and South Vietnam, Cambodia, and Laos. The US carpet-bombed parts of the Mekong Delta where the population density was 1000 people per square mile. This inability to distinguish between the peasants and the enemy led to the torture and execution of peasants, the destruction of villages, and to massacres like the one at My Lai, where hundreds of men, women, and children were executed by U.S. troops. Between 1965 and the end of 1969, there were 30 documented massacres similar to My Lai.

The U.S. dropped over 7.5 million tons (that's fifteen billion pounds) of bombs on Vietnam, more than half of this on the South, which we were supposed to be "saving." An equivalent amount of explosive power was used on the ground, in the form of artillery, and almost all of this was used on the South. The tonnage of bombs dropped on Vietnam was equivalent to 700 bombs the size of the one dropped on Hiroshima or three times the tonnage dropped during the entire Second World War. The result is that Vietnam is pockmarked with 25,000,000 craters, and unexploded bombs and land mines still maim and kill people thirty years after the war.

Nine thousand of the 15,000 villages in South Vietnam were seriously damaged and the accompanying social structures were destroyed. In 1964, 80 percent of the people of South Vietnam lived in rural villages. By 1969, only 50 percent remained in the country-side, and by 1972 that had dropped to 35 percent. The peasants fled to the cities where they lived in abject poverty in refugee camps. By the end of the war there were 12 million refugees, 600,000 prostitutes, and 800,000 orphans.

Notes

Introduction

1 I applied for my FBI files in 1988 and since I had never been arrested or indicted for any crime I didn't expect much. In 1991 I received, to my surprise, some 800 pages and was told that another 1500 pages were being withheld for "security" reasons. I appealed the deletions and finally received another partial release in 1997. I am still waiting for files I applied for ten years ago but the FBI seems to be in no hurry to release them. I have also received partial releases from the Chicago and Detroit Police, the Mississippi Sovereignty Commission, the University of Texas, and the Austin Police.

2 *Rebels with a Cause* is a feature documentary film on the hopes, rebellions, and repression of the 1960s, focusing on SDS. For more information contact Helen Garvy, 26873 Hester Creek Road, Los Gatos, CA. 95033 (www.sdsrebels.com) The film is distributed by Zeitgeist Films, 247 Centre St. New York, NY 10013 (mail@zeitgeistfilm.com).

Chapter 1

3 I have chosen to use the words blacks or black people for people of African descent, which became our common usage during the sixties, replacing the word Negro and more recently replaced by the term African-American.

4 On November 14, 1947, President Truman stated that the purpose of the loyalty program was to ferret out "potential subversives." The questions from these loyalty hearings included: "the employee advocated the Communist Party line, such as favoring peace and civil liberties." "There is a suspicion in the record that you are in sympathy with the underprivileged. Is this true?" One loyalty board member was overheard saying, "Of course the fact that a person believes in racial equality doesn't prove that he's a communist, but it certainly make you look twice, doesn't it?" Robert J. Goldstein, *Political Repression in Modern America.*

5 I recently learned that, in 1959, the student body president of my high school, who was black, was asked to leave a popular student hang-out after being told it was a private club.

Chapter 2

6 South Vietnam's President Diem was not married and his sister-in-law Madame Nhu was the acting First Lady of South Vietnam. She was on a speaking tour to drum up support for an expanding US military presence in Vietnam.

7 Dwight D. Eisenhower, *Mandate for Change*, p. 333, 372.

[8] I use the term Viet Cong to mean the forces fighting for the independence of Vietnam, including the National Liberation Front and the North Vietnamese Army, and with no negative connotation.

[9] This history of Vietnam is necessarily brief. For much more detail see Stanley Karnow's *Vietnam*, James P. Harrison, *The Endless War,* and Neil Sheehan, *A Bright Shining Lie.*

[10] Poll taxes required each individual to pay a fee before being allowed to vote. Literacy tests were also often used to disenfranchise black voters. While a white voter might be asked to sign their name, black voters might be asked to write out the Constitution from memory.

[11] This is in the wording of the Supreme Court's 1857 Dred Scott decision. It ruled that black people were "so far inferior, that they had no rights which the white man was bound to respect."

[12] The fact that this was almost never true was ignored by the courts until the landmark decision in 1954 in *Brown v. Board of Education of Topeka* where the Supreme Court declared that separate by definition wasn't equal.

[13] James W. Loewen, *Lies My Teacher Told Me,* p. 18-19, 158.

[14] Marxist and Marxism refer to a method of analyzing the socio-economic system by examining conflicts between economic classes as defined by their relationship to ownership of the means of producing goods.

[15] Within days of Diem's assassination, President Kennedy taped a statement in which he expressed regret for having approved the coup. He said that neither Defense Secretary McNamara nor General Maxwell Taylor was consulted and that they both disapproved of the coup. This tape was played on NPR's Morning Edition on November 25, 1998.

[16] SDS was actually the revitalized youth organization of the League for Industrial Democracy (LID), which was founded in 1905 as the Inter-collegiate Socialist Society by Upton Sinclair and Jack London, among others. In 1958, Alan Haber joined its almost extinct student group, the Student League for Industrial Democracy (SLID) with a vision of creating a nationwide student movement. Al recruited a small band of activists who shared his vision and changed the name to Students for a Democratic Society (SDS) in June 1960. A detailed history of the LID can be found in the appendix to Kirkpatric Sale, *SDS.*

[17] In the usage of the time "men" meant everyone. This was before the women's liberation movement made us aware of sexist language.

Chapter 3

[18] Civil rights activity involving students began in Austin in 1960. I didn't know it at the time, but several people from the University of Texas were key early members of national SDS. Robb Burlage had been a progressive editor of the *Daily Texan*. Dorothy Dawson (later Burlage) and Sandra Cason (known as Casey) were among the early members of the civil rights movement in Austin. Casey and Dorothy both went to work with SNCC,

in the deep South. Casey married Tom Hayden in Austin in 1961 and was influential in early SDS and with SDS's *Port Huron Statement*.

[19] The League for Industrial Democracy was small, but some of its members were still active. Bayard Rustin was a primary organizer of the 1963 March on Washington at which Martin Luther King gave his "I Have a Dream" speech. See also note 16.

[20] The Ghetto was a concern to the university administration and they kept files on students who they considered to be part of this loose group. In 1990 some of these files were thrown away by a retiring administrator and recovered from the dumpster by an enterprising sixties veteran. These files contain lists of students with information on where they were living, social security numbers, parents' occupations, a brief summary of academic standing, and information on drug use among the men and sexual activity of the women. This was at a time when we were taught that one of the evils of communism was the lack of personal privacy – "Big Brother" was always watching – but here in the United States we were supposed to be free from that type of invasion of privacy. While we were taught how lucky we were to live in a free country, the university was busily collecting personal files on us. As we would find out later, this was just the tip of the iceberg.

[21] Michael Beschloss, *Taking Charge: The Johnson White House Tapes, 1963-64*, p. 402.

[22] Karnow, *Vietnam*, p. 342.

[23] H. R. McMaster, *Dereliction of Duty*, p. 72. Also Harrison, *The Endless War*, p. 232.

[24] Doris Kearns, *Lyndon Johnson and the American Dream*, p. 259-60.

Chapter 4

[25] Carey McWilliams, *Witch Hunt*, p. 141.

[26] Kenneth O'Reilly, *Racial Matters*,.p. 158.

[27] O'Reilly, *Racial Matters*, p. 29, 98-99.

[28] The US Constitution reserves all powers not given to the federal government to the states. The southern states argued that "states rights" covered their treatment of blacks. The civil rights movement believed that the rights of citizens were more important than the right of the states to maintain segregation.

[29] Norman Ollestad, *Inside the FBI*, p. 129.

[30] O'Reilly, *Racial Matters*, p. 86-90.

[31] I have refreshed my memory about the White Folks Project with personal conversations with Ed Hamlett, Judy Schiffer, Sue Thrasher, and Nelson Blackstock. The "White Folks Project" is covered in Len Holt's *The Summer That Didn't End*, p. 129-148.

[32] Karnow, *Vietnam*, p. 364-73. The plan for attacking North Vietnam was called "Operation Plan 3A" and was approved by President Johnson on

February 1, 1964. Although the government claimed that the *Maddox* was there by coincidence, Defense Secretary McNamara admitted to the Senate Foreign Relations Committee that the Captain of the *Maddox* had been warned ahead of time that there might be an incident. See: David Wise, *The Politics of Lying,* p. 43-46.

[33] Karnow, *Vietnam,* p. 360-61.

[34] Karnow, *Vietnam,* p. 374.

[35] O'Reilly, *Racial Matters,* p. 186-189.

[36] O'Reilly, *Racial Matters,* p. 160.

Chapter 5

[37] *America and the New Era* (SDS paper), p. 20.

[38] My contact with the JOIN project was very limited. After I left, others came to work in Uptown and the JOIN project became established in the community and lasted into the 1970s.

[39] After the demonstrations, HUAC produced a documentary called, *Operation Abolition,* to show how naive students were being used by the Communist Party. The film was shown on campuses across the country and I had seen it in 1962 while I was at the University of Colorado. Word got around quickly that it was a great movie about student activism and the film served the opposite purpose from that intended by HUAC.

[40] Michael Rossman, *The Wedding Within the War,* p. 99-101. Also David Lance Goines, *The Free Speech Movement,* p. 113-119.

[41] Speech by Mario Savio on December 2, 1964 at Sproul Hall at U.C. Berkeley, quoted in David Goines, *The Free Speech Movement,* p. 361.

[42] Nelson Peery, "The Historical Significance of the Watts Uprising" *People's Tribune/Tribuno del Pueblo* (online edition), Vol. 27, No. 8, August, 2000.

[43] To combat the Republican charges, LBJ solicited an FBI report from Hoover that would show that the riots were caused by conditions that his programs would help to eliminate, and he enlisted former Republican presidential candidate Thomas Dewey to write a report based on FBI data. The riot report identified poverty and discrimination as principal causes of the unrest, implying that the Johnson administration programs represented the best possible response. This report helped to blunt Goldwater's challenge and played down the theory that the riots were caused by "outside agitators." Once he was elected, however, LBJ asked Hoover to expand the riot control curriculum at the FBI National Academy.

[44] Wise, *The Politics of Lying,* p. 46.

[45] SDS was an umbrella under which people with many different political perspectives could work together. PEP, largely a two-person operation run by Steve Max and Jim Williams, appealed to those who were more interested than most SDS members in electoral politics. One of their goals was the realignment of the political parties by forcing the Southern

Dixiecrats out of the Democratic Party, thus making it more liberal. Such a realignment did happen, beginning with the presidential election of 1964 when the Republican Party began wooing the Dixiecrats by playing on racial fears.

46 The voting age was lowered from 21 to 18 in June, 1970. Before that, young men could be drafted to kill people, but they weren't considered to be mature enough to vote and they couldn't drink alcohol in most states.

47 Wise, *The Politics of Lying*, p. 47.

48 Kearns, *Lyndon Johnson and the American Dream*, p. 251.

49 Beschloss, *Taking Charge*, p. 368-70.

50 Robert McNamara, *In Retrospect*, p. 62-64, 71-72.

Chapter 6

51 H. Bruce Franklin, "Antiwar and proud of it," *The Nation*, December 11, 2000, p. 6.

52 Wise, *The Politics of Lying*, p. 46.

53 Karnow, *Vietnam*, p. 415, 454.

54 Neil Sheehan, *The Pentagon Papers* (NY Times), p. 400-402. See also Karnow, *Vietnam*, p. 416-20.

55 McMaster, *Dereliction of Duty*, p. 241-42. Also Hubert Humphrey, *The Education of a Public Man*, p. 320-24.

56 PREP was initially headed by Dick Flacks and then by Todd Gitlin and Paul Booth. Chris Hobson and Marv Holloway did much of the research on bank loans to the South African government.

57 Mary King, *Freedom Song*, p. 475-79.

58 The May Second Movement was a student front group for the Progressive Labor Party (PL). I agreed with the statement on the basis of the ideas and didn't worry about which group was sponsoring it. PL later abandoned the May Second Movement and urged its members to join SDS. For that story, see chapters 11 through 16.

59 McMaster, *Dereliction of Duty*, p. 241-274.

60 Several officers of SDS did initially negotiate an agreement, but some members disagreed and the issue was referred to the National Council, which rejected the deal. The march went on under sole SDS sponsorship, welcoming the participation of anyone who agreed with the SDS call.

61 Speakers included Senator Ernest Gruening, Bob Moses from SNCC, journalist I.F. Stone, Yale history professor Staughton Lynd, who had directed the Freedom Schools in Mississippi, and SDS president Paul Potter. Entertainers included Phil Ochs, the Freedom Singers, and Judy Collins.

62 At first we didn't realize the differences between the challenges of civil rights struggle and the anti-war struggle. The process of breaking down

legal discrimination and Southern feudalism had been accelerating since the end of World War II. The civil rights movement was like trying to roll a flat rock down hill – it was hard and dangerous but gravity was on our side. Although it didn't come easily, change was inevitable because the South couldn't maintain its feudal structure and join the "modern world." The Cold War, with its religion of anti-communism, was the opposite. For the military it meant a chance to experiment with new weapons and for officers to get higher commissions. For industry it meant lucrative contracts and for labor it meant jobs. The destruction of Vietnam was very profitable and very hard to stop.

[63] Clark Clifford, *Counsel to the President*, p. 417.

[64] Carl Oglesby, "Trapped in a System," speech given November 27, 1965.

Chapter 7

[65] At an SDS reunion in 1996, Robb Burlage jokingly presented a rule that I fully endorse: "Just because you want to say it doesn't mean you have to say it <u>now</u>, and just because it needs to be said now doesn't mean <u>you</u> have to say it." I would add: "If it's already been said twice, you don't need to say it again."

[66] Much of the social democratic left was strongly anti-communist and many LID members supported the war in Vietnam at the beginning. They had watched with horror as the Russian revolution turned into the dictatorship of Stalin. They had battled the American Communist Party over control of the unions during the 1930s. Following World War II, when anti-communism grew in the US and communists were interrogated, persecuted, and jailed, these social democratic organizations survived because of their anti-communist position.

[67] The National Council, the major policy-making body of SDS, had fifteen at-large members elected at the convention. In addition, each chapter had one representative for the first 5 to 25 members and one representative for every 25 members beyond that.

[68] Jeff Shero presented a paper titled, "MDS – Movement for a Democratic Society" at the 1965 convention. MDS became a popular concept but never became a reality. There were a few chapters started in the late sixties, but there was little connection between them and none lasted for long.

[69] The feeling of safety of the SDS staff changed when Jim Russell was pistol-whipped during a robbery of the staff apartment during the fall of 1965.

[70] One letter from Carol McEldowney says, "The quality of the mailing is absolutely inexcusable. It says almost nothing …about what SDS is doing now and what SDS has been doing for the past 2½ months….The summary of the convention is terrible." After two single-spaced pages of telling us everything we're doing wrong,, she ends with, "Sorry the tone of this borders on the nasty." Another letter from Todd Gitlin began, "Warning: This is going to sound bitter, but <u>please</u> don't take it that way."

He describes the mailing as, "a collection of bureaucratic notes and directives that do not raise issues, that propose matters for disposition and not discussion, that obscure real problems and sound as though we are so fragile that we can't afford to look into our program, we can only boost it; we can't afford to accept the reality of choices, we can only celebrate, in a vacuous way." Toward the end he says, "I guess I sound mad. I guess I am. It is a shitty world, it overwhelms me, and I realize I'm taking a lot of anguish out on you." In his 1987 book, *The Sixties: Years of Hope, Days of Rage*, Todd says that the old guard made a mistake at Kewadin when it failed "to take these 'prairie people' into our old-boy networks." (p. 186) Those of us in the national office felt this distance, and after letters that were more hostile than helpful, we were hesitant to call on the old guard for help.

71 Letter from Helen Garvy to Carl Oglesby, June 22, 1965.

72 Terry H. Anderson, *The Movement,* p. 132-35.

73 Edward Doyle, Samuel Lipsman *et al, The Vietnam Experience: America Takes Over, 1965-67*, p. 42.

74 McNamara, *In Retrospect*, p. 156-58. Also Karnow, *Vietnam,* p. 405, 423.

75 Doyle, et al, *The Vietnam Experience,* p. 38-43.

Chapter 8

76 The history of what happened in the office during the summer of 1965 has been increasingly distorted as time passes. In his 1973 book, *SDS* (p. 217), Kirkpatrick Sale tells us:

> to achieve this egalitarianism they instituted a system whereby the person who mailed out the last copy of any pamphlet or paper would be the one to mimeograph, collate, and staple new stacks of them. What happened in practice was simply that no one sent out the last copy of any item requested, and the literature shelves were papered with single copies undistributed for weeks on end. By the end of June almost no literature was going out at all and only a few worklist mailings trickled out from time to time.

This same theme is picked up by James Miller in his 1987 book, *"Democracy is in the Streets"* (p. 244), where it is embellished by adding:

> But nobody liked to mimeograph, collate, and staple. Nobody liked to stuff envelopes. Consequently, nobody did these things. Elitism was routed – but virtually no mail was processed.

By 1994, in Tom Wells, *The War Within*, (p. 47) the summer office staff has been relegated to the class of vermin:

> the office – infested with anti-organization anarchists – was a shambles. There was nobody minding the store.

77 Vern Cope, letter to his daughter, excerpt in possession of author.

78 This incident is referred to in my FBI file with the note that we were angry at being out-maneuvered. That seems to indicate that the FBI had an informant in our chapter.

79 *The Dallas Morning News*, October 24, 1965.

[80] Todd Gitlin, *Sixties*, p. 197.

[81] Young people from all sectors of society united in opposition to the war and within a few years some of the sons and daughters of the war makers in the White House and the Pentagon were demonstrating against the policies of their fathers. See Wells, *The War Within*, p. 107-110.

[82] Oglesby, "Trapped in a System," 1965.

[83] Sam Bennett Paper, Wisconsin State Historical Society, SDS archive.

[84] Wisconsin State Historical Society, SDS archive.

[85] Jeff Shero to Dick Howard, Dec. 15, 1965. Wisconsin State Historical Society, SDS archive. Quoted in James Miller, *"Democracy is in the streets,"* p. 247-48.

[86] Robert Pardun, "Organizational Democracy," Wisconsin State Historical Society, SDS archive.

[87] Both Jeff and I proposed ways to make the officers responsible to the membership. Jeff's paper, "The SDS National Office: Bureaucracy, Democracy and Decentralization," is a good analysis of the SDS national office at that time and remains relevant as a way of looking at how power can be misused by people who have no intention of doing so.

[88] Pardun, "Organizational Democracy."

[89] At the time, I didn't get the complete story of this incident. After talking with a number of people who were at the conference I pieced together the following story. Lee Ellis, a black man originally from Mississippi, came to the conference with the Cleveland ERAP delegation. Dickie Magidoff of the Cleveland project described him as being aggressive toward whites, particularly if he thought they were racists. Jim Russell recalls that Lee demonstrated a card trick to a group of people and that Dick Howard from Texas said something inappropriate like, "My daddy always told me to beware of a nigger card shark." Lee Ellis, who everyone describes as huge and intimidating, reacted by threatening people, pushing people around and making sexual advances toward some of the women. This apparently went on for a long time since one woman remembers locking herself in the boiler room for the night for safety. Another woman woke up the next day with Lee standing at the foot of her bed saying that he wanted to have sex with her. Scott Pittman said that Bob Speck, from Austin, warned Lee to stop what he was doing and when he didn't, Speck decked him. Dickie Magidoff remembers driving back to Cleveland with Lee and Scott Pittman as they tried to work things out. When Speck and the Texans were accused of racism by some of the SDS delegates, they responded that if Ellis hadn't been stopped he would have seriously hurt someone and that not confronting a bully just because he was black was itself racist behavior. Sources: Jane Adams, Dickie Magidoff, Charlotte Pittman Dethoff, Scott Pittman, Jim Russell, Mariann Wizard (Vizard).

[90] Casey Hayden and Mary King, "Sex and Caste: A Kind of Memo," reprinted in *Liberation*, April 10, 1966, p. 75-87.

Chapter 9

[91] Carl Oglesby, "A letter to newly elected Congressman Wes Vivian," November 12, 1964." Printed in *Generation* (Ann Arbor, Michigan) Christmas 1964, p. 8.

[92] Karnow, *Vietnam*, p. 483.

[93] In a memorandum to President Johnson on November 30, 1965, Secretary of Defense McNamara wrote: "...there should be a three-or four-week pause in the program of bombing the North before we greatly increase our troop deployments to Vietnam or intensify our strikes against the North. The reasons for this belief are, first, that we must lay a foundation in the mind of the American public and in world opinion for such an enlarged phase of the war." *The Pentagon Papers*, document #107, point #4.

[94] B-52 Stratofortress bombers were almost 160 feet long (a little more than half a football field) with a wing-span of about 180 feet. They could carry 60,000 pounds of bombs and could fly thousands of miles to their target. Flying at over 50,000 feet, they were unheard and unseen by the people on the ground below.

[95] George McTurnan Kahin and John W. Lewis, *The United States in Vietnam*, p. 239, 330, 368-370.

[96] Eric Norden, "American Atrocities in Vietnam" and Seymour Hersh. "Chemical Warfare in Vietnam" in *Crimes of War*, edited by R. Falk, G. Kolko and R. Lifton, p. 265-84.

[97] Noam Chomsky, "Memories," *Z-Magazine*, July/August 1995, p 33.

[98] Harrison, *The Endless War*, p. 191-95. Also Eric Norden. "American Atrocities in Vietnam" and Seymour Hersh. "Chemical Warfare in Vietnam" in *Crimes of War*, p. 285-290.

[99] One legacy of the war is that thousands and thousands of these small bombs didn't go off and are still waiting to be set off.

[100] Gen. William C. Westmoreland quoted by Murray Kempton in "Heart of Darkness," *New York Review of Books*, November 24, 1988, p. 26.

[101] King, *Freedom Song*, p. 506-07. Also Anderson, *The Movement and the Sixties*, p. 154-56.

[102] "SNCC speaks for itself" (A paper of the Radical Education Project of SDS), in Judith Clavir Albert and Stewart Edward Albert (eds.), *The Sixties Papers: Documents of a Rebellious Decade*, p. 120.

[103] SNCC was a staff organization rather than a membership organization. All the white people who had been involved were active organizers. After they left SNCC, many found other ways to work in the movement and some were among the early organizers of the draft resistance movement.

[104] "SNCC speaks for itself" in Albert and Albert (eds.), *The Sixties Papers*, p. 117-18.

Chapter 10

[105] Dow Chemical manufactured Napalm and defoliants that were heavily used in Vietnam. Many other companies had Pentagon contracts and were developing weapons to be used in Vietnam. Bendix, for example, had a contract to learn what size droplet of liquid would fall to what depth of the forest canopy. It sounded purely academic, but the Defense Department wanted to know how to spray the defoliant Agent Orange on the jungles of Vietnam. An important factor in the war was that many companies were profiting from it.

[106] Microsoft *Encarta Encyclopedia 99*, Vietnam war, United States Strategy. In *Newsweek*, April 26, 1999, ex-Secretary of Defense Robert McNamara used a figure of 3,500,000 for the number of Vietnamese killed during the war. This doesn't count the approximately 2,000,000 Laotians and Cambodians killed. The total number of Americans killed is about 58,000.

[107] McNamara memo to President Johnson on May 19, 1967. McNamara, *In Retrospect*, p. 269.

[108] King, *Freedom Song*, p. 236.

[109] Paul Potter speech at the April 1965 march on Washington.

[110] Richie Rothstein, who I had worked with in the JOIN project in Chicago, coined this phrase to emphasize the long-term nature of the struggle.

[111] In 1971 the draft was eliminated and military service became voluntary.

Chapter 11

[112] Karnow, *Vietnam*, p. 490.

[113] Greg Calvert, "From Protest to Resistance," *New Left Notes*, January 13, 1967.

[114] Greg Calvert, "White America: Radical Consciousness and Social Change," in Masimo Teodori, *The New Left*, p. 412-418.

[115] I didn't realize at the time that Greg Calvert was struggling with his own sexual identity. Homosexuality was still widely misunderstood and condemned and, even within SDS, gay men and women stayed in the closet. See Greg Calvert, *Democracy from the Heart*.

[116] SDS was essentially gone by the time the modern gay rights movement started at the Stonewall Inn in New York City in June 1969, about a week after SDS's last convention. One of the early gay statements, "The Gay Manifesto," was written by SDS member Carl Wittman in 1970

[117] *Austin American Statesman*, April 7, 1967.

[118] This memo was among the papers thrown away by a UT administrator.

[119] While SDS was the largest student organization in Austin, there were smaller groups whose members were also members of SDS. There were differences of politics, but before Progressive Labor arrived the relationship was one of cooperation. The Austin chapter of the

Communist Party was probably one of the few truly psychedelic chapters in the country.

[120] McNamara, *In Retrospect*, p. 238, 275.

[121] Carl Oglesby, "This is Guernica," *New Left Notes*, September, 1967.

[122] Garrow, *Bearing the Cross*, p. 554-55.

[123] Donner, *The Age of Surveillance*, p. 440-46.

[124] *New Left Notes*, May 22, 1967. This paper was an update of an earlier paper titled, "Praxis and the New Left." Praxis is the dynamic tension between theory and practice. The implication was that their analysis and theory came from real world data and that the theory could be refined by applying it.

[125] The term "middle class" comes from American sociology and describes people's place in society based on their income, consumption, and attitudes. It is most often used to convince people that they are well off and obscures what Marx was trying to make clear – people's relationship to power. PL's nineteenth century Marxism had no place for large numbers of university students from working-class backgrounds. Rather than trying to understand this new phenomenon by applying Marx's analytical methods, PL resorted to using a term that was totally at odds with their supposed methodology.

[126] *New Left Notes*, May 29, 1967.

Chapter 12

[127] *New Left Notes*, July 10, 1967.

[128] Letter from Jason Serinus (Guy Nassberg) to author. March 16, 2000.

[129] Guy Nassberg, "Chicago T.O. Institute: An Analysis," *New Left Notes*, October 30, 1967.

[130] A routine investigation concentrating on George's friends led nowhere and eventually the case was shelved as an unsolved murder. Years later it was reopened as part of another murder investigation and Robert Zani, a former UT student, was convicted of the murder. There has always been speculation among George's friends that he was killed because of his politics – he was a member of the Communist Party, as well as SDS, and very visible. In 1993 a source close to the Austin police department told me that George had been warned that he was in possible danger. This source said that there was evidence that the murder was political, but that the prosecutors didn't need that evidence in order to get a conviction and that "influential people" didn't want it brought up.

[131] Jane Stembridge worked with SNCC in the South and wrote many poems about the experience. This quotation is from "The Peoples Wants Freedom."

[132] *Report of the National Commission on Racial Disorders* (the Kerner Commission), p. 143-48, 196, 206. *Intellegence Activities and the Rights of Americans. Book II*, Senate Report No. 94-755, 1976, U.S. Government

Printing Office, p. 77-78. See also O'Reilly, *Racial Matters*, p. 249-51, and Anderson, *The Movement and the Sixties*, p. 169-70.

Chapter 13

[133] Sale, *SDS,* p. 369-74. Also Tom Bates, *RADS*, p. 81-93.

[134] Report on the demonstration in *New Left Notes*, November 6, 1967. See also *The Movement*, November, 1967. (*The Movement* newspaper was published monthly in San Francisco during the sixties. It was associated with SNCC and then SDS)

[135] Mike Goldfield, "Power at the Pentagon," *New Left Notes*, October 30, 1967. See also Calvert, *Democracy from the Heart*, p. 244-251.

[136] McNamara, *In Retrospect*, p. 305.

[137] McMaster, *Dereliction of Duty*. See the index under "McNamara, Robert, deception and lies" for a long list of incidents.

[138] Wells, *The War Within*, p. 198.

[139] Robert Pardun, "The Direction of Resistance," *New Left Notes*, November 6, 1967.

[140] Carl Davidson, "Toward Institutional Resistance," *New Left Notes*, November 13, 1967.

[141] Carl Davidson and Greg Calvert, "Ten Days to Shake the Empire," *New Left Notes*, December 4, 1967.

[142] Robert Pardun, "National Program, Local Organizing, etc.," *New Left Notes*, December 18, 1967.

[143] *New Left Notes*, December 11, 1967.

[144] Milt Rosen "Build a Base in the Working Class," June 1967. Reprinted in *Revolution Today USA* in 1970.

[145] McNamara, *In Retrospect*, p. 299-300.

[146] McNamara, *In Retrospect*, p. 305-310.

[147] McMaster, *Dereliction of Duty*, p. 241. Also McNamara, *In Retrospect*, p. 196-97.

Chapter 14

[148] The government liked to use "conspiracy" as a way to attack groups. Conspiracy implied intent to act rather than action itself and created the image of a few people secretly planning illegal actions. This justified government action to stop it. Many of the trials of activists in the next few years were conspiracy trials. Although almost all of those trials ended in acquittals for the defendants, they took years and lots of money to fight, diverting these resources from other movement activities.

[149] Karnow, *Vietnam*, p. 463.

[150] Clifford, *Counsel to the President*, p. 473-78.

[151] O'Reilly, *Racial Matters*, p. 256-57.

[152] Churchill, *The COINTELPRO Papers* and O'Reilly, *Racial Matters*, p. 256.

[153] Jomo Kenyatta led the anti-colonial movement in Kenya and became President of Kenya in 1964. The Mau Mau was an anti-colonial guerrilla movement that was put down by the British in the mid-1950s. Jomo Kanyatta wasn't a member.

[154] Ward Churchill, *The COINTELPRO Papers*, p. 110, 126. Another goal was to prevent the rise of a "messiah" who could unify the black nationalist movement. In particular they were concerned about both Stokely Carmichael and Martin Luther King. King was assassinated in April 1968 and Carmichael was driven into exile.

[155] *New Left Notes*, April 11, 1968.

[156] "The December National Council: A Different View," *New Left Notes*, January 22, 1968.

[157] Carl Davidson, "A Critique of our Critics," *New Left Notes*, January 22, 1968.

[158] *National Guardian*, April 22, 1967, p. 2.

[159] For much more detail on the FBI's war against Martin Luther King and the black movement in general see O'Reilly, *Racial Matters*, and Ward Churchill, *The COINTELPRO Papers*.

[160] *Chicago Daily News*, April 17, 1968.

[161] Anderson, *The Movement and the Sixties*, p. 216.

[162] My interview for Kirkpatrick Sale, *SDS*, in about 1970.

Chapter 15

[163] The first indication of the FBI's coordinated attempt to destroy the movement came in March 1971 when hundreds of FBI documents were stolen from the FBI office in Media, Pennsylvania. These documents were published and led the way to Senate hearings and a US Senate report titled, *Intelligence Activities and the Rights of Americans*, published in 1976.

[164] Churchill, *The COINTELPRO Papers*, p. 33.

[165] O'Reilly, *Racial Matters*, p. 276.

[166] FBI document dated 5/9/68 in *The COINTELPRO Papers*, p. 177.

[167] Churchill, *The COINTELPRO Papers*, p. 179.

[168] J. Edgar Hoover, "Turbulence on Campus" *PTA Magazine*, February 1966.

[169] Churchill, *The COINTELPRO Papers*, p. 177.

[170] Churchill, *The COINTELPRO Papers*, p. 183-84.

[171] Dick Flacks, a professor at the University of Chicago was the subject of one of these letters. He later noted that a real *alumnus* of that university would never have signed a letter as "a concerned *alumni*."

[172] Frank Donner, *The Age of Surveillance*, p. 305-07.

[173] Churchill, *The COINTELPRO Papers*, p. 148-52.

[174] For more detailed information see Churchill, *COINTELPRO Papers*.

[175] We never had an exact count of the number of members in SDS because we never cared about formal membership. We considered anyone who was active in a chapter to be a member, even if they didn't carry an SDS card. Our estimates were made by taking the number of paid members and multiplying by our estimate of how many non-paying members there were for each paid member.

[176] Richard G. Powers, *The Life of J. Edgar Hoover*, p. 430.

[177] By 1971, in a survey done for *Playboy* magazine, the number had jumped to 1,170,000. Since these were surveys of university students, there could easily have been twice this many who were in the high schools or who weren't students at all. What the students meant by revolution is not known but most of this talk of revolution came out of frustration about the ongoing Vietnam War and the US government's unresponsiveness.

[178] Senate hearings on "Riots, Civil and Criminal Disorders," Part 18, p. 3654. Quoted in Sale, *SDS*, p. 456.

[179] The text of the speech has been preserved thanks to the presence of a spy from the Young Americans for Freedom who turned in a report to the FBI. It was included in the release of files from the Chicago office of the FBI as part of my appeal.

[180] A year later, in June 1969, SDS split. The Revolutionary Youth Movement retained the SDS office in Chicago, while those who went with PL also called themselves SDS and opened an office in Boston. Later that summer, two of PL's leaders, Jared Israel and Jeff Gordon, were called before the "real" leadership of PL, including Milt Rosen, and told to forget the war and make the Worker-Student Alliance a reality. The word was passed on to the membership and PL-SDS died soon thereafter. Zaroulis and Sulivan, *Who Spoke Up?*, p. 262-63.

[181] Amerika, with a "k," symbolized the similarities we saw between the German Holocaust and what the US was doing in Vietnam. We also used the spelling Amerikkka when we wanted to stress how the government, in particular the FBI and police, was treating the black movement.

Chapter 16

[182] Gitlin, *The Sixties*, p. 334.

[183] Knowing what we now know about the FBI's COINTELPRO I have no doubt that they may have helped exaggerate the hostility between the American people and the anti-war movement as part of their plan to destroy the movement.

[184] Clifford, *Counsel to the President*, p. 581-84.

[185] U.S. B-52 bombers killed perhaps 750,000 Cambodians between 1969 and 1973 as Nixon extended the war beyond Vietnam. The direct result was the rise of the Pol Pot and the Khmer Rouge, which with U.S. financial support, killed at least another million and a half people. "The

Friends of Pol Pot," *The Nation*, May 11, 1998.

[186] Clifford, *Counsel to the President*, p. 581-87.

[187] Just days before the meeting in Boulder, the Mexican army opened fire on student demonstrators with automatic weapons. The number killed was classified as top secret by the Mexican government but has been estimated at between 200 and 2,000. At the Olympics in Mexico City several weeks after the shooting, two black American medal winners silently raised their fists in solidarity with the Mexican students and were expelled for "violating the standards of sportsmanship and good manners which are so highly regarded by the United States." The next day three black winners of the gold, silver, and bronze medals raised their clenched fists in defiance of the ruling.

[188] This information is in my personal FBI file.

[189] Wells, *The War Within*, p. 327.

[190] Fred Branfman, "The President's Secret Army – A Case Study – The CIA in Laos 1962-1972," *The CIA File and the Cult of Intelligence*, J. Marks, ed.

[191] US Senate Report No. 94-755. *Intelligence Activities and the Rights of Americans.*

[192] Quoted by Elizabeth Drew, "Washington," *Atlantic*, May, 1969, p. 4-12.

[193] O'Reilly, *Racial Matters*, p. 297-98. Note the word *possible* (italics mine). Instead of having a crime and looking for the criminal, the FBI picked the "criminal" and tried to find a crime to pin on him.

[194] Churchill, *The COINTELPRO Papers*, p. 147-153.

[195] Dan Baum, *Smoke and Mirrors: The War on Drugs and the Politics of Failure*, p. 6-20. President Reagan's drug advisor, Carlton Turner, made explicit what Nixon had kept hidden – the drug war was also a war against the left. He said that marijuana was part of a pattern of behavior that included "anti-military, anti-nuclear, anti-big business, anti-authority demonstrations; of people from a myriad of different racial, religious or otherwise persuasions demanding 'rights' or 'entitlements' politically while refusing to accept corollary civic responsibility." (Baum, p. 154.)

[196] Rossinow, *The Politics of Authenticity*, p. 176.

[197] Greg left the national office in the spring of 1968 and moved to Austin to work on organizing a Movement for a Democratic Society. He was living with Carol Neiman and they were writing a book, *Disrupted History: The New Left and the New Capitalism*.

[198] The underground railway was a series of safe houses along a route leading to Canada. Once a person was in the system they were moved from one station to another. This was modeled on the underground railway used to help slaves escape to the North. Each person on the route knew only as much as necessary to function.

[199] In order to protect the people involved in clandestine activity, it was important that no one know more than they needed to know.

[200] Gitlin, *The Sixties*, p. 354-61.

[201] Ashley, Ayers, Dohrn, *et. al.*, "You Don't Need a Weatherman to Know Which Way the Wind Blows," *New Left Notes*, June 18, 1969.

[202] Bill Ayers was from the University of Michigan and had done regional organizing in that area. Jeff Jones had attended Antioch College and later worked in the NY regional office. Mark Rudd was active in the actions at Columbia University.

[203] The Weathermen adopted the position that "anyone who acts like a pig is a pig" meaning that those who didn't completely share their politics were the enemy. They believed that a street fighting movement would attract working class youth and began a series of actions to put the idea into practice. RYM II didn't believe that the United States was in a revolutionary situation and advocated building a base through organizing. They saw violent demonstrations as alienating to industrial workers, the only real agents of revolutionary change, and wanted to build a broad-based anti-imperialist movement of students and workers. They emphasized organizing at community colleges and trade schools because that was where many of the sons and daughters of the working class were in school.

[204] Zaroulis and Sullivan, *Who Spoke Up*, p. 262-63.

Chapter 17

[205] We discovered later that both these groups were used to attack us. In San Diego, the Minutemen were used to attack the people and offices of the left. For detail see Donner, *The Age of Surveillance*, p. 440-46.

In Chicago, many people believe that the Legion of Justice was behind the attack on Professor Richard Flacks, an SDS member. The attacker came to Dick's office at the University of Chicago with a crowbar and beat him nearly to death. (Interview with Dick Flacks for the film *Rebels with a Cause* by Helen Garvy.)

[206] They had started out as the Chicago Eight, but Bobby Seale of the Black Panthers demanded his own lawyer and protested loudly about the proceedings. Judge Julius Hoffman finally had him bound and gagged in the courtroom. When that didn't stop him, he was removed from the group and tried separately, leaving the Chicago Seven.

[207] Wells, *The War Within*, p. 366-69.

[208] *U.S. News & World Report*, June 16, 1969, p. 11.

[209] To my knowledge, other than the three Weathermen killed by their own bomb, only one person was killed accidentally in all the bombings. At 3 AM on August 24, 1970, a bomb destroyed the Army Math building at the University of Wisconsin. One research scientist, Bob Fassnacht, was in the building and was killed. The Weathermen were not involved in this bombing. See Bates, *RADS*.

[210] Wells, *The War Within*, p. 355-57.

[211] Wells, *The War Within*, p. 107. A few of the government officials whose children were anti-war activists are: Secretary of Defense Robert McNamara, Secretary of State Dean Rusk, Secretary of the Navy Paul Nitze, Attorney General Nicholas Katzenbach, Secretary of the Army Stanley Resor, and Head of the National Security Council McGeorge Bundy.

[212] Churchill, *The COINTELPRO Papers*, p. 139-141. The Chicago police paid almost $2 million to the families of Fred Hampton and Mark Clark.

[213] Churchill, *The COINTELPRO Papers*, p. 142.

[214] Geronimo Ji Jaga was released in 1998 when the courts finally decided to look at evidence proving that the FBI withheld wiretap records that proved Geronimo was in Oakland at the time of the murder. It was also shown that the FBI had sent inflammatory letters to the Oakland Panthers that appeared to be from the L.A. Panthers. The Oakland Panthers, fooled by the fake letters, had originally refused to testify that Geronimo was in Oakland at the time of the murder.

The total number of Panthers killed as a result of police attacks or attacks by rival groups that were provoked by the police/FBI is uncertain but about forty have been documented. Sources include *Lest We Forget*, a pamphlet by Safiya A Bukhari and letter from independent historian Craig Ciccone to author.

[215] The number of people in the Weather Underground was probably no more than a couple of hundred.

[216] Survey of The Alcohol, Tobacco, and Firearms division of the US Treasury, part 24, July 1970.

[217] "Dallas News Interviews Bartee Haile of the John Brown Revolutionary League," *Dallas News*, August 12, 1970.

Chapter 19

[218] Based on my experience as a steel fabricator, I wrote *How to Build with Steel* (Shire Press, 1999), a manual for people who work full-time as steel fabricators or have an occasional project.

Chapter 20

[219] *Rebels with a Cause*, documentary film on SDS by Helen Garvy, 2000.

Appendix

[220] Statistics come from: Harrison, *The Endless War*; Karnow, *Vietnam*; Bernard Nietschmann, "Battlefields of Ashes and Mud." *Natural History*, November 1990; *World Book Encyclopedia*, 1986 edition. For an excellent description of America's military might and its effects on the people, culture and environment of Vietnam told by a first-hand observer see Karnow. *Vietnam*, Chapter 12.

Bibliography

Albert, Judith Clavir and Stewart Edward Albert, eds. *The Sixties Papers: Documents of a Rebellious Decade.* New York: Praeger, 1984.

Ali, Tariq and Susan Watkins. *1968: Marching in the Streets.* New York: The Free Press, 1998.

Aptheker, Herbert. *American Negro Slave Revolts.* New York: International Publishers, 1969.

Anderson, Terry H. *The Movement and the Sixties.* New York: Oxford Univ. Press, 1995.

Bates, Tom. *RADS: The 1970 Bombing of the Army Math Research Center at the University of Wisconsin and its Aftermath.* New York: HarperCollins, 1992.

Baum, Dan. *Smoke and Mirrors: The Drug War and the Politics of Failure.* New York: Little Brown and Company, 1996.

Beschloss, Michael. *Taking Charge: The Johnson White House Tapes, 1963-1964.* New York: Simon and Schuster, 1997.

Bloom, Alexander and Wini Breines, eds. *"Takin' it to the Streets:" A Sixties Reader.* New York: Oxford University Press, 1995.

Branfman, Fred. "The President's Secret Army: A Case Study—The CIA in Laos, 1962-1972." In J. Marks, ed., *The CIA and the Cult of Intelligence.* New York: Alfred A. Knopf, 1974.

Breines, Wini. *Community and Organization in the New Left, 1962-1968. The Great Refusal.* New Brunswick: Rutgers University Press, 1989.

Burr, Beverly. "History of Student Activism At the University of Texas at Austin (1960-1988)." Thesis 1988.

Calvert, Gregory. *Democracy from the Heart: Spiritual Values, Decentralism, and Democratic Idealism in the Movement of the 1960s.* Eugene, OR.: Communitas Press, 1991.

Calvert, Greg, and Carol Neiman. *Disrupted History: The New Left and the New Capitalism.* New York: Random House, 1971.

Chomsky, Noam. "Memories." *Z Magazine,* July-August 1995.

Churchill, Ward, and Jim Vanderwall. *The COINTELPRO Papers: Documents from the FBI's Secret Wars Against Domestic Dissent.* Boston: South End Press, 1990.

Clifford, Clark, with Richard Holbrooke. *Counsel to the President: A Memoir.* New York: Random House, 1991.

Cowan, Paul, Nick Egleson, and Nat Hentoff. *State Secrets: Police Surveillance in America.* New York: Holt, Reinhart and Winston, 1974.

Dallek, Robert. *Flawed Giant: Lyndon Johnson and his Times 1961-1973.* New York: Oxford University Press, 1998.

Dellinger, Dave. *More Power Than We Know: The People's Movement Toward Democracy.* Garden City, NY: Anchor/Doubleday, 1975.

Debray, Regis. "Revolution in the Revolution: Armed Struggle and Political Struggle in Latin America." New York: *Monthly Review Press*, 1967.

Donner, Frank J. *The Age of Surveillance: The Aims and Methods of Americas's Political Intelligence System*. New York: Vintage Books, 1981.

Doyle, Edward, Samuel Lipsman, *et al. The Vietnam Experience: America Takes Over 1965-67*. Boston: Boston Publishing, 1982.

Du Bois, W.E.B. *The Souls of Black Folk*. New York: Fawcett, 1961.

Eisenhauer, Dwight D. *Mandate for Change: 1953-56*. Garden City, NY: Doubleday 1963.

Falk, Richard, Gabriel Kolko, and Robert Jay Lifton. *Crimes of War*. New York: Vintage Press, 1971.

Fanon, Frantz. *The Wretched of the Earth*. New York: Grove Press, 1963.

Garrow, David J. *Bearing the Cross: Martin Luther King and the Southern Christian Leadership Conference*. New York: Morrow, 1986.

Gitlin, Todd. *The Sixties: Years of Hope, Days of Rage*. New York: Bantam Books, 1987.

Gitlin, Todd and Nanci Hollander. *UPTOWN: Poor Whites in Chicago*. New York: Harper Colophone, 1970.

Glick, Brian. *War at Home: Covert Action against U.S. Activists and What We Can Do About it*. Boston: South End Press, 1989.

Goines, David Lance. *On the Free Speech Movement*. Berkeley: Ten Speed Press, 1993.

Goldstein, Robert Justin. *Political Repression in Modern America: 1870 to Present*. New York: Two Continents Publishing Group, 1978.

Goodman, Mitchell, ed. *The Movement Toward a New America: The Beginnings of a Long Revolution*. New York: Knopf, 1970.

Green, Felix. *VIETNAM! VIETNAM!* Palo Alto: Fulton, 1966.

Harrison, James P. *The Endless War. Vietnam's Struggle for Independence*. New York: Columbia University Press, 1989.

Hayden, Casey and Mark King. "Sex and Caste: A Kind of Memo." *Liberation*, April 10, 1966.

Hayden, Tom. *Reunion: A Memoir*. New York: Random House, 1988.

Hersh, Seymour M. *The Price of Power: Kissinger in the Nixon White House*. New York: Summit Books, 1983.

Holt, Len. *The Summer That Didn't End: The Story of the Mississippi Civil Rights Project of 1964*. New York: De Capo Press. 1992.

Humphrey, Hubert. *The Education of a Public Man*. Garden City, NY: Doubleday, 1979.

Jacobs, Harold, ed. *Weatherman*. San Francisco: Ramparts Press, 1970.

Jacobs, Ron. *The Way the Wind Blew*. London: Verso, 1997.

Jezer, Marty. *The Dark Ages: Life in the United States 1945-1960*. Boston: South End Press, 1982.

Kahin, George McTurnan and John W. Lewis. *The United States in Vietnam: An Analysis in Depth of the History of America's Involvement in Vietnam*. New York: Dell Publishing, 1969.

Karnow, Stanley. *Vietnam: A History*. New York: Penguin Books, 1991.

Karnow, Stanley. "Never Again," a review of *Argument without End: In Search of Answers to the Vietnam Tragedy* by Robert McNamara *et al* in *The Los Angeles Times*, Sunday, May 16, 1999.

Kearns, Doris. *Lyndon Johnson and the American Dream*. New York: Harper and Row, 1976.

Kempton, Murray. "Heart of Darkness." *New York Review of Books*, November 24, 1988.

Kerr, Clark. *The Uses of the University*. New York: Harper and Row, 1963.

King, Mary. *Freedom Song: A Personal Story of the 1960s Civil Rights Movement*. New York: Quill-William Morrow. 1987.

Lawson, Rev. William. "Will They Die?" Reprinted in *The Movement*, Sept. 1967. (*The Movement 1964-1967*. Compiled by the staff of the Martin Luther King, Jr. Papers Project, Westport, CN, Greenwood Press, 1993)

Lembcke, Jerry. *The Spitting Image: Myth, Memory, and the Legacy of Vietnam*. New York: New York University Press, 1998.

Loewen, James W. *Lies My Teacher Told Me*. New York: The New Press, 1995.

McCoy, A.M. *The Politics of Heroin in Southeast Asia*. New York: Harper and Row. 1972.

McMaster, Maj. H.R. *Dereliction of Duty: Johnson, McNamara, the Joint Chiefs of Staff, and the Lies that Led to Vietnam*. New York: HarperCollins, 1997.

McNamara, Robert S. *In Retrospect: the Tragedy and Lessons of Vietnam*. New York: Vintage Press, 1996.

McWilliams, Carey. *Witch Hunt: The Revival of Heresy*. Boston: Little Brown, 1950.

Miller, James. *"Democracy is in the Streets:" From Port Huron to the Siege of Chicago*. New York: Touchstone, 1987.

Miller, Timothy. *The Hippies and American Values*. Knoxville: The University of Tennessee Press, 1991.

Nietschmann, Bernard. "Battlefields of Ashes and Mud." *Natural History*, November, 1990.

Oglesby, Carl. "Notes on a Decade Ready for the Dustbin." *Liberation*, August-September, 1969.

Oglesby, Carl. "Trapped in a System." Speech given at the March on Washington, October 27, 1965. In Bloom and Breines, *"Takin' it to the Streets."*

O'Reilly, Kenneth. *"Racial Matters:" The FBI's Secret File on Black America, 1960-1972*. New York: The Free Press, 1989.

Ollestad, Norman. *Inside the FBI*. New York: Lyle Stuart, 1967.

Palmer, R.R. *The Age of Democratic Revolution*. Princeton: Princeton University Press, 1964.

Peery, Nelson. "The Historical Significance of the Watts Uprising." *People's Tribune/Tribuno del Pueblo* (online edition) Vol. 27 No. 8/August, 2000.

Pilger, John. "The Friends of Pol Pot." *The Nation*. May 11, 1998.

Potter, Paul. *A Name for Ourselves: Feelings about Authentic Identity, Love, Intuitive Politics, Us*. Boston: Little Brown and Company, 1971.

Powers, Richard Gid. *The Life of J. Edgar Hoover: Secrecy and Power*. New York: The Free Press, 1987.

Powers, Thomas. *Vietnam: The War at Home*. New York: Grossman, 1973.

Progressive Labor Party. *Revolution Today USA*. New York: Exposition Press, 1970.

Rossinow, Doug. *The Politics of Authenticity: Liberalism, Christianity, and the New Left in America*. New York: Columbia University Press, 1998.

Rossman, Michael. *The Wedding Within the War*. Garden City: Anchor Books, 1971.

Sale, Kirkpatrick. *SDS*. New York: Random House, 1973.

Sheehan, Neil; Smith, Hedrick; Kenworthy, E. W.; and Butterfield, Fox. Edited by Gerald Gold, Allan M. Siegal, and Samuel Abt. *The Pentagon Papers* (NY Times). New York: Bantam, 1971.

Sheehan, Neil. *A Bright Shining Lie: John Paul Vann and America in Vietnam*. New York: Random House, 1988.

Students for a Democratic Society. *The Port Huron Statement*. Chicago: Charles H. Kerr Company, 1990.

Students for a Democratic Society. *America and the New Era*. Wisconsin State Historical Society. SDS archive.

Students for a Democratic Society. *New Left Notes*. Wisconsin State Historical Society. SDS archive.

Swearingen, M. Wesley. *FBI Secrets: An Agents Expose*. Boston: South End Press, 1995.

Teodori, Massimo, ed. *The New Left: A Documentary History*. Indianapolis: Bobbs-Merrill, 1969.

US Senate, *Hearings Before the Select Committee to Study Governmental Operations With Respect to Intelligence Activities of the US Senate, 94th Congress, Volume 6, The Federal Bureau of Investigation*. US Government Printing Office, 1976

US Senate, *Final Report of the Select Committee To Study Governmental Operations With Respect to Intelligence Activities of the US Senate, 94th Congress*. US Government Printing Office, Report number 94-755, 1976.

Walker, Daniel. *Rights in Conflict: The Violent Confrontation of Demonstrators and Police in the Parks and Streets of Chicago During the Week of the Democratic National Convention of 1968.* New York: Bantam Books, 1968.

Waterhouse, Larry and Mariann Wizard. *Turning the Guns Around: Notes on the GI Movement.* New York: Praeger, 1971.

Weisbrot, Robert. *Freedom Bound: A History of America's Civil Rights Movement.* New York: W.W. Norton, 1991.

Wells, Tom. *The War Within: America's Battle over Vietnam.* Berkeley: University of California Press, 1994.

Wise, David. *The Politics of Lying: Secrecy and Power.* New York: Random House, 1973.

Wise, David. *The American Police State.* New York: Random House, 1976.

Zaroulis, Nancy and Gerald Sullivan. *Who Spoke Up?: American Protest Against the War in Vietnam, 1963-1975.* Garden City: Doubleday, 1984.

Zinn, Howard. *A People's History of the United States.* New York: Harper and Row, 1980.

Photo Credits

Austin History Center: 164 (Austin Public Library, detail from
 PICA AS66-55685[1])
Jude Binder: 147, 292
Robert Joyce: 104 (Robert Joyce Photography Collection. Special
 Collections Library, the Pennsylvania State University Libraries,
 University Park, PA.)
C. Clark Kissinger: 74
Peter Levine: 302, 312
Char Pittman Dethoff: 98, 118
Alan Pogue: 289
Jeff Shero Nightbyrd 40, 41, 75, 83, 114, 119, 132
Steve Shapiro (Black Star): 56
Jack A Smith: 199, 254, cover (right)
Mariann Wizard: 163

Index

Order Form

If you can't find *Prairie Radical* in your local bookstore, additional copies are available from Shire Press.

Prairie Radical is the memoir of a young man whose life was radically changed when he joined the civil rights movement and spoke out against the war in Vietnam. It is an inside history of Students for a Democratic Society (SDS), the largest student organization of the 1960s, as seen by one of its national officers who spent 1967-68 in the SDS national office at the height of the antiwar movement. It is also the history of the vibrant and innovative SDS chapter at the University of Texas in Austin, one of the Prairie Power strongholds, where the cultural rebellion and the political movement were united. Robert Pardun's story is set within the context of what was happening in Vietnam and interwoven with what we now know was happening inside the government and the FBI.

SHIRE PRESS • 26873 Hester Creek Rd, Los Gatos, CA 95033

Send _____ copies of *Prairie Radical* ($15) $_____

 (postage & handling: $2 per book) $_____

 Total $_____

Please enclose payment with your order. California residents add sales tax.

Send to:
